THE MODERN
THAI HOUSE

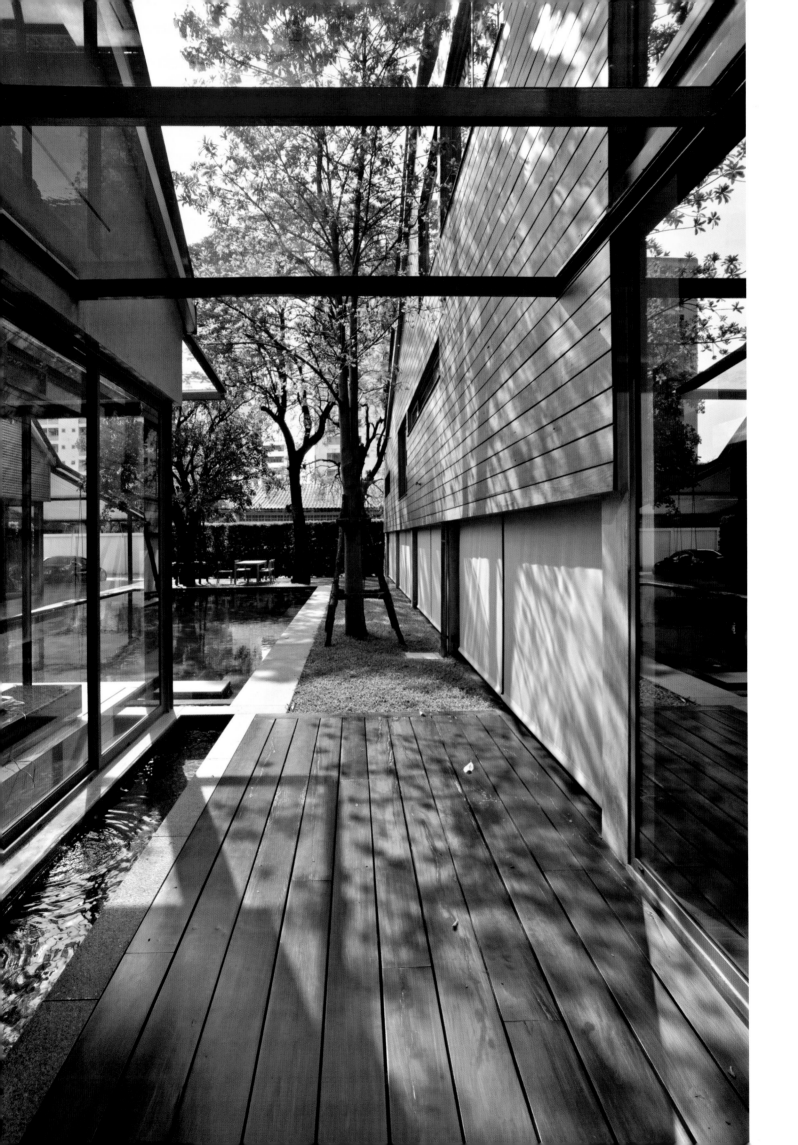

THE MODERN THAI HOUSE

INNOVATIVE DESIGN IN TROPICAL ASIA

Robert Powell

Photography by Albert Lim KS

TUTTLE Publishing

Tokyo | Rutland, Vermont | Singapore

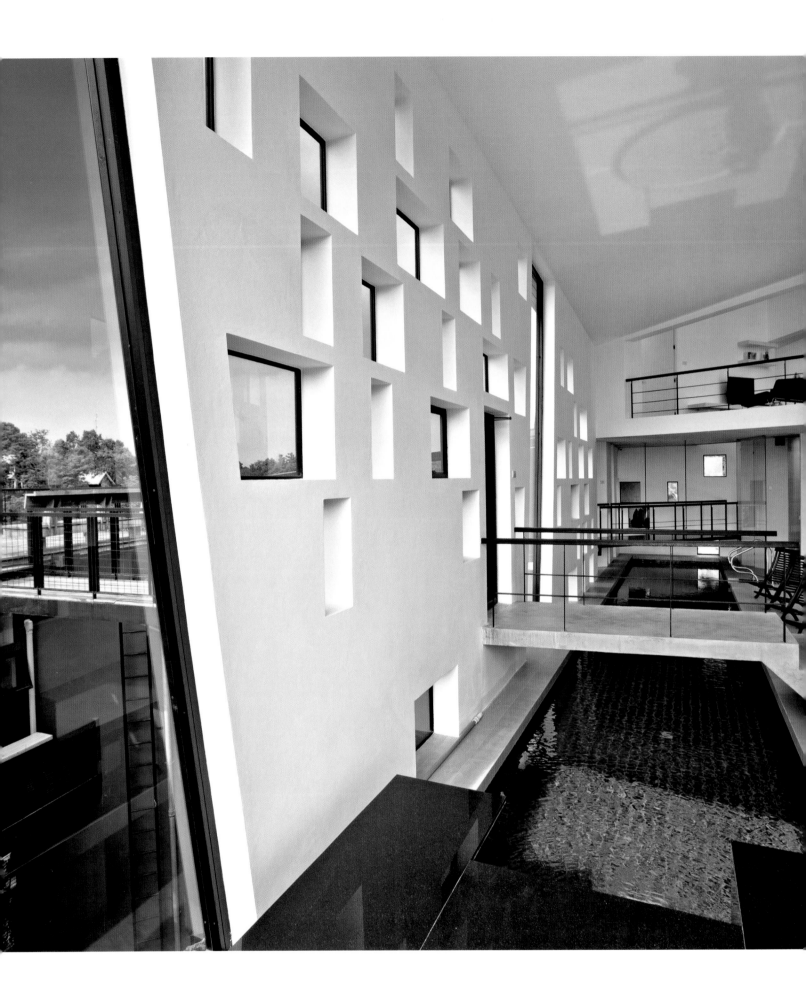

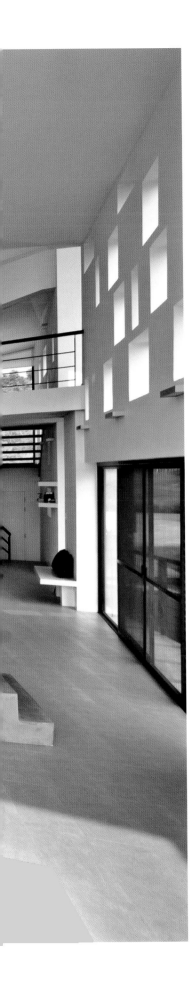

CONTENTS

THE MODERN THAI HOUSE

Robert Powell

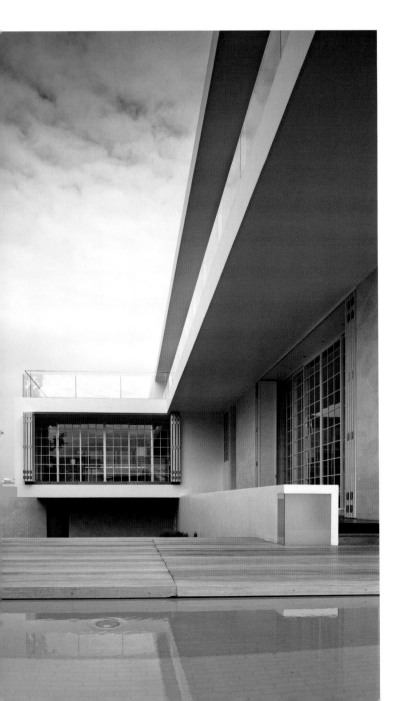

'Modern architecture is a creation of the West. In a non-Western context, it normally reflects a direct intervention of the Western powers through colonization. However, Thailand is an exception. Thai people adopted and assimilated Modern Architecture into their unique cultural tradition without being directly colonized.' *Koompong Noobanjong*[1]

A decade has elapsed since the publication of my first book on houses in Thailand, entitled *The New Thai House*,[2] which was, arguably, the first publication in the English language to bring to the attention of an international audience the ground-breaking residential designs of an emerging generation of Thai architects, including Kanika R'kul (Ratanapridakul), Duangrit Bunnag and Somchai Jongsaeng. An informative essay in the book by Duangrit Bunnag, entitled 'Co-Evolving Heterogeneity',[3] provided the historical context to the imaginative dwellings that were springing up in Thailand as the world entered a new millennium.

Ten years later, with rapid globalization and the penetration of digital technology into all aspects of life, the architectural landscape in Southeast Asia is changing rapidly and it is an appropriate time to assess the progress of the architects who I encountered in 2002 and, in addition, to visit the work of others who have attracted attention in the architectural media, among them Vasu Virajsilp and Boonlert Deeyuen of VaSLab Architecture, Tanit Choomsang and Khwanchai Suthamsao of Plankrich Architects and Boonlert Hemvijitraphan of Boon Design.

It was also an opportunity to renew a friendship with Dr Sumet Jumsai, a polymath and one of Thailand's most respected modern architects. Now in his early seventies, Dr Jumsai devotes much of his productive time to painting. I heard that he had designed and built an entrancing Le Corbusier-inspired weekend studio in Sriracha, one hour south of

Left The modern architectural language of the Komkrit House, Bangkok (page 192).

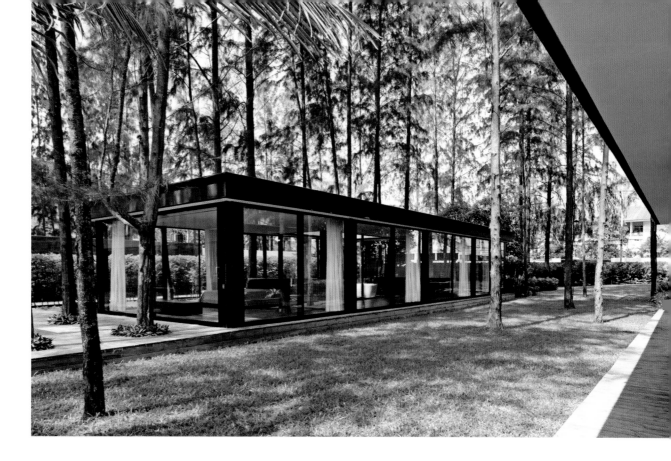

Bangkok, and this was enough to entice me back to the Thai capital.

But first let me explain how I came to be interested in Thailand's architecture. In June 1984, I took up an appointment in the School of Architecture at the National University of Singapore (NUS). Although my brief was to teach a design studio and to give Urban Design lectures based on mid-twentieth century European and American sources such as Kevin Lynch, Christopher Alexander, Rob Krier, Gordon Cullen and Jan Gehl, my real interest lay in contemporary Southeast Asian architecture. Thus, I set out in September of that year to backpack through Thailand. One of my colleagues in the School of Architecture in Singapore in 1984 was Mathar 'Lek' Bunnag, a Thai architect, recently graduated from Harvard University, who had taken up a teaching post at NUS prior to setting up his own successful practise. With Mathar's assistance, I planned a route that took me from Bangkok to Chiangmai by train and thence by local transport to Fang where I boarded a ferryboat on the Fang River and journeyed downriver (accompanied by an armed guard) along the Burmese (Myanmar) border to Chiangrai, and then on to Mae Sae in the Golden Triangle overlooking Laos and Myanmar, before returning south on buses via Sukhothai and Ayuthaya.

The following year I was invited by Dr Suha Özkan, then the Deputy Secretary-General of the Aga Khan Award for Architecture (AKAA) in Geneva, and now the President of the World Architecture Community (WAC) based in Istanbul, to edit a series of seminar proceedings. The first of these seminars was held in Kuala Lumpur to debate *Architecture and Identity*.[4] One of the participants in that symposium was Sumet Jumsai, who contributed a paper entitled 'House on Stilts: Pointer to South East Asian Cultural Origin'. It was a condensed version of his major publication, *Naga: Cultural Origins in Siam and the West Pacific*.[5] Hard on the heels of the Kuala Lumpur seminar came another in Bangladesh that explored the notion of *Regionalism in Architecture*.[6] A year later, the AKAA assembled

on the Mediterranean island of Malta, conveniently close to North Africa, to discuss *Criticism in Architecture*,[7] and a fourth seminar one year later in Zanzibar addressed the subject of *The Architecture of Housing*.[8] It was at this gathering in East Africa that I first encountered and subsequently befriended Geoffrey Bawa, the renowned Sri Lankan architect who had such a profound influence on young architects in Southeast Asia from the mid-1980s onwards.

The informed discussions that took place at these four gatherings fueled my interest in residential architecture in Southeast Asia, and in the early 1990s I was commissioned by Lena Lim U Wen of Select Books (later Select Publishing) in Singapore to write *The Asian House*,[9] an investigation of new houses in the region. I included five houses in Thailand, two of them—Baan Rim Nam (1990) and Baan Soi Klang (1990)—designed by Nithi Sthapitanonda of A49. Khun Nithi, the Chairman of A49, was the pivotal figure in my early research on new houses in Thailand. Through his firm's promotion of the journal *art4d*, he has brought the work of many young Thai architects to the attention of a wider audience. Today, he continues to do this through Li-Zenn Publishing.[10]

Other houses that featured in my first foray into Thailand included Baan Ton Son (1990) designed by Prapapat and Theeraphon Niyom of Plan Architect Co. Ltd., the Vacharphol House (1990) designed by John Rifenberg, a long-time American resident in Bangkok, and the Tiptus House (1983), a seminal dwelling built for their own occupation by Booyawat and Pussadee Tiptus. The latter house was a conscious act of resistance to the intrusion of 'international style' architecture into Thai culture, and it received the Association of Siamese Architects under Royal Patronage Gold Medal in 1984.

Baan Ton Son was thought-provoking for it was the first time I had encountered the concept of a 'three-generation house'. It is a form of family dwelling not commonly found in the UK where I spent my

Above A Miesien pavilion at Villa Noi, Phuket (page 110).

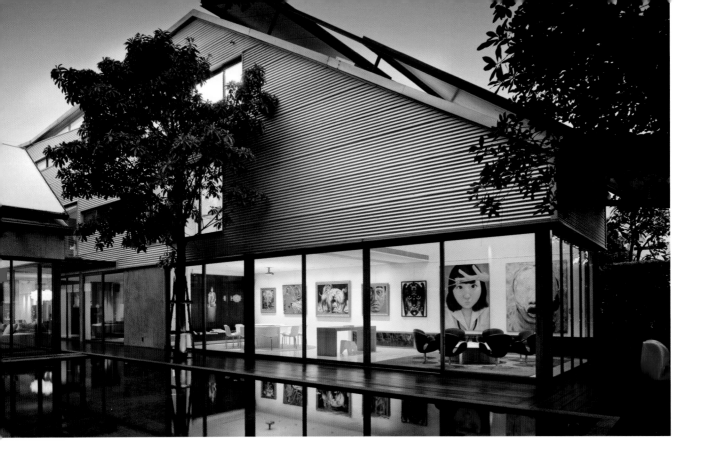

childhood and, indeed, it seems to be a uniquely Asian concept closely tied to a culture of filial piety. I will return to this later.

The other issue that I found enthralling in the five houses was the discourse on Thai 'identity' expressed through architecture. It paralleled discussion elsewhere in Southeast Asia and brought to mind the issues that were debated at the seminar in Kuala Lumpur in 1983. Architectural identity was often seen as the resolution of a 'paradox' expressed by the French philosopher Paul Ricour in his oft-quoted 1965 essay on 'Universal Civilisations and National Cultures'. In this he wrote: 'In order to get on the road to modernisation, is it necessary to jettison the old cultural past...? On the one hand the nation has to root itself in the soil of its past, forge a national spirit and unfurl this spiritual and cultural revindication of the colonists personality. But in order to take part in modern civilisation, it is necessary at the same time to invest in scientific, technical and political rationality; something which often requires the pure and simple abandonment of a whole cultural past. There is the paradox; how to become modern and to return to your sources.'[11] Notwithstanding the fact that Thailand has never been under colonial rule, all five houses, it occurred to me, were attempts to resolve this paradox.

Duangrit Bunnag has succinctly summarized this situation in the Thailand context. 'Part of the political agenda of Siamese architecture', he wrote in his 2003 essay, 'has been to reject the international move-ment in architecture as a heretic idea capable of destroying "locality" in Thai architecture. Nevertheless in the latter half of the 20th century Thai architecture could never have advanced without the foreign factor.... The idea of a global lifestyle utilizing contemporary forms, modern materials and information technology has become the crucial "external force" that co-evolves with Thai "internal forces" of culture, tradition, environment and context.'[12]

Three years later, I published another book, *The Tropical Asian House*,

that continued my investigation.[13] Once again, I returned to consult Nithi Sthapitanonda at A49 and included Baan Chang Nag, a vacation house he had designed in Chiangmai (1994). This house was closely aligned with traditional forms, as was Baan Bill Bensley (1992), the faithful reconstruction of two traditional dwellings in Bangkok by Bill Bensley and Saichol Saejew of Bensley Design studio to form an urban home for the expatriate American landscape architect and his partner Jirachai. A third home, the Dutchanee House (1980), was another reconstructed traditional dwelling in Chiangrai by the controversial artist Thawan Dutchanee. In complete contrast were two houses that employed a totally modern architectural language, namely the Cubic House (1990) by Vittvat Charoenpong, an assistant dean in the Faculty of Architecture at Rangsit University, and Baan In-Chan (1993) by Chirakorn Prasongkit of ACP Co. Ltd.

In 1997, I was invited by Duangrit Bunnag to address the Association of Siamese Architects Under Royal Patronage on 'Regionalism in Architecture'. The previous year, the annual lecture had been delivered by Zaha Hadid on 'Urban Phenomena' and the following year by Rem Koolhaas on 'Brave New World', so the invitation appeared to recognize the relevance of the issues raised in my earlier books.

The *Tropical Asian House* proved to be a huge success and my publisher encouraged me to write a third volume, *The Urban Asian House*.[14] This book included Baan Prabhawiwat (1997), another house designed by Vittvat Charoenpong, and Baan Impuntung (1997), the home of Vira Impuntung, an associate professor at the School of Architecture at Silpakorn University.

Two more years passed and I returned to Thailand while researching a fourth book, *The New Asian House*.[15] It was evident there was increasing confidence among a younger generation of architects returning from their studies overseas. House U3 designed by Kanika Ratanapridakul

Above The formal guest reception area in the Three Parallel House, Nonthaburi (page 38).

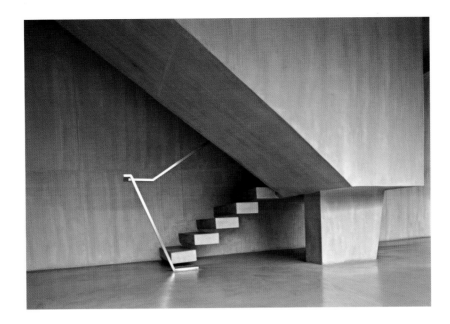

(1997) was a seminal residence that was modern and yet embodied the spirit of a traditional dwelling. The Chindavanig House (1992) by Thanit Chindavanig, an assistant professor at Chulalongkorn University, also explored a modern expression of a traditional form. Two other houses, the Krissana Tanatanit House (1997) by Channa Sumpalang of A49, and a modern house designed for his own family by Somchai Jongsaeng of DECA Atelier (1990), completed the entries in the book.

The following year, my publisher decided to bring all sixteen houses together in a single volume, *The New Thai House*,[16] and I added four more houses—the V42 House (2002) by DBALP, the emerging practise of Duangrit Bunnag; Baan Tawan-ork (2002) by Pirast Pacharaswate, an assistant professor in the School of Architecture at Chulalongkorn University; Baan Rimtai (2000), a resort villa in Chiangmai by Nithi Sthapitanonda of A49, and the innovative modern Prabhakorn House (2002) by the successor to Khun Nithi as chairman of A49, Prabhakorn Vadanyakul. The twenty houses were together a condensed summary of the development of the modern Thai house from 1980 to 2002.

THE MODERN THAI HOUSE 2002–2012

'Throughout history the private house has played [a] role. Unlike large projects, which normally require broader societal corporate or political consensus, the private house can be realized through the efforts of a few people. It often expresses in the most uncompromising way possible, the vision of a client or architect, or both.' *Terence Riley*[17]

Fast forward ten years to the current publication—*The Modern Thai House*. In 2010, I assembled a list of houses, initially seeking advice from the architects whose work appeared in previous books, and in April 2011 I embarked on an extensive journey with photographer Albert Lim KS to visit some forty houses that we had identified.

The houses are located in or are readily accessible from Bangkok, Phuket and Chiangmai and are, with several notable exceptions, the product of a generation of Thai architects who at the time of writing are in their late thirties or early forties. They include Aroon Puritat, Boonlert Deeyuen, Boonlert Hemvijitraphran, Bundit Kanisthakhon, Duangrit Bunnag, Juthathip Techachumreon, Kanika R'kul (Ratanapridakul), Kwanchai Suthamsao, Pattawadee Roogrojdee, Pirast Pacharaswate, Ponlawat Buasri, Somchai Jongsaeng, Songsuda Adhibai, Srisak Phattanawasin, Surachai Akekapobyotin, Tanit Choomsang and Vasu Virajsilp.

It is, perhaps, not surprising that the work of this youthful generation of Thai architects has an affinity with the products of their contemporaries in Malaysia, Singapore, Indonesia and the Philippines, although there is little evidence of an overarching bond other than ARCASIA, the regional forum of the professional institutes of these and other Asian countries and organizations, such AA Asia, based in Singapore, and Asian Design Forum (ADF), the brainchild of Malaysian architect Ken Yeang.

Most of the architects named above and in my earlier publication, *The New Thai House*, completed their undergraduate studies at one of the established architecture schools in Thailand—Chulalongkorn University in Bangkok, Silpakorn University, also in Bangkok, Rangsit University, King Mongkut Institute of Technology Ladkrabang University (KMITL), Thammasat University Bangkok, Ratchamangala University of Technology Lanna Chiangmai (RUTLC) and King Mongkut University of Technology Thonburi (KMUTT).

With two exceptions, all the architects featured in this new publication pursued graduate studies in the US or the UK. Sumet Jumsai was

Above A minimalist staircase detail in the Transverse Convergence House in Sukhumvit, Bangkok (page 68).

awarded his doctorate by Cambridge University and Duangrit Bunnag and Stefan Schlau studied at the Architectural Association in London. Boonlert Hemvijitraphran gained his Masters qualification at the Bartlett School of Architecture, also in London, and Tanit Choomsang gained a Masters degree in Urban Design at the University of the West of England (UWE) at Bristol, while John Bulcock is a graduate of the Hull School of Architecture in the north of England. These six architects are responsible for eleven of the houses illustrated in this volume. The European experience is in one sense a 'rite of passage' that began as early as the reign of King Rama VII when, according to Professor Pussadee Tiptus, 'many Thai students, supported by Government scholarships or private funds, set out to England and France in quest of further education in western architecture'.[18]

The USA has been the chosen route for graduate studies for eight other architects featured in this book. Kanika R'kul (Ratanapridakul) studied at SCI-Arc and Southern Illinois University and Srisak Phattana-wasin gained his Masters degree at Ohio State University, while Bundit Kanisthakhon studied at the University of Washington and MIT. Vasu Virajsilp gained his qualifications at Pratt Institute and Columbia University New York and Songsuda Adhibai at the University of Colorado. Three architects—Pirast Pacharaswate, Surachai Akekapobyotin and Juthathip Techachumreon—studied for their Masters qualifications at the University of Michigan, Ann Arbor. The architects who followed the USA path are responsible for ten of the houses illustrated in this publication, while Ernesto Bedmar, who trained at the University of Cordoba, Argentina, is the designer of another.

Thus, architects who have pursued a master's degree or Ph.D. in America or Europe designed twenty of the twenty-five houses featured here and, even if the sample is not large, my conclusion is that Thai architects are closely allied to architectural production in the West. It confirms a trend I noted in *The New Thai House,* published in 2003, where architects who pursued their higher architectural qualifications in the US or the UK designed fifteen of the twenty houses featured.

At the same time, the first decade of the twenty-first century has seen a huge shift in the way in which ideas are disseminated. The influence of the Internet and www is pervasive and the work of signature architects is immediately accessible 'on line'. It is evident that the towering figures of twentieth-century modernism, including Le Corbusier, Gerrit Rietveld, Rudolf Schindler, Walter Gropius, Louis Kahn, and particularly Mies van der Rohe, have been a significant influence on the current generation of architects. The work of the Bauhaus and De Stijl movement are also relevant, and the projects of signature architects such as Peter Zumthor, Rem Koolhaas, Zaha Hadid, Coop Himmelblau, Luis Barragan, Morphosis, Miguel Angel Roca and Ken Yeang surface in discussions with Thai architects, while Japanese architects Tadao Ando, Kazuo Shinohara, Toyo Ito, Kengo Kuma and Kazuyo Sejima have also been influential. Geoffrey Bawa's sensitive modernism has inspired several architects, while nearer home Mathar Bunnag and Kanika R'kul are both described as 'inspirational' practitioners and teachers and Nithi Sthapatinonda has furthered the career of several young architects.

Academic mentors have been an important source of inspiration, too, so that theoretical constructs and design methodologies can often be traced back to Peter Cook, Jeffrey Kipness and Michael Lloyd in the UK, and to Bernard Tschumi, Raymond Abraham, Jim Schaffer, Hasan-Uddin Khan and José Oubrerie in the US. An earlier generation of academic gurus that included Colin Rowe and Buckminster Fuller is also acknowledged.

This roll call of professional and academic influences indicates a strong connection to mainstream modernism emanating from Europe and North America.

Above A staircase at
Villa Noi in Phuket
(page 110).

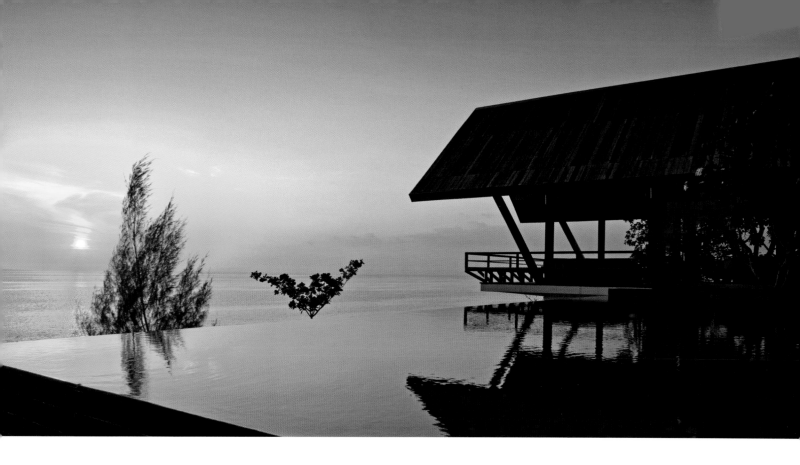

THREE-GENERATION HOUSES

'The regionally unique family compound ... merits far greater analysis than has been given to it as yet.... Are the spaces as layered and veiled as they appear to be? How do they allow for the subtle ranges of "knowing" and "choosing-not-to-know" that must characterise the relationships between the three genera-tions of the family that inhabit a commune?' *Leon van Schaik*[19]

Six of the houses in this new book are so-called three-generation houses. I first encountered the concept of an extended family living together in 1992 when visiting Baan Ton Son (1990) designed by Prapapat and Theeraphon Niyom of Plan Architects. The compound accessed by a narrow lane off Ploenjit Road in Bangkok has four separate dwellings— the architects and their two children occupied one with an adjacent dwelling occupied by Prapapat Niyom's mother. A third house was the home of her elder sister's family and a fourth the residence of her brother's family. It is a form of cohabitation that is largely unknown in my own (British) culture. The concept of an extended family living together was also evident in House U3 (1997), a seminal dwelling in Bangkok designed by architect Kanika Ratanapridakul for herself, her parents and her sister.

In this new publication, there are several examples of this cultural phenomena, including the Three Parallel House (Baan Sam Kanan), also designed by Kanika R'kul. Somprasong Sahavat, one of the owners, says of the design: 'Our house is essentially a place where the extended family can live together but be independent.' This is also the case with the Baan Taab 1, which occupies a shared compound. 'In the three-generation compound we are', says the architect/owner, 'connected but separate. This is the future; we live together so that we take care of my wife's parents, one of whom is disabled and they in turn get to enjoy their offspring.' Similarly, the Yellow Hole House in Chiangmai designed by Plankrich Architects and owned and occupied by Sivika Sirisanthana and her younger brother, is built in the garden of their parents' house. The Komkrit House too is a three-generation home designed by Boonlert Hemvijitraphan where, in addition to two lawyers and their daughter, the house is also home to a sister in a self-contained apartment on the lower floor of the main house, and a retired parent, formerly an engineer with a Japanese automotive firm.

Another example is the Harirak House, where the owner's mother currently occupies an old house behind her daughter's residence but the family hope that she will at some time in the future move to what is already referred to as the 'mothers house', currently used as a study and guest accommodation. It is a sentiment echoed by other house owners; indeed, it would appear that the three-generation house is enduring in Thai culture. There may be economic as well as cultural reasons for this, for the cost of land is high in the city and often the only way for a young couple to afford a home is to build in the garden of their parents' home.

The multigenerational home presents a number of challenges for the designer. There are hierarchies of privacy to consider, and it is necessary for the architect to understand the relationships between members of the family. There is a balance to be maintained between intimate and private space and shared space that reflects the family structure.

Factored into the design there must also be provision of 'maid space'. Few of the houses in this book would be able to function without domestic staff employed to care for children or elderly relatives or in countless other roles as cooks, cleaners, gardeners, drivers and security personnel. Staff must be accommodated in a manner that does not intrude into the privacy of the family but simultaneously be on hand to perform often intimate tasks. Domestic employees are paradoxically required to be present but 'invisible'.

Above A stunning sunset over the Andaman Sea viewed from Laemsingh Villa No. 1 in Phuket (page 120).

ARCHITECTURAL PATRONAGE

'The houses in this book represent a spectrum of responses to cultural change in Southeast Asia.... The houses are a barometer of taste and changing attitudes.... The owners may be collectively termed the well educated and relatively wealthy. It is often those who can afford to build their own houses and commission architects to design them who determine the aspirations of others.' *Robert Powell*[20]

In common with Indonesia, Singapore and Malaysia, the growth of a highly educated and widely traveled middle and upper middle class in Thailand has changed the profile of clients. Thus, the patrons of the houses illustrated in this book include academics, international lawyers, an investment analyst, an art dealer, a popular singer, a TV personality, a newspaper editor, a public relations and advertising consultant, a photographer, an artist, several architects, a financial controller and a global banker, many of whom also pursued their education overseas.

In the first decade of the twenty-first century, the notion of globalization pervades the language of political, economic and cultural discourse. This has a significant effect on architecture and urban forms. In the contemporary world system, architecture is a commodity that flows across national boundaries. In addition, the people who commission private houses are via the Internet 'wired' to current fashion.

For an architect, the design of an individual family dwelling is a demanding yet ultimately rewarding task. Rarely will the designer have such a close relationship with the end user. The most successful houses arise out of a strong empathy between the client and the designer. This compatibility is of critical importance because a house is ultimately 'a social portrait of its owner'.

Above Vertical timber shutters aid natural ventilation in the Harirak House, Bangkok (page 54).

WEEKEND AND VACATION HOMES

'Could it be that it will become more common for people to spend less on their homes-workplaces and save their earnings to buy weekend houses, thereby reintegrating solitude into an otherwise wired world?' *Terence Riley*[21]

The rapid growth of Bangkok and the accompanying problems of increased density, traffic congestion and pollution have seen the proliferation of a parallel phenomenon—second homes. When city dwellers have sufficient means to escape the frenetic pace of life in the city, they acquire a site some distance from the city to build a second home. Preferably the site will be off the beaten track yet accessible, and although somewhat isolated not without basic services.

The owners of The Other Residence at Khao Yai have their main residence in central Bangkok but they enjoy escaping from the city at every possible opportunity. 'The capital is a quality place to work,' says Jens Niedzielski, 'but not to live. This house is an antidote to life in Bangkok.' Both he and his wife, Paramee Thongcharoen, were united in their requirement that the house should be 'a home away from home'. Likewise, the Acharapan House is a sanctuary for its owner, the veteran TV personality and actress Pa Ji. When the owner arrives at her house in Nakorn Chaisri, she is happy to live a simple life amidst natural surroundings. 'When I have to work, I stay in my house in Bangkok,' she remarks. 'But whenever I am free from all burdens, I will head to my second home, my favorite place to relax my body and soul.'[22]

Similarly, Sumet Jumsai attempts to frequently escape to his painting studio in Sriracha, a one-hour drive from Bangkok, for it is a place where, unlike the metropolis, the skies are clear in the afternoons and evenings and the light is excellent. 'This house has been designed for the use of

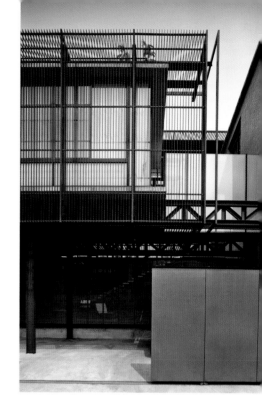

one person,' explains the architect/owner. 'I come here on weekends solely to paint.'

Other houses are vacation homes and the primary residence of their owner is elsewhere. Laemsingh Villa No. 1 at Surin Beach, Phuket, is the holiday home of Australian Julien Reis and his Singaporean wife Yen. The couple are the proprietors of Gallery Reis, located in the Palais Renaissance retail mall in Singapore. And Villa Noi, the vacation home of Hong Kong banker H. Chin Chou and his wife Veronica, is located at Natai Beach, adjacent to the Aleenta Resort and Spa in Phuket.

SUSTAINABILITY

In a world where climate change and carbon emissions will impact upon every region and every country, there is evidence of an increasing awareness of the responsibility of architects to build in a sustainable manner. Sustainability, ecological design, bioclimatic performance and green credentials are now high on the agenda of many prospective house owners and, interestingly, these are now marketable aspects. The houses in this book generally show a grasp of the principles of designing with climate. They are concerned with orientation in relation to the sunpath and to wind. Overhanging eaves are part of the vocabulary that most architects draw upon, as are high ceilings, louvered walls, and the use of the 'skin' of the building as a permeable filter.

It is evident also that architects appreciate that buildings in the tropics should be designed in section rather than in plan. The roof is frequently the most important element in the design of a house, providing shade from the sun and shelter from the monsoon rains. Water is incorporated into a number of dwellings, and increasingly it is recycled.

I make no apologies for reiterating these and other attributes of a dwelling in the tropics that I summarized in 1996 in *The Tropical Asian House* and have repeated in subsequent publications. The first three criteria were articulated in a discussion with Geoffrey Bawa while dining on the terrace of his home at Lunuganga in Sri Lanka.[23] He asserted that a house in the tropics is about living in close proximity to the natural world and therefore a house in the tropics should not destroy any substantial trees on the site. A house in the tropics, he said, should be designed with the minimal use of glass while other attributes include the use of gardens and non-reflective surfaces to reduce radiated heat, wide overhanging eaves to provide shade, the omission of gutters, in-between spaces in the form of verandas, terraces and shaded balconies, tall rooms to create thermal air mass and provide thermal insulation, permeable walls facing prevailing winds to give natural ventilation, and plans that are one room deep with openings on opposite sides capable of being adjusted to promote natural ventilation by the 'venturi' effect.

Several architects in this book are adherents to what I call the 'Bawa principles'. Of the Dama zAmya House in Phuket, the architect John Bulcock states: 'All our projects incorporate passive design, including orientation to minimize the area of exposed heat absorbing hard surfaces, roof overhangs, rainwater harvesting, and landscape as an integral design element for shading and cooling.' Further cooling

strategies include roof surfaces that are either vegetated or pebbled, creating garden spaces for entertaining as well as providing additional insulation for interior spaces. 'For ten months of the year we don't use air-conditioning,' affirms the owner of the house, Gary Dublanko. 'There is abundant natural ventilation and the house cools down quickly at night. On still days a fan is utilized.' Rainwater is collected from the roofs and channeled into an 80,000-liter underground storage tank. During the dry season, water from a 72-meter-deep well supplements the tank. All wastewater is treated on site by an Aerotol septic system.

Similarly, upon deciding to build her house in Chiangmai, Carol Grodzins drew on her earlier experience of living in a Dayak longhouse in the 1960s. She recalled the wisdom of cross-ventilation, orientation to catch the prevailing breeze, balconies and verandas, and wide overhanging eaves to provide shade, and resolved, when instructing her architect, to draw upon what she terms the 'ancient wisdom'. All of this would have been recognizable to Bawa, while another dwelling, the Soi Wat Umong House, also in Chiangmai, embodies another Bawa edict. The owners, Rirkrit Tiravanija and Antoinette Aurell, declared that their house was to be built without destroying any trees on the site, so at the outset all the trees were marked.

In yet another response to climate, Kanika R'kul, the architect of the DKFF House in Bangkok, carried out extensive solar studies. A planted sedum grass roof was seriously considered but eventually a decision was made to go for a relatively light roof, insulated with shredded newsprint. The roof has wide overhanging eaves to shade the glass and for energy conservation. Solar studies also informed the design of shading devices to deal with sunlight in the late afternoon.

Yet, a major challenge facing architects in Bangkok is to design houses that permit their clients to live a relaxed open lifestyle with verandas, terraces and courtyard spaces while simultaneously solving issues of

Above The striking entrance to Open House II, Bangkok (page 94).

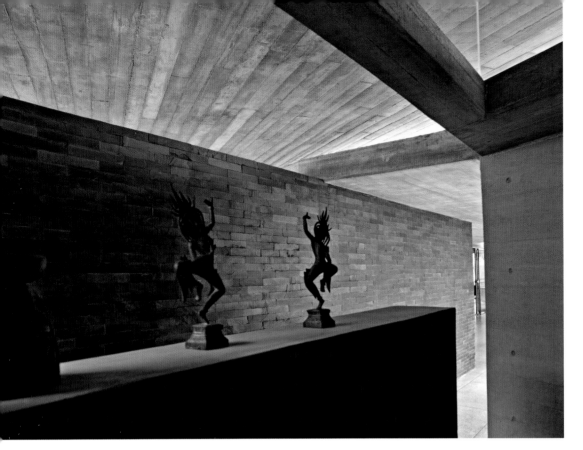

security. Living in a conurbation necessitates a variety of responses to the perceived threat of intruders, including high perimeter walls and electronic surveillance devices. A house in the city invariably includes some means of isolating and securing the family sleeping quarters at night.

The houses frequently embody a hierarchy of privacy, with a public façade that seeks not to attract undue attention or to make an extravagant display of wealth, and interior spaces that embrace and shelter their occupants while opening out to courtyards and terraces. The houses provide a haven of calm and a refuge from the frantic pace of life in the city and seek to modify the effects of air pollution, noise and increasingly high temperatures that inevitably necessitate air-conditioning in some parts of a house.

The Aurapin House in the Ladprao area of Bangkok has a calm atmosphere that, amidst the frenetic bustle of the city, is a quiet retreat. No matter how hot the climate, architect Boonlert Hemvijitraphan asserts, the house is always cool. The house is lightly 'clothed' with steel and bamboo screens that form a second 'skin', and because of the movable components permits cross-ventilation. The simple concept underlying the design of the house is 'to be part of the garden—to live in the garden', the architect explains.

In the L71 House, also in Ladprao, owners Tosaporn and Samorn Wongweratom required the separation of 'public' and 'private' spaces. The various functions of reception, living and dining are consequently rationally planned in a linear configuration of interlocking spaces, while external landscape is 'inserted' into the spatial planning. The house owners have occasional parties and thus the public areas are located close to the parking at the entrance to the house whereas private areas such as the dining room are located at the rear.

In the Bunker House at Lopburi, architects Vasu Virajsilp and Boonlert Deeyuen have succeeded in answering the owners expressed desire for

privacy while simultaneously requiring interaction with the outside. They have worked with the contradictions inherent in the request, such as 'hidden versus visible' and 'secure versus open'. The house is private, yet the owners can observe life on the street from their living room.

CULTURAL MEMORY

Several houses in this book are raised on concrete piles. The Aurapin House, the Harirak House, Baan Jew, the Soi Wat Umong House and the Acharapan House are all elevated approximately one meter above ground level and entered by a short flight of stairs, while Carol Grodzins' House and the Lampyris House are built on tall piloti. Whether consciously or otherwise, these dwellings appear to confirm Sumet Jumsai's contention that the aquatic origins of the Siamese still exist.[24]

There is a constant reminder of these aquatic origins with the presence of water in every house showcased in this book. Four of the houses are located on the coast. Villa Noi and Laemsingh Villa No. 1 in Phuket overlook the Andaman Sea, while Serenity, another house on the island of Phuket, has vistas over Phang Nga Bay. Sumet Jumsai's own studio at Srirachi, an hour south of Bangkok, faces the Gulf of Siam. Dama zAmya is perched atop a hill in Phuket, with magnificent views to the north of Ngam Island and Pa Yu and with Kung Bay in the foreground.

Inland, the Acharapan House and DKFF House on the outskirts of Bangkok are located alongside large ponds, while Carol Grodzins' House in Chiangmai overlooks a small inland lake. The site of the Harirak Residence includes the remains of an urban *klong* formerly part of a network of inland waterways in Bangkok. In every other house featured here, the owners have incorporated water in some form or other—a lap pool, a koi pond, a fountain or a waterfall.

Above At Dama zAmya in Phuket (page 128), the architect employs a carefully selected palette of materials.

Several houses incorporate a high 40-degree pitched roof underdrawn with a sloping timber soffit. This construction detail is evident in the Trop V House, the Harirak House, Laemsingh Villa No. 1, Carole Grodzins' House and the Acharapan House, and instantly evokes memories of the interior of traditional timber houses in Thailand, as indeed does the open-to-sky timber 'deck' found in the Soi Wat Umong House, Laemsingh Villa No. 1 and Villa Noi that suggests a tenuous link to the traditional dwellings of the central region of Thailand in the Rattanakosin period (1782 onwards), which comprised a series of pavilions arranged around a wooden platform. Carole Grodzins' House, with its broad timber veranda, similarly embodies features of a traditional Northern Thai House.[25]

All these cultural references reinforce the conclusions of Duangrit Bunnag in 'Co-Evolving Heterogeneity' that introduced my earlier book, where he noted that 'Throughout the history of modern architecture in Thailand, houses have been generally a form of negotiation between foreign architectural ideas and the local context which includes lifestyle and culture, climate and traditional architectural vocabularies. The significant fact is that where negotiation ends, co-evolution begins. In the hands of local architects the external forces seem to develop an internal force, and vice versa, so that the result is a coherent structure and not a collision of styles.'[26]

A REMARKABLE DECADE

A significant number of sophisticated and sensitively designed dwellings have been produced in Thailand in the first decade of the twenty-first century. The houses illustrate radical design investigation and architects are producing work that is comparable with and in some cases surpasses the very best in the world.[27] Nurtured by increasingly knowledgeable patronage, modern Thai houses are emerging in a variety of innovative architectural expressions.[28]

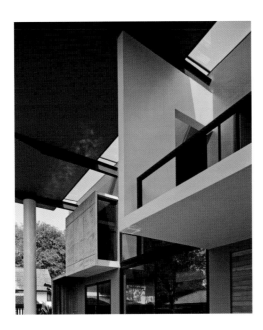

Above The key elements of the Yellow Hole House in Chiangmai (page 138) are highlighted.

ENDNOTES

1 Koompong Noobanjong, 'A Literature Review', *Power, Identity and the Rise of Modern Architecture: From Siam to Thailand*, College of Architecture and Planning, University of Colorado, 2001, p. 1.

2 Robert Powell, *The New Thai House*, Select Publishing, Singapore, 2003.

3 Duangrit Bunnag, 'Co-Evolving Heterogeneity', in Robert Powell, *The New Thai House*, Select Publishing, Singapore, 2003, pp. 10–21.

4 Robert Powell (ed.), *Architecture and Identity: Exploring Architecture in Islamic Cultures*, Vol. 1, The Aga Khan Award for Architecture, Concept Media, Singapore, 1983.

5 Sumet Jumsai, *Naga: Cultural Origins in Siam and the West Pacific*, Oxford University Press, Singapore, 1987.

6 Robert Powell (ed.), *Regionalism in Architecture: Exploring Architecture in Islamic Cultures*, Vol. 2, The Aga Khan Award for Architecture, Concept Media, Singapore, 1987.

7 Robert Powell (ed.), *Criticism in Architecture: Exploring Architecture in Islamic Cultures*, Vol. 3, The Aga Khan Award for Architecture, Concept Media, Singapore, 1989.

8 Robert Powell (ed.), *The Architecture of Housing: Exploring Architecture in Islamic Cultures*, Vol. 4, The Aga Khan Award for Architecture, Aga Khan Trust for Culture, Geneva, 1990.

9 Robert Powell, *The Asian House*, Select Books, Singapore, 1993.

10 Nithi Sthapitanonda (ed.), *Houses by Thai Architects*, Vol. 1, Li-Zenn Publishing, Bangkok, 2008.

11 Paul Ricouer, 'Universal Civilisations and National Cultures', *History and Truth*, Northwestern University Press, Evanston, 1965, pp. 271–84.

12 Duangrit Bunnag, 'Co-Evolving Heterogeneity', p. 11.

13 Robert Powell, *The Tropical Asian House*, Select Books, Singapore, 1996.

14 Robert Powell, *The Urban Asian House*, Select Books, Singapore, 1998.

15 Robert Powell, *The New Asian House*, Select Publishing, Singapore, 2001.

16 Powell, *The New Thai House*, op. cit.

17 Terence Riley, *The Un-Private House*, Museum of Modern Art, New York, 1999, p. 28.

18 Pussadee Tiptus, 'Architecture in Thailand in the Rattanakosin Period', in Chadanuch Wangroongaroona (ed.), *Thailand: Two Decades of Building Design*, Sang-Aroon Arts and Culture Center, Bangkok, 1989, p. 8.

19 Leon van Schaik, 'SCDA Architects: A Review', *SIA-GETZ Architecture Prize for Emerging Architecture*, exhibition catalog, Singapore, 2006.

20 Powell, *The Asian House*, pp. 10–11.

21 Riley, *The Un-Private House*, p. 35.

22 'When a house is more than a home', Estates Report, *Bangkok Post*. http://www.estatesreport.com/a349381

23 Geoffrey Bawa, in discussion with the author, November 1994.

24 Sumet Jumsai, *Naga*, p. 60.

25 William Warren, *Thai Style*, Asia Books, Bangkok, 1988, pp. 202–3.

26 Duangrit Bunnag, 'Co-Evolving Heterogeneity', p. 21.

27 Inevitably, this book is a 'snapshot' taken at a specific time (October 2011) and as such there are omissions. The intention was to include houses designed by A49, Architect Kidd, Cholatis Tamthal, Idin Architect, Natee Suphavilai and Pornchai Boonsom. A combination of time constraints, publishing deadlines and, in some cases, the reluctance of owners to reveal their private domain meant that houses designed by these architects missed the cut.

28 The forty-five houses in this book and my earlier publication, *The New Thai House*, are a comprehensive catalog of the evolution of the modern Thai residence over the three decades 1980–2011.

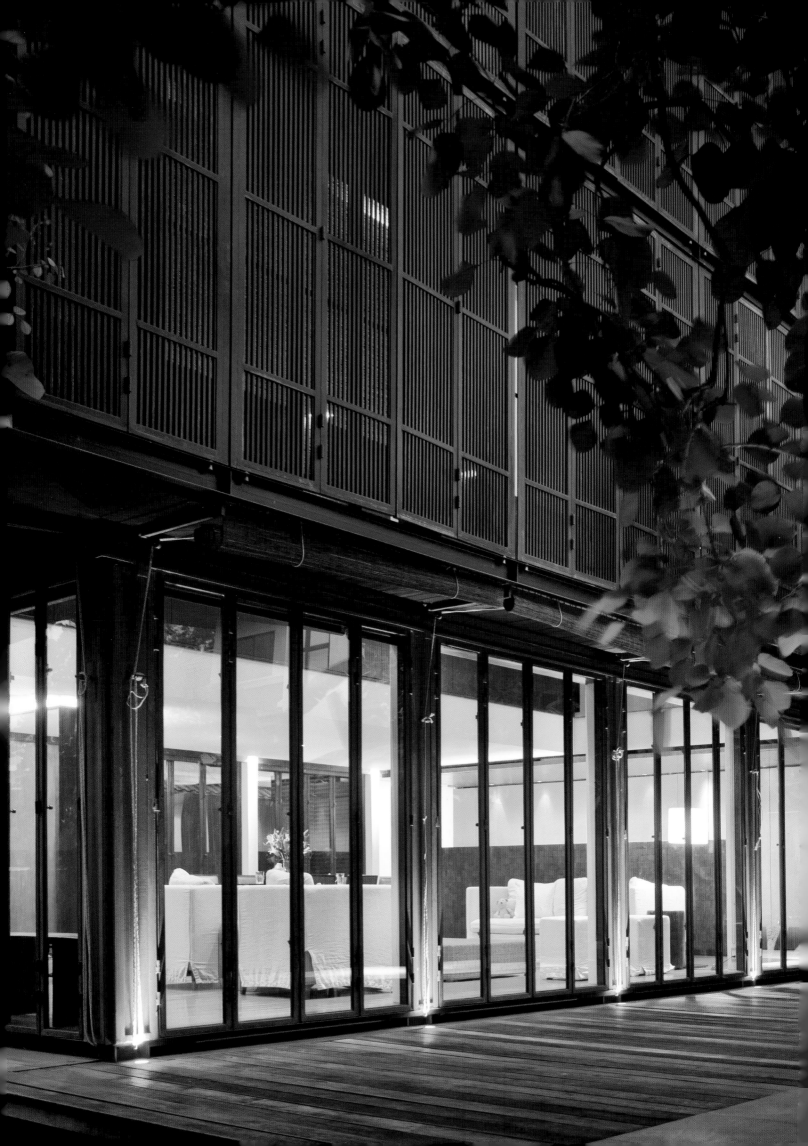

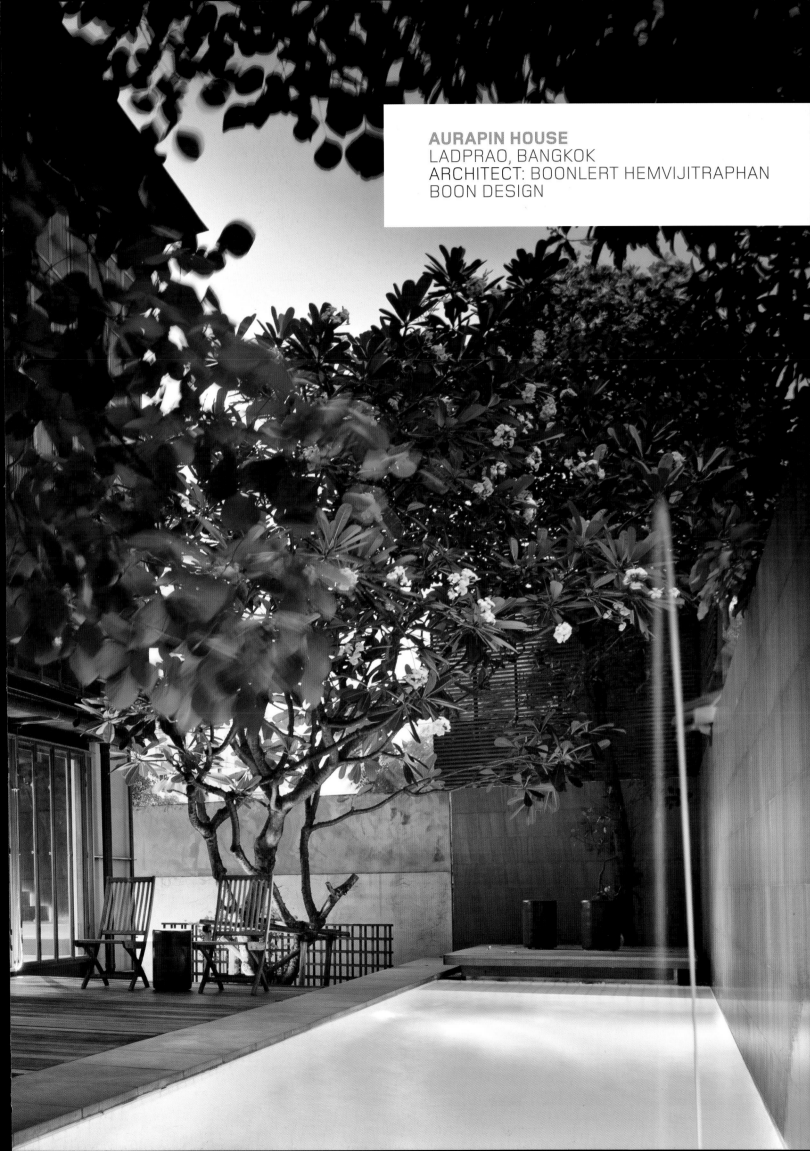

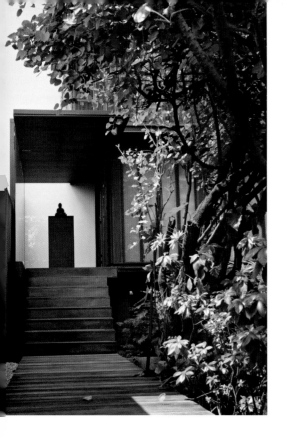

The simple concept underlying the design of the Aurapin House is 'to be part of the garden—to live in the garden', explains architect Boonlert Hemvijitraphan of this dwelling for his own family of two boys, designed in close collaboration with his wife after whom the house is named. 'We wanted a living space that merges with the garden,' he continues, 'so the materials of the façade have a rustic quality. The vertical bamboo and distressed steel screen that forms the external skin of the house merges with the surrounding trees. It forms a transparent curtain and there is visual connectivity between interior and exterior.'

Bangkok is prone to flooding, and although the house does not lie in a flood plain, it is nevertheless raised above the ground in the center of the site to provide ventilation and to avoid termites. In this way the house draws upon traditional responses to site and climate while having a modernist sensibility. The air-conditioning equipment is located in the space beneath the raised ground floor.

Now in his early forties, Boonlert is a graduate of the Bartlett School of Architecture in London where he studied under Peter Cook from 1995 to 1996. Prior to that, he was an undergraduate in the Faculty of Architecture at Silpakorn University, Bangkok, where he gained his B.Arch.

'Peter Cook opened my eyes,' says Boonlert. 'He was a catalyst for ideas and encouraged me to visit the work of European architects such as Coop Himmelblau in Vienna and Rem Koolhaas in Rotterdam. I was also inspired by the work of Peter Zumthor and Luis Barragan and by the courtyard houses of Geoffrey Bawa in Sri Lanka.' Upon his return to Thailand, Boonlert resumed work in his own practise—Boon Design—which is now eight strong and encompasses interior design and landscape. Most of the firm's work has been on private residences, but at the time of writing he was working on a forty-room hotel and has moved his practise into unconventional new office accommodation that he has designed using shipping containers.

The house, in the Ladprao area of Bangkok, has a calm atmosphere that, amidst the frenetic bustle of the city, is a quiet retreat. No matter how hot the climate, asserts Boonlert, the house is always cool. The house is lightly 'clothed' with steel and bamboo screens that form a second 'skin', and because of the movable components permits cross-ventilation. There is a small azure blue swimming pool and a fountain beside the

sand-colored wall on the eastern flank of the house. The pool cools the breeze, and the sound of splashing water from the fountain masks the rumble of distant traffic and enhances the peaceful ambience. Every room in the house can be opened to the exterior, and there is a wonderful double-height space above the living area. A mature tree in the courtyard provides shade.

Boonlert extols the virtues of *wabi–sabi* philosophy in relation to the design of beautiful objects. It is a Japanese concept derived from the Buddhist assertion of impermanence. Characteristics include asymmetry, asperity, simplicity, austerity and modesty. It also includes an appreciation of the ingenuous integrity of natural objects and processes. Consequently, the house has a strong orthogonal plan form. At the same time, it is a modest dwelling with an abundance of greenery.

The house is not immediately visible from Ladprao 71. A high wall and a sliding timber gate conceal it from passers-by, but to the left of the vehicular entrance a pedestrian gate gives access to the courtyard. The house is elevated and overlooks the entrance court.

Pages 16–17 The swimming pool deck at dusk.
Top A Buddha image is located in the entrance porch.

Above The house is hidden from the public highway.
Opposite A mature tree provides shade to the pool deck.

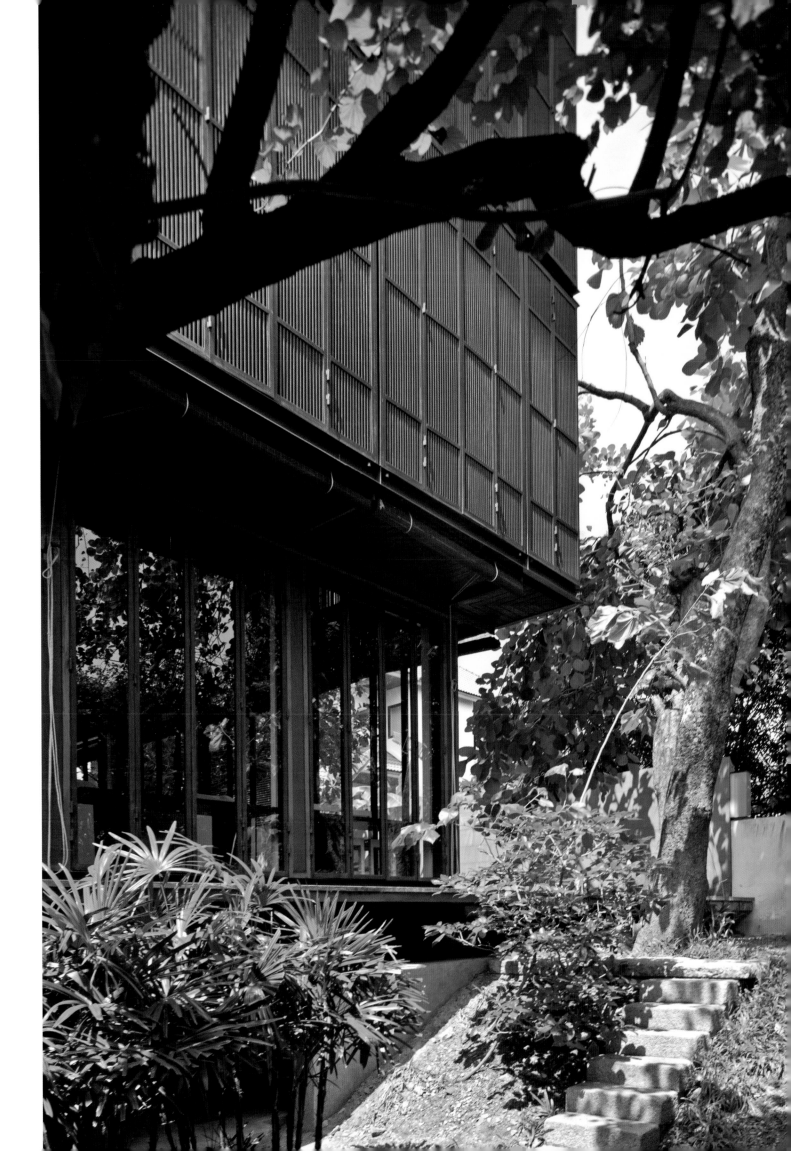

Proceeding along a timber walkway and dispensing with shoes at the base of a flight of stairs, a visitor arrives at a terrace on the western flank of the house to be confronted by a small statue of Buddha in front of a frosted glass wall.

A sharp right turn leads to a lobby giving access to the open-plan living/dining/kitchen area. It is a wonderful double-height space— a glass box with structural steel columns surrounded by the bamboo screen that insures that solar radiation does not penetrate. The kitchen is concealed behind a high counter. The living/dining area has a rich sense of materiality, with timber flooring and chairs and tables upholstered in natural fiber. Stairs at the rear of the house, leading to the upper floors, are flanked by a frosted glass wall. At first floor level, a large family room overlooks the ground floor living area. The interlocking spaces ensure interconnectedness between the multiple facets of family life.

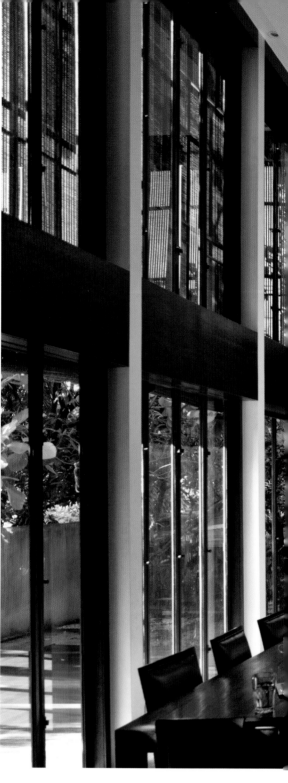

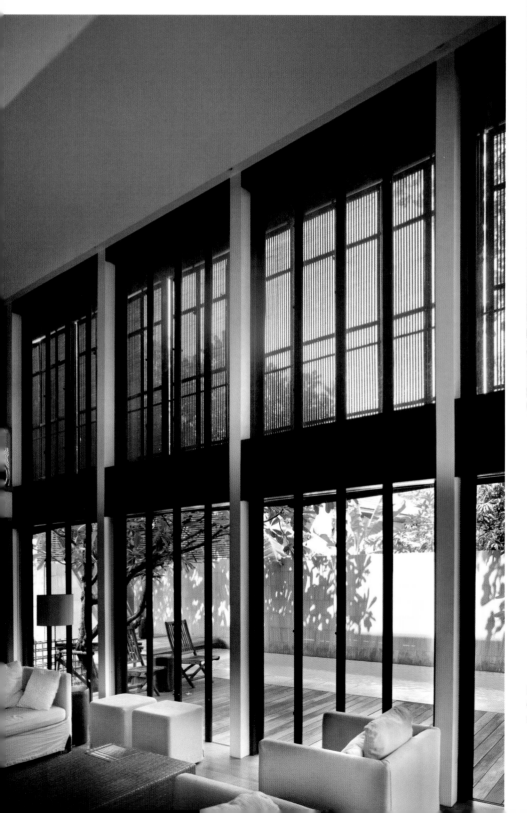

Left The living room overlooks the plunge pool.

Above Steel and bamboo louvers filter the rising sun at dawn.

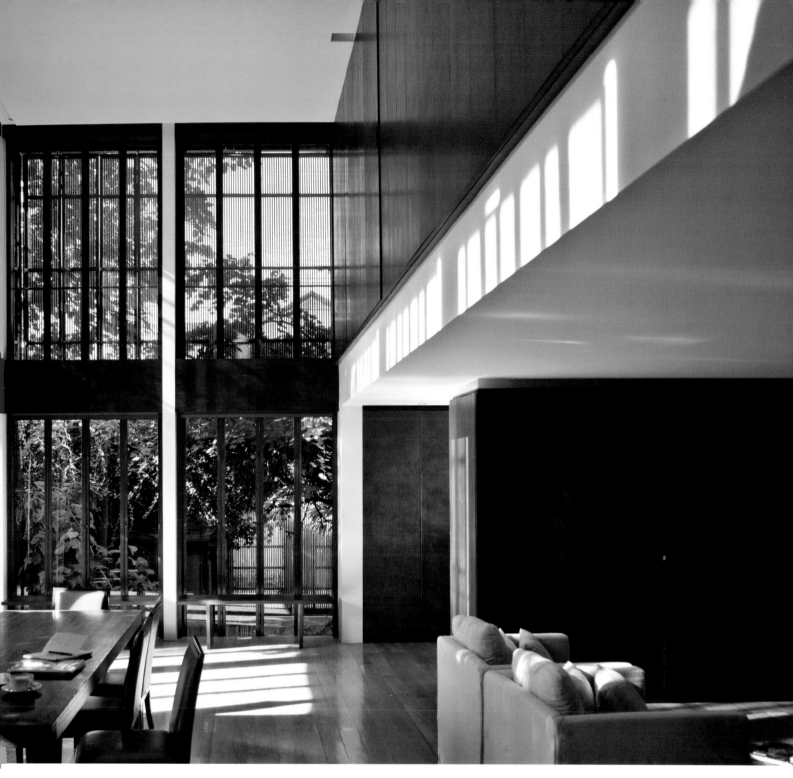

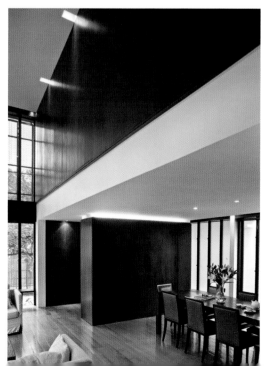

Left The entrance lobby leads directly to the living/dining area, which is interchangeable.
Right A garden play sculpture designed by the architect.

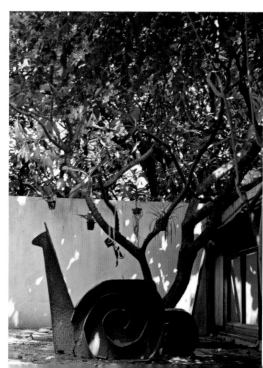

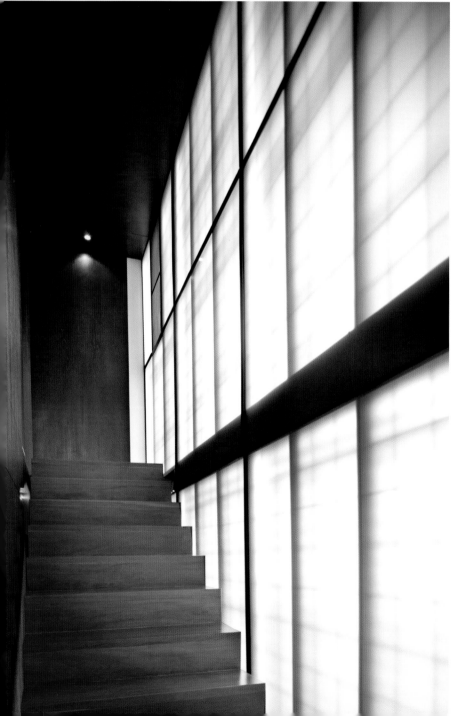

1	Entrance	7	Kitchen
2	Carport	8	Laundry
3	Foyer	9	Timber deck
4	Living area	10	Swimming pool
5	Dining area	11	Maid's room
6	Pantry	14	Bedroom

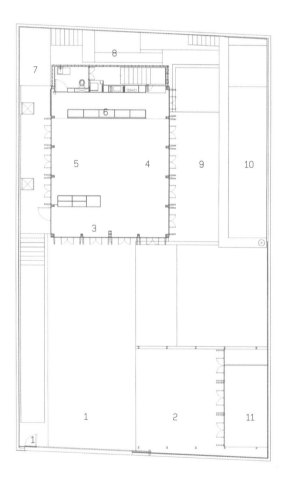

0 1 5 10 meters

Left A frosted glass wall flanks the staircase. **Top** Section drawing.
Above First floor plan.

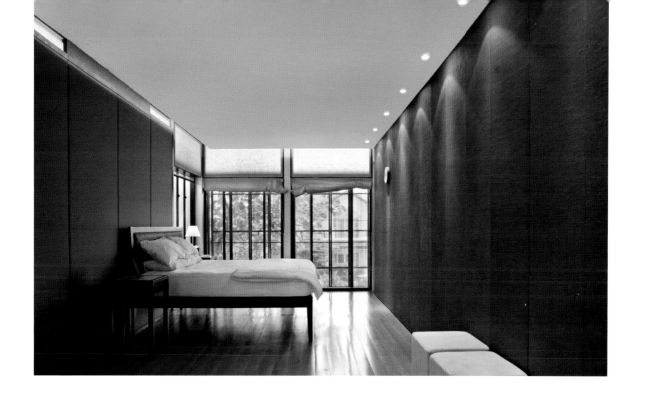

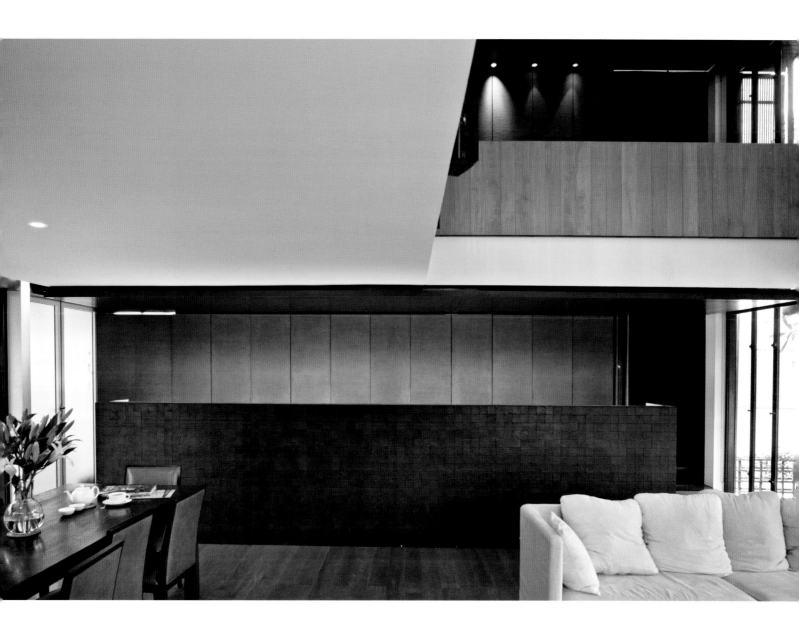

Top The master bedroom on the second floor.
Above A long bar counter conceals the pantry.

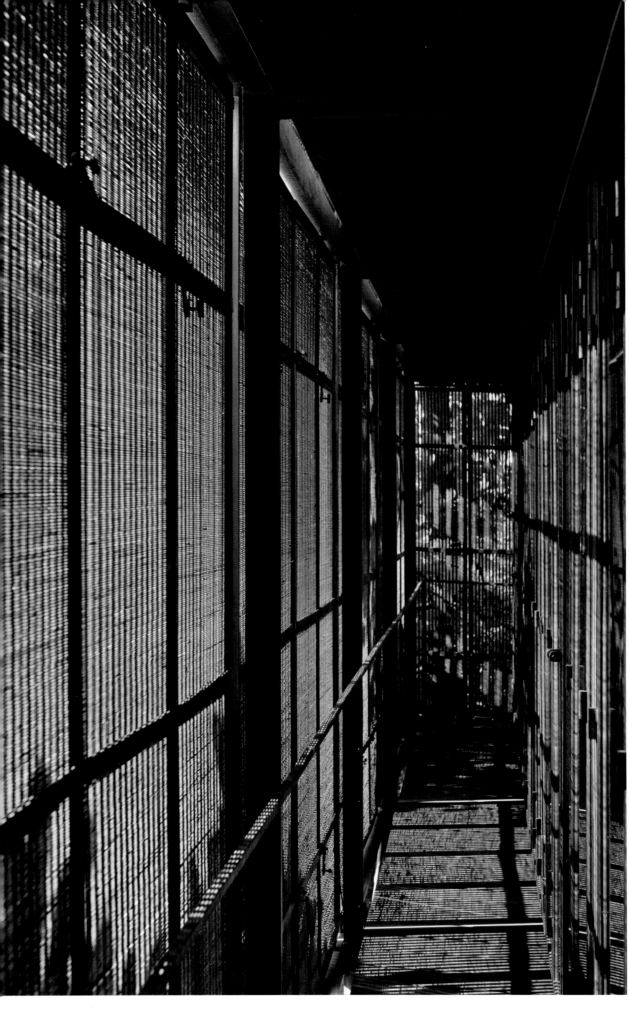

Above The privacy of the house is protected by a precision-made veil of steel and bamboo.

Opposite above Louvered shutters can be adjusted to control daylight and ventilation.

Opposite below left The generous timber deck provides space for outdoor recreation.

Opposite below right A high sand-colored wall flanks the azure blue pool.

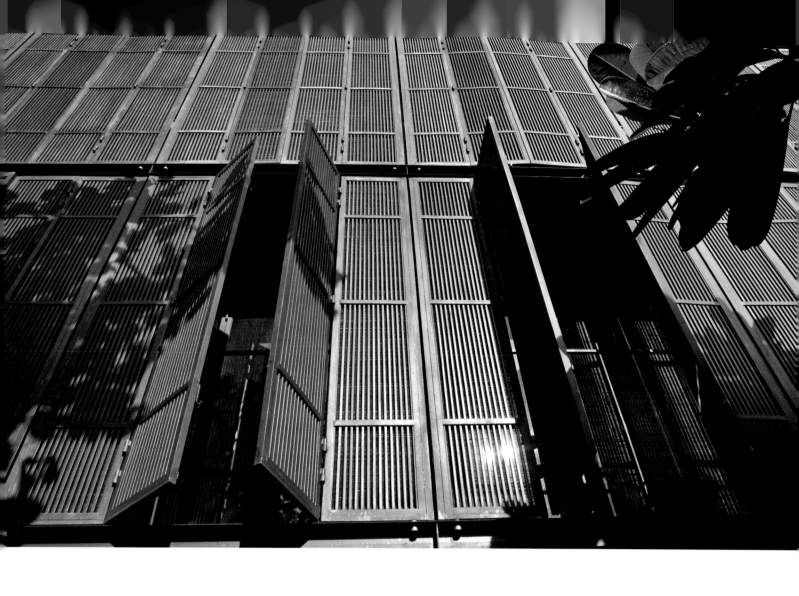

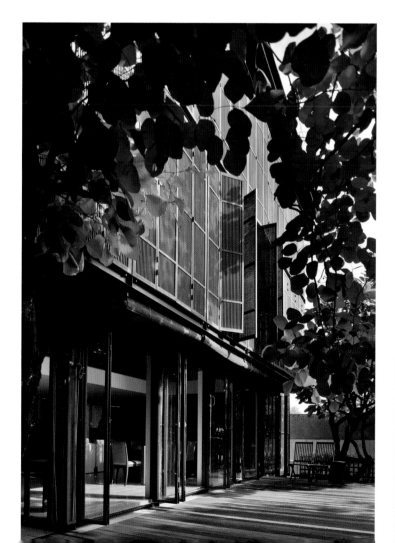

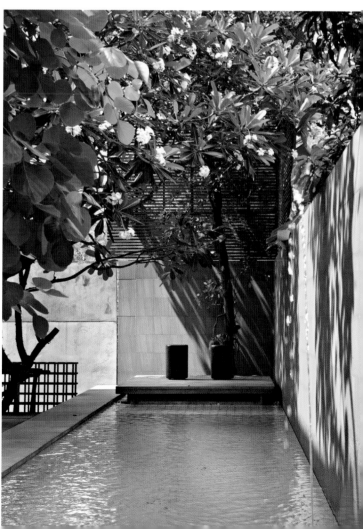

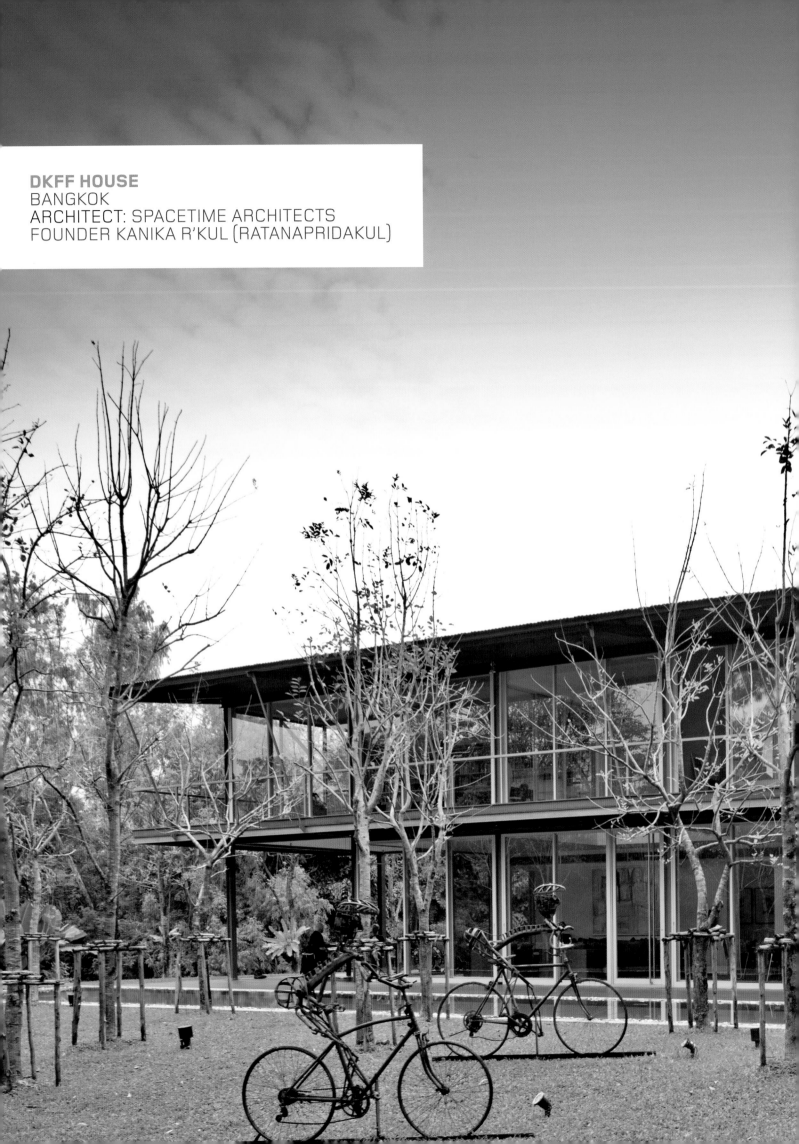

DKFF HOUSE
BANGKOK
ARCHITECT: SPACETIME ARCHITECTS
FOUNDER KANIKA R'KUL (RATANAPRIDAKUL)

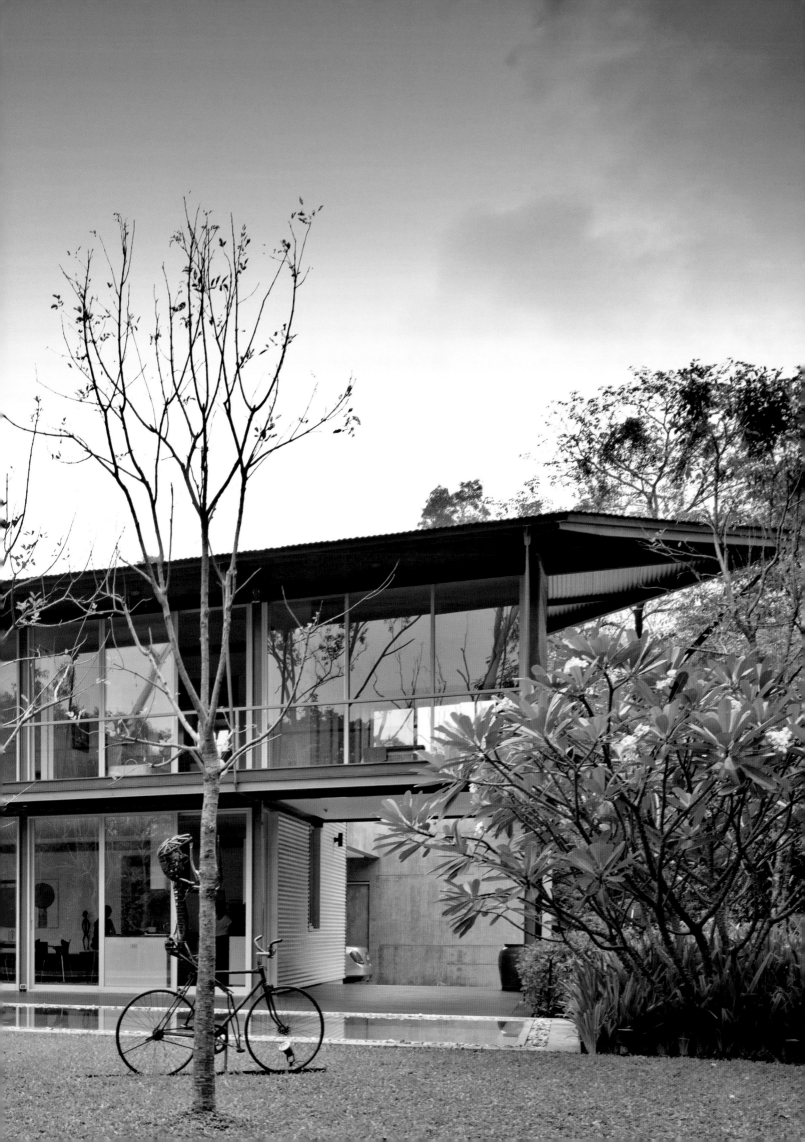

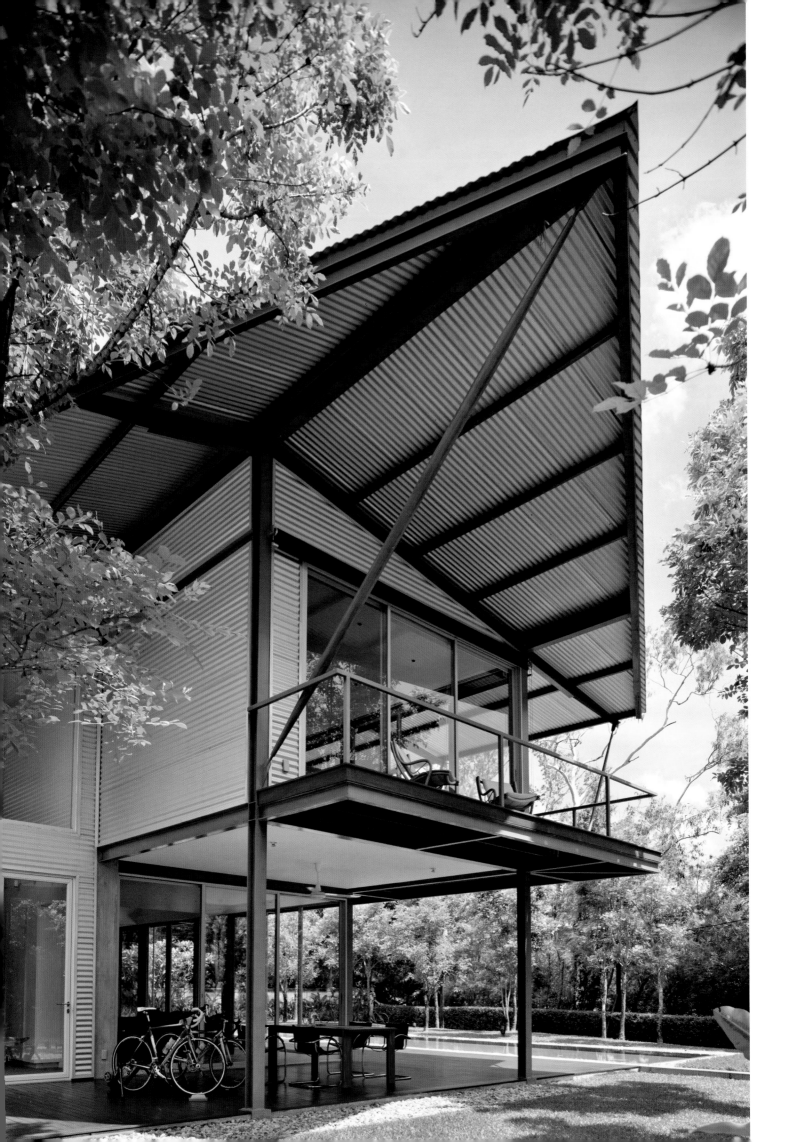

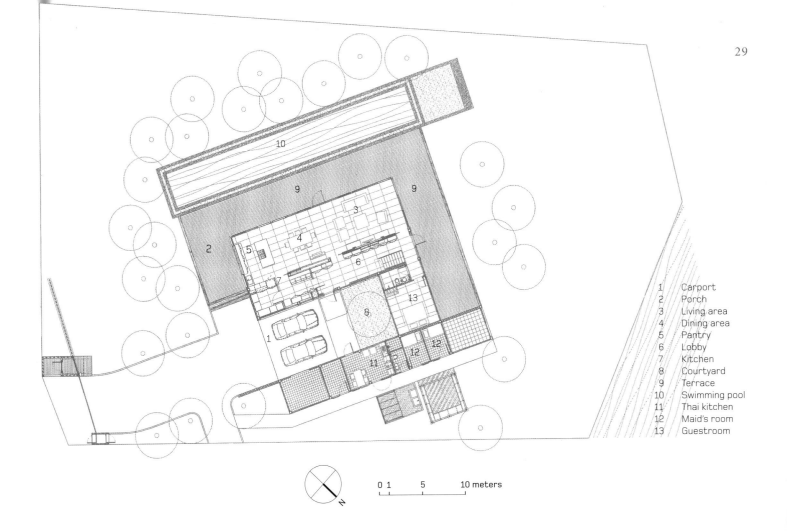

1 Carport
2 Porch
3 Living area
4 Dining area
5 Pantry
6 Lobby
7 Kitchen
8 Courtyard
9 Terrace
10 Swimming pool
11 Thai kitchen
12 Maid's room
13 Guestroom

0 1 5 10 meters

The owners of the DKFF House are Frank Flatters, a Canadian of British origin, and his Thai wife, Duangkamol Chotana (Jeab). Frank spent three years working in Jakarta, Indonesia, and ten years in Bangkok before deciding to make the city his permanent home. He previously lived in a 180-year-old house by Lake Ontario but it is now ten years since he left Canada. He retains the title of Professor Emeritus of Economics at Queens University Canada, while Jeab is President and former editor of *Krungthep Turakij*, Bangkok's leading business newspaper.

The couple found the site in 2004 during a period of economic downturn. The property, which overlooks a lake just 25 kilometers to the east of central Bangkok, was in an exceptionally rundown condition. It had been on the market for five years and was completely overgrown although a dilapidated villa on the site had once enjoyed high-profile visitors such as Prince Sihanouk, the erstwhile ruler of Cambodia. Looking for a quiet and secure place within easy reach of the city, yet remote from the urban hubbub,

Frank and Jeab immediately saw the potential of the place and were prepared to put up with the occasional frustrated shouts of errant golfers from the course that lies to the west of the site beyond a belt of trees. Wild life abounds in the area—there are monitor lizards in the lake and cormorants, king-fishers, herons, hornbills and storks are attracted by the water. Frank soon became an avid bird watcher.

Having found the site, Frank and Jeab next turned to selecting an architect and settled upon Kanika R'kul. The couple had seen the P-cube House in Pranburi overlooking Naresuan Beach and were impressed with the design. Their instructions to the architect were that 'we require a simple, open plan with high ceilings'.

Labeled 'the leader of a home-grown revival ... of an indigenous strain of archi-tecture that would reflect the native spirit and lifestyle' on the basis of her design of the House-U3 for her own family,[1] Kanika lived for sixteen years in the USA. She initially studied interior design at Southern Illinois University and worked for two years in

Alabama before enrolling at Southern California Institute of Architecture in Santa Monica where she studied from 1986 to 1991. She interned with Morphosis for one and half years. In 1991, she headed back to Thailand, but she found it difficult to settle down, and it was another two years, including a year working in Germany before she finally returned to her roots in Bangkok. In part, it was the commission from her parents and her sister to design a house on the site of her childhood home that brought her full circle. House-U3 was completed in 1997 and remains one of the seminal private houses in Thailand.

The DKFF House took three years from inception to completion. The structure of the house is a combination of RC post/beam and steel frame while the gray and white stone used as cladding material is from China. The external finish is either polished cement or corrugated metal. The owners and the architect like this material for its industrial elegance and solar protection. The architect explains: 'We wanted to experiment with the use of this materials in a residential design,

Pages 26–7 The southwest elevation overlooks a lap pool.
Above First floor plan.

Left Wide overhang-ing eaves shade the principal outdoor space.

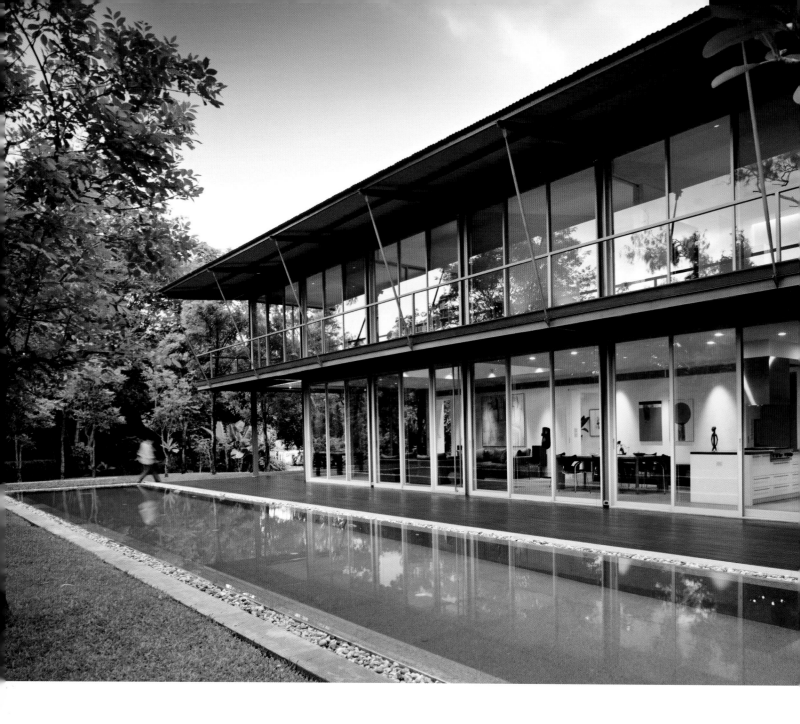

for it is not often found in Thai houses.' Extensive solar studies were carried out before deciding on the roof material. A planted sedum grass roof was seriously considered, but eventually a decision was made to go for a relatively light roof, one insulated with shredded newsprint. A unique feature of the house is its steel roof propped up by steel struts. The roof has wide over-hanging eaves to shade the glass and for energy conservation. Diagonal bracing at the end of the roof adds to its elegance.

Solar studies also tested the requirement for shading devices to deal with sunlight in the late afternoon from the west. 'The roof design is an attempt to discover new con-temporary design possibilities for a pitched roof with an overhang,' explains Kanika R'kul. 'It has often been shunned by a younger generation of architects and clients for being "too traditional" and un-innovative. But for us, a pitched roof with an overhang is very practical and perfect for the Thai climate. Frank and Jeab shared our view and made it possible.' Appropriately, the house now sits like a bird on the site, appearing, with its expansive roof profile about to take off in flight.

The two-story, one-bedroom house has a remarkably simple plan orientated west. The ground floor consists of a two-car carport leading to a spacious entrance porch that gives access to an open-plan arrangement of kitchen, dining area and double-height space connecting to the living area over-looking the outdoor lap pool and timber deck that runs along the west side of the house. There is a TV/guestroom and the usual back-of-house provision, including maid's accommodation. The upper floor consists of a study, master bedroom suite, huge bathroom and exercise room.

Above A balcony skirts the house at second floor level on the south and west elevations.

Above right The living room at dusk.
Right The service courtyard is a functional space.

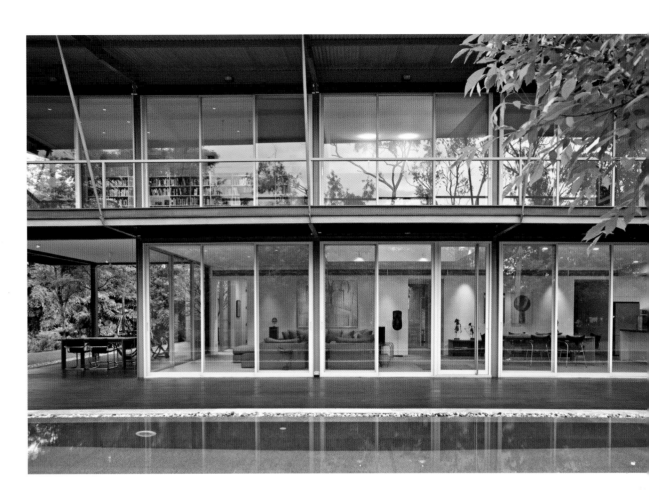

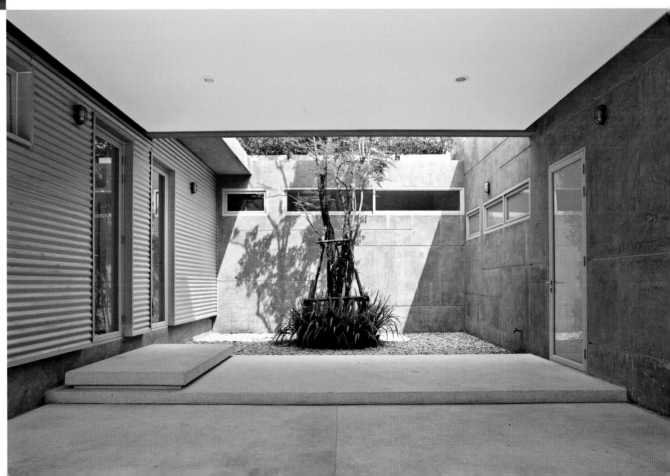

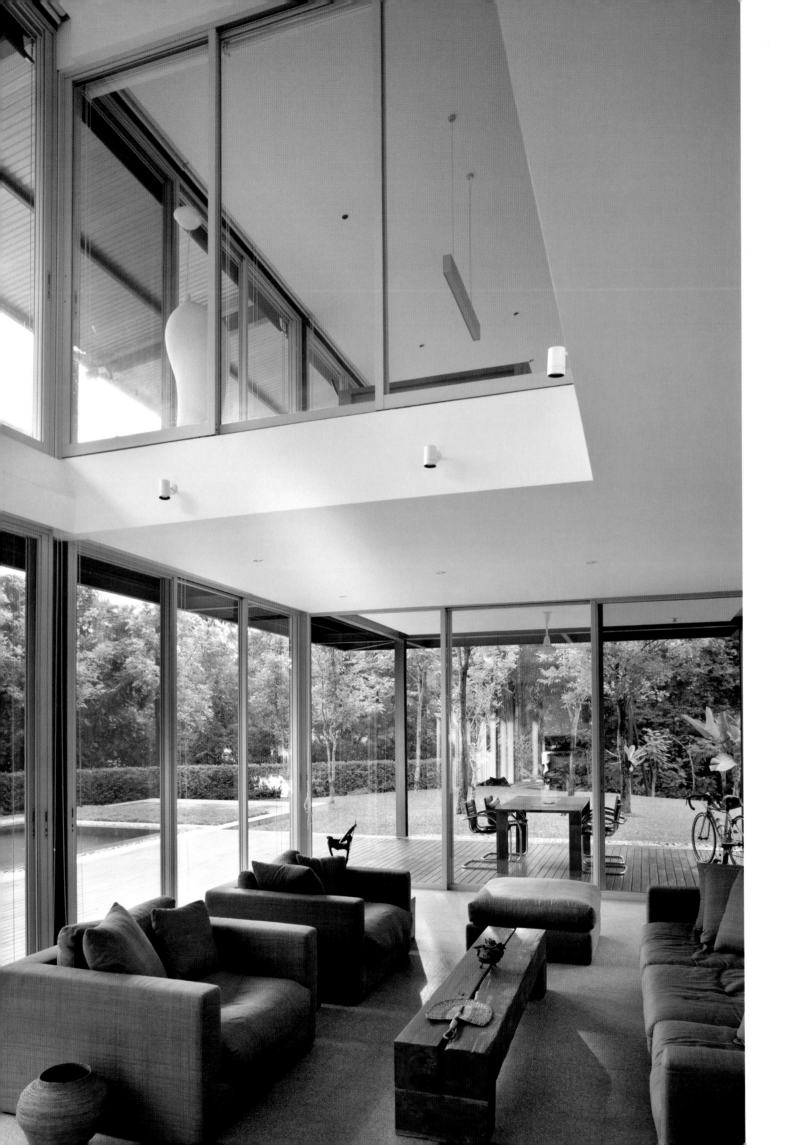

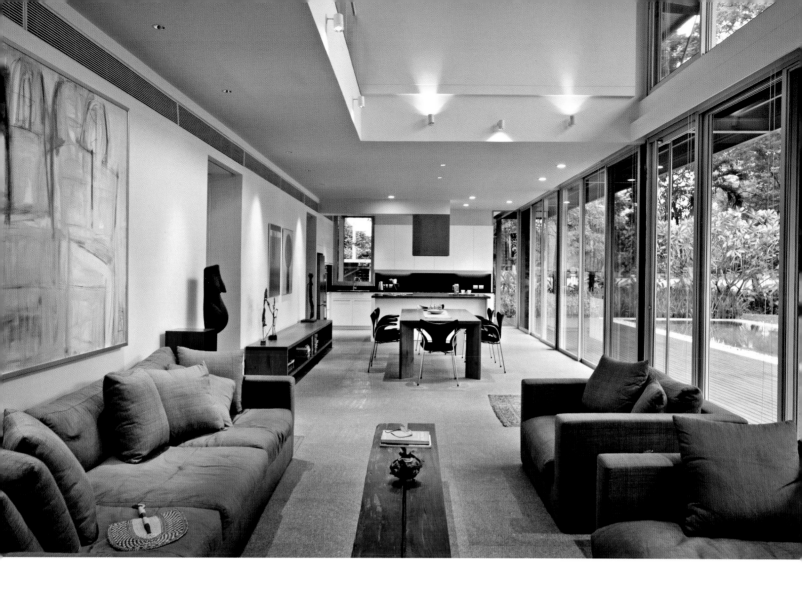

The west-facing first story veranda shades the lower floor in the afternoon. Trees help to reduce solar heat gain and there are external motorized louvers. Sliding doors on the west side are full height and can be opened to permit natural ventilation or closed for air-conditioning. The prevailing wind blows over water and the house cools quickly because of low thermal mass, green surroundings and cloud cover.

In this house, Kanika R'kul displays her renowned skill at detailed design, while in the garden there are several pieces of sculpture made from recycled bicycles by the famous Thai artist Saiyart Sema-ngern.

1 Robert Powell, *The New Asian House*, Select
 Publishing, Singapore, 2001.

Opposite The living area and the second floor study/sitting area are visually connected by a double-height space.

Top The linear living and dining area extends along the southwest flank of the house.

Above The study and sitting room occupy a quiet corner of the residence.

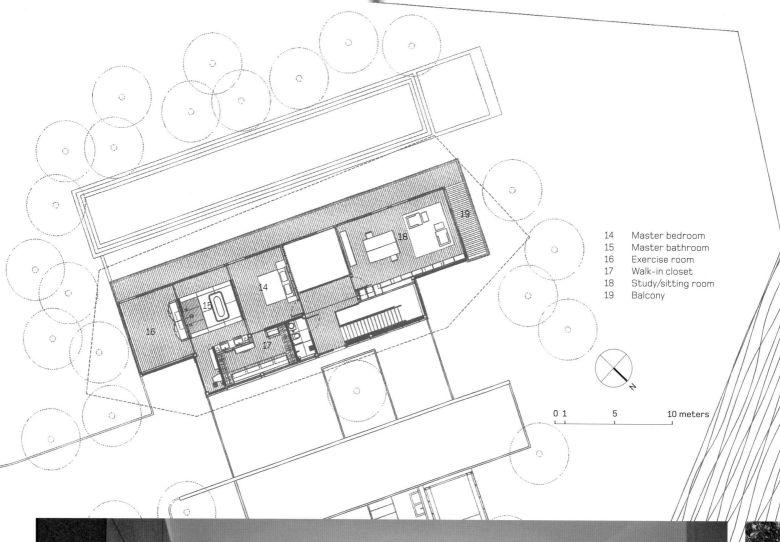

14 Master bedroom
15 Master bathroom
16 Exercise room
17 Walk-in closet
18 Study/sitting room
19 Balcony

0 1 5 10 meters

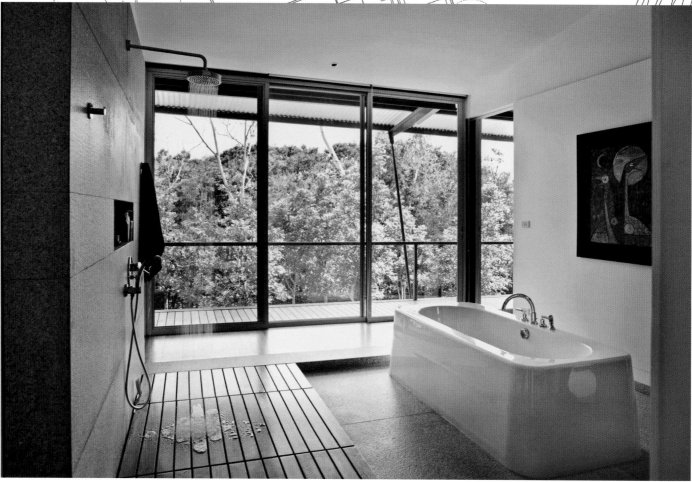

Top Second floor plan.
Above The spacious *en suite* master bathroom.

Opposite above left and right The overhanging roof shades the glazing.

Right New tree planting assures privacy from an adjoining golf course.

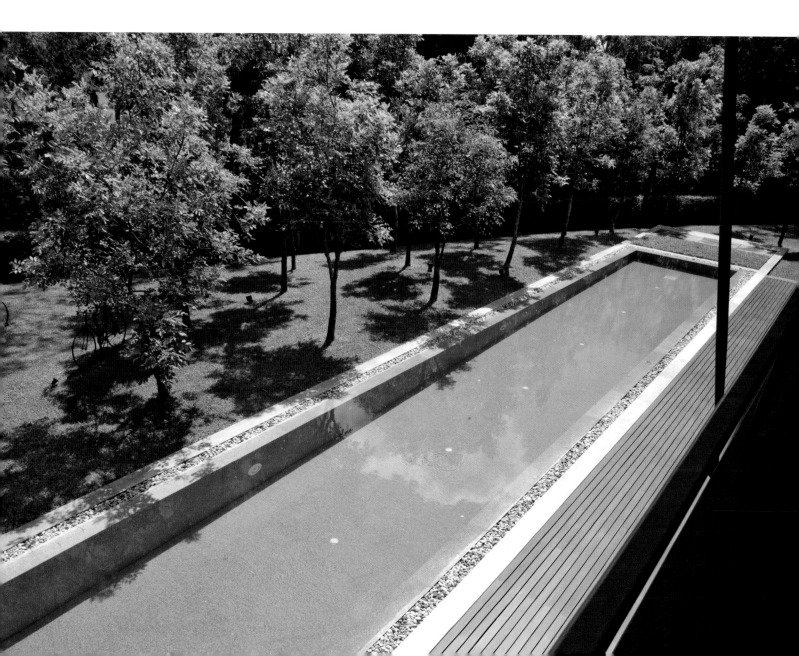

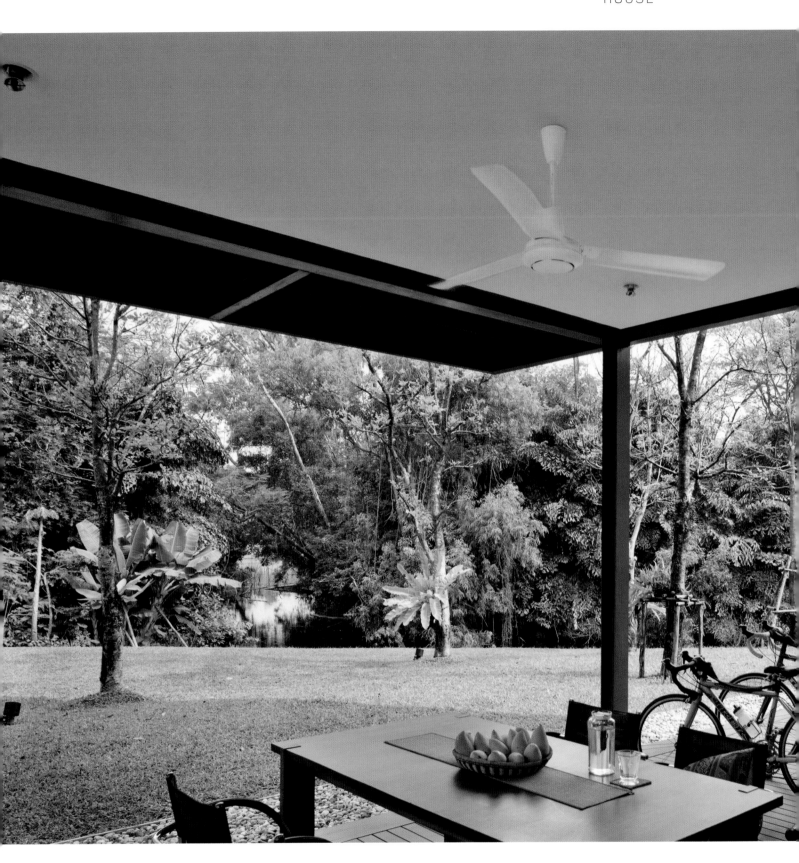

Above The owners'
stationary exercise bikes
provide an opportunity
to also bird watch.

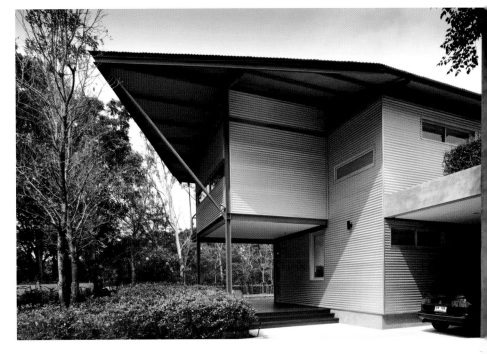

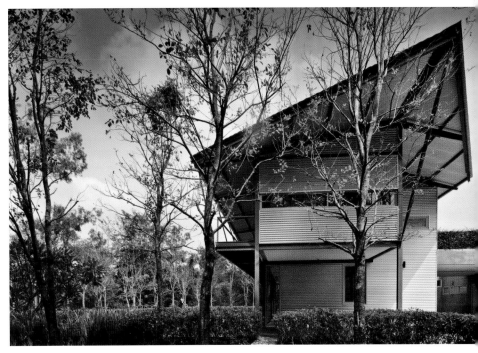

Top The entrance portico adjoining the carport.

Above The dramatic form of the entrance elevation.

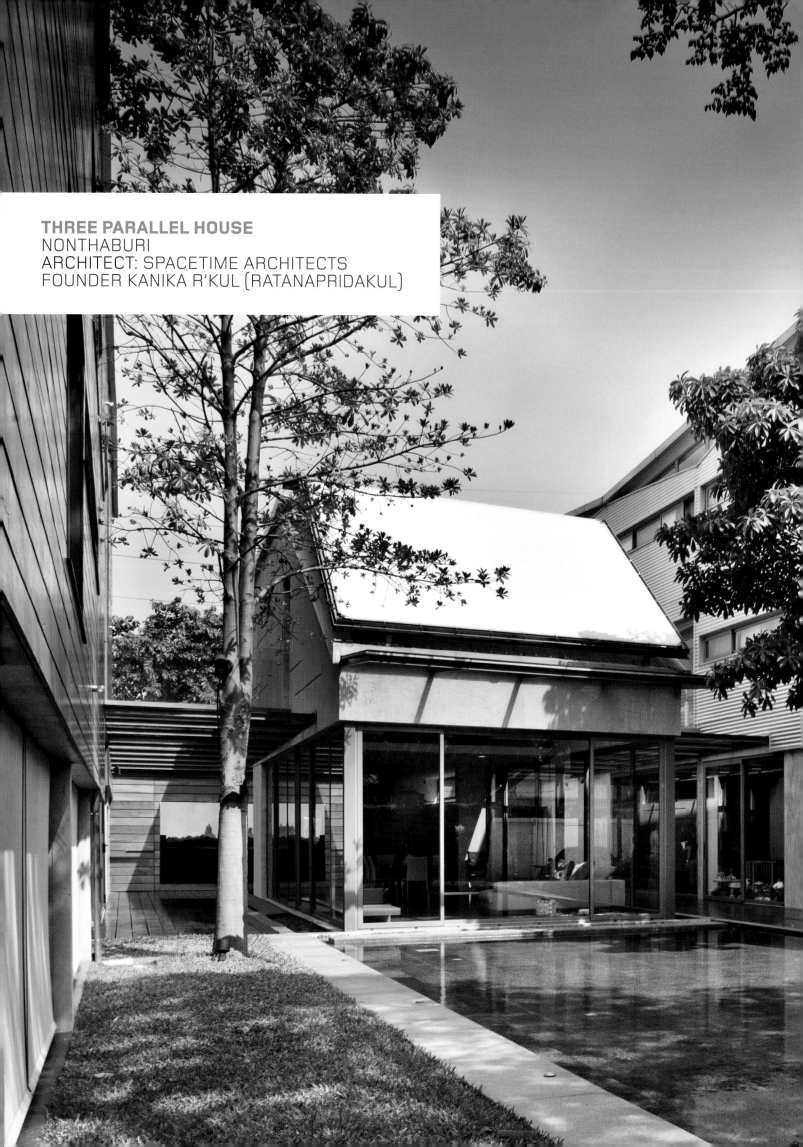

THREE PARALLEL HOUSE
NONTHABURI
ARCHITECT: SPACETIME ARCHITECTS
FOUNDER KANIKA R'KUL (RATANAPRIDAKUL)

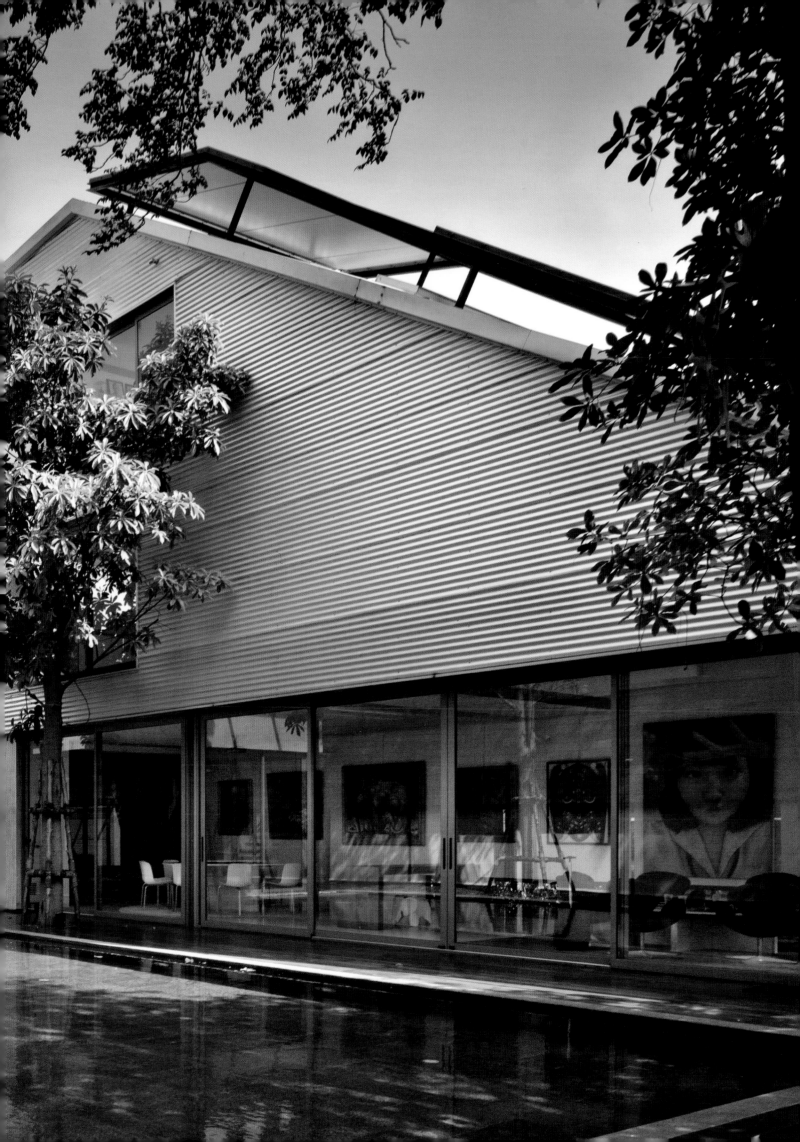

The Three Parallel House (Baan Sam Kanan) is, as its name suggests, a 'three-generation residence', although the architect prefers to describe it as about three entities rather than about three generations. One of the co-owners, who also happens to be the 'man of the house', is (Chang) Somprasong Sahavat, the proprietor of a chipboard/ plywood manufacturing business. His wife, Buachompoo Ford, is a celebrated pop singer in Thailand with several albums to her name. 'We live together with his mother and his sister,' Bua says, 'and now we have a young son, Matt, a name chosen by my English father.' Somprasong adds: 'Our house is essentially a place where the extended family can live together and at the same time be independent.'

Somprasong's mother has one floor above the garage in the northern dwelling and his sister has the top floor. There is a massage room adjacent to his mother's domain. The central parallel dwelling is the main space for family gatherings. This is the focus of the plan, with views of all activities and within easy reach of the kitchen and back-of-house activities. The upper floor is devoted to the Buddha room and the ancestor room. The southern parallel dwelling has a shared ground floor that is a formal meeting space and art gallery, while the first floor is the space for Somprasong and his wife, with the very top floor allocated to children. Provision has been made for a larger family, but for the present, with the arrival of their first child, the music room has become the nursery and

Somprasong's office is temporarily the son's bedroom.

Embraced by the three parallel linear dwellings is a central court with a cool gray swimming pool and trees on the western boundary. The striking double-roof structure is the unifying element in the whole composition. Orientated to the west, it cascades down the site in an attempt to meet the human scale of the approaching visitor. The air space beneath provides shade and ventilation.

Somprasong first came to know of Kanika R'kul, who he describes as 'a famous female architect', when he read of her design for a dwelling in The Commune by the Great Wall at Shui Guan, one hour north of Beijing in the People's Republic of China.[1]

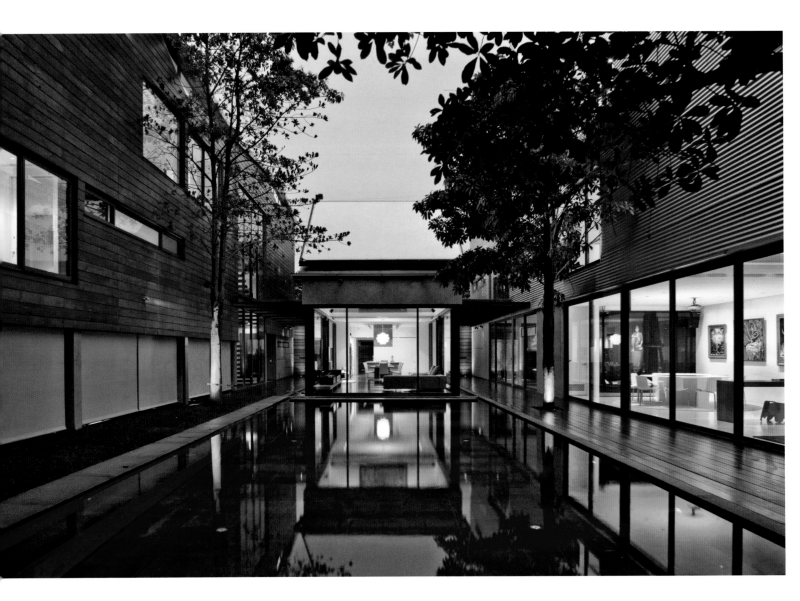

Pages 38–9 The three parallel elements of the plan are arranged around a pool court.

Above The owners' art collection is visible (right) in the reception/ dining area.

13 Maid's room
14 Maid's bathroom
17 Carport
28 Mother's deck
29 Mother's living area
30 Mother's bedroom
31 Mother's walk-in closet
34 Mother's massage room
39 Daughter's living area
40 Daughter's workspace
42 Daughter's bedroom
43 Daughter's outdoor deck

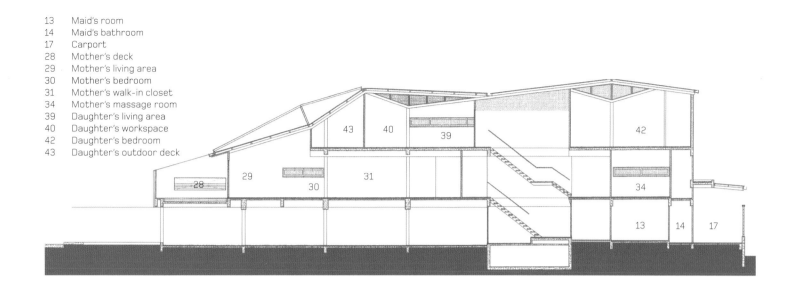

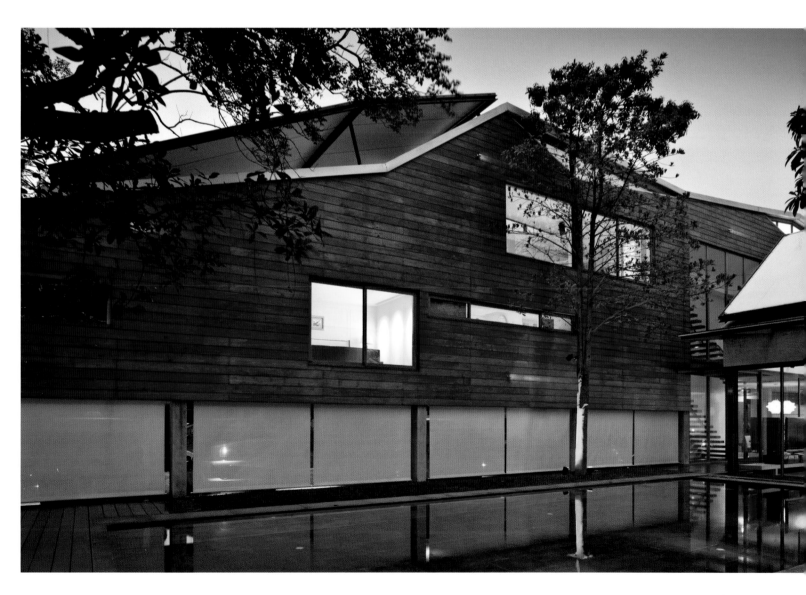

Top Section drawing.
Above The 'matriarch's wing' and the pool court at dusk.

1 Entrance
2 Front porch
3 Formal guest reception
4 Formal dining/meeting
5 Son's living/exercise
6 Store
7 Family gathering area
8 Family dining area
9 Western kitchen
10 Asian kitchen
11 Maid's dining area
12 Laundry
13 Maid's room
14 Maid's bathroom
15 Rear entrance
16 M and E room
17 Carport
18 Circulation deck
19 Swimming pool
20 Family deck

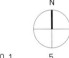

0 1 5 10 meters

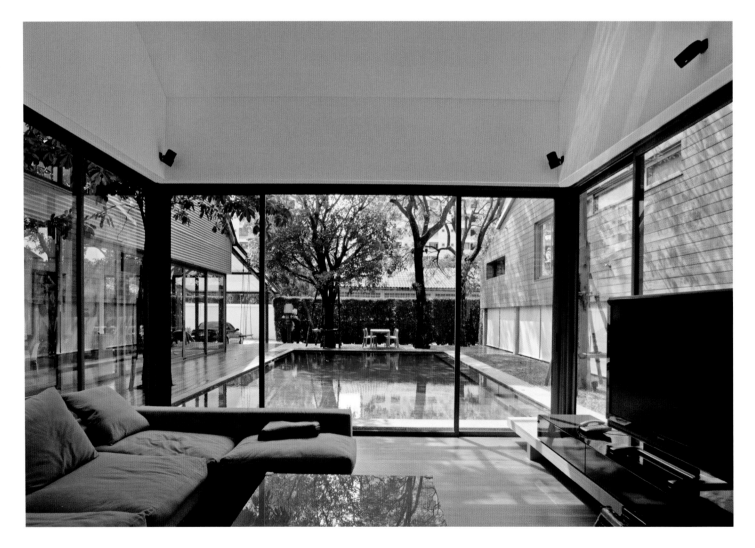

Top First floor plan.
Above The family
room overlooks the
swimming pool.

Right The three parallel
elements of the plan
are separated by timber
walkways.

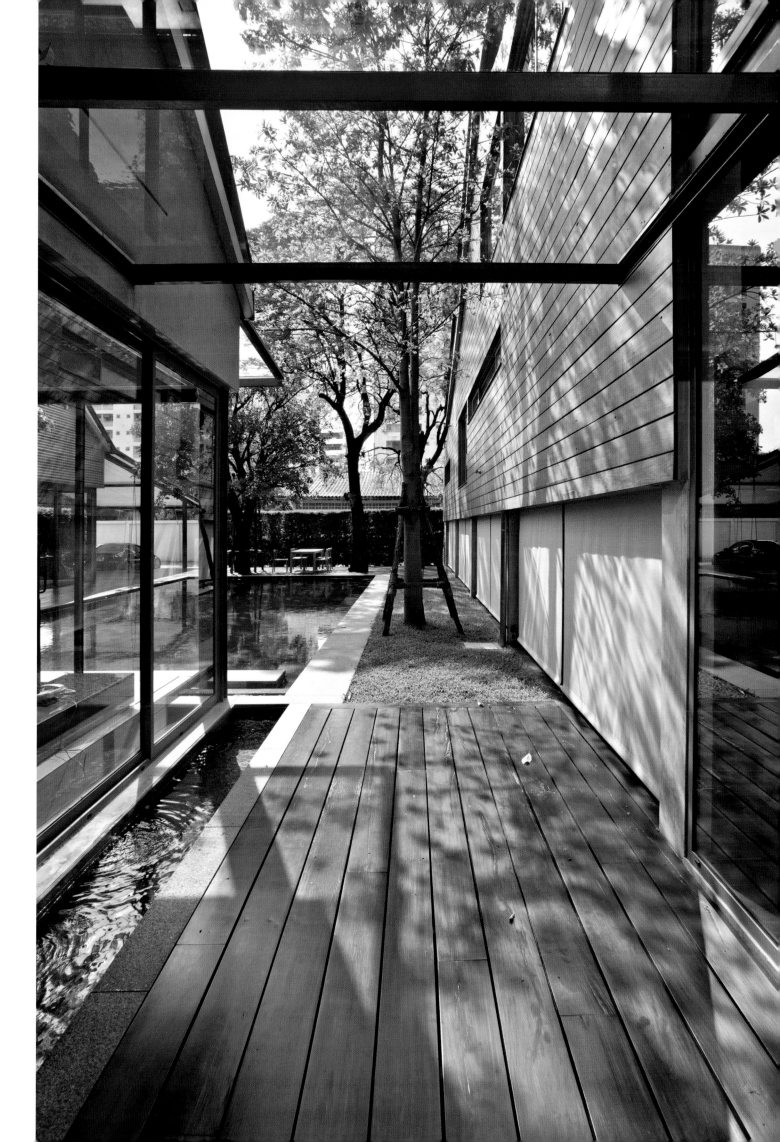

Somprasong found the house inspirational and asked some of his architect friends about her. It transpired that she was their instructor at King Mongkut Institute of Technology Ladkrabang University. She had the reputation of only working with students who took their work seriously and whose projects were meaningful. His friends helped Somprasong to contact her but warned him that she only designed two houses each year and she would only work for people she was happy with.

The different functions of the three parallel dwellings are expressed in materials. The northern dwelling is clad in teak boarding salvaged from an old demolished house, the central dwelling is essentially concrete, while the southern dwelling is finished in horizontal corrugated metal sheets. 'The materials,' explains Somprasong, who attended high school in California and university in Boston, 'represent who we are as individuals and what we are like. My mother is very conservative while my sister,' he says with a smile, 'is young and playful.' Yet, the extraordinary bold composition is entirely logical. The center is solid and reveres the family ancestors—at the core is a Buddha room. His sister's realm is at the top of the house—free! The different character of each member of the family and each generation is also reflected in individual paintings and decoration. The owner's passion for modern art is evident in his collection of paintings, each chosen carefully to reflect aspects of contemporary life in Thailand.

Above left The roof terrace in the matriarch's wing is enclosed for privacy.

Above right A glass bridge on the second floor connects the three components of the plan.

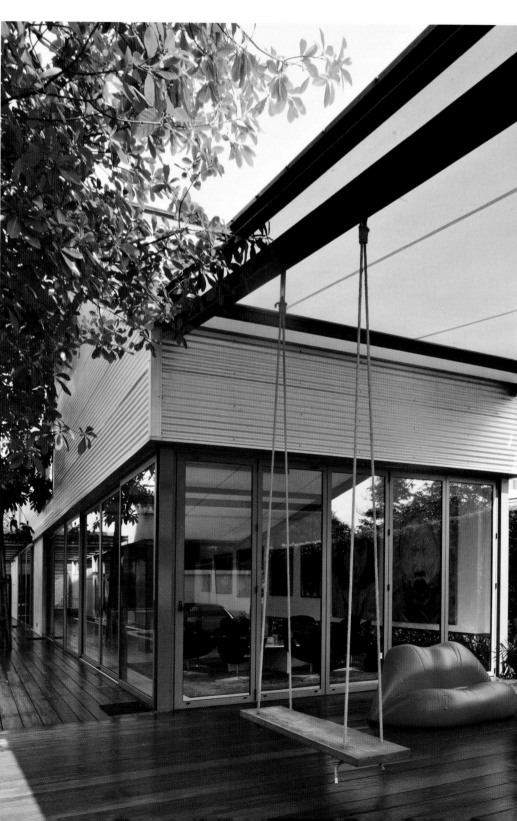

The residence is located in a gated com-pound of six houses of paternal relatives. As security is provided around the clock, there is no provision for a wall or a gate. Within the lofty entrance portico is a timber deck with a couch—a shaded place to greet guests before proceeding to the reception space and formal dining area. Typical of most houses in Thailand, there is a small spirit house (also designed by Spacetime) at the front of the site. There is also a *bhodi* tree on the opposite side of the road, facing the house. 'We own the site and our intention is to build a warehouse/studio for the family,' says Somprasong.

The three-story, 1,000-square-meter house, completed in 2009, is higher than existing houses in the vicinity. It almost fills the site. Indeed, it is slightly unfriendly by its close proximity to neighbors although it does not contravene regulations that permit building up to one meter from the boundary. The east elevation is essentially the back of the house and is almost blank apart from numerous air-conditioning units. Beyond the rear boundary fence is an 8-meter-wide canal and a 10-meter-wide perimeter road.

Architect Kanika R'kul, who shot to prominence in 1997 with the design of House-U3, a seminal dwelling for her own family, shows that she is still at the top of her game with this intriguing new take on the three-generation home.

1 'Commune by the Great Wall', *D+A (Asia)*, No. 009, Singapore, 2002, pp. 26–38.

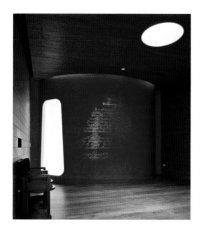

Left A suspended seat in the entrance portico is a place to informally greet visitors.

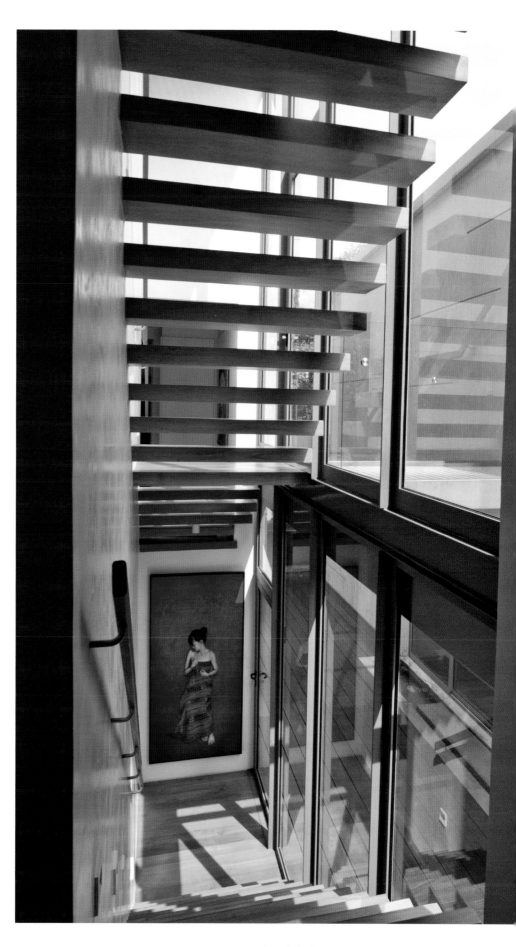

Above left The Buddha room and the family shrine are located in the middle section of the house.

Above An open-riser staircase gives access to the sister's apartment.

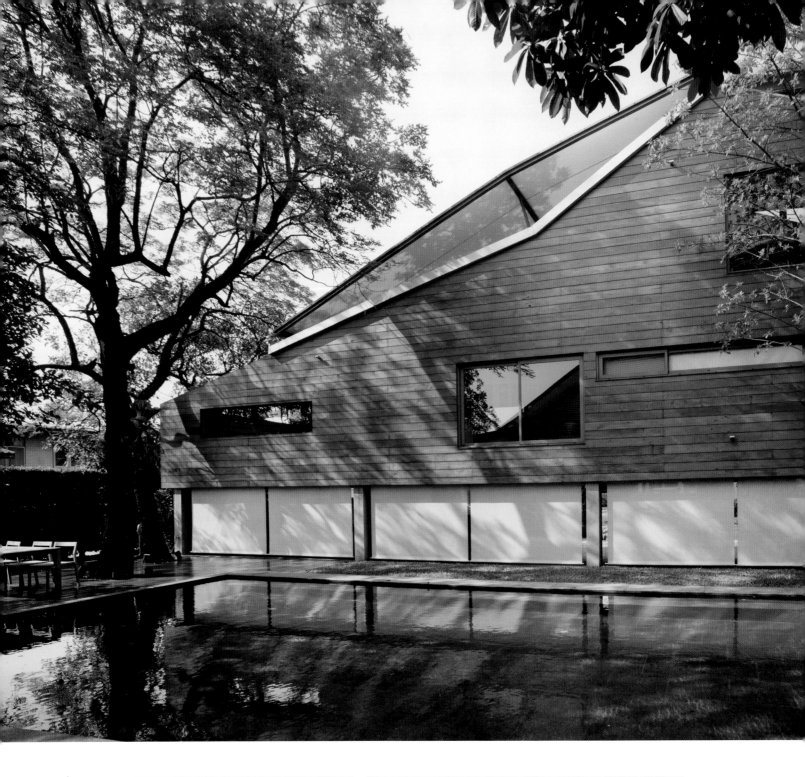

Top A family enter-
tainment deck is at the
far end of the pool.

Above left and right
Details showing the
material palette that
includes timber and
metal cladding.

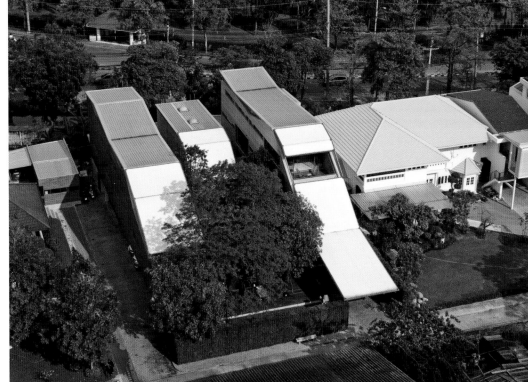

Above right The stylish
master bathroom.
Right From a nearby
tower block the three
parallel components
of the house are
immediately evident.

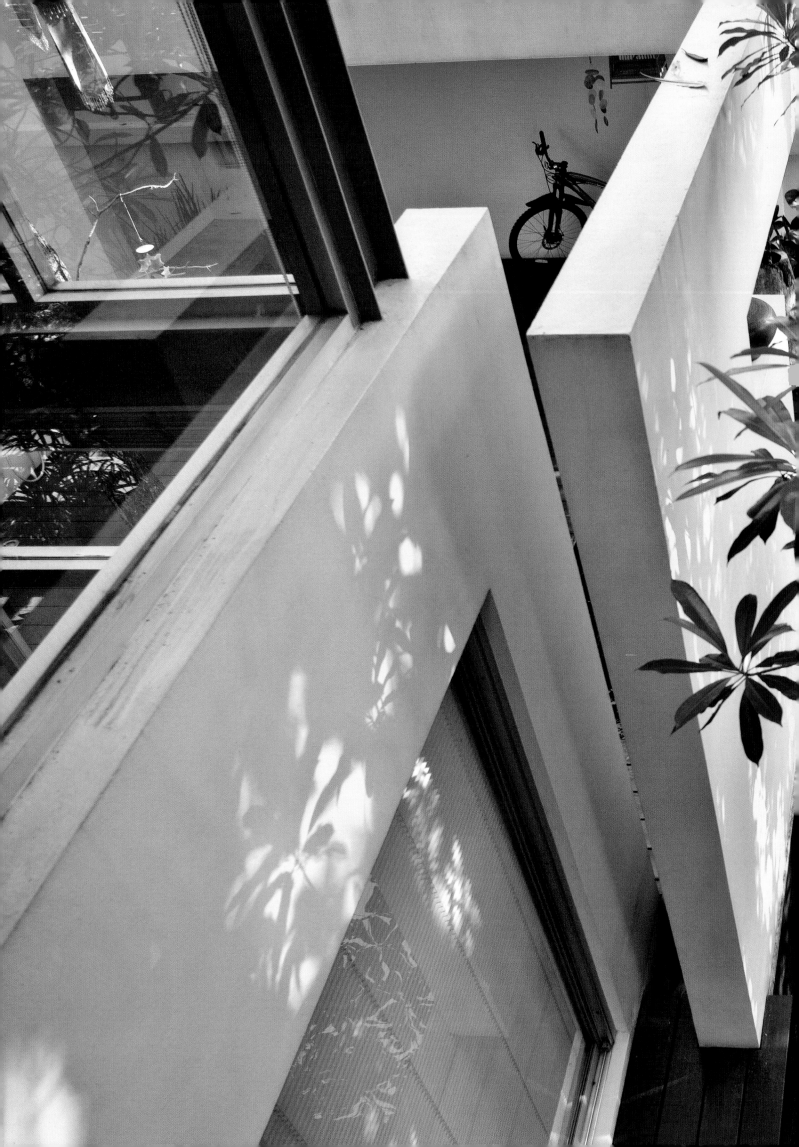

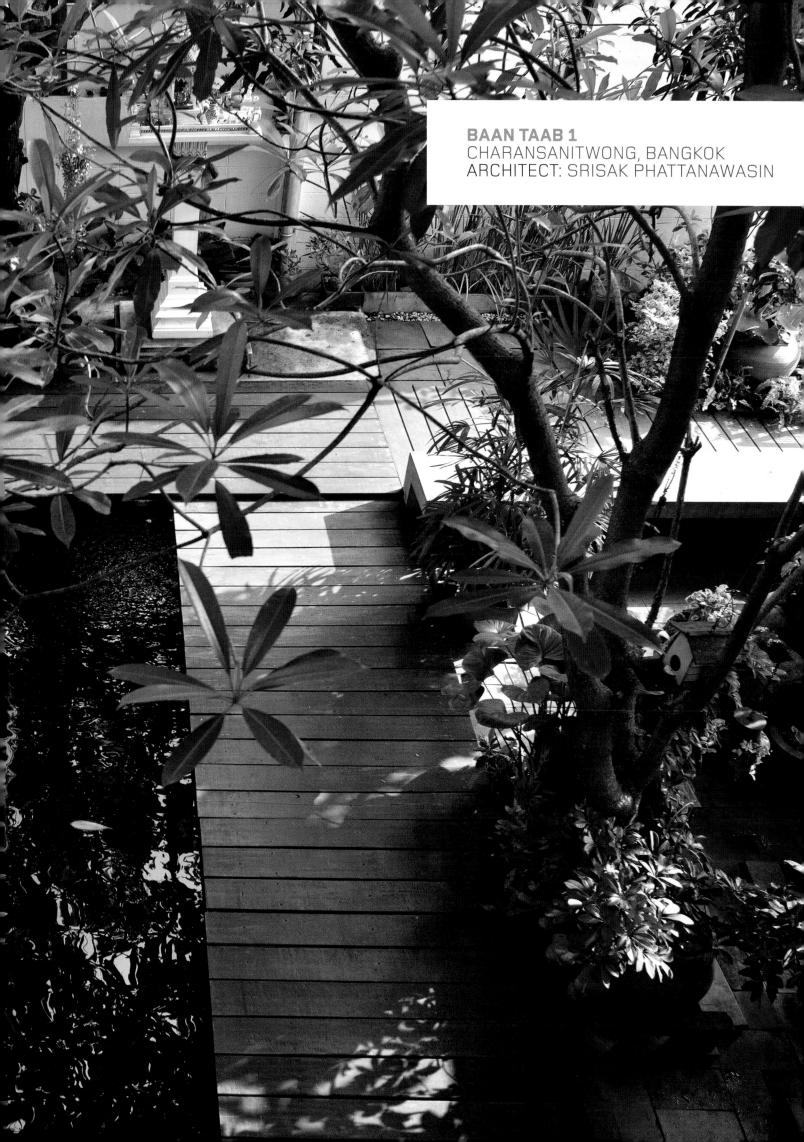

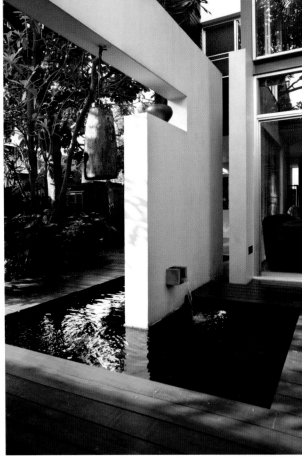

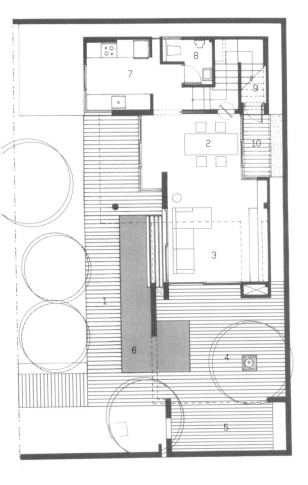

1	Boardwalk
2	Dining area
3	Living area
4	Open court
5	Outdoor sitting area
6	Pond
7	Kitchen
8	WC
9	Storage
10	Terrace

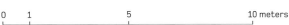

0 1 5 10 meters

N

Pages 48–9 The house
is entered via a timber
deck past a traditional
Thai spirit house.
Above First floor plan.

Baan Taab 1 is a superb example of the
creative manipulation of space within a
small urban site. The three-story house
was designed by Srisak Phattanawasin,
an assistant professor at Thammasat Uni-
versity, for himself and his wife Panadda,
who teaches Pharmacy at Silpakorn Uni-
versity. The site area is just 176 square
meters, but Srisak has managed to squeeze
132 square meters of net internal area onto
the footprint without sacrificing outdoor
amenities in the form of a spacious court-
yard. The architect explains: 'You have to
know the building regulations thoroughly
so that you can use them to your advantage.
For example, the regulations permit a house
of less than 150 square meters to be built
half a meter from the site boundary, other-
wise it has to be one meter.'

Now in his early forties, Srisak was edu-
cated at Silpakorn University in Bangkok
and worked with Kanika Ratanapridakul
at her former practise of Leigh & Orange
before embarking on graduate studies at
Ohio State University where he obtained a
Masters degree in architecture in 1997.

The major influence on Srisak's design
methodology was Professor Jose Oubrerie,
a French-American teacher at Ohio State
University who had worked with Le
Corbusier. He also acknowledges the
encouragement of Mathar 'Lek' Bunnag
with whom he worked for one year after
returning to Thailand. 'He was a good
teacher', says Srisak, 'and especially good
on detailing. I learned from Mathar that
you should always carry a measuring tape
for he would constantly ask "exactly how
wide is this?"'

Srisak also refers in conversation to the
influential monograph by Brian Brace
Taylor on the Sri Lankan architect Geoffrey
Bawa,[1] sometimes referred to as 'The White
Book', from which he gleaned ideas on
internal and external connectivity, views in

Top left A koi pond is
located alongside the
entrance.
Center left A short
ramp leads to the
entrance court.

Right Existing trees
on the site have been
carefully retained.

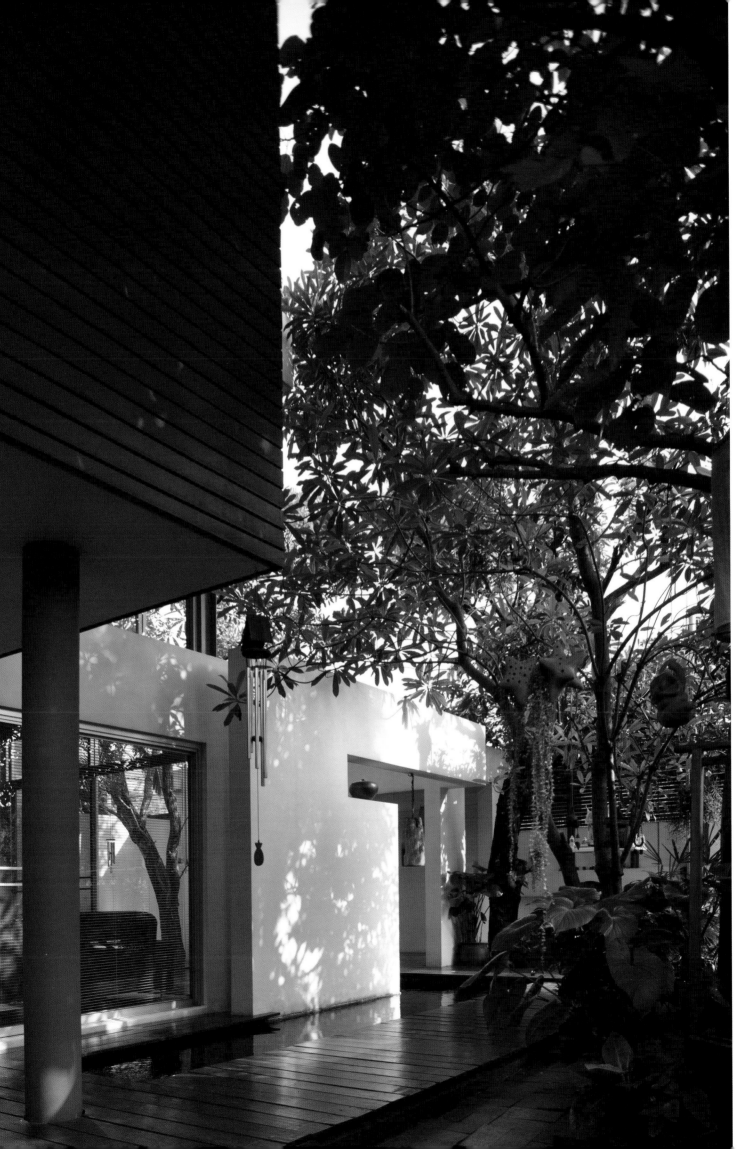

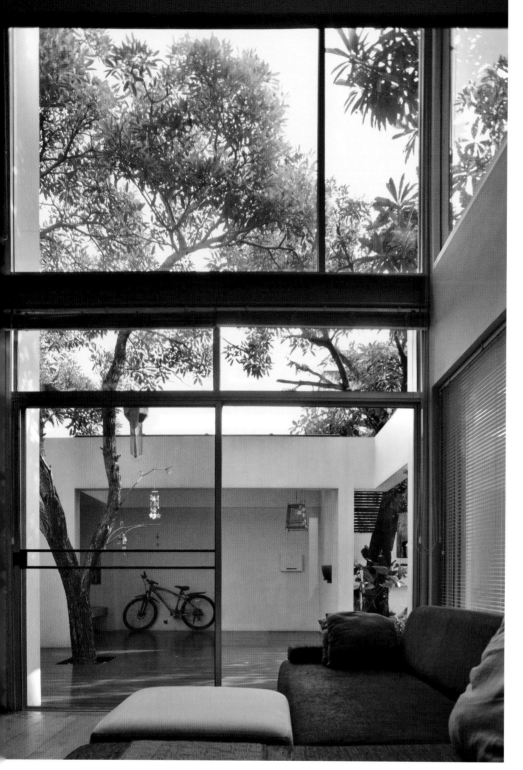

and out, borrowed views and the relationship between the built form and its context. Adhering to Bawa's oft-quoted maxim not to chop down trees, Srisak retained most of the existing mature trees on the site and also planted new ones to shade the house and courtyard. A spirit house that was on the site has been retained.

The compact design of Baan Taab 1 (or Baan/1) is a brilliant counterpoint to the often excessively large houses of a growing affluent middle class. The one-bedroom home has a second, smaller bedroom for guests but the compact planning, with its interlocking spaces and overlapping functions, reduces the space required for circulation to a minimum. The house can be entered by two routes—one via a courtyard fronting the double-height living space, the other alongside a koi pond that gives access directly into the kitchen.

Srisak is concerned with the 'spatial flow'. The design, he explains, is about 'connections'—both internal and external and vertically—within the shell. The bathroom is connected to the bedroom via a sliding wall that is, in turn, connected visually with the living room and the courtyard beyond through a two-story void. There is also a rotating TV. The paradox is that the house is small yet the spaces appear large.[2]

2 Living area
3 Dining area
4 Open courtyard
5 Outdoor sitting area
11 Master bedroom
17 Studio
19 Roof terrace

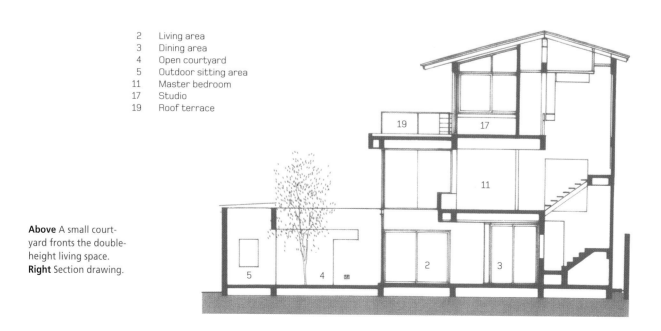

Above A small courtyard fronts the double-height living space.
Right Section drawing.

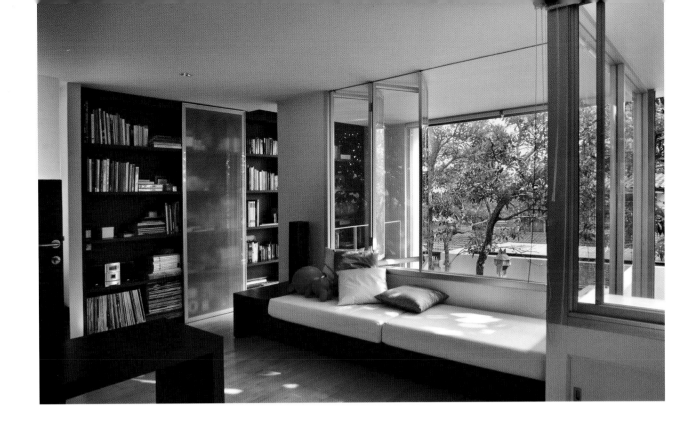

The house was essentially designed in section, with many study models being tested to ascertain how light would enter the spaces. In this, Srisak was influenced by the Japanese architect Tadao Ando, whose work he has visited and clearly admires. It is evident from the numerous models in his top floor studio that physical modeling of options is his preferred mode of making architecture. The design takes clues from vernacular two-story timber-clad dwellings, and Srisak has carried out a thoughtful process of integration with the context. A roof terrace gives views over the surrounding houses.

The couple share access with an existing house on the adjoining plot occupied by Panadda's parents and they back onto another plot owned by her sister's family. 'In the three-generation compound', Srisak remarks, 'we are connected but separate. This is the future. We live together so that we can take care of my wife's parents, one of whom is disabled, and they, in turn, get to enjoy their children and grandchildren.' The house is utterly modern and yet it sits comfortably alongside its older neighbors.

1 Brian Brace Taylor, *Geoffrey Bawa*, Concept Media, Singapore, 1986.
2 Chutarat Noochniyom, 'A Smaller House', *art4d*, No. 108, 2004.

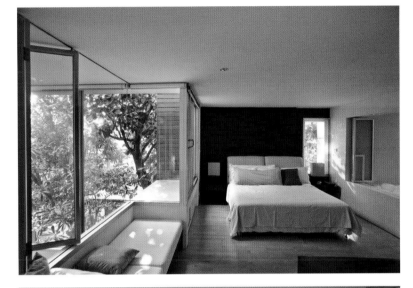

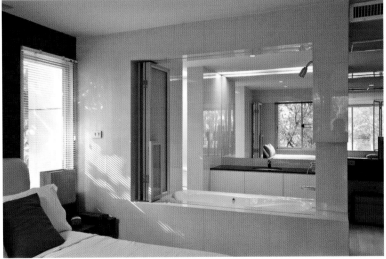

Top and center A window seat in the master bedroom suite overlooks the courtyard.

Above The connecting master bedroom and bathroom.

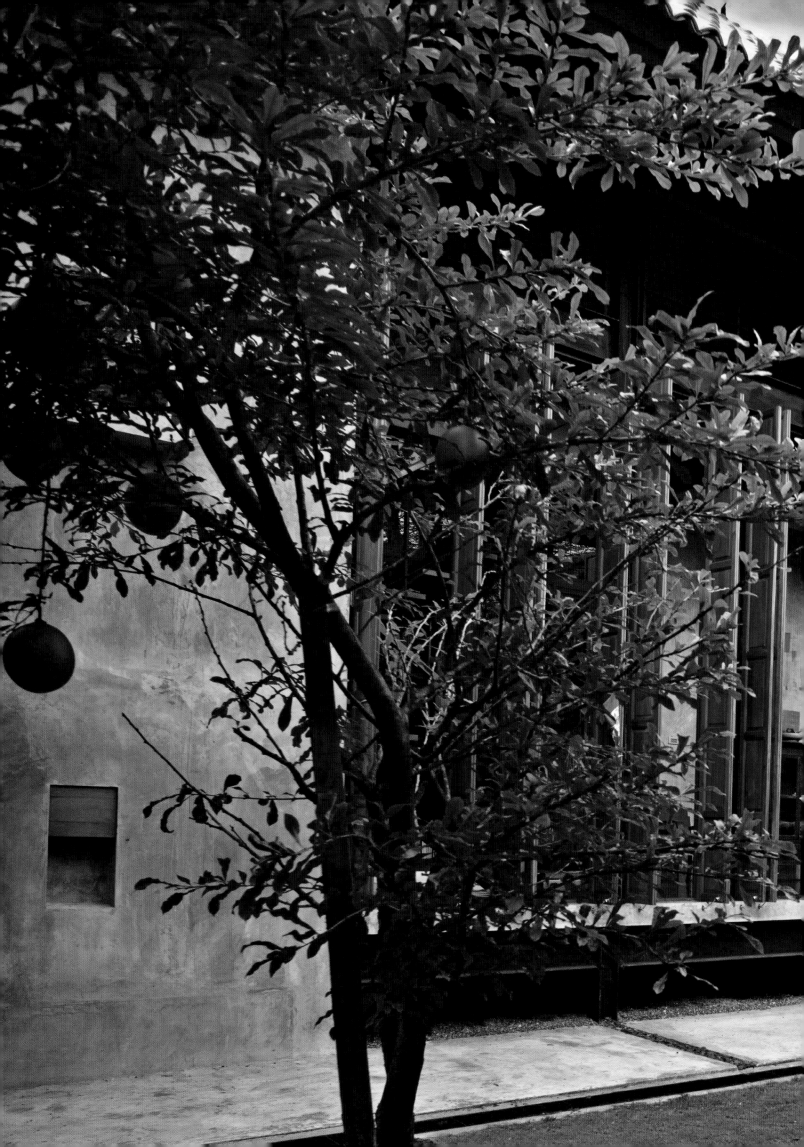

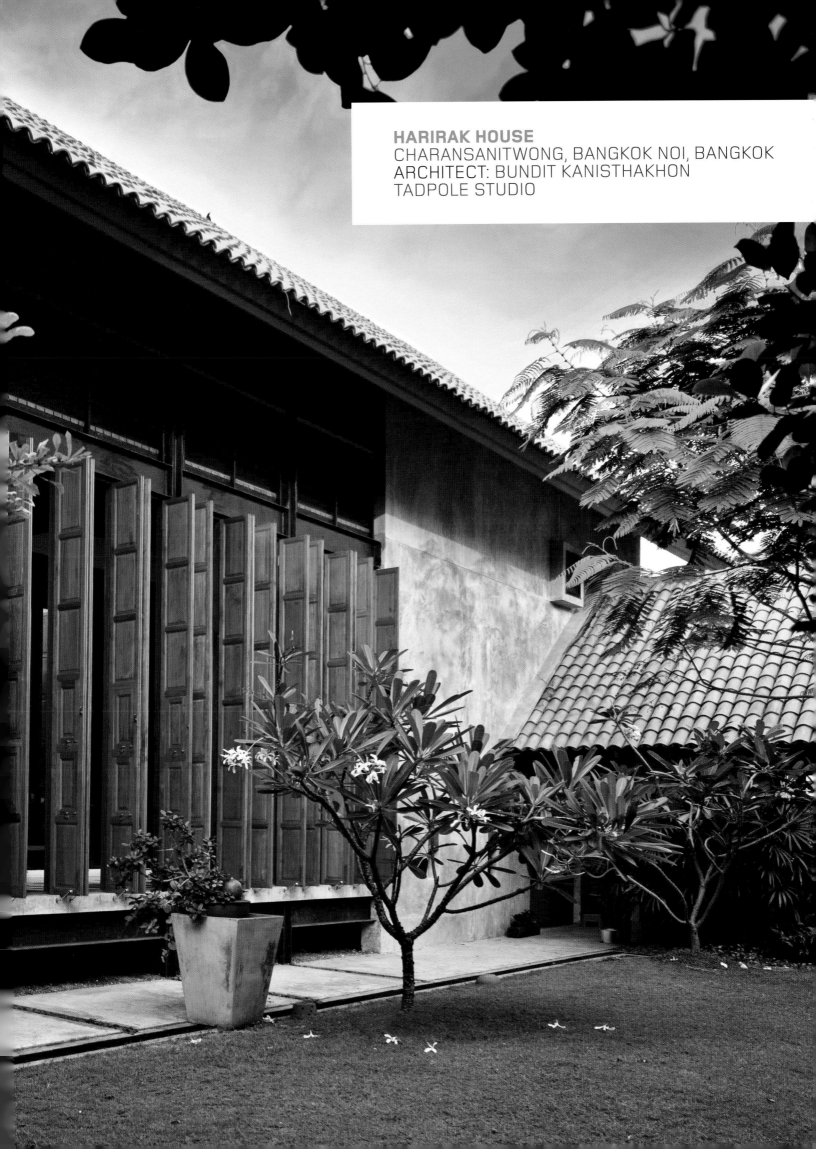

HARIRAK HOUSE
CHARANSANITWONG, BANGKOK NOI, BANGKOK
ARCHITECT: BUNDIT KANISTHAKHON
TADPOLE STUDIO

The immediate impression one gets of the Harirak House is that it is modern and yet it embodies many memories of a traditional Thai house. The house is located in the maze of narrow streets (*soi*) off Charansanitwong in the Bangkok Noi area of the metropolis. Although it is deeply embedded in the urban fabric of the city, upon entering the compound there is an immediate sense of calm because the house is hidden and secluded and feels almost rural. Trees are visible beyond the rooftops and there is the distinct sound of birdsong.

The 500-square-meter house was designed by Bundit Kanisthakhon. Completed in 2007, it is the residence of his sister Busakorn (Kai) Harirak, her husband Panupong and their two children. Both husband and wife studied at Seattle Pacific University in the USA whereas Bundit studied architecture at the

University of Washington and pursued his Masters degree at Massachusetts Institute of Technology, where his career was influenced by the former editor of MIMAR, Hasan-Uddin Khan. Bundit presently lives and practices architecture in Honolulu, Hawaii.

The area where the house is located was formerly a durian plantation consisting of roads lined by durian trees and separated by *klong* (canals). Later, houses were built on the land, mostly for government employees. The residential layout followed the same plot pattern as the durian plantation. Kai was born here, then moved away and later returned with her husband.

There are three components of the house—a main linear building, a carport and a guesthouse. The three buildings encompass a courtyard garden with a beautiful flame tree—a royal poinciana—at the heart. The design provides ample semi-outdoor spaces for the family to gather. Bundit greatly admires the work of Geoffrey Bawa, and he and his wife have visited Bawa's work in Sri Lanka. The influence of the Sri Lankan master can be seen in the sensitive arrangement of shifting axes, vistas and enclosed courtyards. There are numerous places to sit and contemplate.

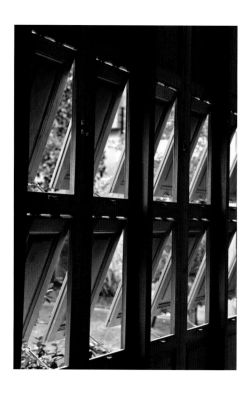

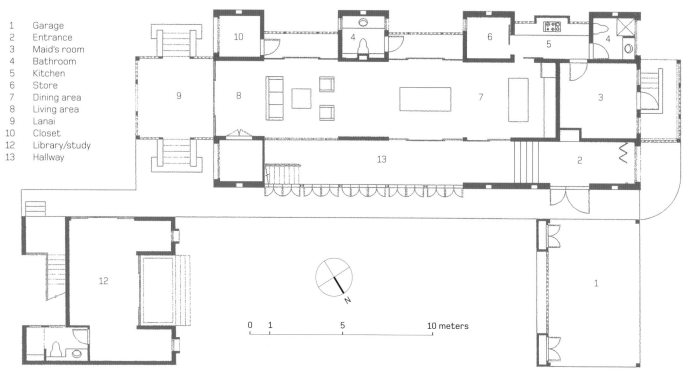

1	Garage
2	Entrance
3	Maid's room
4	Bathroom
5	Kitchen
6	Store
7	Dining area
8	Living area
9	Lanai
10	Closet
12	Library/study
13	Hallway

0 1 5 10 meters

Pages 54–5 The house is arranged around a garden court.
Above First floor plan.

Top Operable timber shutters in the southwest elevation permit natural ventilation.

Right A gallery extends along the northeast flank of the house.

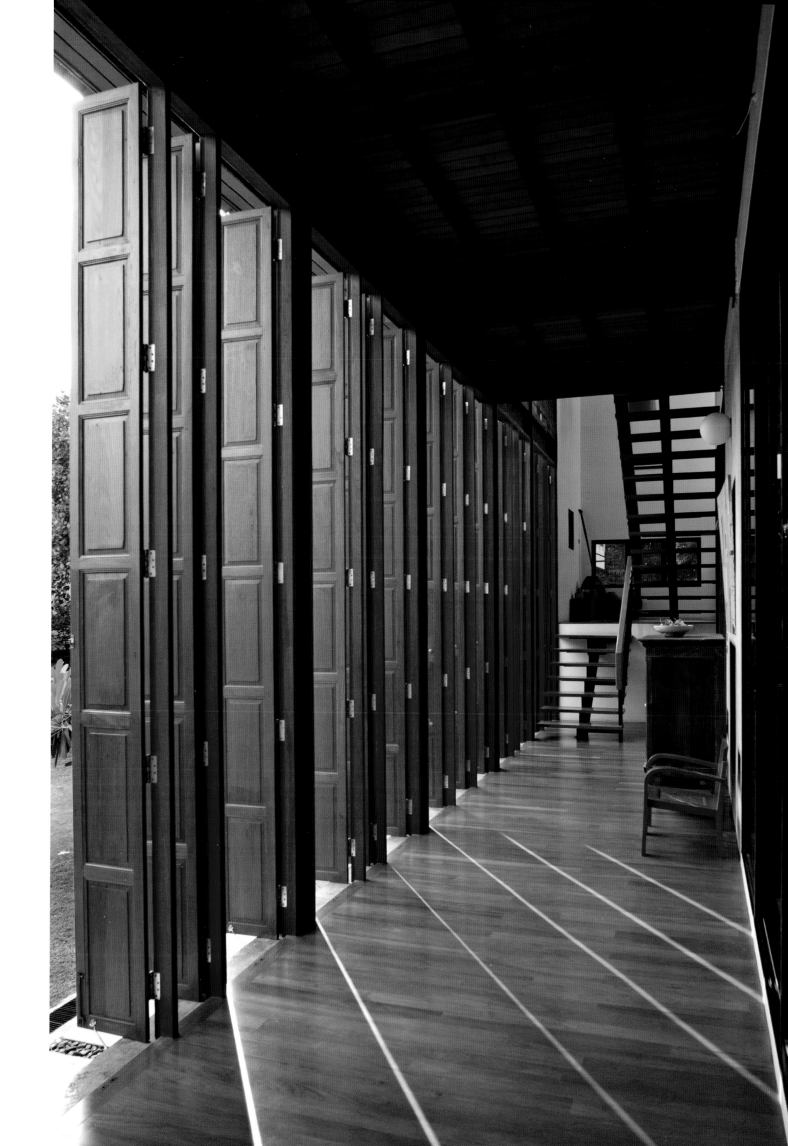

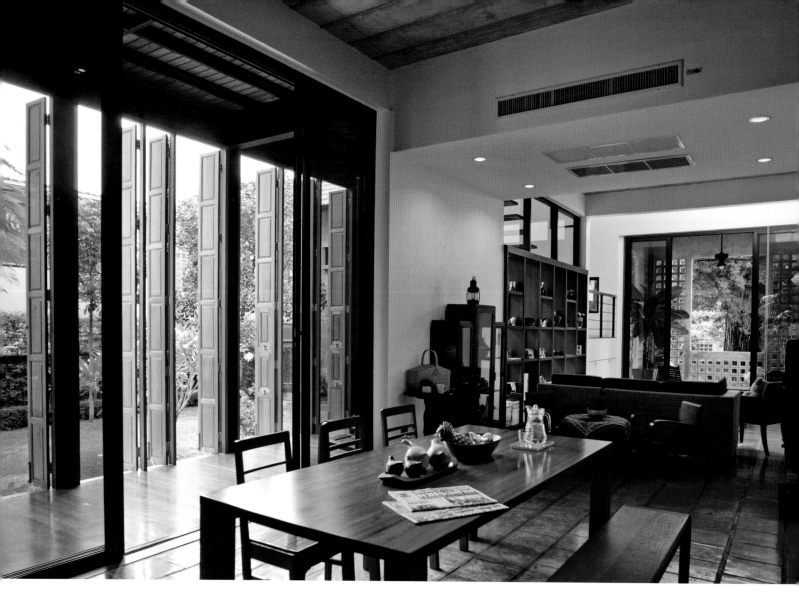

At the northern end of the house, over-looked by a veranda, are the remains of an algae-covered *klong* (canal). The still, green water and the reed bed in its midst connect with Bangkok's history as a water city.

Kai's mother currently occupies an old house behind her daughter's residence in what is essentially a three-generation compound, but the family hope that she will at some time in the future move to what is already referred to as the 'mother's house', currently used as a study and guesthouse, which has a superb view into the garden.

The main house is entered via a tall, pivoted entrance door that gives access to a linear circulation gallery with operable timber shutters on the southwestern flank

of the house. The internal areas of the house glow with a gold and brown hue in contrast to the off-form concrete and cement render of the structural walls. The principal staircase is located at the very end of the gallery.

The focus of the house is a high-ceilinged living and dining space, with the kitchen occupying one end and a semi-enclosed patio the other. The linear space is flanked on the southwestern side by the circulation gallery and on the opposite side by a double-glazed veranda. Tall, black, aluminum-framed doors slide open to give access from the main living space into the parallel terraces. There is a double-height void above the dining area and another above the television area. The upper floor contains three bedrooms, also

accessed by a linear gallery on the western flank. The master bedroom has an exquisite *en suite* bathroom. The key to the success of the internal spaces is the excellent cross-ventilation, assisted by ceiling fans.

Bundit has created a thoroughly modern house that is deeply embedded in Thai tradition. It has steep-pitched, clay-tiled roofs without gutters, tall rooms, ceiling fans, permeable walls for natural ventilation, adjustable teak shutters and clay floor tiles. Wherever possible, local materials have been used. Perforated concrete blocks are also used both structurally and strategically to allow for natural light and ventilation, while the veranda on the upper level has slatted timber louvers for ventilation. The folding wood

Above The heart of the house is the high-ceilinged living and dining room.

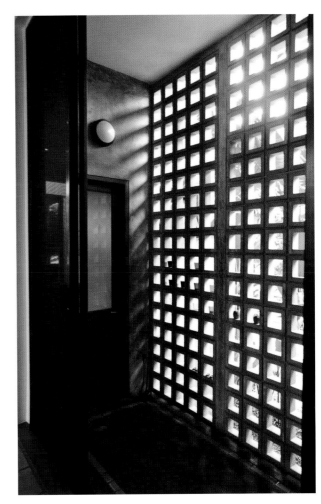

doors and wood floors in the main house have been constructed from salvaged teak.

The house is raised one meter above ground level in the manner of a traditional Thai house. Wide, overhanging eaves are designed to provide ample shade. The 40-degree angle of the roof follows Thai traditional practise but is also intended to accommodate photovoltaic panels at some future date. The orientation of the house is therefore very important. Three towers located on the southwest side of the house function as the service space and they shade the house from the late afternoon sun.

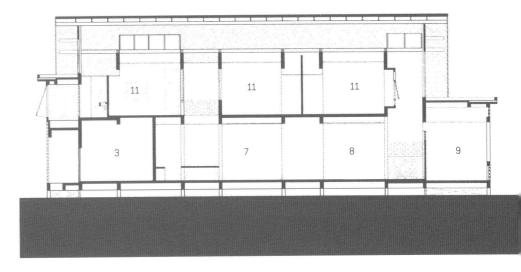

3	Maid's room	9	Lanai
7	Dining area	11	Bedroom
8	Living area		

Top left and right Sliding screen doors give access from the dining area to the veranda.

Above Section drawing.

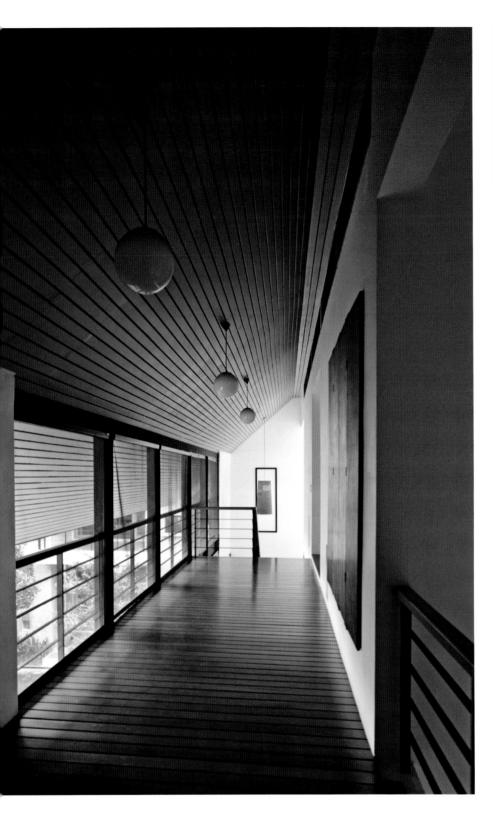

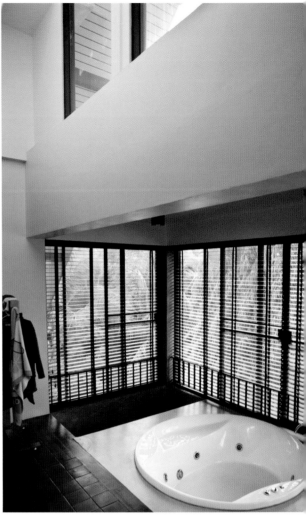

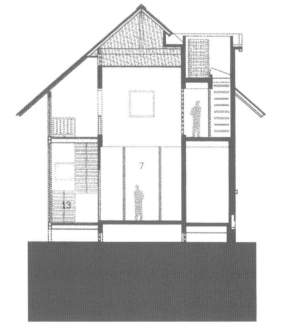

7 Dining area
13 Hallway

Above At second floor
level there is a linear
circulation space.

Top There is a delightful
view from the master
bathroom into a leafy
garden on the eastern
flank of the house.

Above Section drawing.

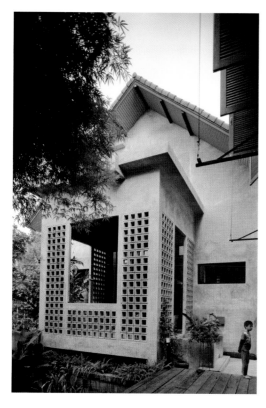

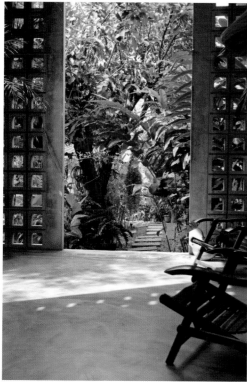

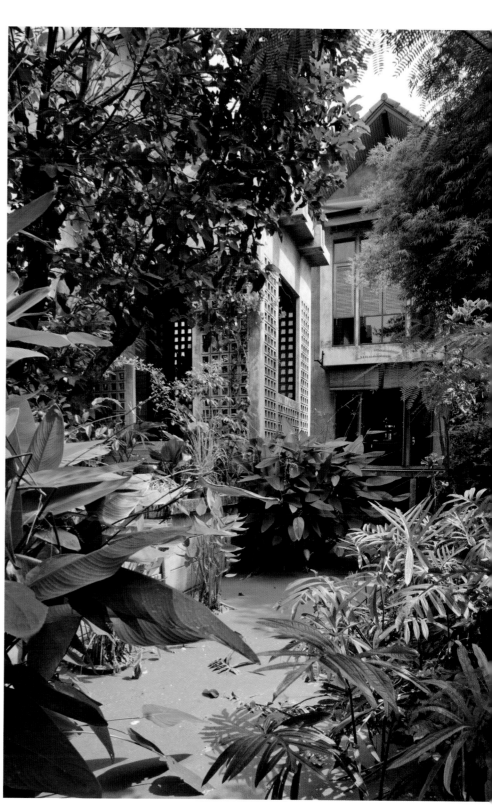

Top and above At the northern end of the living area, an external patio overlooks a pond.

Above The algae-covered pond is a reminder of an era when Bangkok was served by numerous *klong* (canals).

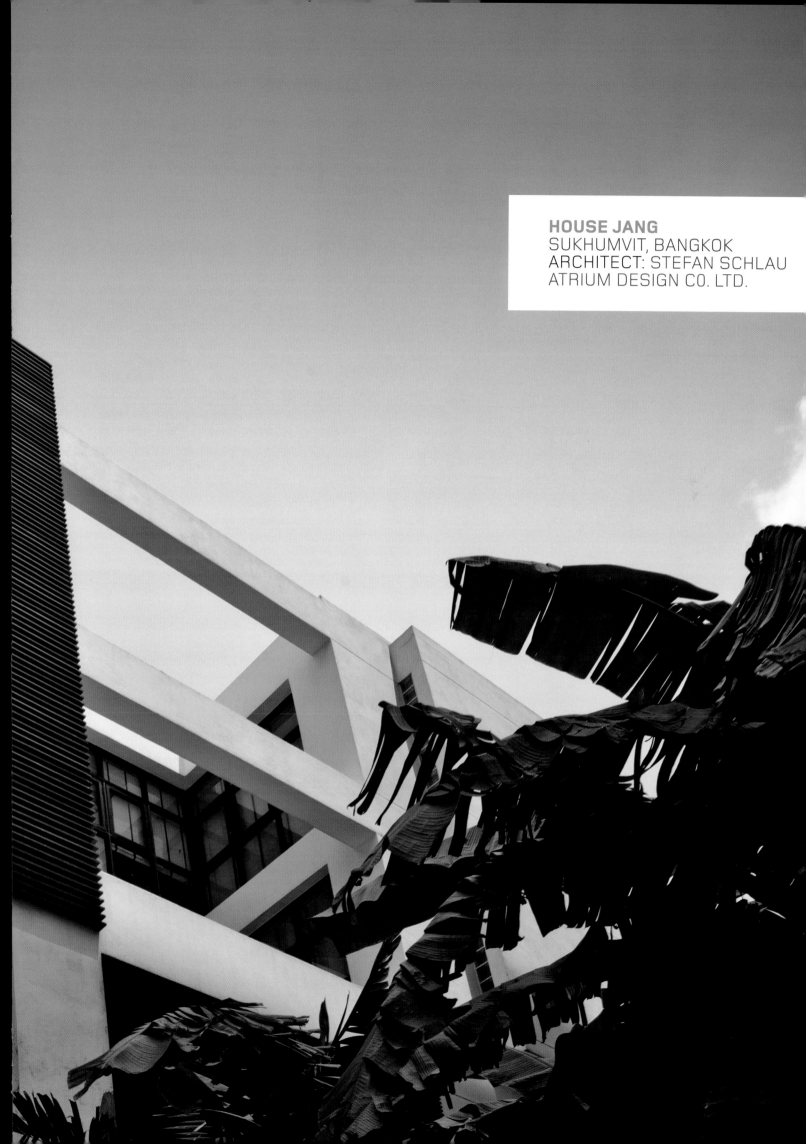

HOUSE JANG
SUKHUMVIT, BANGKOK
ARCHITECT: STEFAN SCHLAU
ATRIUM DESIGN CO. LTD.

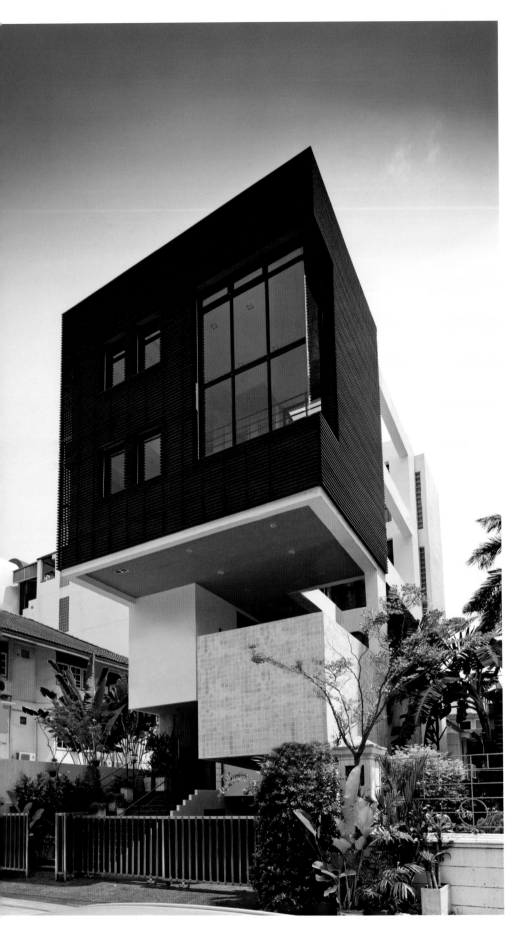

House Jang is a family home in the very heart of Bangkok at Ruan Rudee Soi 2, off the busy Ploenchit/Sukhumvit Road. The house is built on a sliver of 'left over' land measuring just 160 square meters. Unusually for the center of Bangkok, the land is freehold.

The initiator of the project was Stefan Schlau, a German-born British architect who has lived in Bangkok for almost two decades. He was born in Hamburg and received his architectural education at the Technische Universität in Karlsruhe and Berlin and the Architectural Association in London where he gained a diploma in 1977. His contemporaries included Zaha Hadid and David Chipperfield. He returned to the AA to teach in Peter Cook and Christine Hawley's Unit in 1978 and ran his own unit in 1980–1 with Sotores Polydorou and Tom Heneghan.

Stefan lived in London for twenty years, working initially with OMRANIA, Buro Happold and Frei Otto in Saudi Arabia before setting up his own practise, CLS Architects, in 1983. He designed a number of restaurants for Thai clients, including 'Chiang Mai', the first Thai restaurant in Soho, London, and various houses for Thai clients in London and France. When commissioned to design a large resort in northern Thailand in 1995, he moved his base to Bangkok and later built his own studio and residence in Soi Polo.[1] Subsequently, he has designed several private villas, apartments and resorts.

Acknowledging the location of the expensive site that is surrounded by high-rise towers, it was a given that the clients, Radja Smutkojon, a manager of an international company, and his wife Ravee Purananda would require a huge amount of floor space.

Pages 62–3 The house occupies a challenging urban site surrounded by high-rise towers.

Above The design is a bold geometric composition.

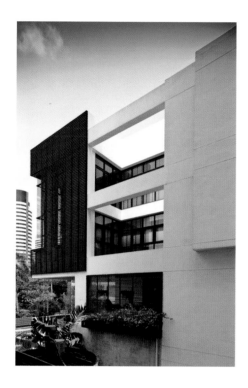

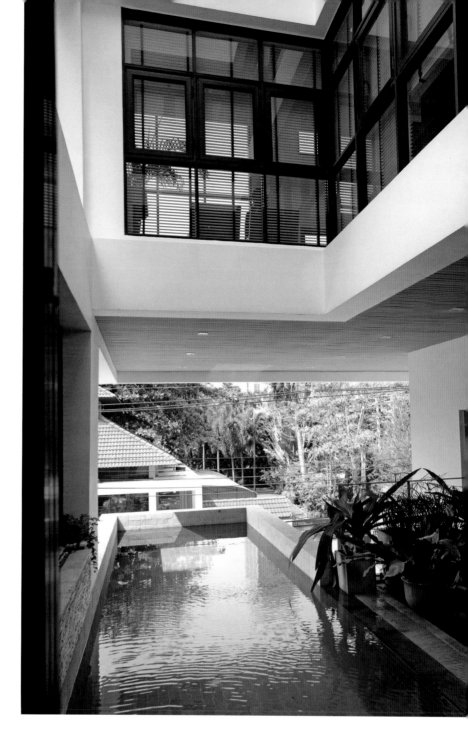

With incredible ingenuity, the architect has achieved 340 square meters (plot ratio 1:2), notwithstanding the restriction that the permitted height of the building should not exceed 15 meters. To accommodate this, he designed a 4.5-story structure (excluding carpark) that is built up to one meter from the site boundary on all sides. A glass elevator facilitates access to the upper floors.

There are a small number of recessed windows on three sides of the cubist composition, but a rectangular lightwell 'carved' from the center permits daylight to enter. The main living areas facing the street have views of the city skyline and of a neighboring garden immediately opposite the site. A 10-meter-long plunge pool cantilevers over the carpark, and above it is a brown timber-clad box (originally intended to be copper) projecting over the pool and main entrance.

Architect Stefan Schlau has made up for what the house lacks in external vistas with a beautifully composed internal space. The interior is remarkably spacious, with a double-height living room that overcomes any possible sense of claustrophobia. The living room faces north so that there is minimum sunlight and solar gain in the living room, and this also allowed the windows to be clear glass. At dusk, as the lights of the city are switched on, there is a magical panorama.

The condominium on the adjoining site has its air-conditioning coolers sited immediately adjacent to the swimming pool deck, with the consequent whine of fans. A waterfall has been introduced alongside the pool that effectively masks the noise.

In summary, House Jang is an artful infill urban residence that makes maximum use of a restricted site.

1 Robert Powell, '173 Polo House', *d+a (Asia)*, Issue 007, Singapore, 2007, pp. 47–9.

Above left In the absence of external views, a rectangular lightwell is carved from the center of the block.

Above right A plunge pool is ingeniously incorporated in the design.

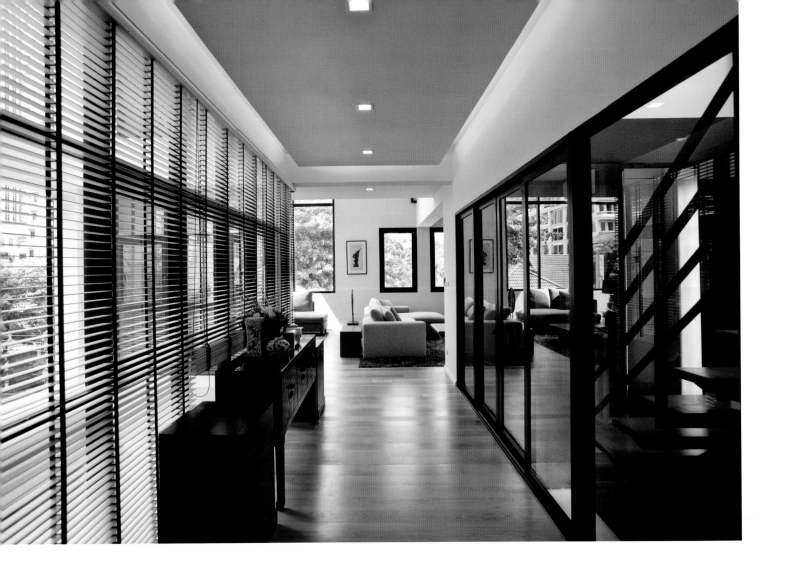

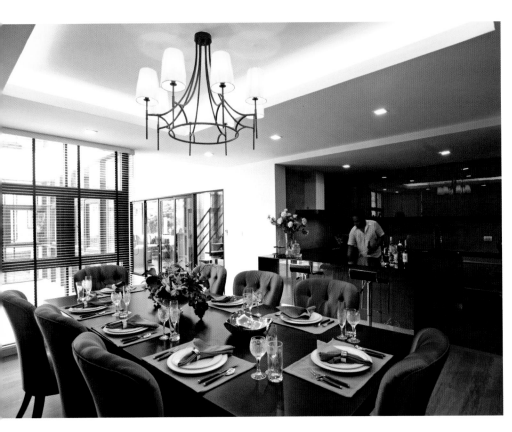

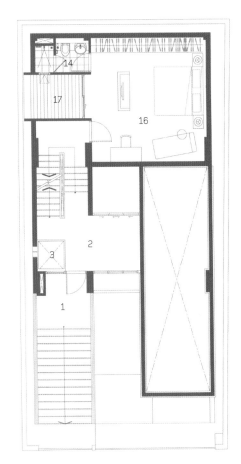

Top Given the compact inward-orientated plan, there is a surprising sense of space and light in the house.

Above The dining area exudes luxury living.
Right First floor plan.

Opposite above left Section drawing.
Opposite above right The hall and the glass elevator.

Opposite below left Second floor plan.
Opposite below right A magnificent double-height living space is the focus of the urban house.

1 Entrance
2 Hall and staircase
3 Glass elevator
4 Pool deck
5 Swimming pool
6 Guest bathroom
7 Living room
8 Dining room
12 Gallery
13 Master bedroom
14 Master bathroom
15 Bedroom
16 Bedroom
17 Balcony
18 Carpark

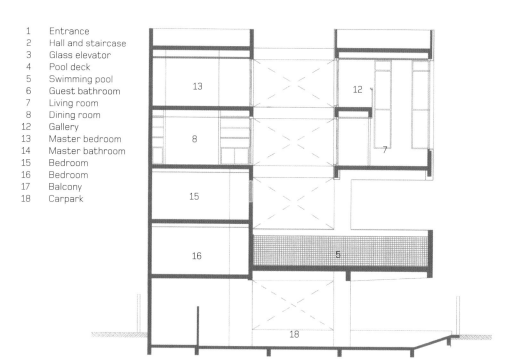

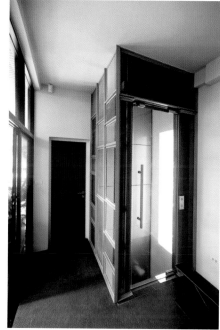

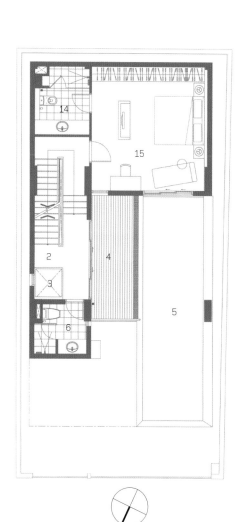

0 1 5 10 meters

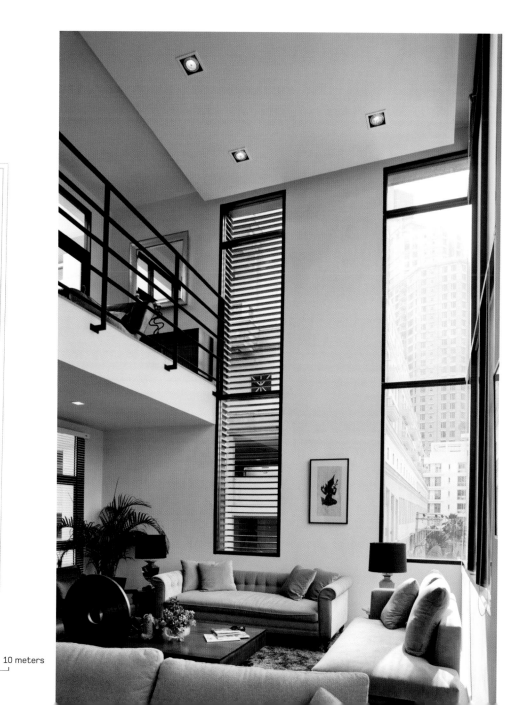

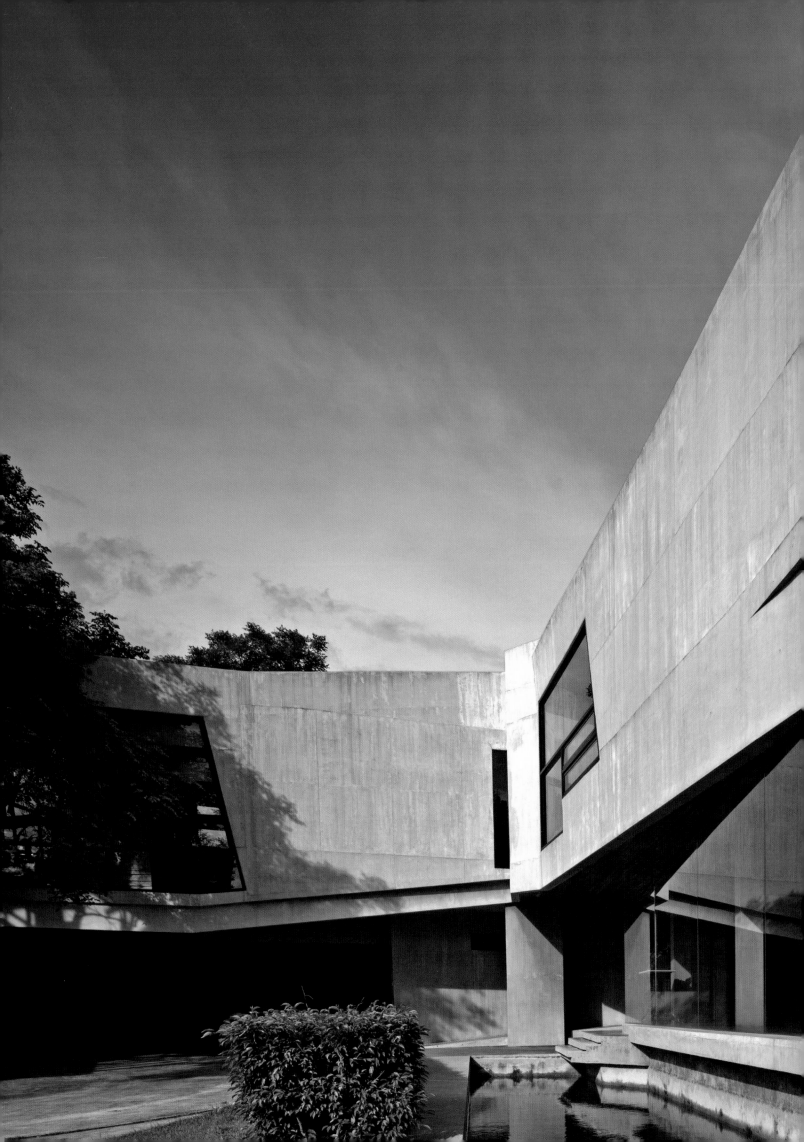

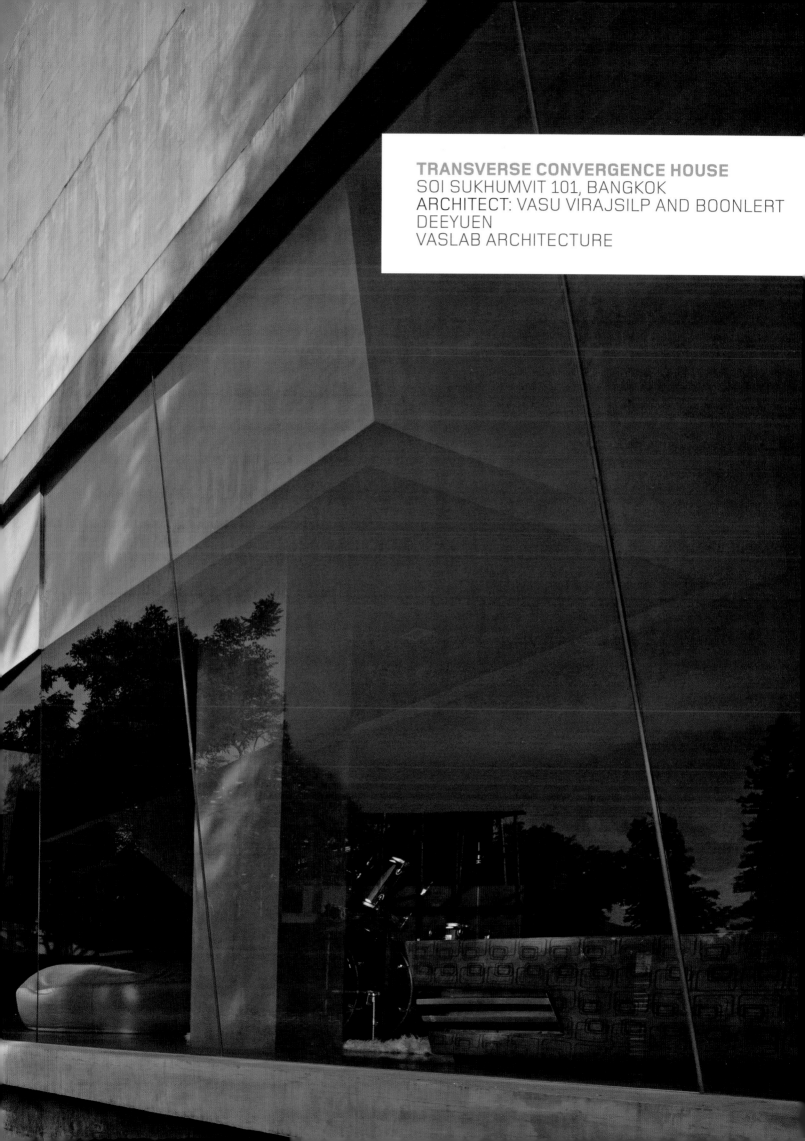

TRANSVERSE CONVERGENCE HOUSE
SOI SUKHUMVIT 101, BANGKOK
ARCHITECT: VASU VIRAJSILP AND BOONLERT
DEEYUEN
VASLAB ARCHITECTURE

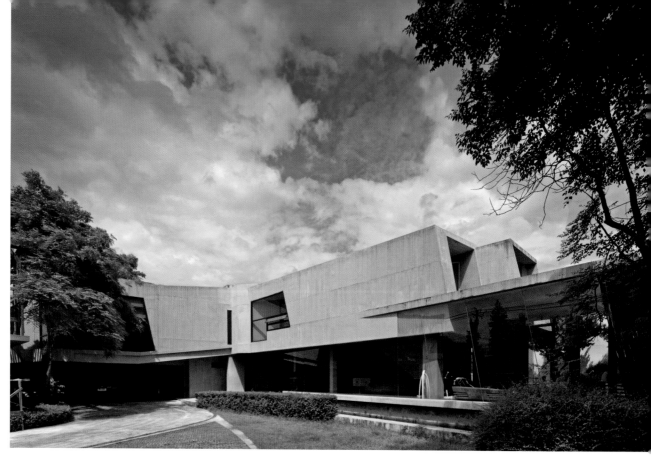

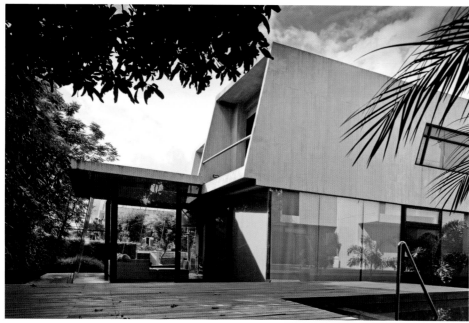

The Transverse Convergence House is the residence and design studio of architect Vasu Virajsilp. The two-story 550-square meter house/studio, which is located off Sukhumvit Road, is remarkable for the plastic use of concrete to achieve a sculptural form. Its distinctive and extraordinary manipulation of space and form, with interlocking volumes, ramps and stairs, is also a complete break with Thai tradition.

Vasu Virajsilp obtained his B.Arch. (Hons) at the Pratt Institute in Brooklyn, New York, in 1996, where the major influence on his studies was Raymund Abraham. Later, he trained at Columbia University New York under Professor Bernard Tschumi, and obtained an M.Sc. in Advanced Architectural Design in 1998. He and Boonlert Deeyuen, who is a graduate of Silpakorn University in Bangkok (1996), set up the practise of VaSLab Architecture in 1999 (registered 2003). The two partners admit to influences from the work of provocative art and from architecture movements such as Cubism, Abstract Art, Modernism, Dada, Surrealism and Deconstruction.

The sinuous form of the Transverse Convergence House is an enigma. Underpinning the seemingly simple external form is a complex methodology. The arrangement of the internal space is much more intricate than the elevations. There is throughout the house a sustained ambiguity about which spaces are for living and which are for working. The boundaries are indeterminate and paths between the two are entwined so that, for example, the house entrance has the feel of an office lobby but immediately morphs into a comfortable sitting area with, alongside it, a drum kit. Visible beyond the

Pages 68–9 The house is noteworthy for the plastic use of concrete. **Top** The public façade of the house facing the site entrance.

Above A swimming pool deck on the private side of the house is concealed from the public gaze.

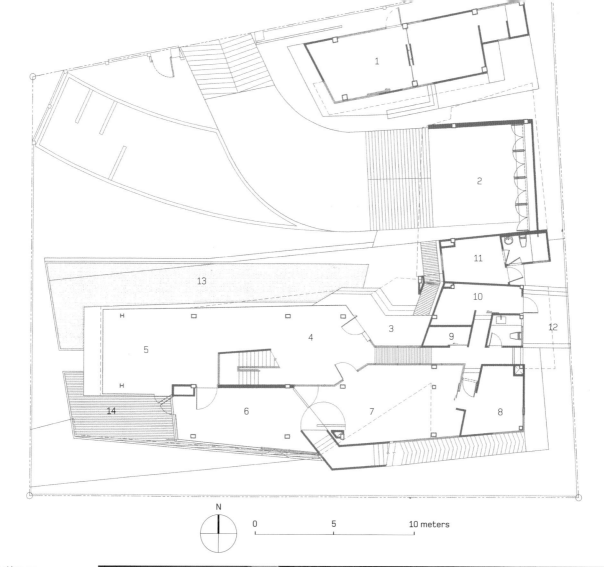

N

0 5 10 meters

1 Guesthouse
2 Carport
3 Entrance
4 Hall
5 Living room
6 Family room
7 Dining room
8 Kitchen
9 Store
10 Laundry
11 Maid's room
12 Wash area
13 Pond
14 Timber deck

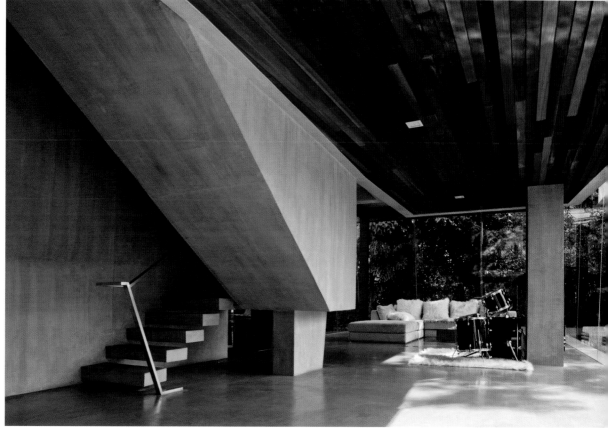

Top First floor plan.

Above The public reception area morphs into a private living space.

office entrance is the residential dining room—a double-height space located behind a black aluminum-framed glass wall with a splendid chandelier by Bellacor. Adjoining the dining room is the family room from which access is obtained via a security door to a staircase leading to the master bedroom. At the southeast corner of the house are a timber deck and a swimming pool reached from the living area.

Between the living room and the family room, the route to the first floor design studio is signaled solely by the inclined soffit of a sculptural concrete stair. Arriving at the upper floor, a short concrete ramp, a thrusting angular bookcase and an architectural model indicate the transition from residence to workplace. At this point, there is an administration desk fronting a meeting room and, paradoxically, a guest suite. To the north of the studio is a single-story building that was initially intended as the home of an elderly relative but has now been turned into an 'ancestor's room'.

For the first-time visitor to the Transverse Convergence House, the entrance hall is disorientating, for it is simultaneously a private residential domain and the semi-public entrance of an office. But the duality of the house obviously works for the architect/owner, who appears to reject the pigeon holing of life into categories such as 'work', 'leisure activity' and 'home'. Here, they are all interwoven. In this residence, designed and built specially to suit his needs, the architect is able to explore deeply the interactions and contradictions in daily life and identify areas of intersection and convergence. The house reveals a uniquely personal concept of 'dwelling'.

The use of metaphor is a key feature of VaSLab's design methodology. In the Transverse Convergence House, the architect utilizes a metaphorical interpretation of how three different paths are related. The house represents a journey in which three diverging and converging paths are translated into a series of space–form interactions, such as living/working and resting/meeting. Read in this manner, the initial confusion is replaced by the desire to more closely interrogate and comprehend the narrative.[1]

The intertwined activities in the building are visible from the forecourt. At ground floor level, floor-to-ceiling clear glass walls permit views of the hall and living areas, while the large windows on the upper floor reveal the architect's office at work. Residence and workplace share the same palette of materials, namely off-form concrete, unpainted plaster, polished cement floors, timber ceilings and black aluminum window frames.

Another deconstruction of the notion of work and place is evident when I arrive at the house to find Vasu and Boonlert—the latter oversees detailing and construction—setting off in their 'mobile office', a six-seater van with comfortable seats. 'We spend four hours a day in Bangkok traffic,' explains Vasu. 'It is one way to use the time productively.'

1 Pirak Anuraywachon, 'Paths to Paths', *art4d*, No. 126, Bangkok, May 2006.

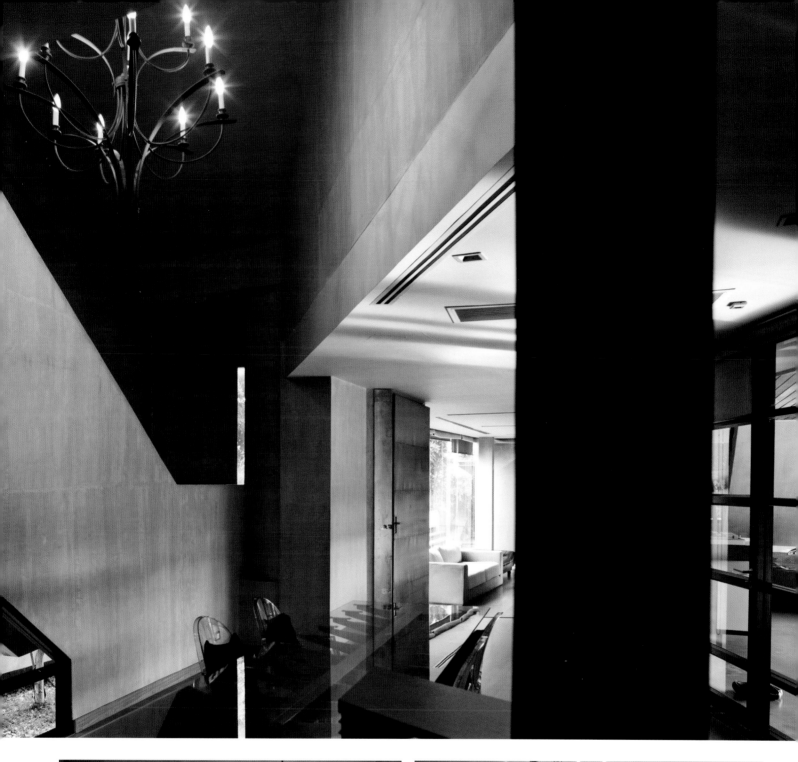

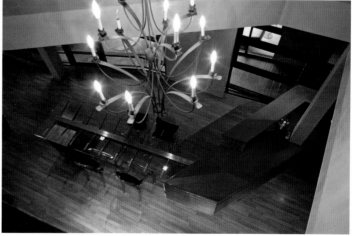

Top Throughout the house, the use of space is ambiguous.

Above left and right Overlooking the dining area.

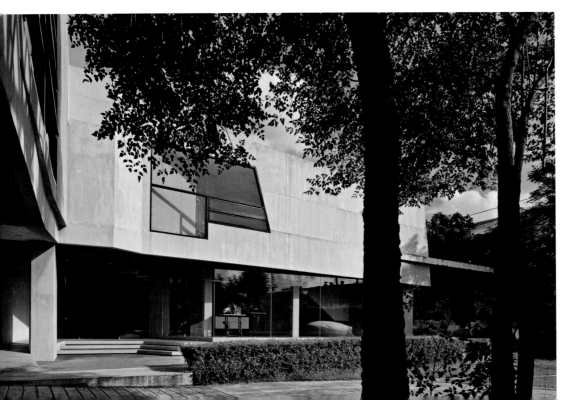

Opposite above Library shelves thrust forward like a projectile and signify the transition from residential to office space.

Opposite below The entrance to the office and the residence from the vehicle forecourt.

Above A shaft of sunlight illuminates the office library.

BUNKER HOUSE
LOPBURI
ARCHITECT: VASU VIRAJSILP AND BOONLERT
DEEYUEN
VASLAB ARCHITECTURE

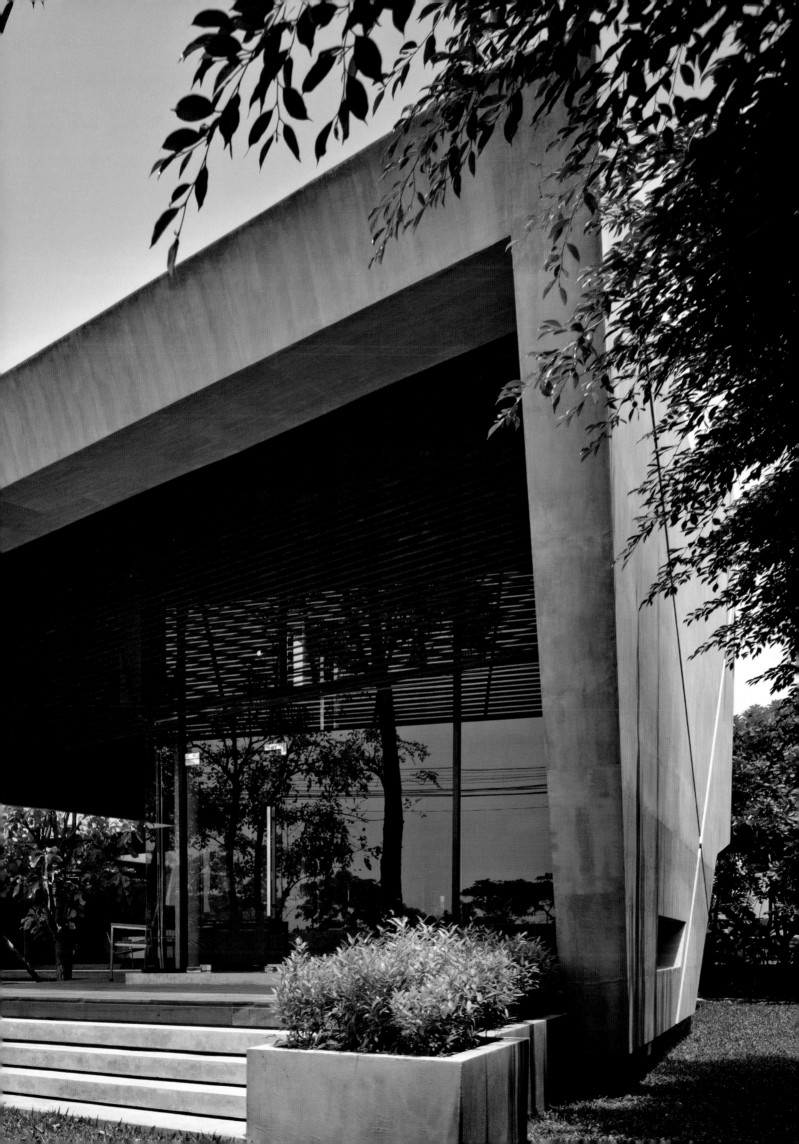

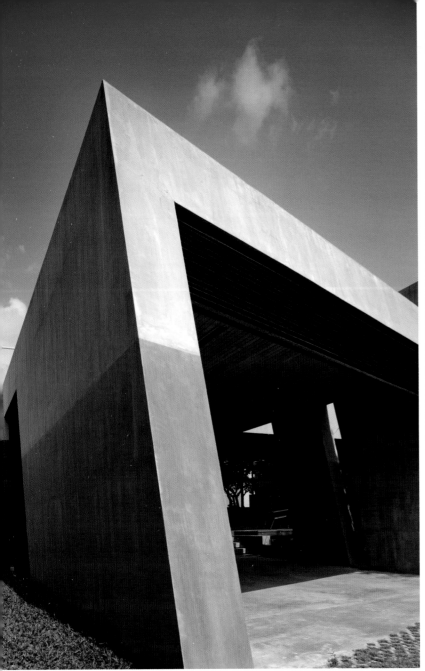

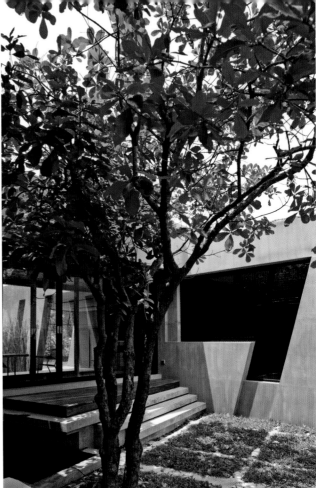

The Bunker House is an intriguing compact residence located at Lopburi, some 180 km and three hours drive north of Bangkok. Like the Transverse Convergence House by the same architectural firm (page 68), this is a plastic composition in concrete. The owners of the house, Siriwan Tiensuwan and Noppasorn Duangtawee, sought out architect Vasu Virajsilip having read an article published in *art4d* on the Transverse Convergence House. The project architect working on the design was Ratthaphon Sujatanonda.

The inspiration for the design, Vasu attests, comes from the book *Bunker Archeology* published by Princeton Architectural Press.

Authored by Paul Virilio, a French urban planner, the book features images of World War ll bunkers on Normandy beaches. They are, he writes 'lonely and vigorous'. The house owners are, like Vasu himself, fascinated by these concrete structures that simultaneously express security and surveillance. Another source of inspiration is said to be the strength and fluidity of the nearby Pasak Cholasit Dam, the largest reservoir in Central Thailand.[1] Furthermore, Lopburi has long had a connection with the Thai military—it was set up as a military settlement by Field Marshall Piboonsongkram in 1938[2]—so perhaps the name of the house is appropriate in these circumstances. Indeed, it is true that

from certain angles the house does resemble a military bunker.[3]

Ultimately, the architect has succeeded in answering the owners expressed desire for privacy while simultaneously requiring interaction with the outside. He has worked with the contradictions inherent in the request, such as 'hidden versus visible' and 'secure versus open'. The house, located in a residential enclave in Lopburi, is private, yet the owners can observe life on the street and a canal beyond from their living room.

The asymmetrical H-shaped plan of the 330-square meter dwelling has two roughly parallel boxes linked by a glazed entrance lobby at ground floor level. The plan embraces two courtyards, with a fountain in the rear court and a pond in the forecourt. The use of water around the house is intended, says the architect, to reduce the 'stillness of concrete'. Trees and landscape are integrated with the plan form.

The interior of the dwelling is designed for open-plan living, with a double-height space over the living area visually connecting with the master bedroom at the upper level that

Above left The off-form carport entrance.
Above right Landscape in the rear patio follows an orthogonal pattern.

Pages 76–7 Military bunkers in northern France inspired the bold concrete form.
Right First floor plan.

gives access to a timber roof deck. There is one guest room that is set apart from the main activity and accessed via the glazed entrance lobby.

The sculptured geometry of the house is consistently angled, and there are striations cast into the concrete walls. Horizontal metal sheets are utilized as cladding on the taller of the two blocks. Thick concrete walls and huge overhangs shield the clear glass windows from solar insolation, while openings on opposite sides of the house allow for cross-ventilation. The 'bunker' analogy is continued with the incorporation of slit windows in the concrete façades.

The quality of detailing is similarly consistent, with narrow slots alongside the staircase to permit daylight to enter, inclined window mullions and louvers, and special attention to the detail of recessed spotlights. The staircase itself is precisely detailed and incorporates a place to sit into the second riser. Finishes include unpainted plaster walls and floors of a reflective composite marble material. Circular concrete columns, 300 mm in diameter, give a Corbusien ambience to the interior. The house is simultaneously austere and comfortable.

1 Pirak Anurakyawachon, 'We Love Concrete,' *art4d*, No. 156, Bangkok, February 2009.

2 Ibid.

3 'Bunker House', *Room: Ideas for Better Living*, No. 79, Bangkok, September 2009, pp. 70–5.

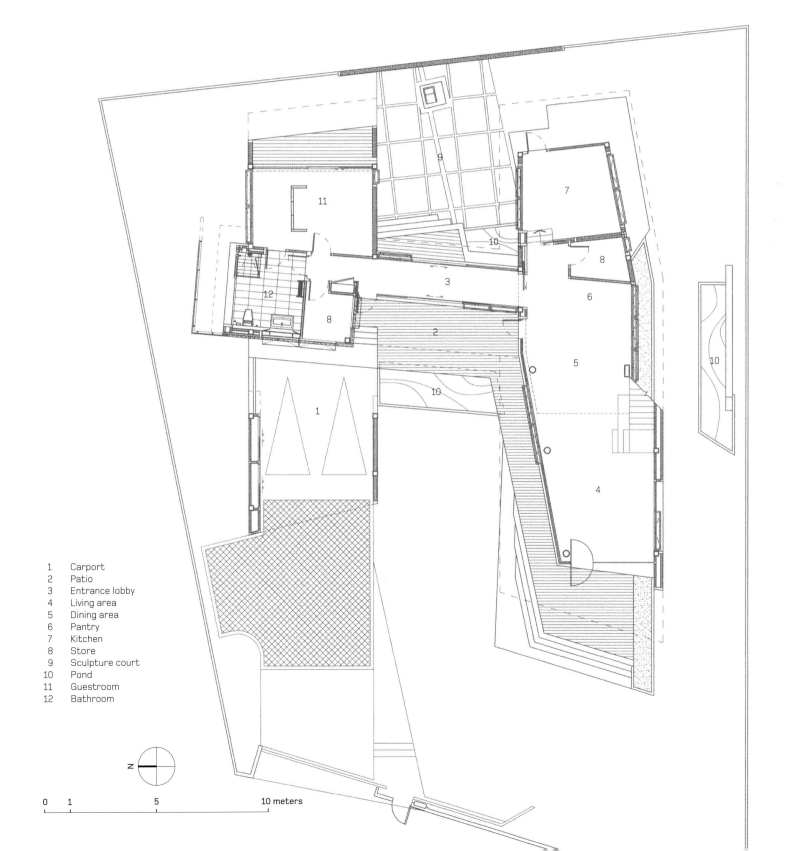

1 Carport
2 Patio
3 Entrance lobby
4 Living area
5 Dining area
6 Pantry
7 Kitchen
8 Store
9 Sculpture court
10 Pond
11 Guestroom
12 Bathroom

0 1 5 10 meters

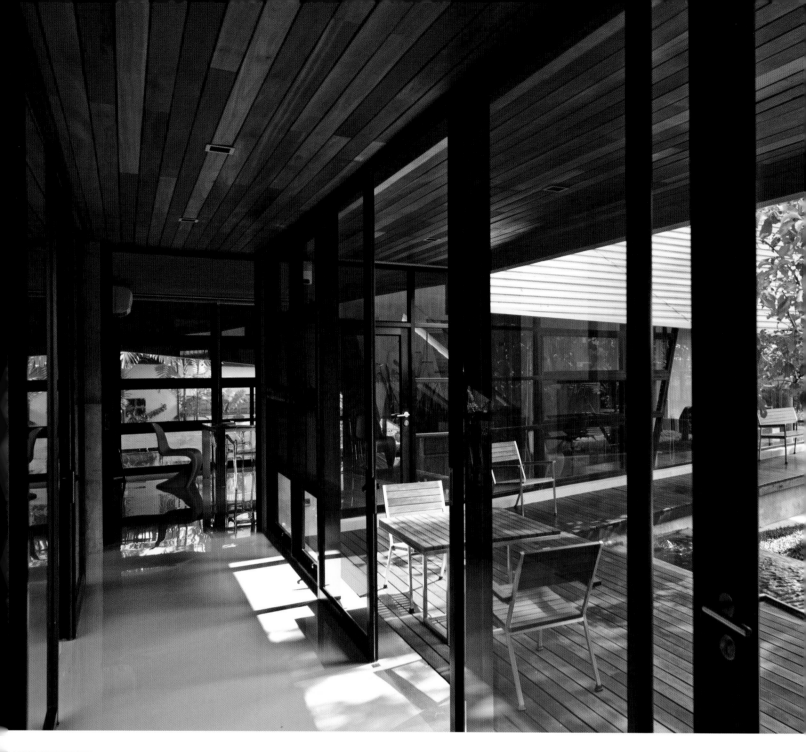

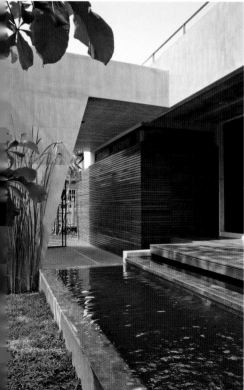

Left There is a consistent architectural language of inclined concrete planes and profiled metal cladding.

Above and far left The entrance to the house overlooks a small pond.

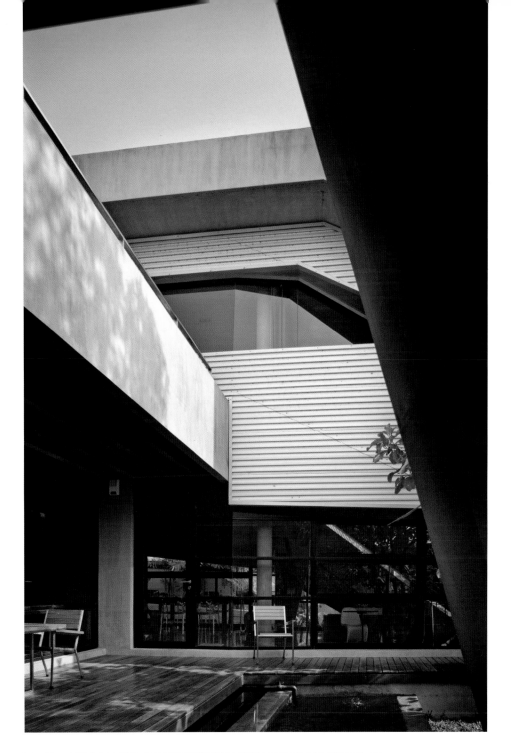

Top The entrance court and timber-floored veranda.

Above Elegantly detailed steps at the entrance to the house.

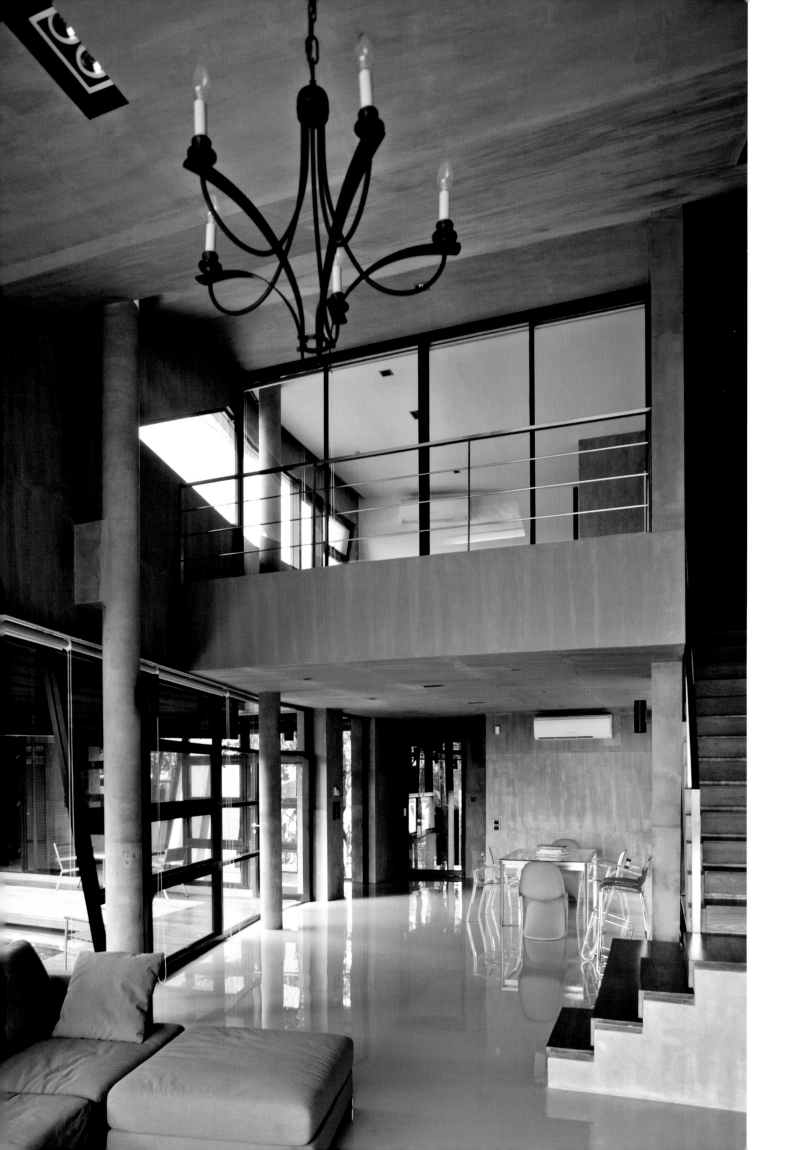

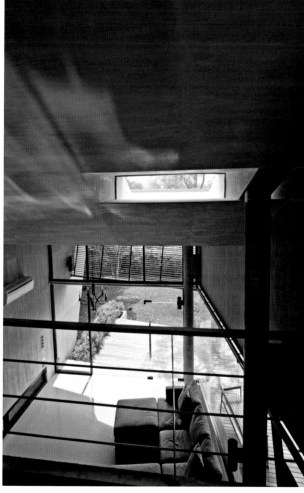

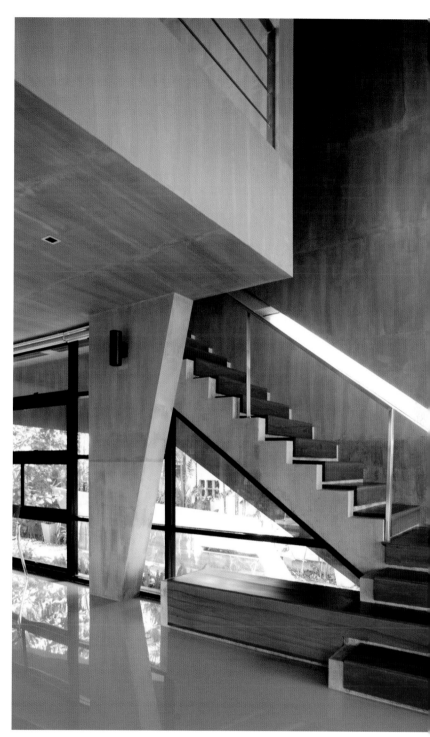

Top A well-considered structural detail.

Above Looking down from the master bedroom to the living space.

Above A finely designed staircase ascends to the private areas of the house.

Opposite The principal double-height living and dining space has a Le Corbusier-inspired aesthetic.

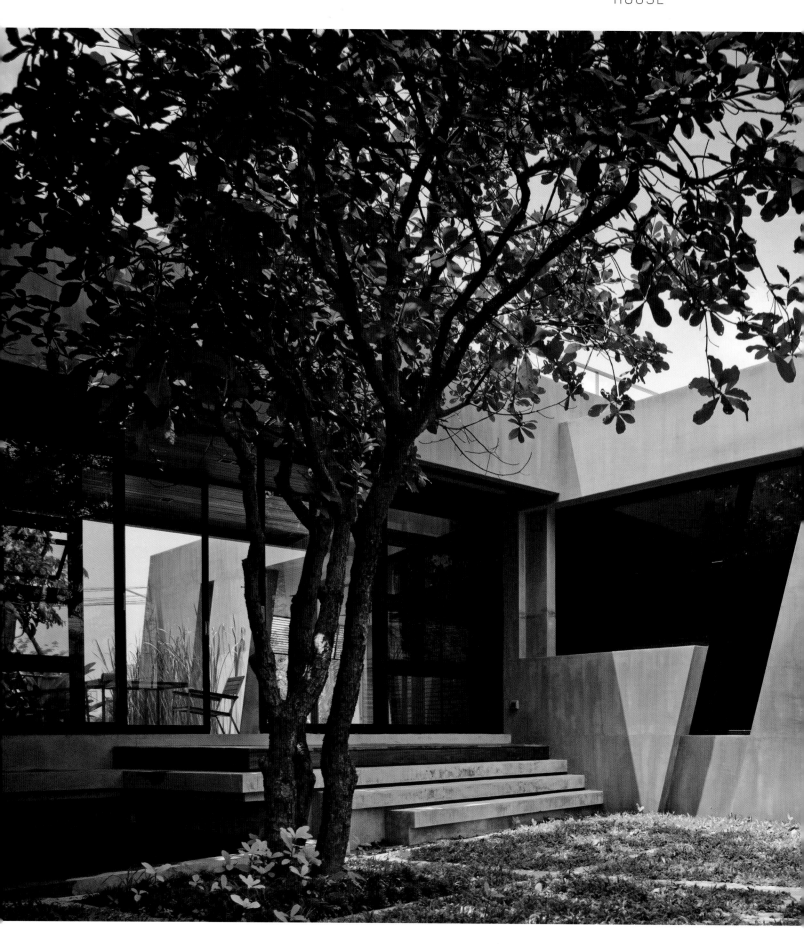

Above The building
is remarkably elegant
given its prosaic military
antecedents.

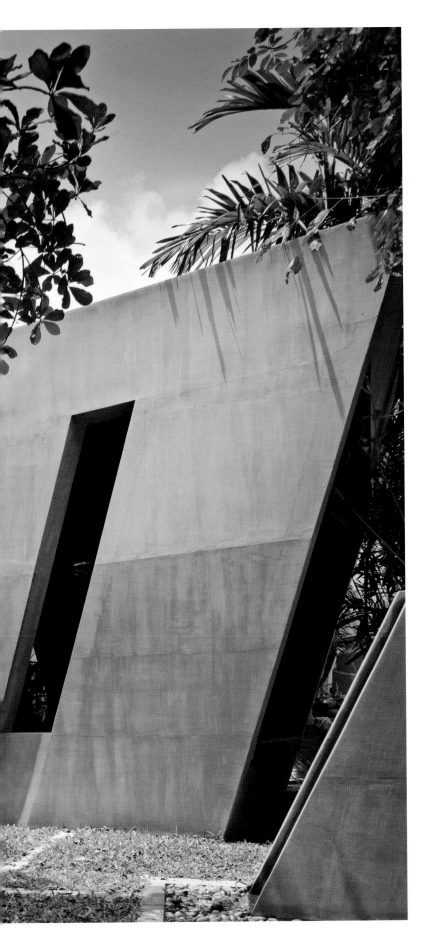

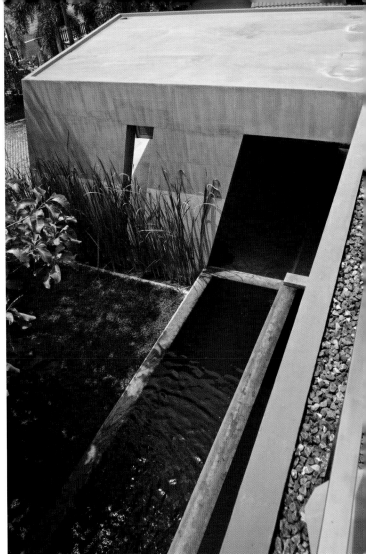

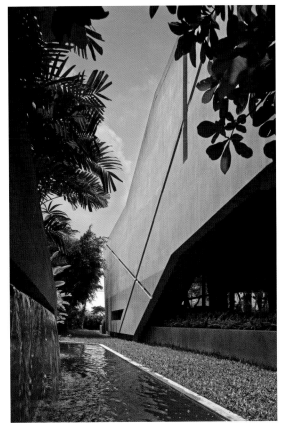

Top Looking down to
the carport from the
roof deck.
Above Striations break
down the concrete
mass.

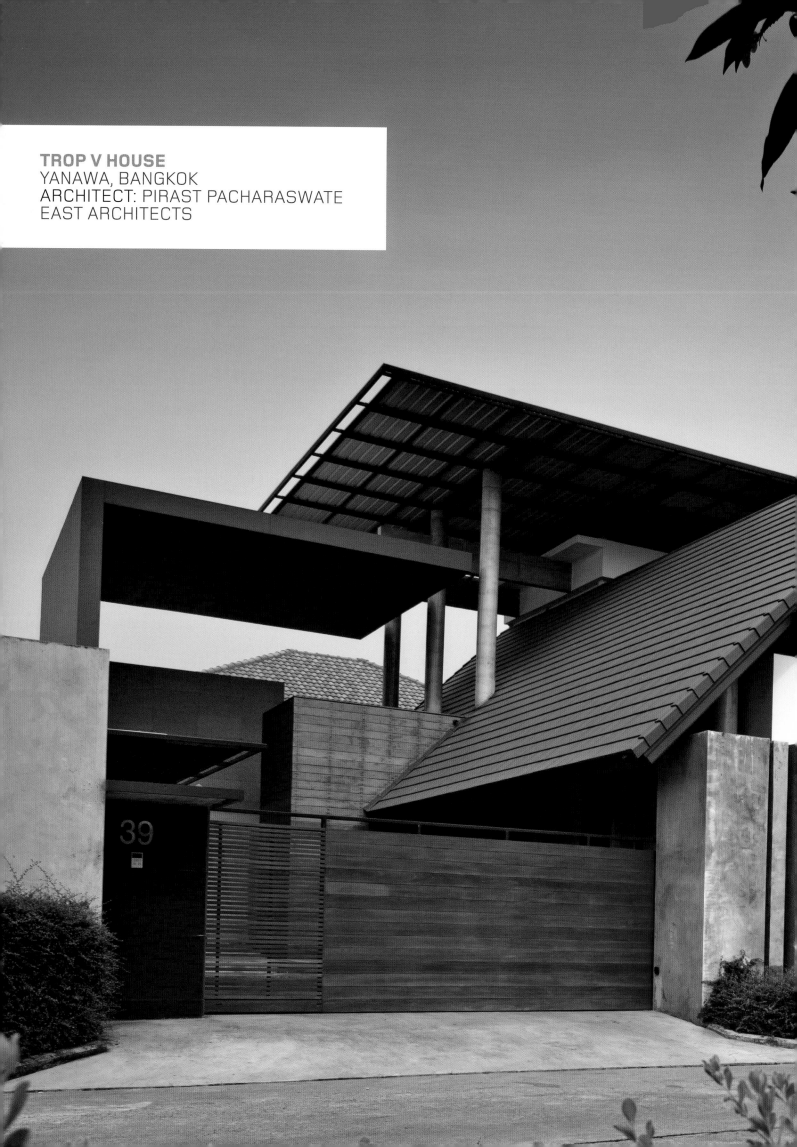

TROP V HOUSE
YANAWA, BANGKOK
ARCHITECT: PIRAST PACHARASWATE
EAST ARCHITECTS

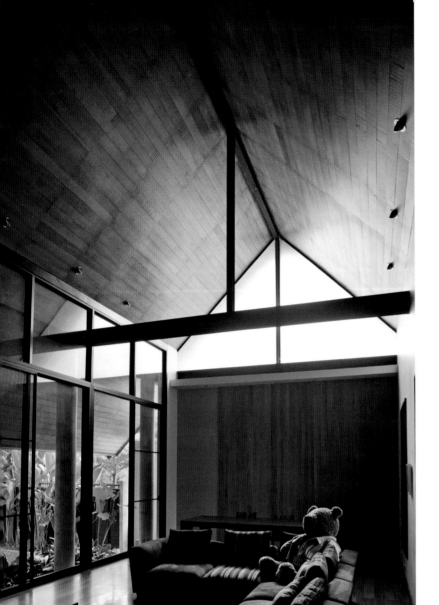

The striking feature of the Trop V House is the double-skin roof that employs steel louvers to create a shaded, ventilated space above a lower tiled roof. The house has a number of features that are reminiscent of the architect's own residence, Baan Tawanork that I featured in *The New Thai House* in 2003.[1] The orthogonal form employs smooth, circular concrete columns that contrast with the traditional pitched Thai roof with wide projecting eaves over the living room. The spacious three-bedroom house, completed in 2009, is the home of landscape architect turned developer Surachai Utaobin and his wife Wannaputt.

The designer of the house is Pirast Pacharaswate, an assistant professor in the School of Architecture at Chulalongkorn University. Pirast is inspired by traditional residential architecture recalled from his childhood, which he successfully synthesizes with modern forms and materials.

The plan of Trop V House takes the form of a linear open-plan progression of spaces stretching along the eastern boundary of a long, narrow site, with the principal rooms facing west. Entering via a vehicular forecourt at the northern end, a route can be traced past the living room and through the dining area that opens to a timber terrace and thereafter, via the family area, to an open court and a shaded lanai beneath the master bedroom. At the southern extremity of the

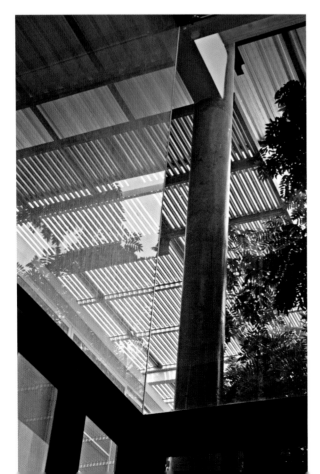

Above left The high timber-lined pitched roof above the family room.

Left A double-skin roof of steel louvers 'floats' above the house.

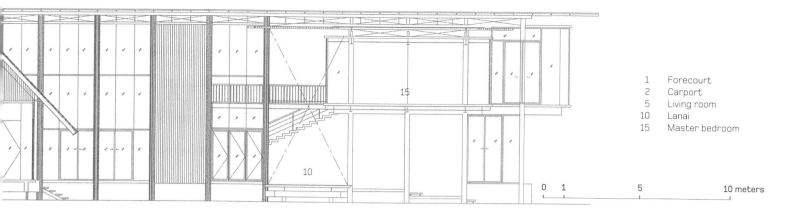

house is a guestroom, which has direct access to the garden. The living room evokes memories of a traditional Thai house, with a high, 40-degree pitched soffit that is lined with timber. In sharp contrast, the structure of the roof has exposed steel 'I' beams.

The family room is a double-height space from which a broad timber staircase ascends to a bridge with a glass balustrade overlooking the room that has a large plasma screen TV. The bridge links the three bedrooms at the upper level and this is the heart of the plan. Yet, the coolest area of the house is the lanai beneath the master bedroom. It is a pleasant, breezy, external sitting space, with a view to the south over the extensive garden designed by the owner of the house. At 08.00, the lanai catches the soft morning sunlight, and again in the late afternoon the setting sun, but at midday when the heat is most intense this area is in deep shade.

As with his own house, the architect, who explores ideas in numerous sketches before producing CAD drawings, exhibits immense skill in fashioning the sequence of spaces and in determining the way in which light enters the house. The muted palette of materials includes white-painted plaster, concrete, dark timber and black aluminum window frames.

1 Robert Powell, *The New Thai House*, Select Books, Singapore, 2003, pp. 96–103.

Pages 86–7 The house is an assured fusion of modern and traditional forms.

Above Section drawing.
Right The double-skin steel roof has a practical purpose—to reduce solar gain.

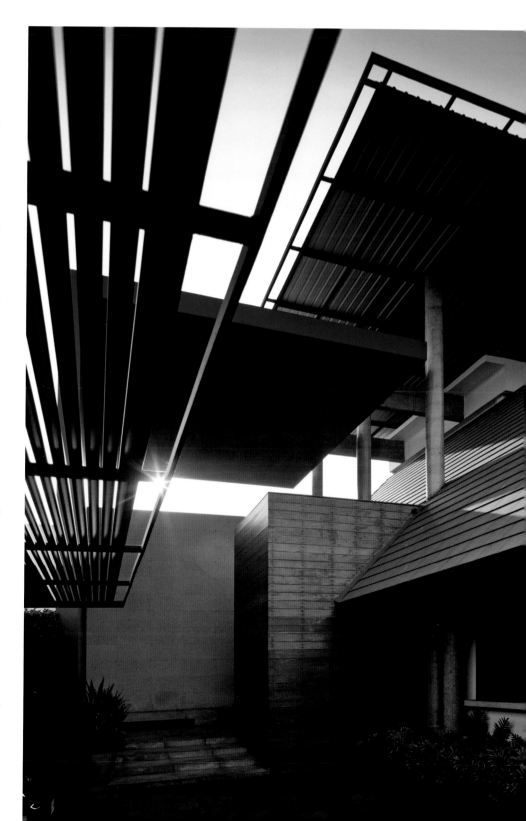

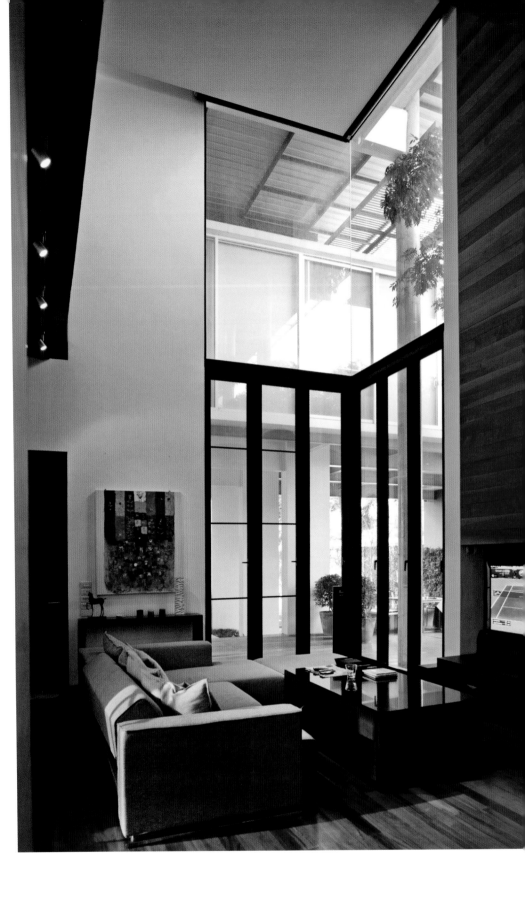

Top The entrance lobby.
Above A narrow bridge with glazed balustrades links the upper rooms of the house.

Above The two-story living room overlooks a tall lanai.

Right An elegant staircase rises to a bridge over the living room.

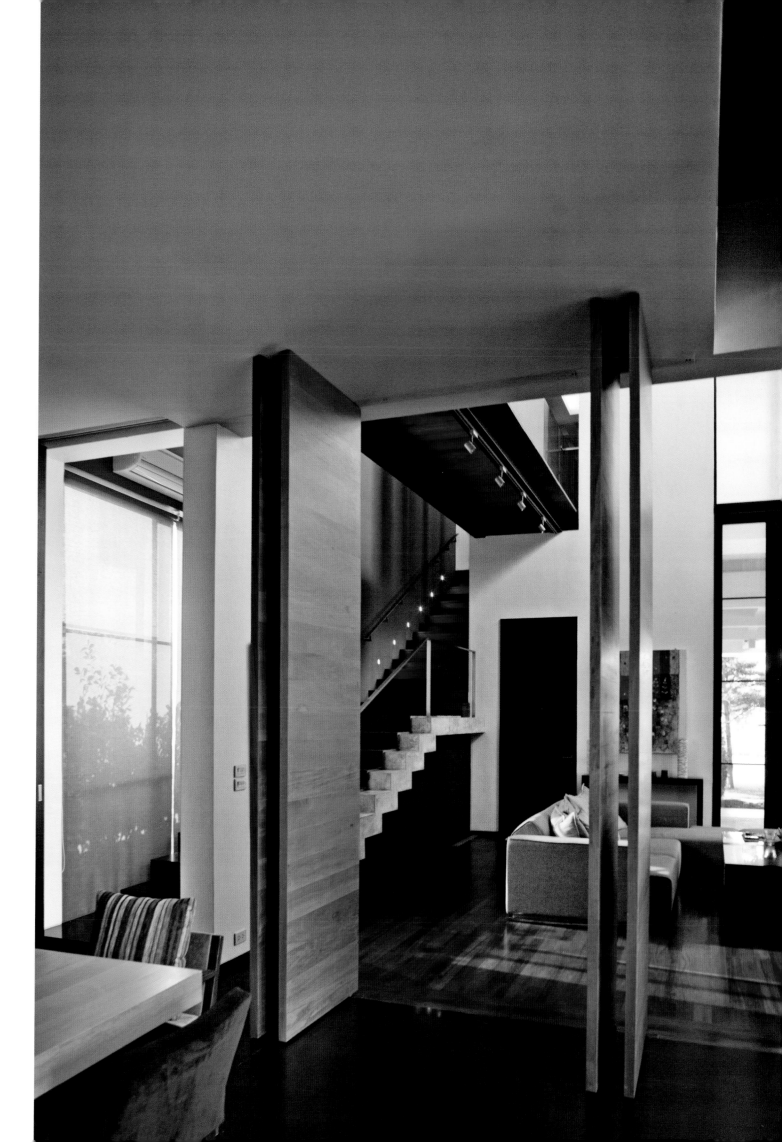

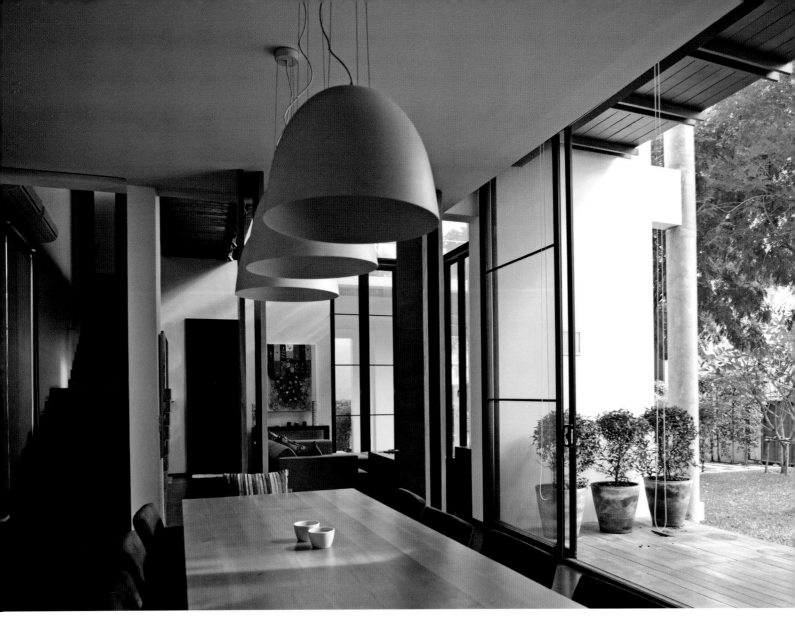

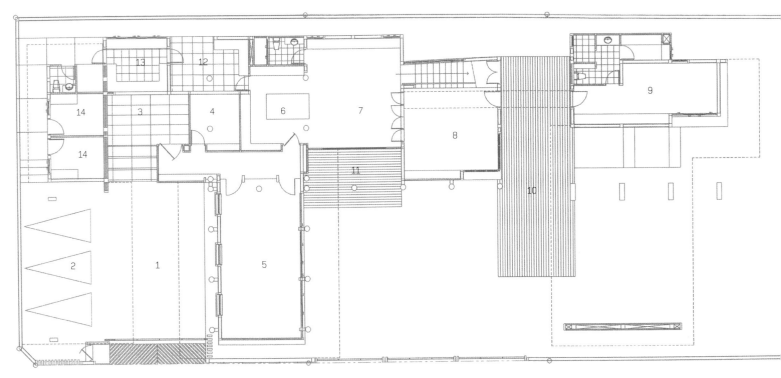

Top The dining room opens out to a shaded veranda.

Above First floor plan.

Above right The house has a relaxed ambience.
Below right The shaded lanai.

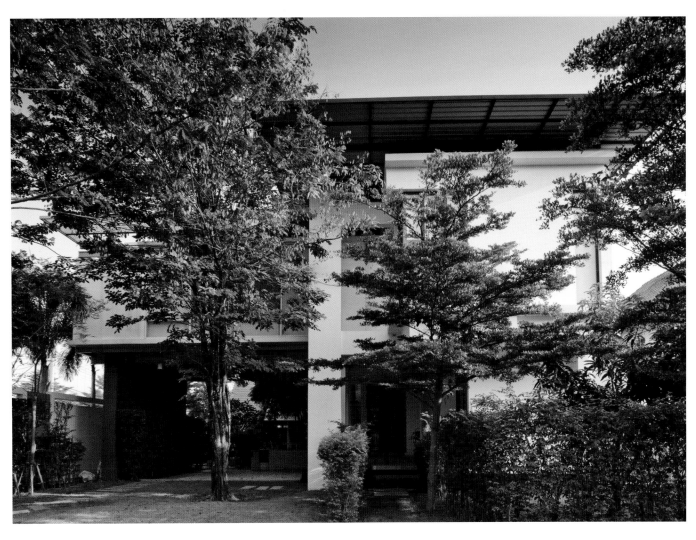

1 Forecourt
2 Carport
3 Foyer
4 Store
5 Living room
6 Pantry
7 Dining room
8 Family room
9 Guest suite
10 Lanai
11 Terrace
12 Laundry
13 Kitchen
14 Maid's room

0 1 5 10 meters

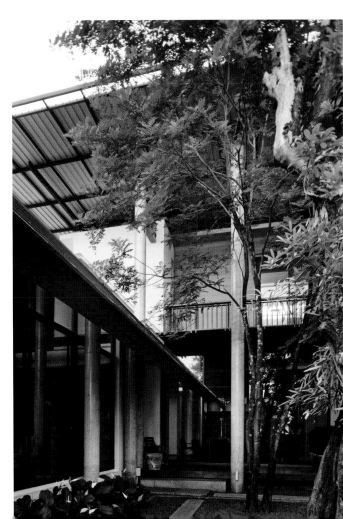

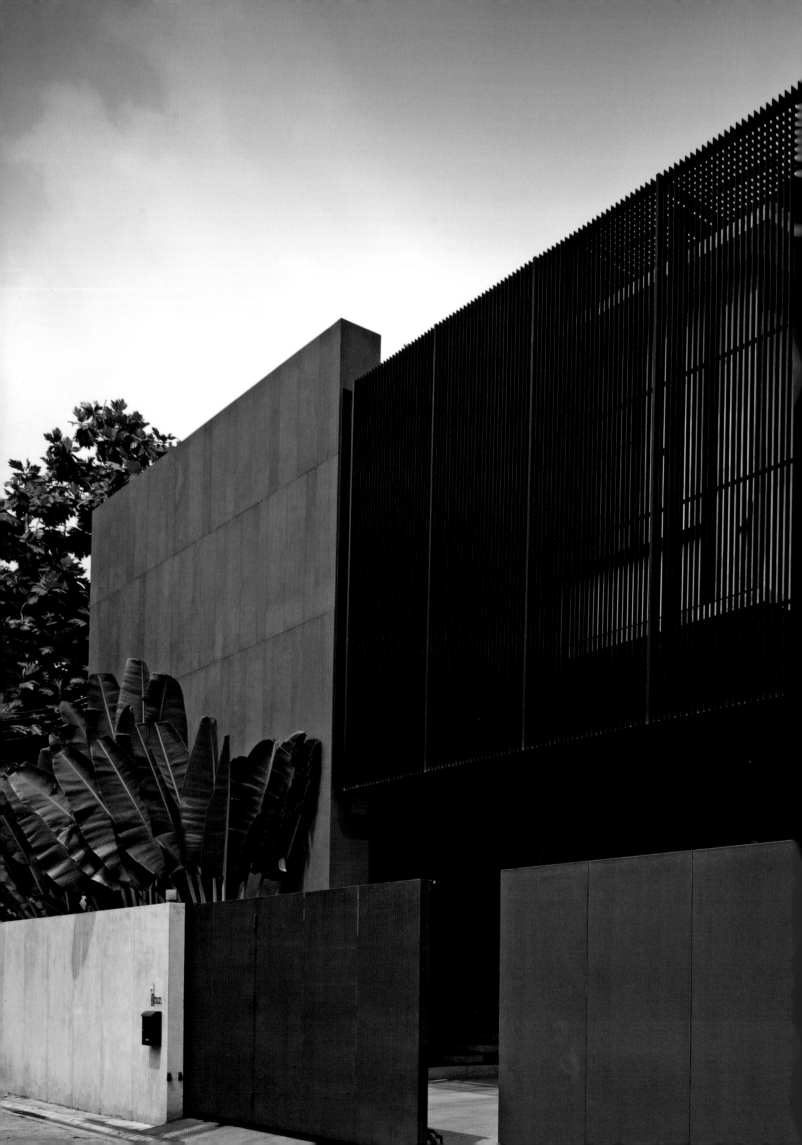

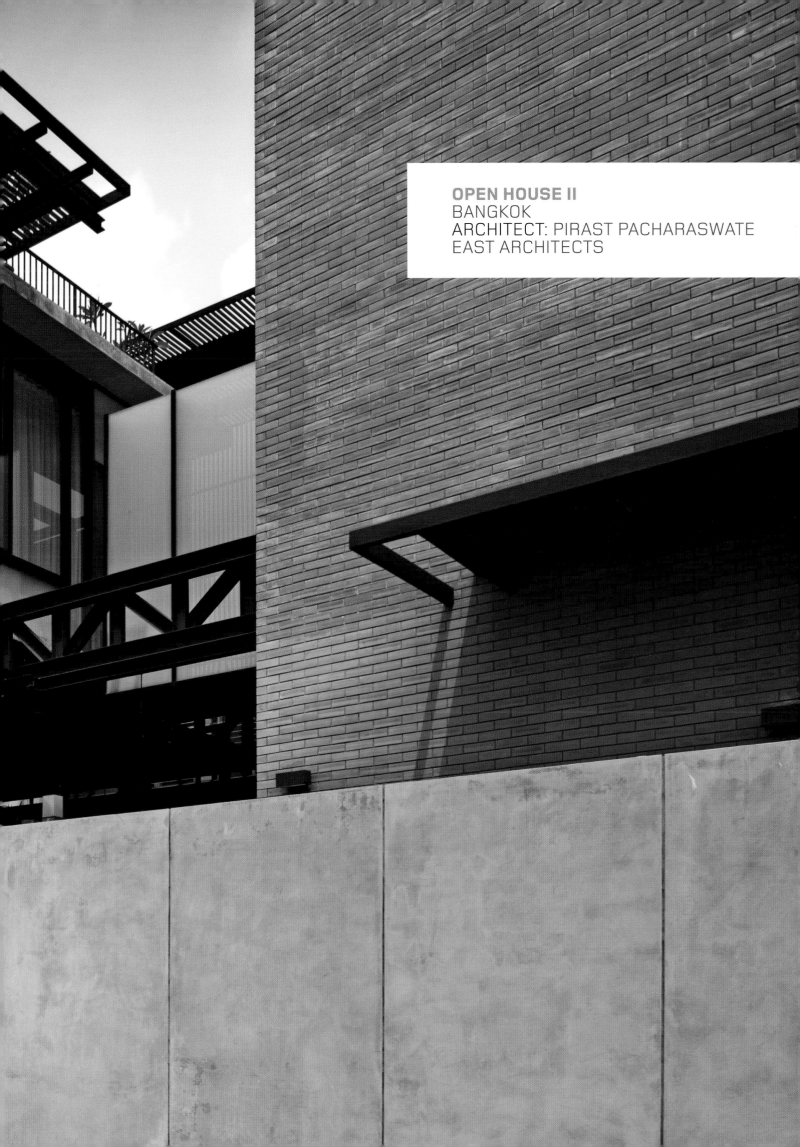

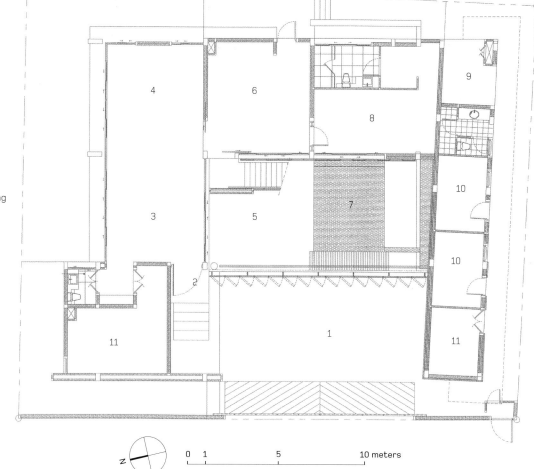

1 Forecourt
2 Entrance
3 Living area
4 Dining area
5 Outdoor living
6 Pantry
7 Pool
8 Bedroom
9 Laundry
10 Maid's room
11 Store

0 1 5 10 meters

Open House ll is a strong formal design arranged around a black swimming pool in a central courtyard. A long raking staircase ascends alongside the pool. The life of the house revolves around the central pool court and all the rooms are inward-looking. The ground floor of the compact rectangular urban site is surrounded by a narrow perimeter garden of palms and banana trees, while a roof terrace provides a view over low-rise housing to the west.

The owners of the house are Naris Siamwalla, a software engineer who holds a Master's degree from Carnegie Mellon University in the USA, and his wife Maria, an Arts and Social Science graduate from the National University of Singapore. They have two small children. Naris's parents have a residence immediately to the north.

The designer of the house, Pirast Pacharaswate, is an assistant professor in the School of Architecture at Chulalongkorn University. He received his own architectural training at Chulalongkorn University under Professor Pussadee Tiptus before embarking on graduate studies at the University of Michigan Ann Arbor in the US where he

studied under Professor Jim Schaffer. Now, in addition to teaching in the School of Architecture, he has an office with seven staff.

The design of the house incorporates a number of responses to the microclimate of the site. There is a solid brick 'box' at the southern end of the house where a stair core above the maid's room acts as a buffer to the sun. The sun enters the courtyard from the west at 3.00 pm but is mitigated by a layer of screens and louvers, while the family

room above the parking area also provides shade from the setting sun.

The architecture is robust and entirely modern without nostalgic references to tradition. Materials include red clay bricks, white glass louvers and black aluminum window frames. The roof detail over the carport appears to be heavily influenced by Constructivist architecture. There is a distinct contrast between the solid and transparent elements in this house.

Pages 94–5 The roof above the entrance appears to be influenced by Constructivist architecture.
Top First floor plan.

Right The shaded carport and forecourt to the house.
Opposite A dramatic straight staircase ascends alongside the courtyard.

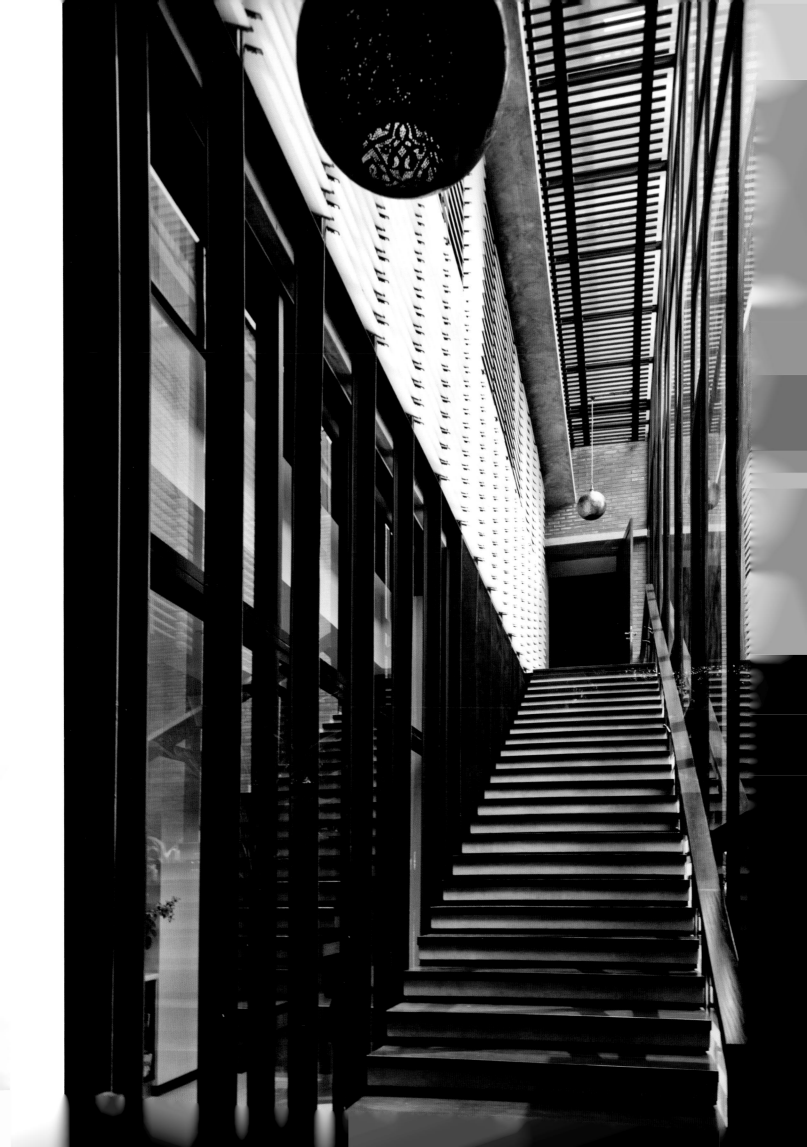

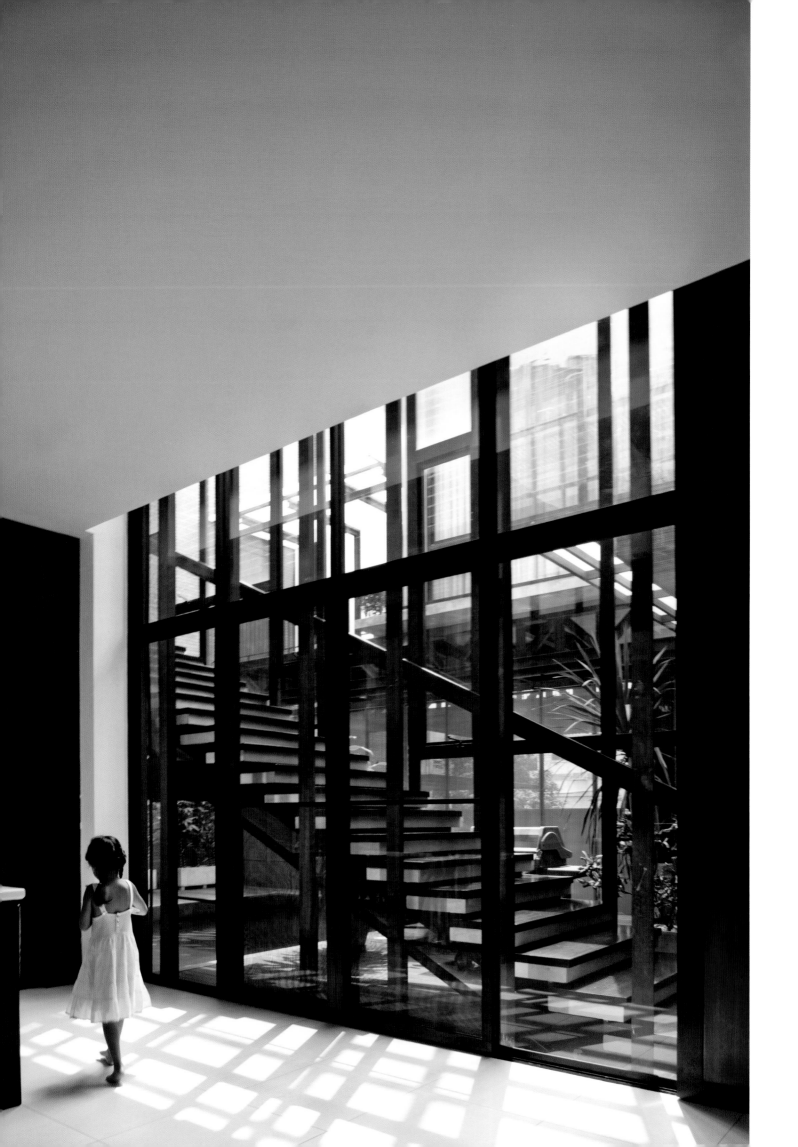

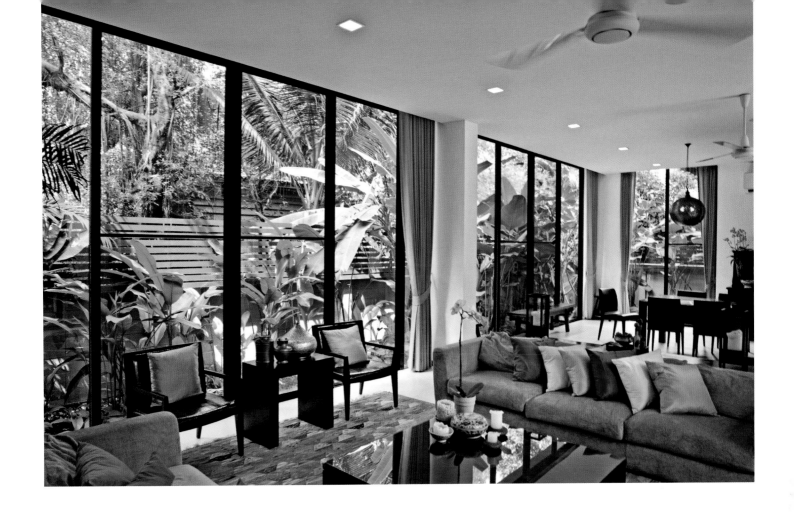

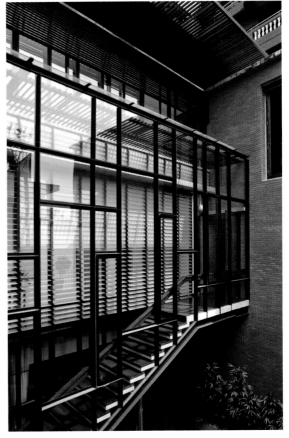

Left The staircase is at the very heart of the plan, between the kitchen/pantry and the pool court.

Top The house is flanked on three sides by a densely landscaped narrow perimeter garden.

Above left and right A louvered wall faces the central court.

SERENITY
CAPE YAMU
ARCHITECT: DUANGRIT BUNNAG
DBALP

Serenity is an incredibly beautiful house that reclines elegantly along the northern shoreline of Cape Yamu on the eastern coast of Phuket Island. The narrow linear site has stunning views of Por Bay and Phae Island in the foreground, while its connection to a wider world is signaled by the flight path to Phuket International Airport 12 kilometers away to the north over Phang Nga Bay. The house is the home of British-born Anthony Wilkinson and his Hong Kong-born wife Anna (Wong). The couple have two daughters, one living and working in Brisbane and the other living and working in Hong Kong.

The house is entered through a large pivoted timber door from a south-facing vehicular courtyard. The door is set in a long gray granite-clad wall; a panoramic view of the ocean is denied at this point. Beyond the door, a transverse corridor leads to an open footbridge over a pond and waterfall that are, conceptually, a protective moat. At this point the spatial compression in the entrance lobby is dramatically released and there is an incredible visual connection with the sea, the offshore islands and the horizon. The element of surprise is an important aspect of the enjoyment of the dwelling.

The orthogonal plan of the house is a series of interlocking rectangular spaces forming a linear composition occupying 60 percent of the 40-meter-long site. The architect has moved the house away from the slope to facilitate cross-ventilation, and the deep courtyards created along the southern edge of the house permit the house to breathe. The result is a sophisticated modernist composition with precise horizontal lines stepping down the slope but stopping short

of the shore. A glittering azure infinity pool stretches along the upper deck, and in the rear courtyard is a dramatic tall fountain. For my visit, Anna Wilkinson has chosen to play a CD of a Parisian jazz ensemble that seemed wholly appropriate for the mood of the house.

I am accompanied on my perambulations by the owners' three dogs—two gentle chocolate labradors, Mooshi and Toffee, and Rusty, a local mongrel of a much more inquisitive nature.

The architect of the residence is Duangrit Bunnag of DBALP, who pursued his first degree in architecture at Chulalongkorn University before studying for a postgraduate diploma at the Architectural Association (AA) in London from 1993 to 1995 where he elected to join the studio of Jeffrey Kipness and Barhan Shirdel. Upon his return to Bangkok, Bunnag worked with Nithi Sthapatinonda at A49 before branching out on his own in July 1998. He was also editor, until 1999, of *art4d*, a leading architecture design and art magazine in Thailand.

The owners of the house met Bunnag through an interior designer friend who had worked for DBALP, and from the outset a firm rapport was established. The couple did not want a traditional pitched roof, and so the house has what is known as a flat 'upside-down' roof, with insulation on the

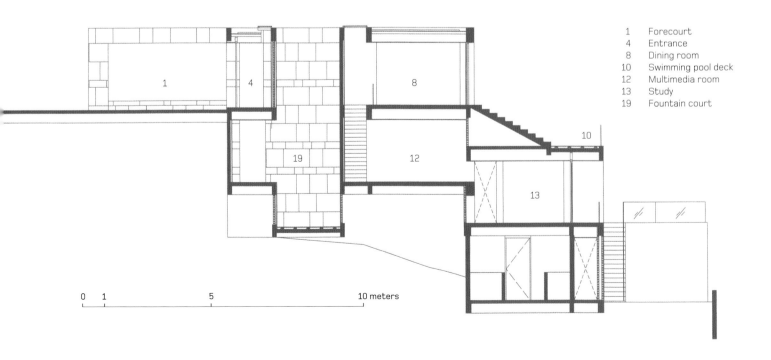

1	Forecourt
4	Entrance
8	Dining room
10	Swimming pool deck
12	Multimedia room
13	Study
19	Fountain court

0 1 5 10 meters

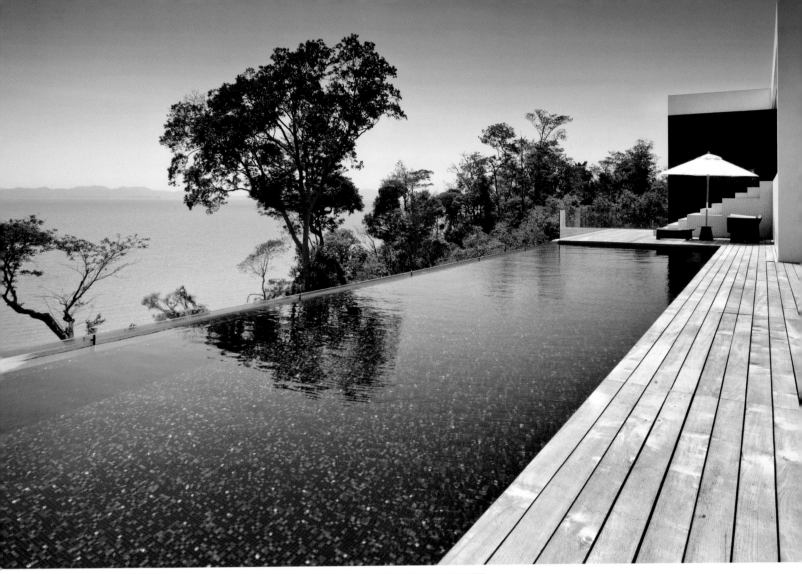

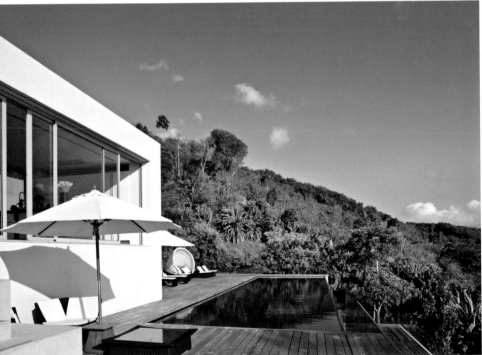

upper surface that maintains the interior at a consistently cool temperature. The sun rises at the end of the pool terrace at 06.45, but by 08.00 has moved south and does not penetrate into the house except in the late afternoon.

The four-bedroom house is within a larger development known as Baan Yamu. Several weeks after visiting the house, I read the Man Booker Prize 2009 nominated novel *The Glass Room* by Simon Mawer. The author might have been writing about the uplifting spatial qualities of Serenity at Cape Yamu when he describes the Glass Room as 'Perfection of proportion, of illumination, of mood and manner. Beauty made manifest.'[1]

1 Simon Mawer, *The Glass Room*, Little Brown, London, 2009, p. 74.

Pages 100–1 The house is designed in a sophisticated modern language with precise horizontal and vertical lines.

Opposite top The residence steps down the steep northeast-facing cliff.
Opposite bottom Section drawing.

Top A glittering infinity pool stretches along the upper deck.
Above Forests climb the ridge to the west.

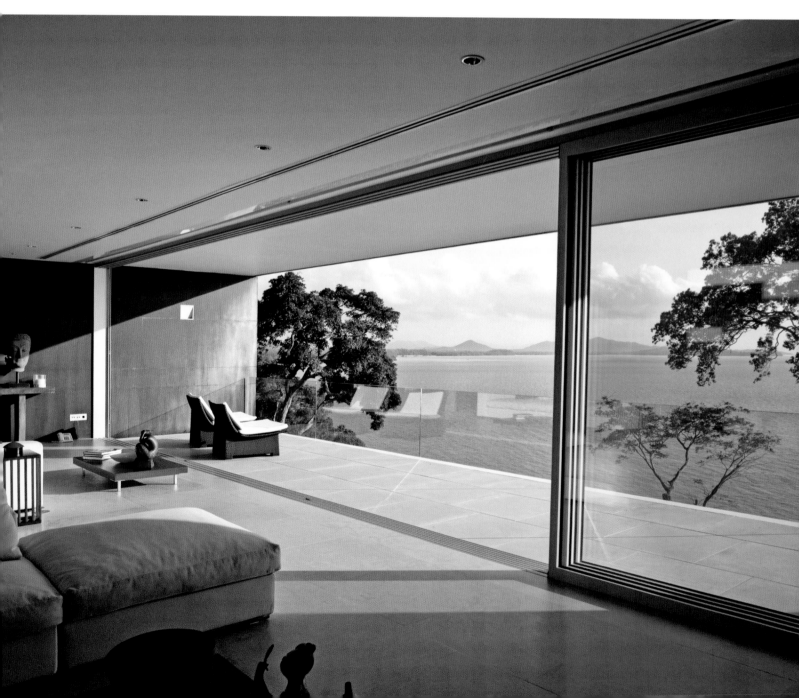

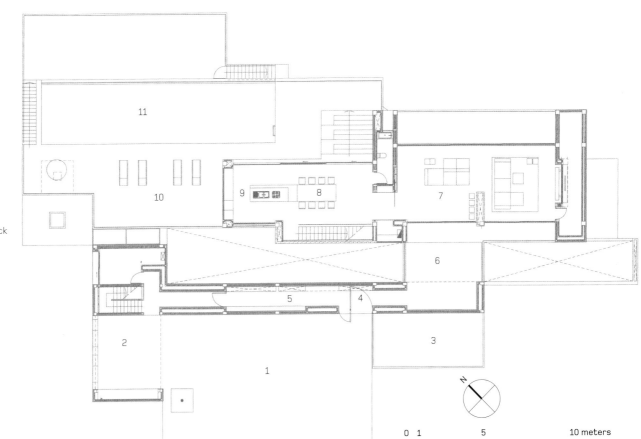

1 Forecourt
2 Garage
3 Lily pond
4 Entrance
5 Corridor
6 Entrance bridge
7 Living room
8 Dining room
9 Kitchen
10 Swimming pool deck
11 Swimming pool

N

0 1 5 10 meters

Opposite above left
The linear kitchen/
dining area.
Opposite above right
The route to the master
bedroom.

Opposite below There
are extensive views
from all the principal
rooms over Phang Na
Bay.

Top First floor plan.
Above A cool *en suite*
bathroom looks into
a courtyard.

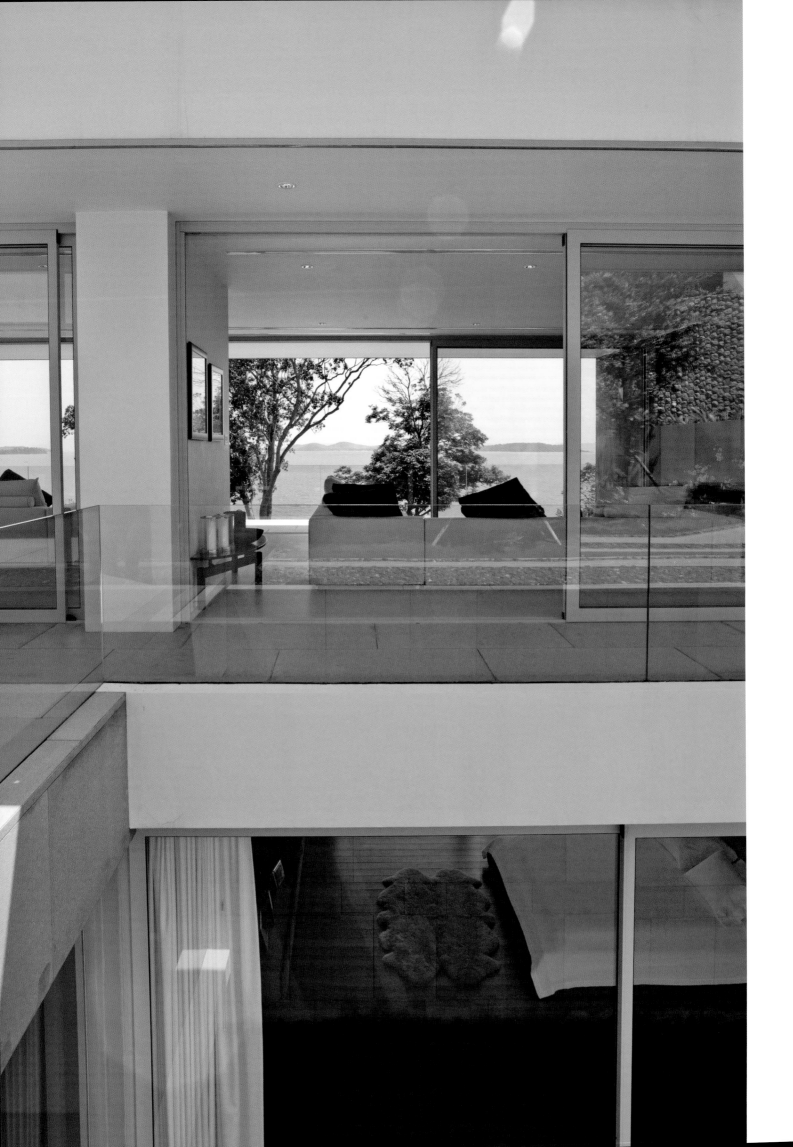

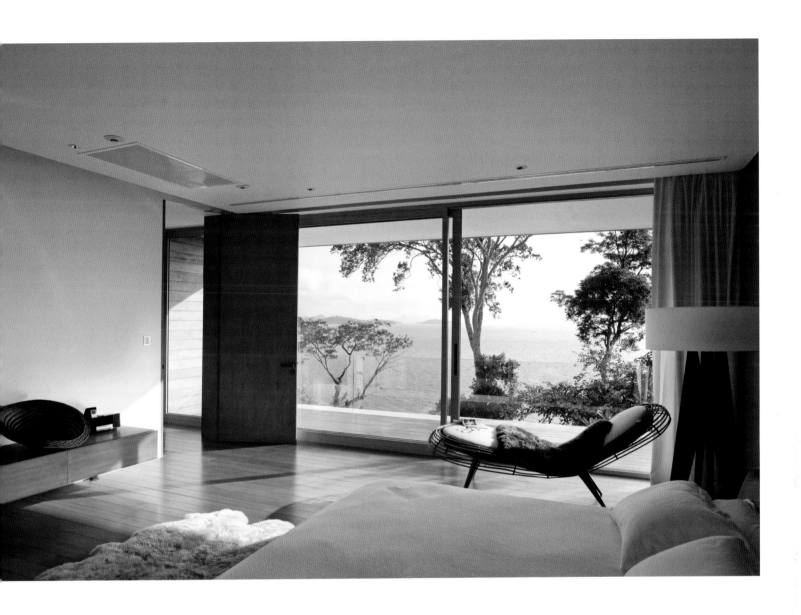

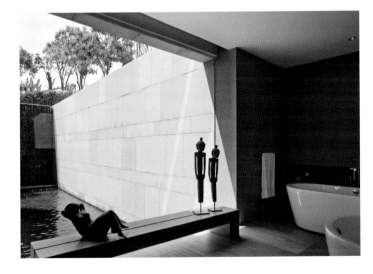

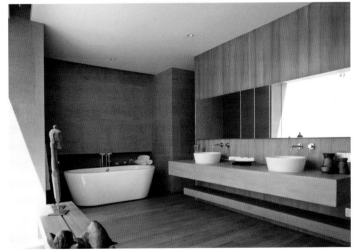

Left A footbridge spans a pond between the entrance lobby and the living area.

Top The master bedroom suite has stunning views to the horizon.

Above left and right The *en suite* master bathroom overlooks a pond.

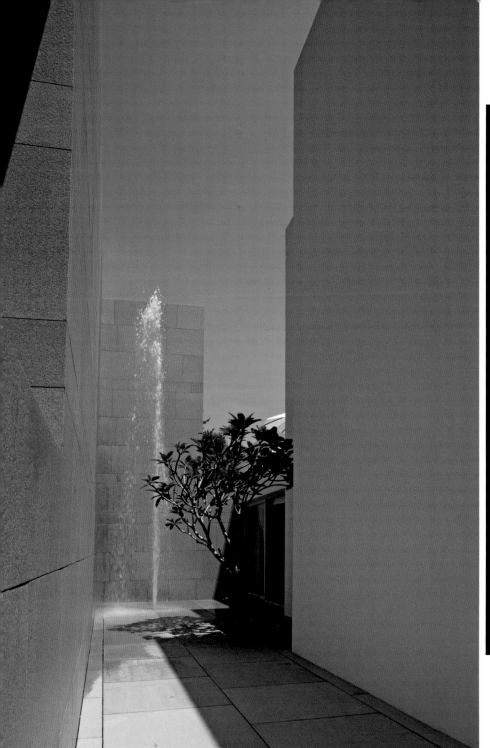

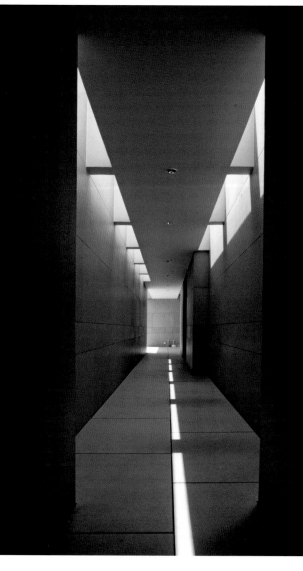

Above A spectacular two-story-high fountain is located in a deep canyon-like courtyard.

Above right The dramatic top-lit service corridor.

Right The pivoted timber entrance door is set in a horizontal gray granite-clad wall.

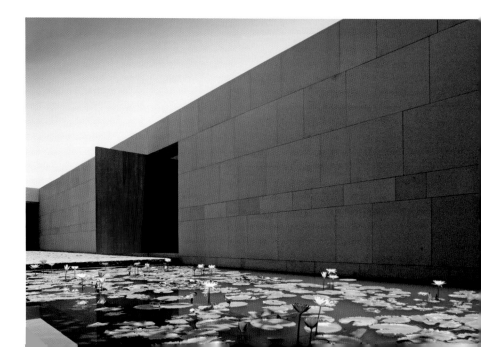

Above A broad flight of stairs leads from the dining area to the pool deck.

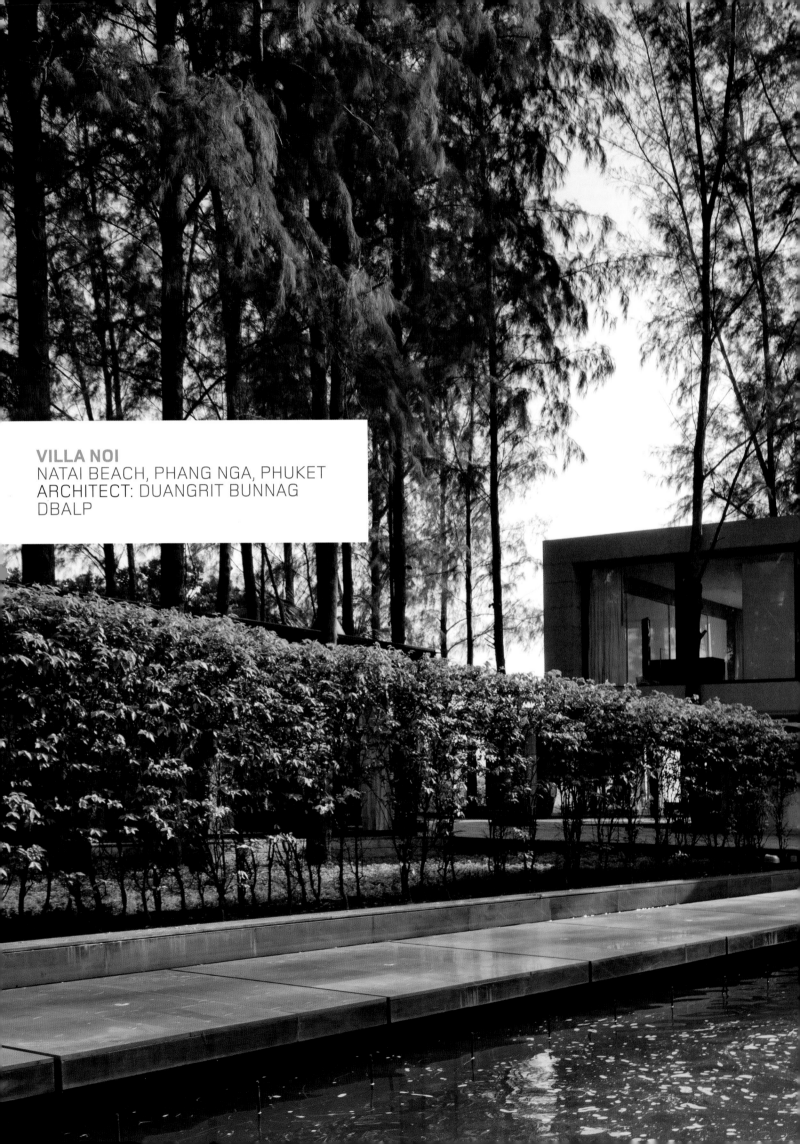

VILLA NOI
NATAI BEACH, PHANG NGA, PHUKET
ARCHITECT: DUANGRIT BUNNAG
DBALP

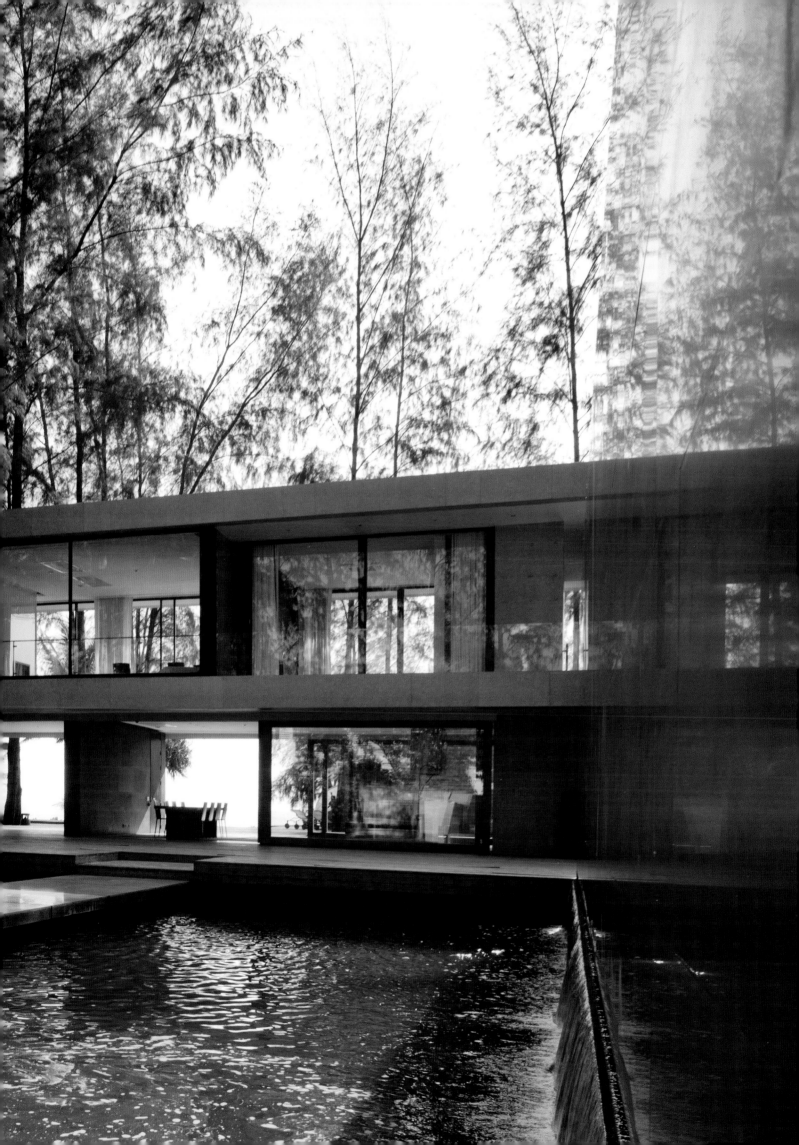

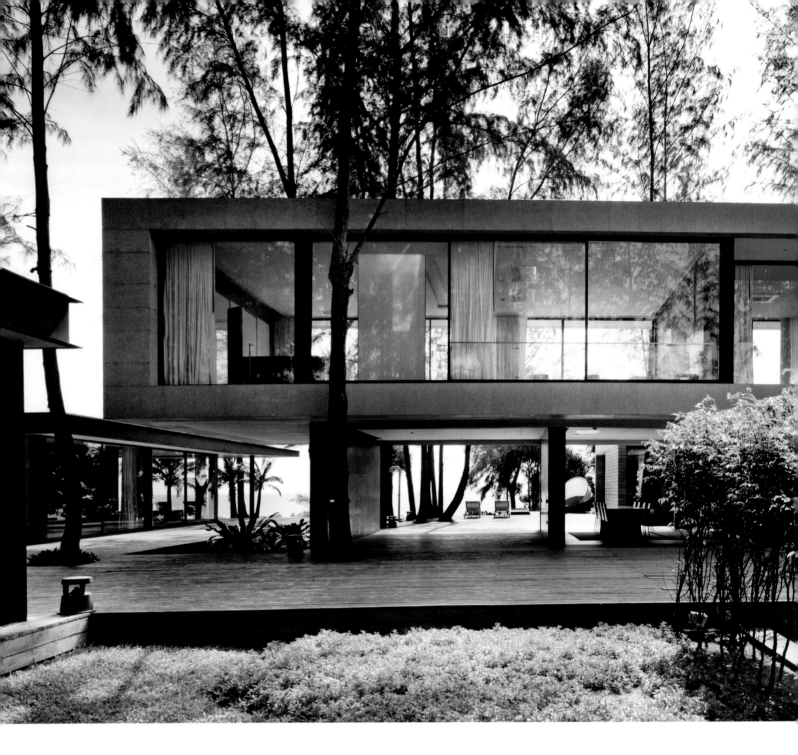

Vila Noi is a cluster of glazed pavilions orientated towards the setting sun at Natai Beach on the shores of the Andaman Sea. The pavilions are located among a stand of towering casuarina trees, whose delicate branches provide a striking contrast to the precise horizontal lines of the architecture. The design pays homage to Mies van der Rohe, one of the acclaimed masters of the Modern Movement. The house, located adjacent to the Aleenta Resort and Spa, is the vacation home of Veronica and H. Chin Chou and their family. Their main residence is in Hong Kong.

Moving around the site, the views are orchestrated superbly. From the entrance court there is an axial route flanked by fountains across a bridge over a rectangular pond. At the end of the vista is a two-story rectangular flat-roofed dwelling housing living and dining space, with the principal bedrooms above, that is set transversely across the axis with views through a lanai to the ocean beyond. Arranged around the main house, with access to the timber pool deck, are three single-story glass pavilions that variously serve as additional family accommodation, guestrooms, a service block

and an entertainment pavilion with a plasma television, a pool table and a bar overlooking the beach. The layout was planned on a Mondrian-like orthogonal matrix. The plan also contains the essence of a traditional Thai compound, with its various family pavilions clustered around a timber deck.

Raised high above the beach, the house has a broad flight of stairs leading down from the pool deck, with a gate at the lower level that provides security and makes the house appear somewhat aloof. Yet, it is not divorced from the ocean, for the sound of waves rushing up the beach is a constant presence.

Above A shaded outdoor living area looks out to the pool deck.

Pages 110–11 Villa Noi is located in a grove of lofty casuarina trees on the Andaman Sea coast.

Opposite above A bridge leads from the entrance gateway across a pond that is illuminated at night.

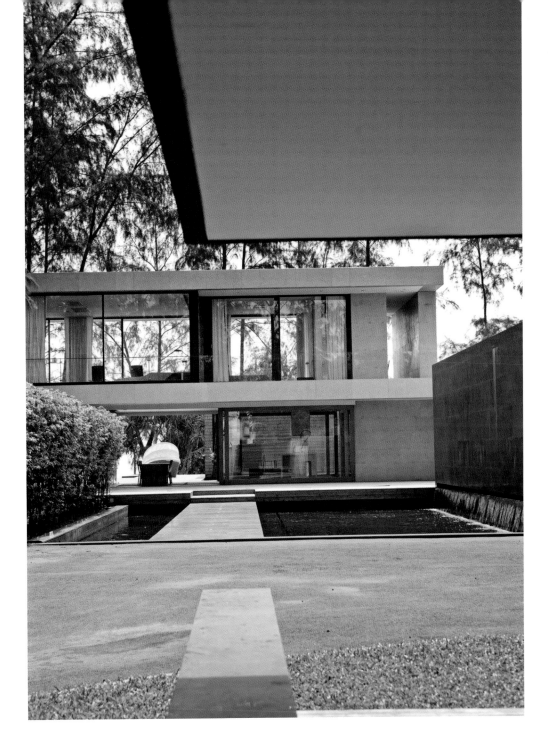

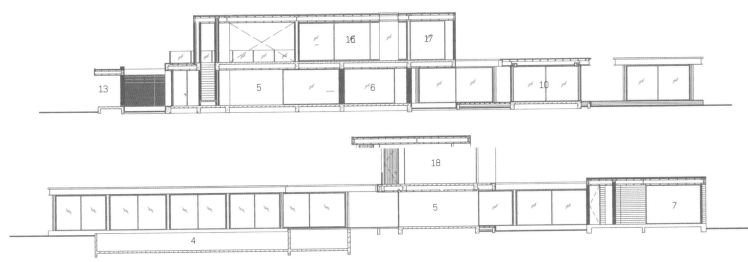

4	Koi pond	13	Service walkway
5	Dining room	16	Master bedroom
6	Outdoor living area	17	Master bathroom
7	Living room	18	Child's bedroom
10	Bedroom		

Above Section drawing.

The glass pavilions that are so integral to the design of the house contain sleeping accommodation and semi-outdoor bathrooms, and expose their occupants to the gaze of other family members and guests. There is an issue here of transparency versus opaqueness, privacy versus openness and exposure versus concealment, for even in a family home the different generations require personal space.

Every member of the family and their guests is given a view of the sea from their bedroom, and the main living rooms are also orientated westwards, while bathrooms, some open to the sky, face east. The architect has gone to great lengths to retain the trees on the site. Some actually grow within the pavilions and penetrate through the roof.

Villa Noi is a large and dispersed space. The distance between individual pavilions discourages walking in the hot sun during the day, but the large timber pool deck comes into its own for large family parties and for corporate entertainment as the sun sets gloriously over the horizon. There is a great calmness about the architecture. Materials include steel cruciform columns, black aluminum window frames, clear glass, horizontal timber boarding and terracotta brickwork.

This is another house designed by Duangrit Bunnag, the talented principal of Bangkok-based DBALP, the architectural firm he founded in July 1998. Houses of this type in Phuket are quite different to Bangkok. Many are the boltholes of expatriates from Hong Kong, Singapore, Kuala Lumpur and elsewhere, who come to the island to escape the pressures of life in the metropolis—to relax and swim or sail.

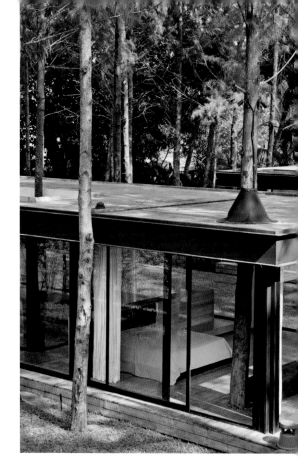

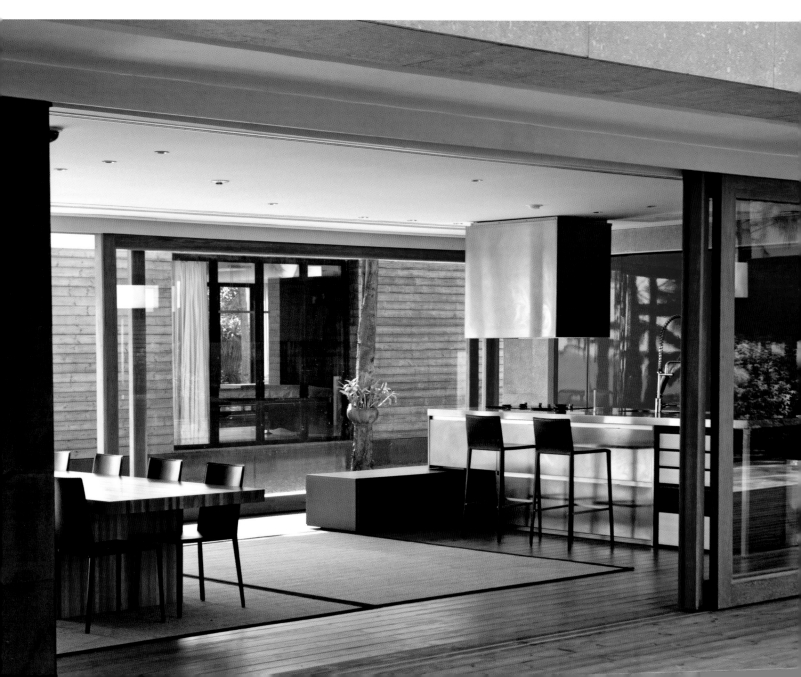

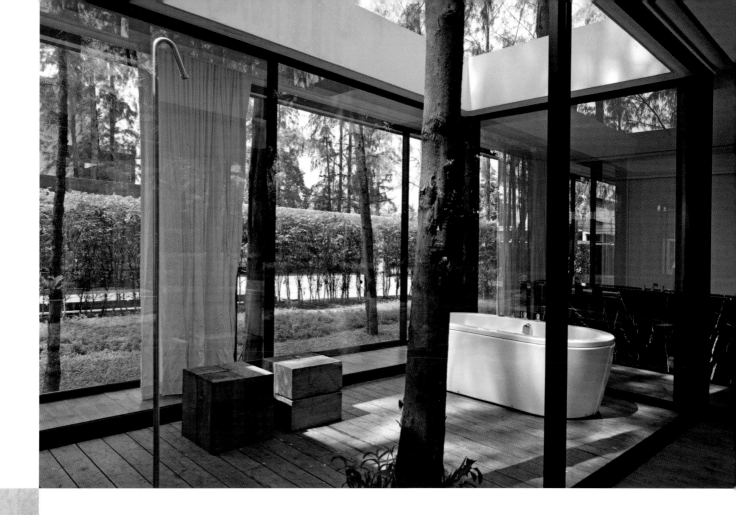

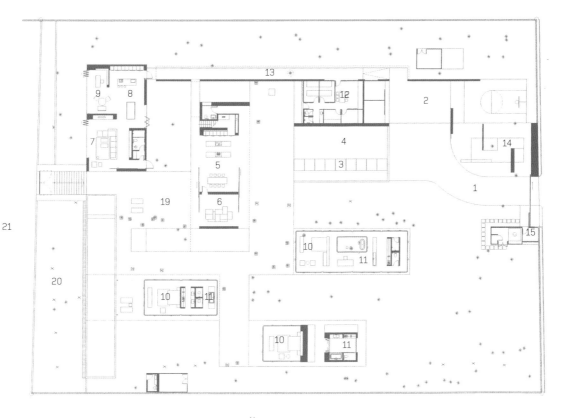

1 Entrance
2 Carport
3 Bridge
4 Koi pond
5 Dining room
6 Outdoor living area
7 Living room
8 Games room
9 Work room
10 Bedroom
11 Bathroom
12 Service quarters
 and kitchen
13 Service walkway
14 Entrance pavilion
15 Security
19 Pool terrace
20 Swimming pool
21 Beach

N

0 1 5 10 meters

Above left Most trees on the site were retained and some are permitted to grow within the pavilions.

Left The dining room and pantry in the main pavilion.

Top An open-to-sky bathroom engages with nature.

Above First floor plan.

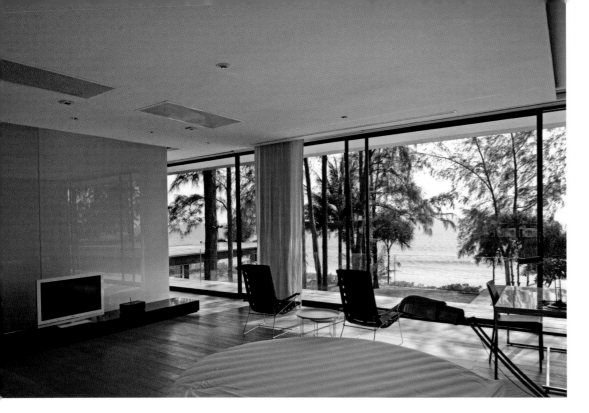

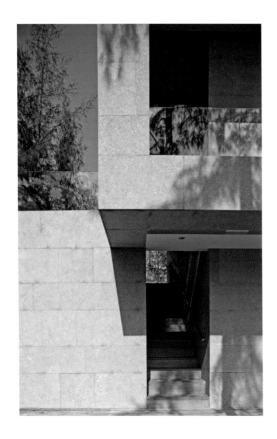

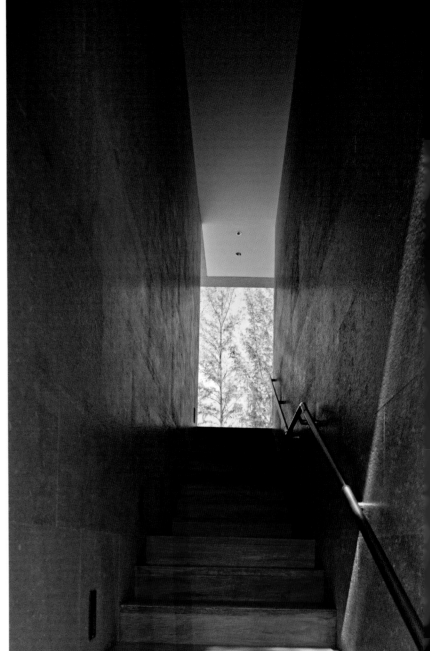

Top The principal rooms overlook the Andaman Sea.

Above and right The staircase from the pool deck to the master bedroom suite.

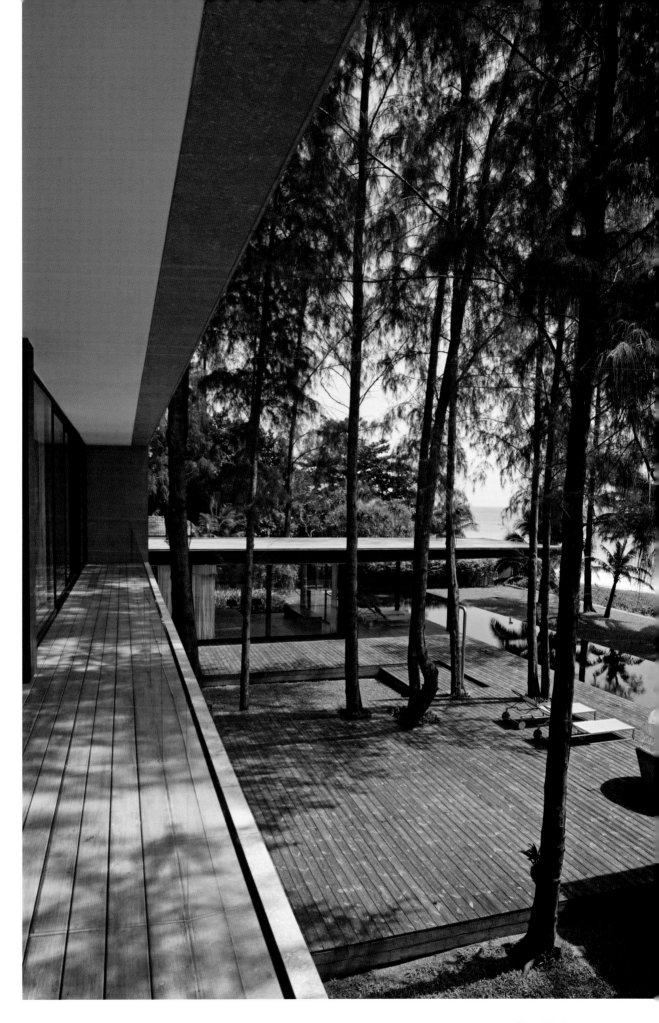

Above The house
has an extensive
timber pool deck
for entertainment
purposes.

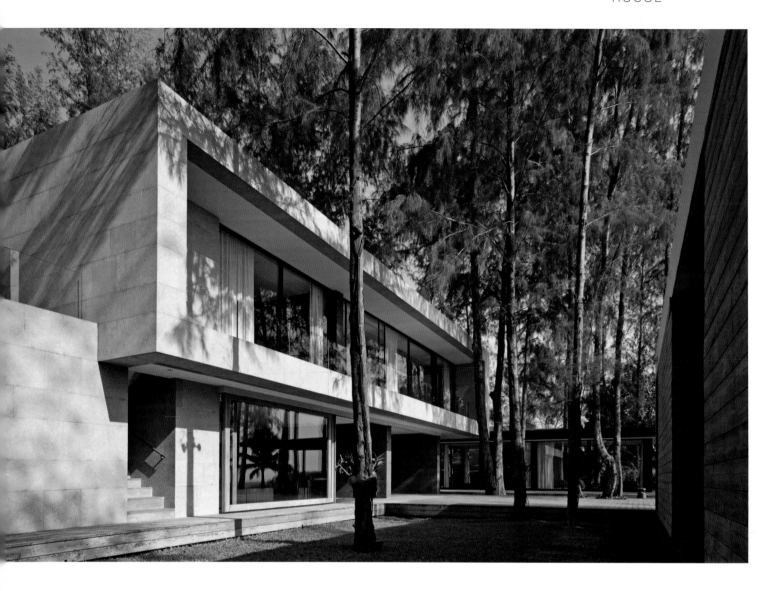

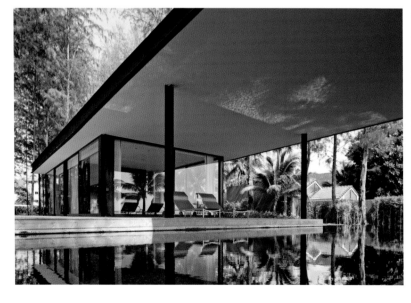

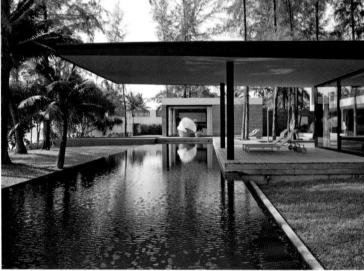

Top The two-story central pavilion.
Above left The roof of one pavilion projects over the swimming pool.

Above right The 25-meter lap pool extends to the family entertainment pavilion.

Right The precise horizontal lines of the architecture contrast spectacularly with the vertical structure of the trees.

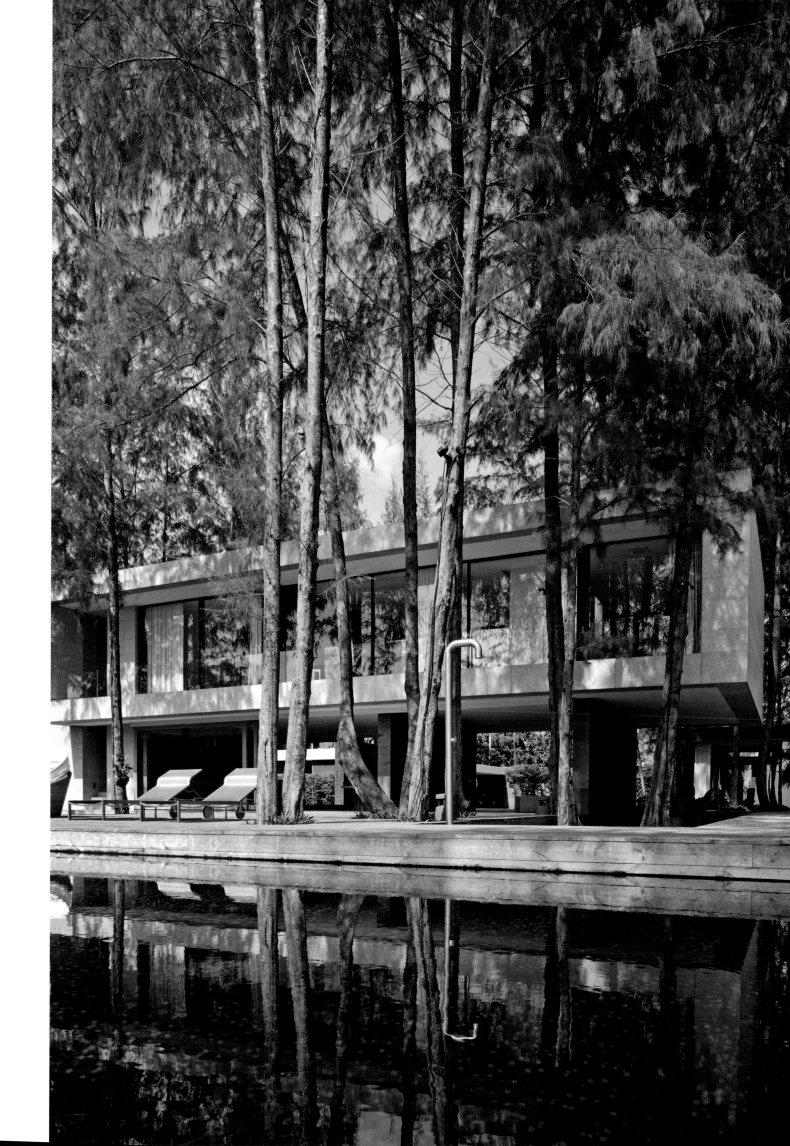

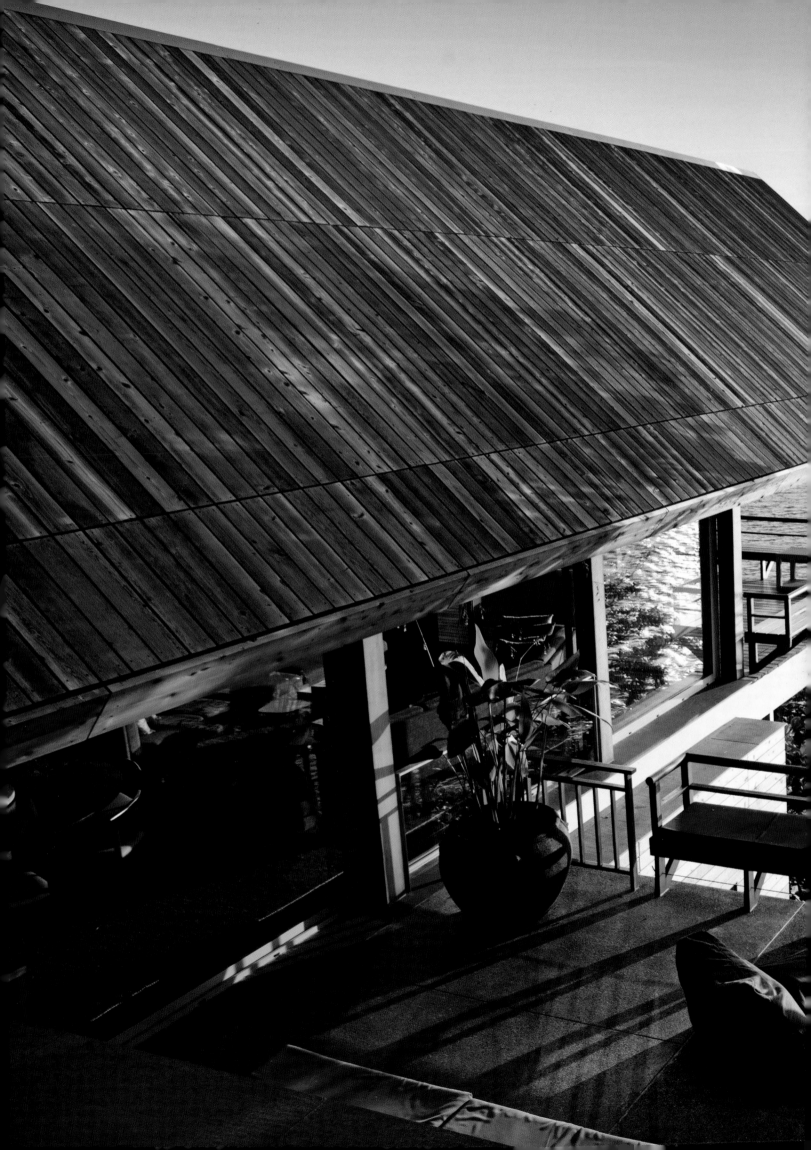

LAEMSINGH VILLA NO. 1
SURIN BEACH, PHUKET
ARCHITECT: ERNESTO BEDMAR
BEDMAR AND SHI DESIGN STUDIO

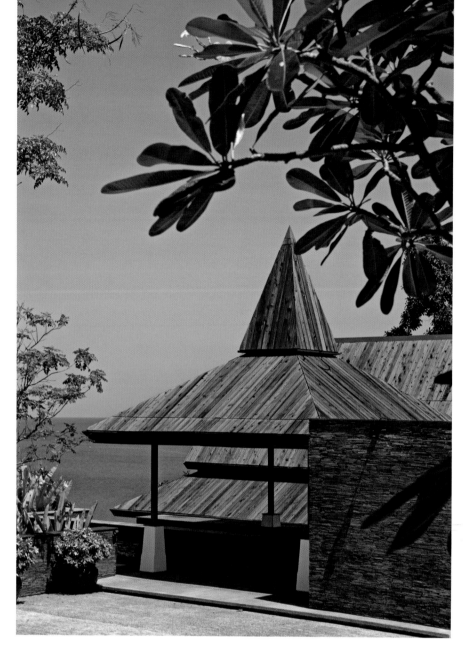

where he worked with compatriot Miguel Angel Roca. Three years later, in 1987, he founded Bedmar and Shi Design Studio with interior designer Patti Shi.

Alighting near the top of the site at a flat-roofed carport with a planted sedum grass roof, the entrance to Laemsingh Villa No. 1 is signaled by a sharply pointed double-pitched Thai-style roof above an open-sided pavilion that affords a framed view of the ocean before descending a relatively narrow stone staircase alongside a tumbling water feature to a pivoted timber door. A sharp right turn brings visitors to the main living area, which has a broad timber deck, a frangipani tree and a panoramic view of the ocean beyond. A shaded outdoor breakfast area and a sun deck overlook a dazzling green infinity swimming pool.

To the right is a pavilion for dining and entertaining, extending out to a timber balcony cantilevered over the cliff. At first the pavilion appears to be open-sided but closer inspection reveals frameless glass windows that permit it to be air-conditioned when the days are particularly humid. Stairs descend from the dining room to the master bedroom and a second bedroom below and to another lap pool at the lower level. Family photographs complete the picture of a family home away from home.

A second staircase descends from the pool deck to another master bedroom suite, while another flight of stairs ascends to two bedrooms above. In this way, Bedmar has ingeniously created a residence that, not unlike a traditional Thai house, permits two or three generations to occupy the dwelling and to share core activities on a communal deck while maintaining a degree of privacy.

Bedmar's skill lies in the orchestration of views and arrangement of spaces as one moves through the house. His architecture is choreographed in a dramatic sequence of

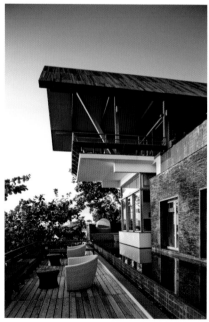

Laemsingh Villa No. 1 is a stunning vacation home located above a precipitous rocky headland on the west coast of Phuket Island facing the Andaman Sea. It is the holiday home of Australian Julien Reis and his Singaporean wife Yen. The couple are the proprietors of the Gallery Reis located in the Palais Renaissance retail mall in Singapore that is 'committed to introducing outstanding contemporary art by established and emerging artists globally'.

The house is one of a group of five villas designed by the Singapore-based Argentinean architect Ernesto Bedmar, a consummate master of sophisticated design in the tropics. Bedmar, a graduate of the University of Architecture and Planning at Cordoba, arrived in Singapore in 1984 via Hong Kong

Top The roof above the entrance portico makes reference to traditional Thai forms.
Above A pavilion for dining and entertaining extends out to a balcony cantilevered over the cliff.
Pages 120–1 The house is located on a precipitous cliff overlooking the Andaman Sea.

Above right The carport gives access to the entrance portico.
Right First floor plan.

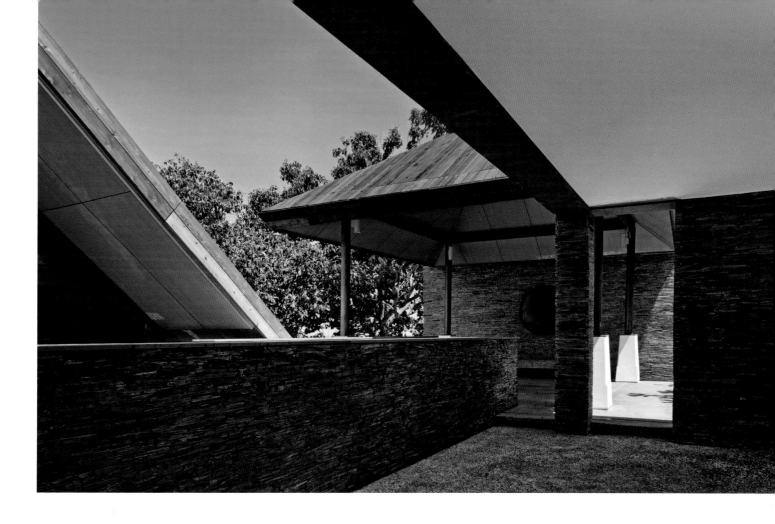

vistas that alternate between specific controlled views as, for example, in the descent to the entrance door, to wide panoramas such as the view from the pool terrace. The views shift from compressed spaces to explosive vistas of the horizon, from foreground to horizon.

For much of the day, the principal rooms are in shade, and consequently the house is deliciously cool. The architect has integrated numerous places to sit and relax—verandas, balconies and projecting decks, in effect outdoor rooms orientated west that provide vantage points from which to view the ocean and the setting sun. There are also near-vertical views down through trees to the rocks below. The sound of waves crashing over the headland is ever present, together with the intermittent buzz of cicadas. The ocean is almost deserted save for solitary white sails on the horizon—a silence that is occasionally broken as a speedboat full of laughing holidaymakers powers by from nearby Surin Beach.

Bedmar has created a strong split-slate podium upon which are placed timber and

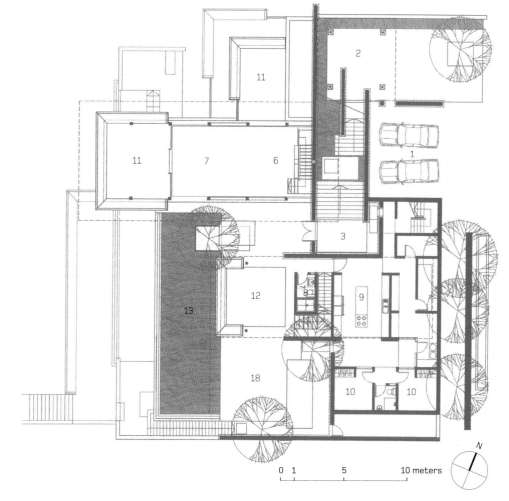

0 1 5 10 meters

N

1	Carport	7	Living area	11	Terrace
2	Entrance pavilion	8	Powder room	12	Veranda
3	Entrance	9	Kitchen	13	Swimming pool
6	Dining area	10	Maid's room	18	Pool deck

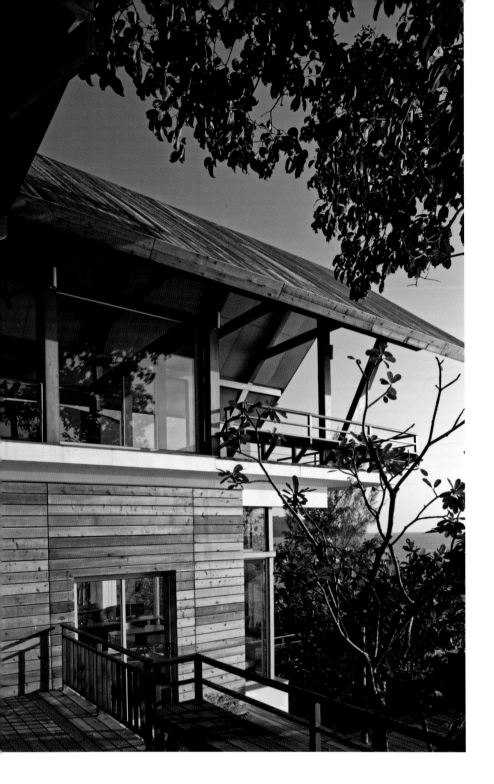

glass pavilions on slender columns topped by projecting pitched roofs that capture the essence of traditional Thai forms. The design is confidently proportioned and Bedmar knows instinctively where to place objects in the landscape. Materials include highly textured gray split slate, gray-brushed concrete, copper and timber. The surface of the main roof is naturally finished Canadian cedar strips above a layer of insulation. The underside of the roof is also timber.

Bedmar has a body of work that extends throughout Southeast Asia. He has also received commissions in India, New Zealand and New York. Two monographs of his work have been published acknowledging his recognition on the international stage.[1]

1 Geoffrey London, *Bedmar & Shi: Romancing the Tropics*, Oro Editions, New York, 2007; Darlene Smyth (ed. Oscar Rierra Ojeda), *5 in Five: BEDMaR & SHi*, Thames and Hudson, London, 2011.

2 Entrance pavilion
6 Dining area
7 Living area
11 Terrace
13 Swimming pool
16 Master suite 2

0 1 5 10 meters

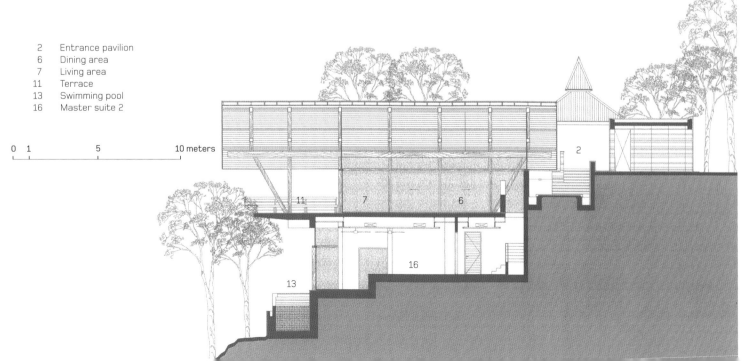

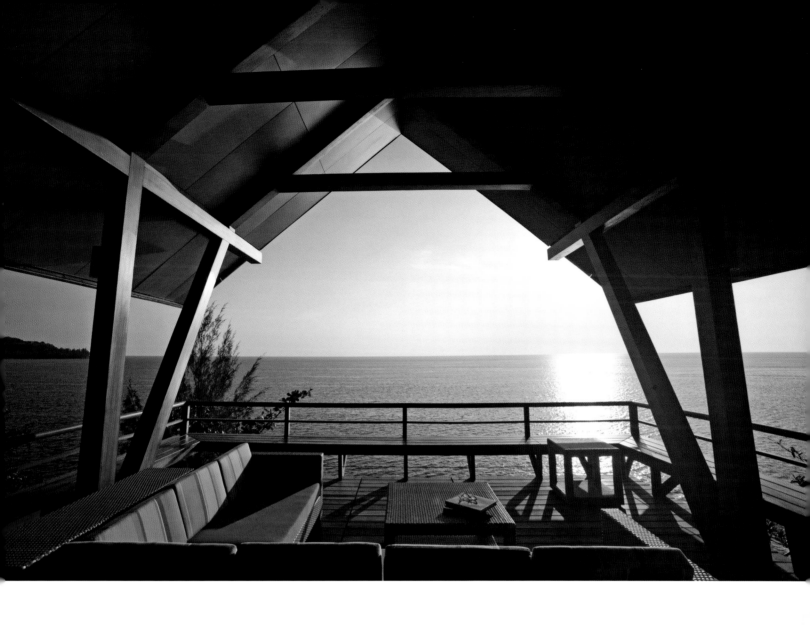

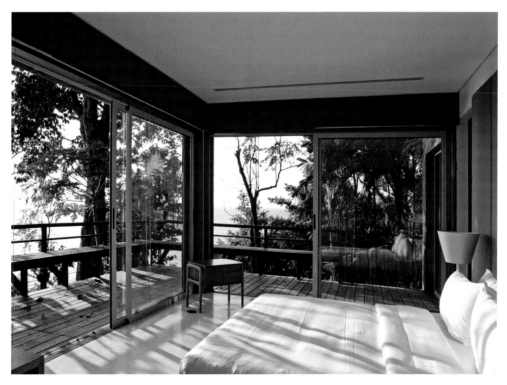

Opposite above left
The architect makes
extensive use of timber
cladding.
Opposite below Section
drawing.

Opposite above right
Stairs descend to the
veranda overlooking
the infinity swimming
pool.

Top The balcony beyond
the dining room frames
the setting sun.
Above There is a
panoramic view of the
ocean from the master
bedroom suite.

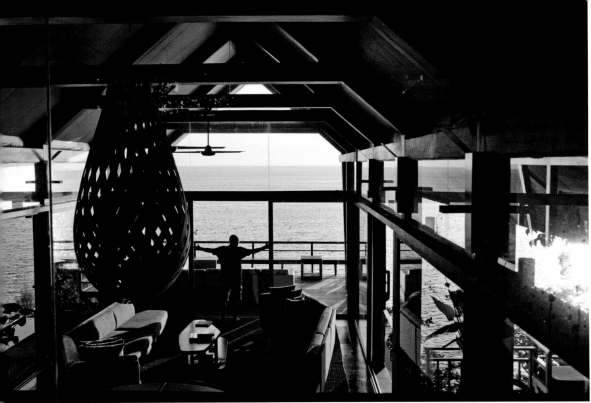

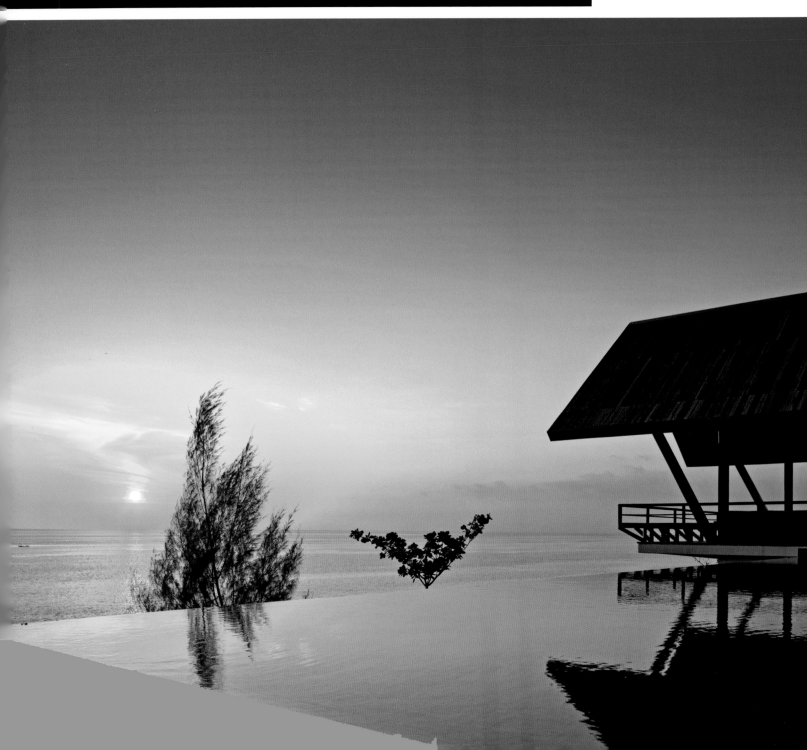

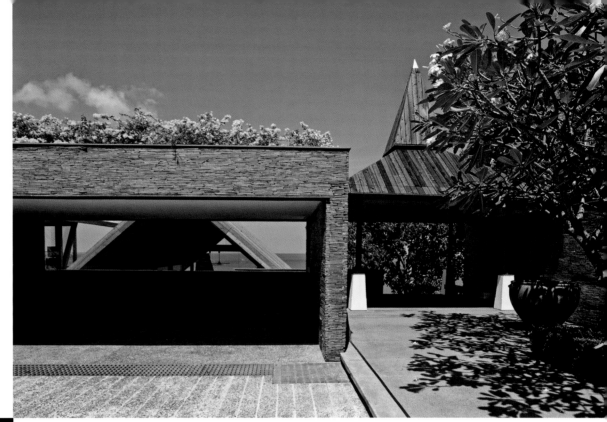

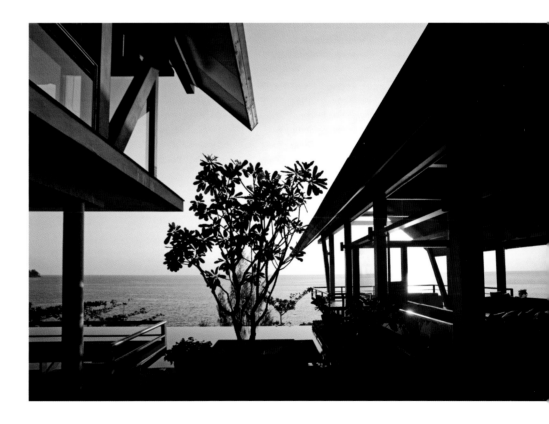

Opposite above The living/dining area can be naturally ventilated or air-conditioned.

Above and opposite below Magical moments as the sun sinks below the horizon.

Top The carport, located at the highest level of the site, offers tempting glimpses of the horizon.

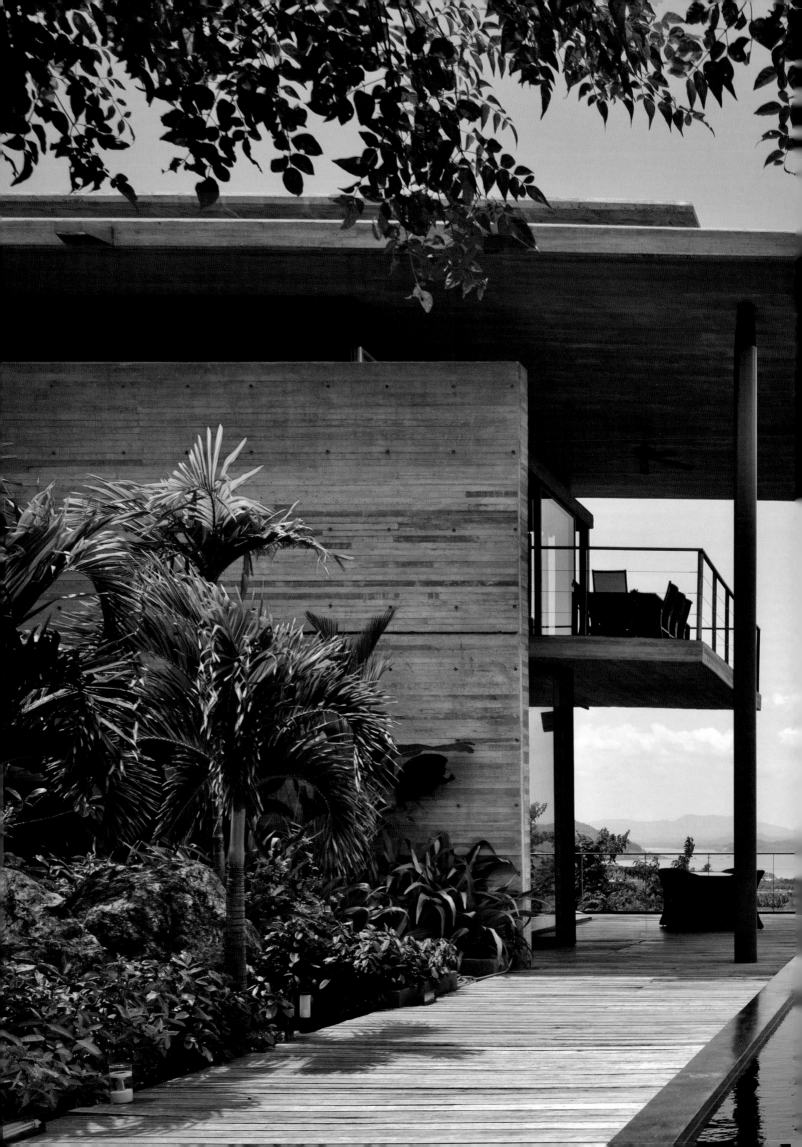

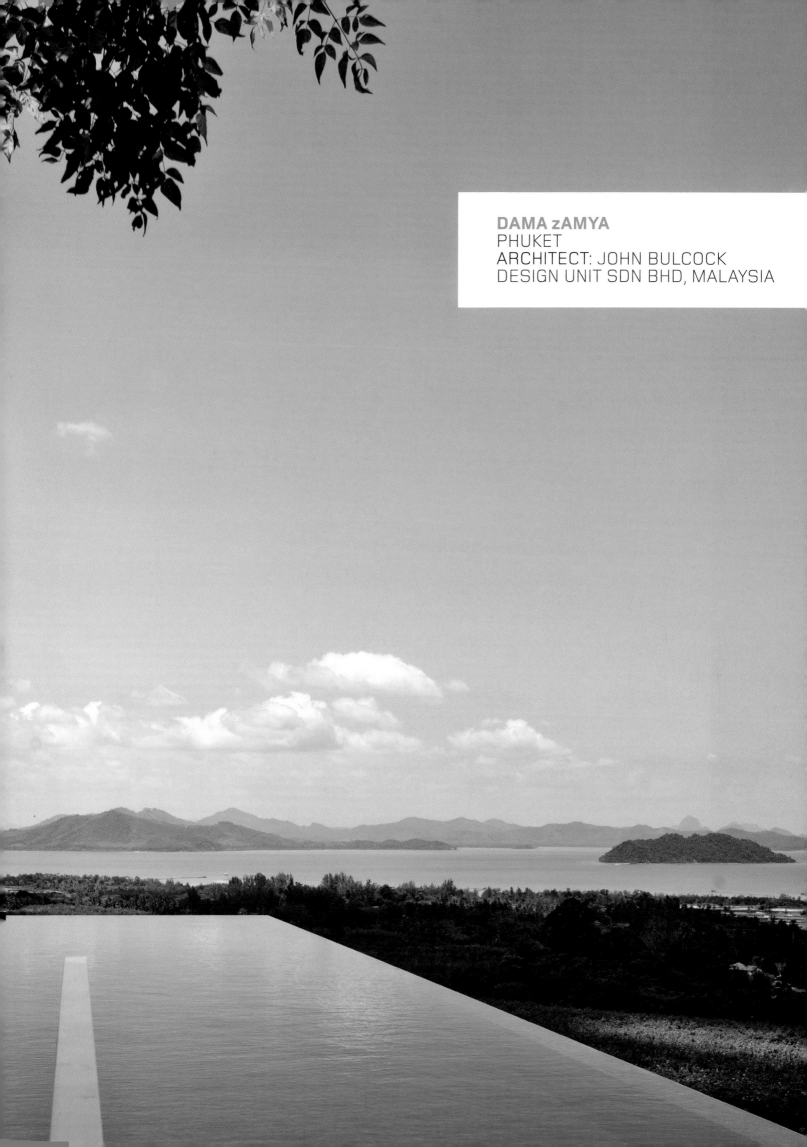

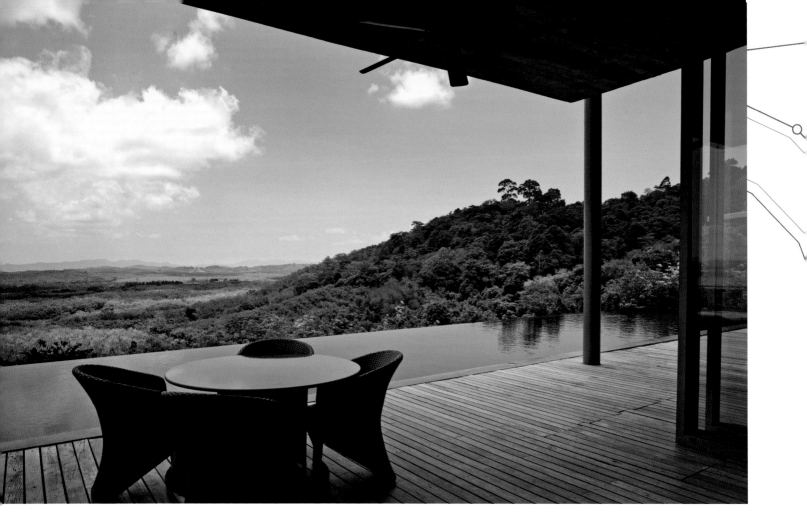

1	Carpark
2	Carport
3	Entrance
4	Upper gallery
5	Kitchen/dining area
6	Laundry
7	Study
8	Dining terrace
9	Pond
10	Roof garden
11	Living room
12	TV room
14	Swimming pool
15	Timber deck
23	Roof garden

Dama zAmya is perched atop a hill on Phuket Island, with magnificent views to the north of Ngam Island and Pa Yu and Kung Bay in the foreground. Remote and isolated, yet only 10 km from the International Airport, it is approached by a narrow, winding 2.1 km road that climbs steadily upward through a rubber plantation from its junction with the coastal highway.

Wildlife, landscape and travel photographer Gary Dublanko and his wife Dea Zoffman own the eco-friendly dwelling. Dublanko specializes in African wildlife and landscape and travel photography in Southeast Asia. The couple have lived in the

tropics for more than a decade, and they acquired the piece of land on a secluded hillside bordering Khao Phra Thaew National Park (a non-hunting area) in 2007. Dublanko decided that sustainable living offered a perfect counterpoint to his former career as an oil industry engineer, and an ideal ethic for the tropics.

The couple's desire for a fully self-sustaining house led them to seek out John Bulcock, a British architect who works out of Kuala Lumpur. Bulcock received his training at the Hull School of Architecture in the UK, which at the time was considered a radical institution led by Michael Lloyd. It followed a structure based on the AA London model. Hull had a very strong 'alternative technology' base, as 'sustainability' was called in the 1980s. After graduating, Bulcock set up his own practise, but six years later decided to travel and he arrived in Malaysia via India. In India he worked for a year with Balkrishna

0 1 5 10 meters

V. Doshi, who was an important mentor. It provided a link with two of Bulcock's architectural heroes—Le Corbusier and Louis Kahn—for Doshi is one of the few living architects who worked for both of the modern masters. Upon his arrival in Kuala Lumpur, Bulcock swiftly found employment, and he soon came to the attention of an international audience with the publication of his design, in collaboration with Hans Carl Jacobson, of a regional headquarters for the Danish firm Novo Nordisk in 2000.[1] He subsequently set up his own consultancy in Kuala Lumpur in 2002.

'At the start of the process, we specified that the house had to be low maintenance and energy efficient,' says Dublanko. After a number of site visits, the architect presented the plans for their new house. 'All our projects incorporate passive design, including orientation to minimize the area of exposed heat absorbing hard surfaces, roof overhangs, rainwater harvesting, and landscape as an integral design element for shading and cooling,' says Bulcock. Accordingly he studied the sun path and the wind cone for the location and sited the house accordingly. Further cooling strategies include roof surfaces that are either vegetated or pebbled, creating garden spaces for entertaining as well as providing additional insulation for interior spaces. 'For ten months of the year we don't use air-conditioning,' affirms Dublanko. 'There is abundant air flow and the house cools down quickly at night. On still days, a fan is utilized.' Banana and papaya trees flank the house, together with shady travellers' palms, so that in every sense the owners endeavor to be self-sustaining.

'My approach was to design a house that would work with the natural contours of the site,' explains Bulcock. 'The steeply sloping site falls 21 meters, so the intention was for the house to hug the slope as it steps down. This has resulted in a series of subterranean and cantilevered spaces. Not only did this reduce the impact on the site in terms of cut-and-fill, but it also helped to create a stable internal temperature. Furthermore, it opened the house to the environment.' The house is constructed from concrete that also helps create a stable thermal mass.

The house is essentially two diverging, primary structures linked by the entrance veranda at the top of the site. Further down the slope, a 25-meter swimming pool and timber deck also link the two major elements. 'The spaces have been kept open as much as possible. The bathrooms are open to the elements. Only the bedrooms, TV room and kitchen can be fully enclosed. Full-height mosquito screens in the living areas allow the spaces to remain open without admitting insects and geckos,' says Bulcock. Arriving at the house, a vehicle court gives access to a broad flight of steps leading to a veranda that extends to the open-plan kitchen and dining area. The principal living area is at a lower level, with direct access to the pool deck and thence to the master bedroom suite that looks southeast to the distant forests and plantations. Looking south along the entrance veranda, there is a small lily pond.

Because of the remote setting, at the start of construction there were no water, electricity or sewerage connections. Even now, only electricity is connected. Rainwater is collected from the roofs and channeled into

Above left There are breathtaking views southeast from the pool deck.
Left Section drawing.

Above First floor plan.
Pages 128–9 The house is located on high ground, with panoramic views to the north over Kung Bay.

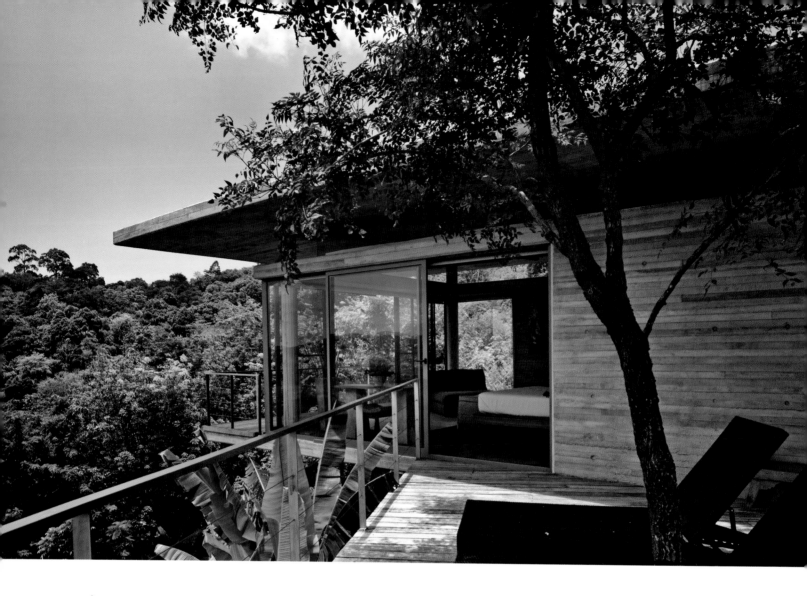

Top A timber deck connects the principal living area to the master bedroom suite.

Above left and right The house is magical in a tropical thunderstorm.

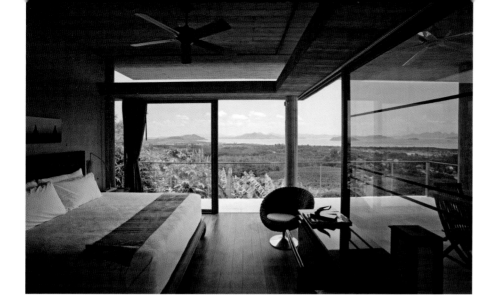

an 80,000-liter underground storage tank. During the dry season, water from a 72-meter-deep well supplements the tank. All wastewater is treated on site by an Aerotol septic system.

Materials include fair-faced concrete, terrazzo, *merbau* wood and bamboo screens. The owners selected natural earth-tone pigments for the walls. The floors and interior doors are made of *merbau* recycled from a 40-year-old house nearby. There is extensive clear glazing, but wide overhanging roofs shade the glass, and windows are located to permit breezes to naturally ventilate the interior. 'It is important for me,' says Bulcock, 'that buildings are "honest". As such, I favor natural materials and materials that do not need finishes and that have their own integrity, for example, off-form concrete, fair-faced brickwork ... also bamboo and rattan as they have low embodied energy. I use a small palette of materials that create simple, calm and uncluttered space.'[2]

After two years of construction, during which time the owners took on the role of building contractors, the finished 560-square meter house—named dama zAmya, which means 'a peaceful retreat' in Sanskrit—is ultimately a brilliant exposition of building in the tropics.

1 Robert Powell, 'Tropical Danish', *Steel Profile*, No. 80, Australia, 2002, pp. 14–17.
2 John Bulcock, in correspondence with the author, 18 August 2011.

Above The guest bedroom suite at the upper level of the house.

Right The design steps down with the contours of the site and has a series of cantilevered spaces.

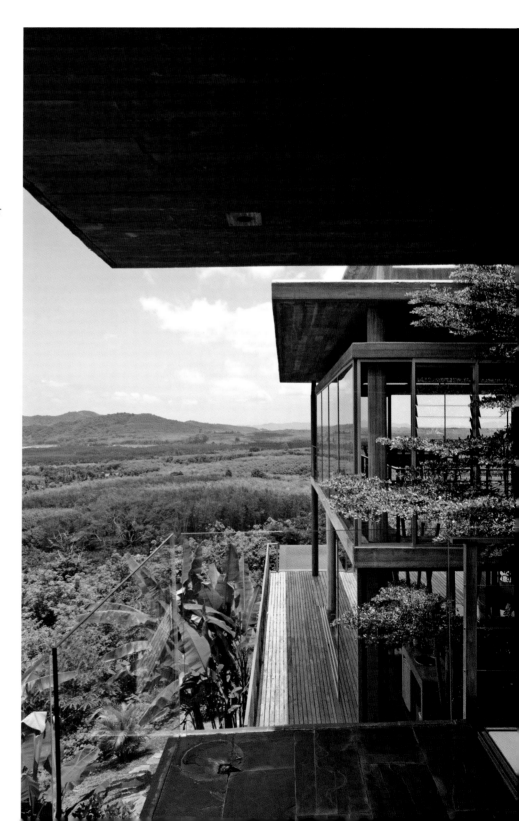

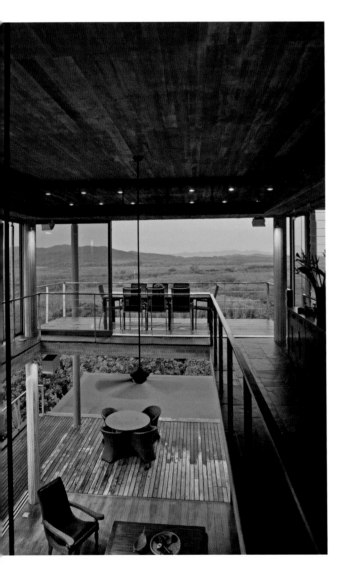

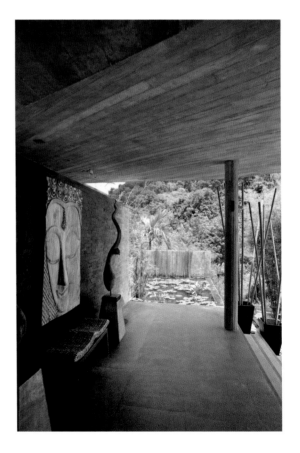

Top The architect employs a limited palette of materials to great effect.

Above The view to the horizon from the upper level of the two-story living area.

Above The entrance veranda with a small lily pond.

Right The lofty living area has views to the north beyond the banana and papaya trees that fringe the garden.

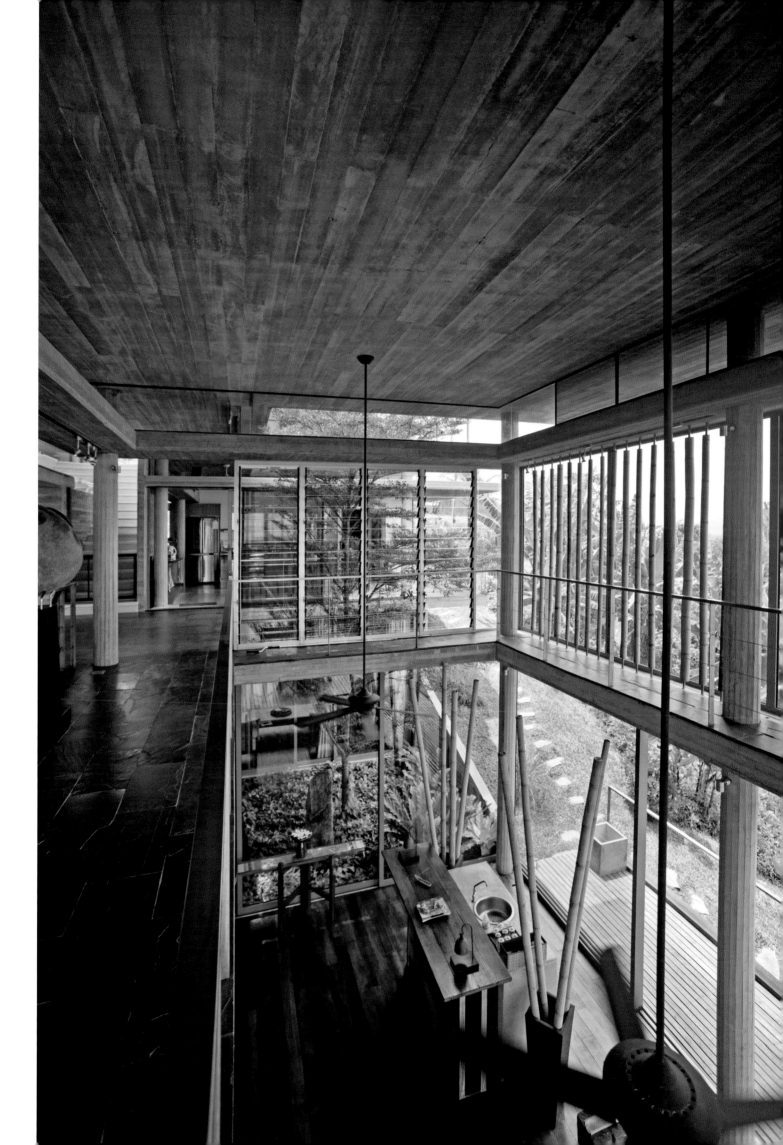

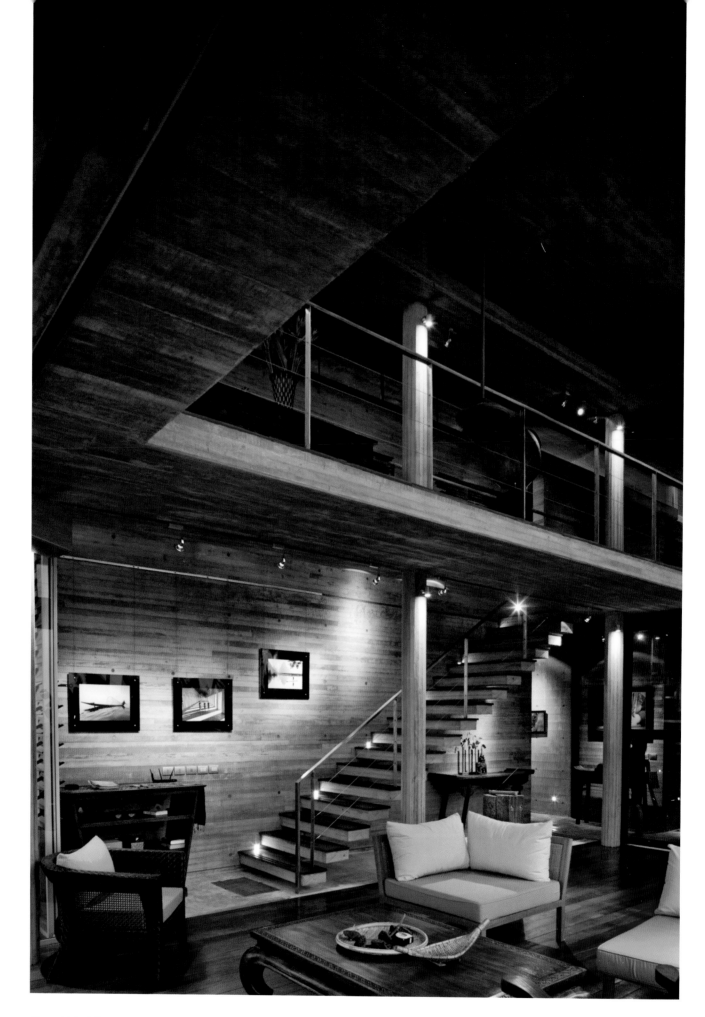

Above At dusk the
house is an enchanting
place, with carefully
placed light fittings
highlighting off-form
concrete and timber.

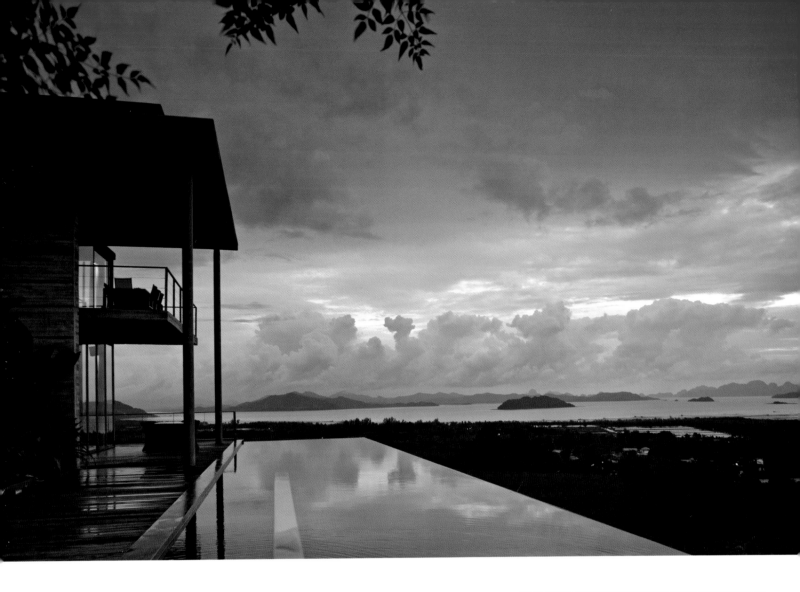

Above left and right
The exquisite entrance
lobby at night.

Top Nightfall after a
thunderstorm.

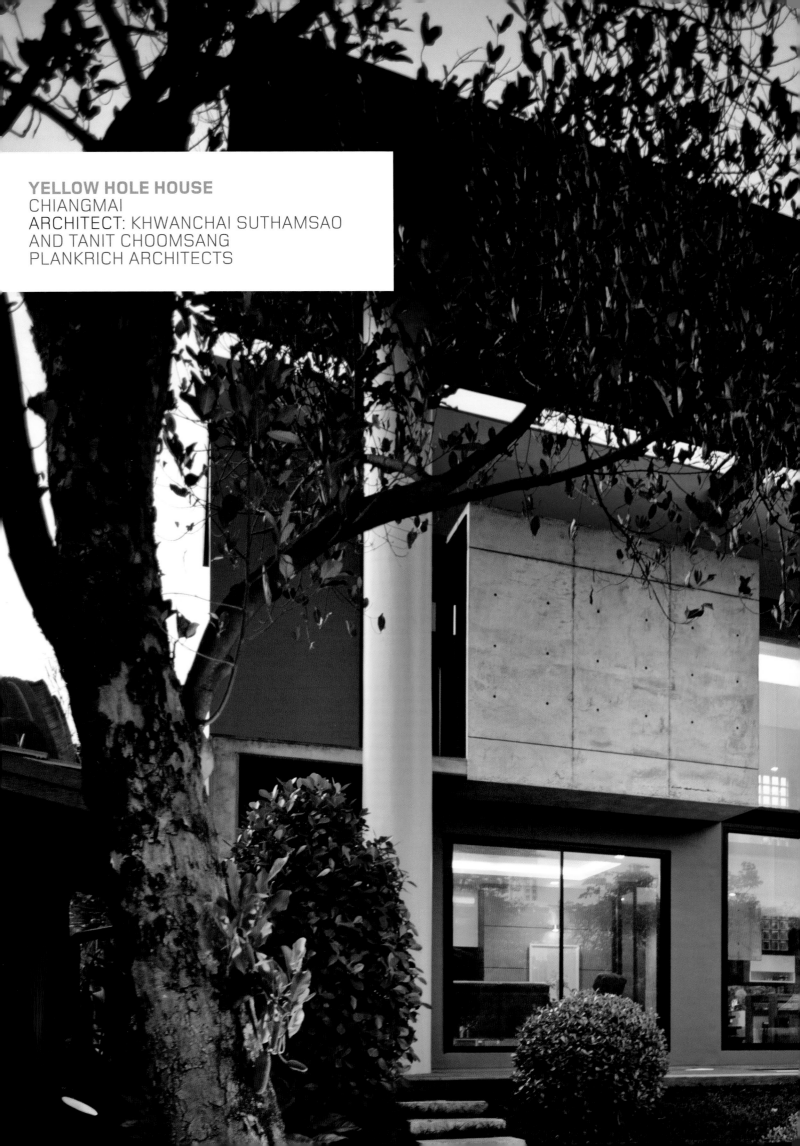

YELLOW HOLE HOUSE
CHIANGMAI
ARCHITECT: KHWANCHAI SUTHAMSAO
AND TANIT CHOOMSANG
PLANKRICH ARCHITECTS

Dormtel, a funky low-cost student hostel and backpacker's lodge with a bar and a souvenir shop, which is clad in recycled washing machine panels. The Plankrich office also accommodates a delightful cake shop adjacent to the entrance, that attracts the public.

Tanit Choomsang is a former president of LANNA, an offshoot of the Association of Siam Architects under Royal Patronage. The firm's designs are driven by a desire to exploit local materials while simultaneously incorporating new technology, all with a view to meeting environmental concerns. From its base in the north, the practise has extended its operations to other regions of Thailand.

Built in the garden of their parents' house, the two-bedroom Yellow Hole House is owned and occupied by Sivika Sirisanthana and her younger brother. Their father is the owner of a Toyota franchise in Thailand.

The plan of the house has a linear organization, with the entrance accessed from a large carport at the eastern end of the site. A short flight of stairs leads to the lobby, and beyond is an open-plan ground floor with all the principal rooms, including the living, dining and kitchen areas, looking north over a luminous blue lap pool to the garden the siblings share with their parents.

A double-height space above the living room connects to a gallery on the upper floor that gives access to the two bedrooms. In the gallery, a dramatic two-story-high bookcase and display cabinet occupies one wall. Horizontal timber cladding and a glass block wall on the rear elevation are crisply detailed, while the air-conditioning units are cleverly concealed on the same rear wall. The raised ground floor level recalls traditional responses to flood-prone areas in Thailand.

The precise orthogonal lines of the Yellow Hole House represent a determined break from traditional Thai residential forms. At the same time, the dwelling maintains the strong family relationship between children and their parents that is evident throughout Thailand.

The Yellow Hole House is an extraordinarily elegant, exquisitely proportioned modern residence. Constructed in off-form concrete, the structure features a tall yellow-painted column and a yellow-painted projecting upper floor, with an oversailing roof like a plane wing. The design is clearly influenced by the mid-twentieth century European architecture of De Stijl, Gerrit Reitveld and Le Corbusier.

The 280-square meter house was designed by Kwanchai Suthamsao and Tanit Choomsang of Plankrich Architects. The philosophy of Plankrich Architects is based on the idea of 'alternative approaches in design, to try to turn crisis (disadvantage) into opportunities'. Anecdotal evidence suggests that it is tough surviving as an architectural practise in Chiangmai.

The reverse side of this situation is that it produces entrepreneurial architects who create opportunities, and Tanit Choomsang is no exception. He owns the Good View restaurant in Chiangmai, which opened its doors in 1996, with other outlets located in Bangkok, Pattaya and Vientiane, and he and his fellow director Khwanchai Suthamsao are the architects and proprietors of Hallo

Above The two-story living space and a wall of books and collectable items.

Pages 138–9 Constructed in off-form concrete, the house is evidently influenced by De Stijl and Le Corbusier.

Above right First floor plan.
Right The open-plan living and dining area on the first floor.

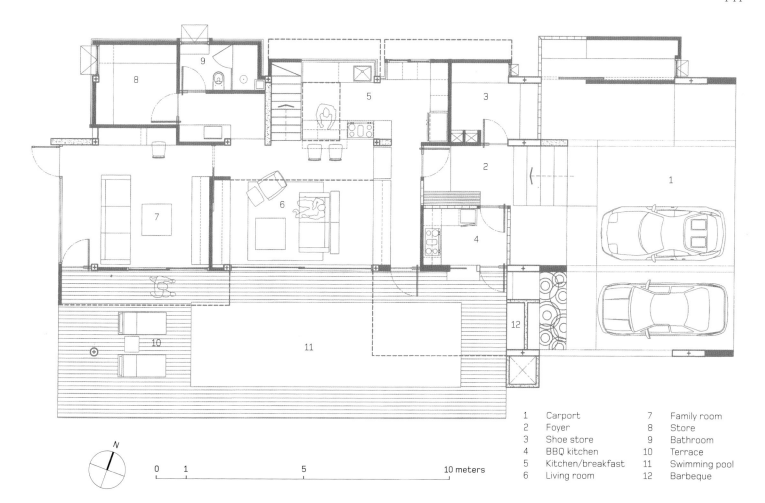

1	Carport	7	Family room
2	Foyer	8	Store
3	Shoe store	9	Bathroom
4	BBQ kitchen	10	Terrace
5	Kitchen/breakfast	11	Swimming pool
6	Living room	12	Barbeque

0 1 5 10 meters

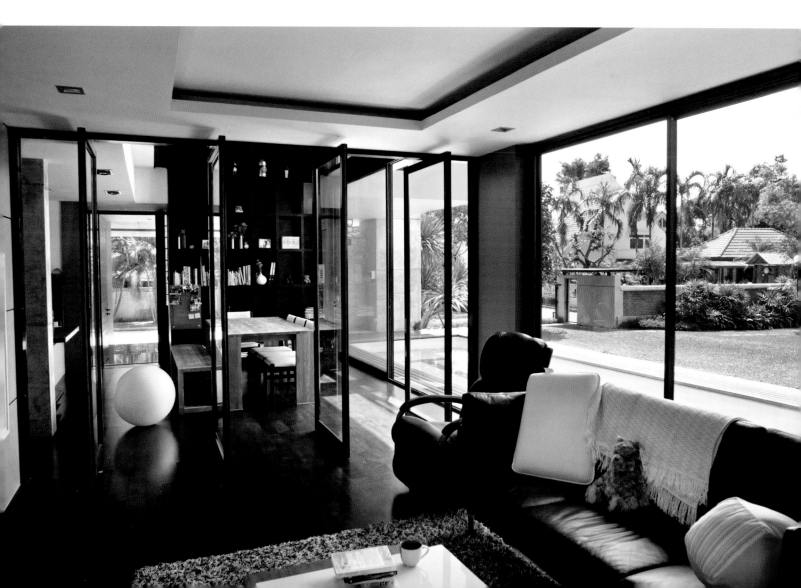

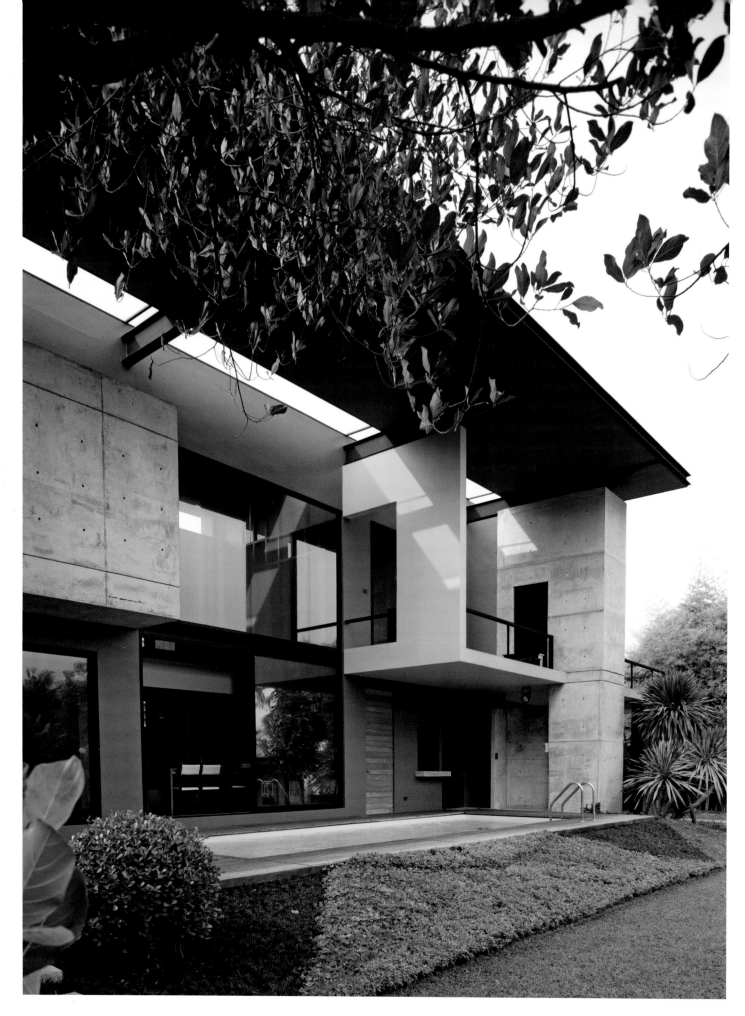

Above and opposite left The principal features of the house are highlighted in yellow.

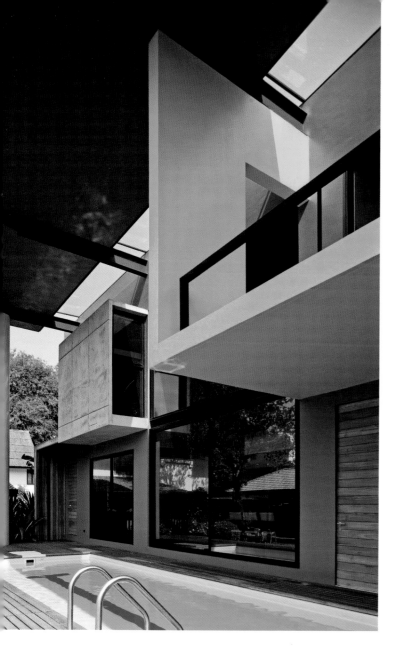

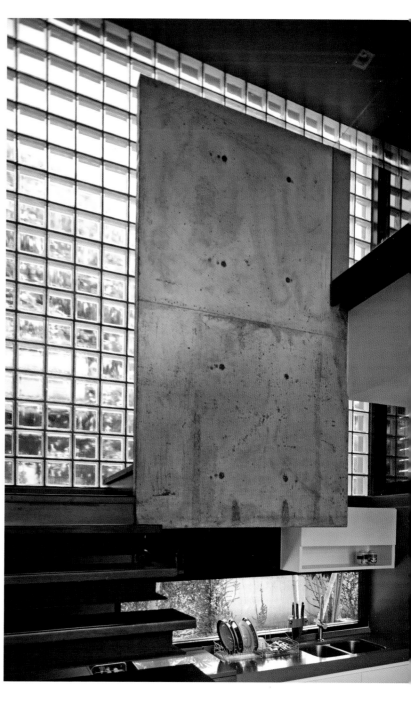

Above A glass block
wall behind the kitchen
is crisply detailed.

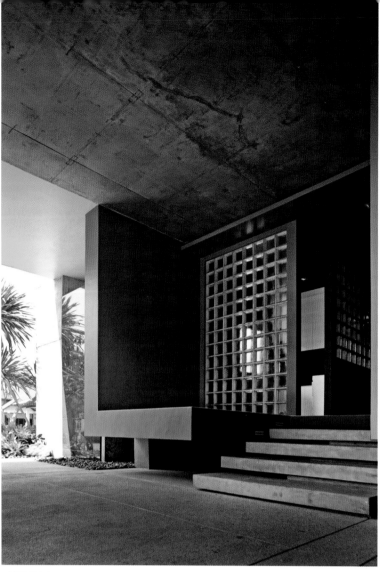

Above left The house is elevated approximately 900 mm above the surrounding ground level.

Left The roof terrace above the carport.

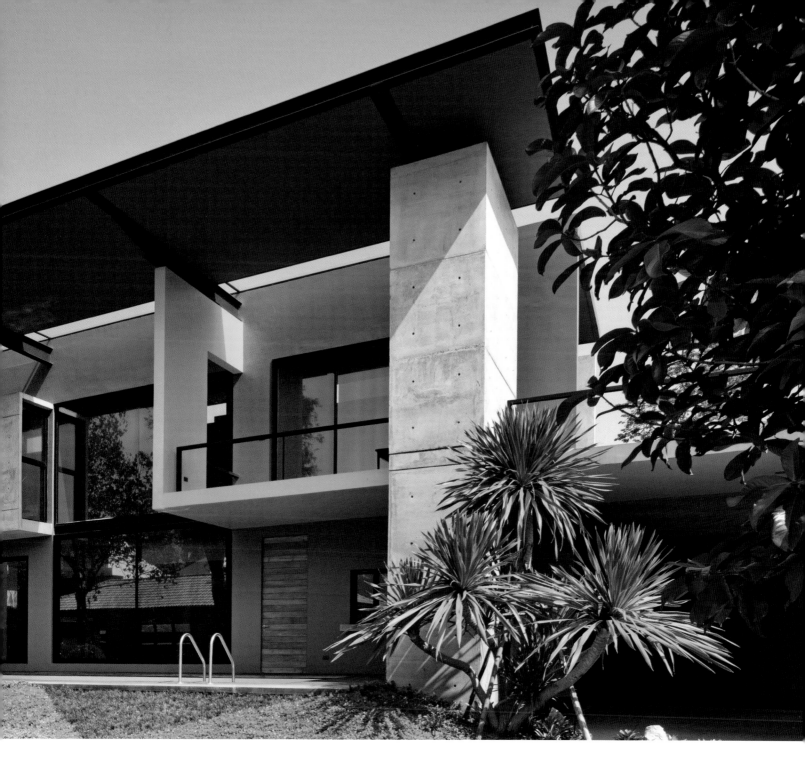

6 Living room
11 Swimming pool
13 Bridge

Above The house,
an elegant essay in a
modern architectural
language, is beautifully
proportioned.

Right Section drawing.

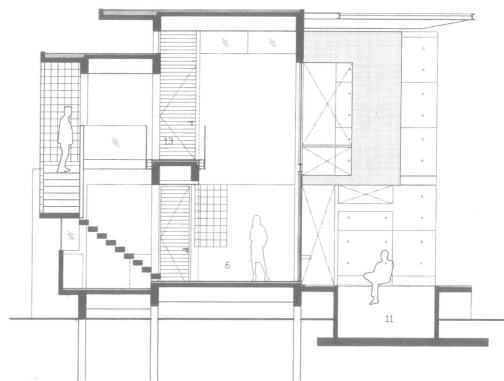

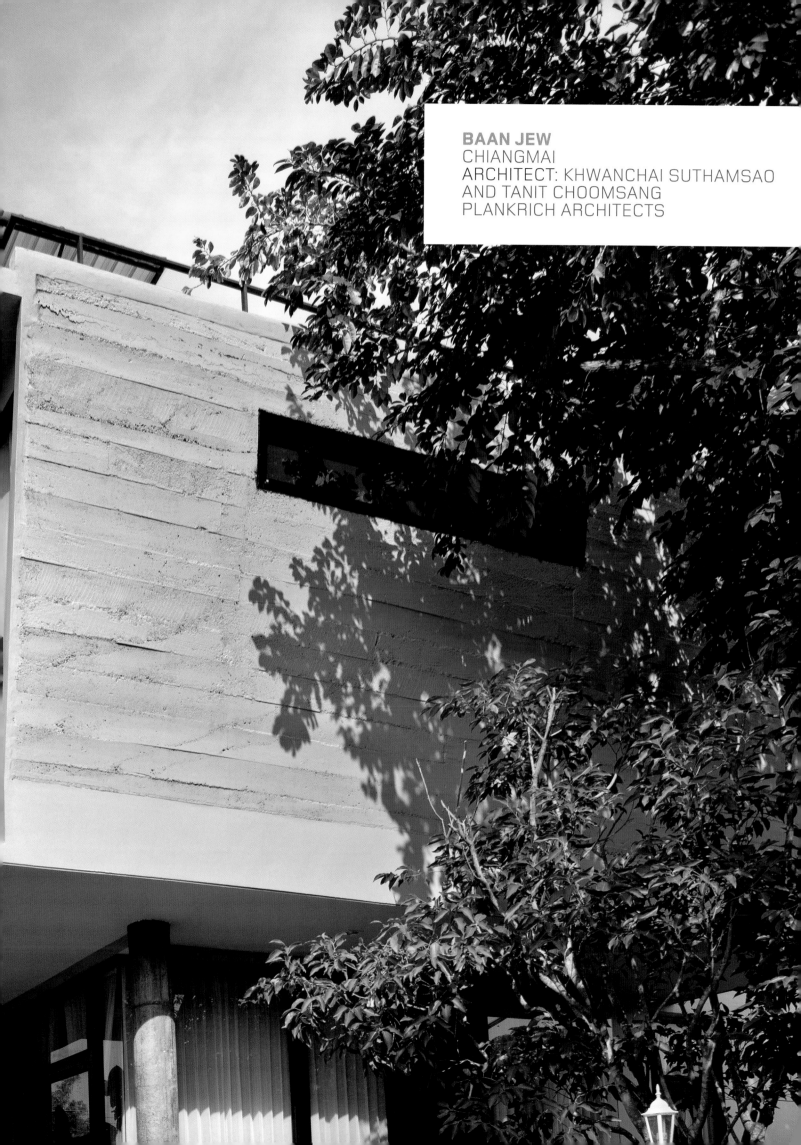

BAAN JEW
CHIANGMAI
ARCHITECT: KHWANCHAI SUTHAMSAO
AND TANIT CHOOMSANG
PLANKRICH ARCHITECTS

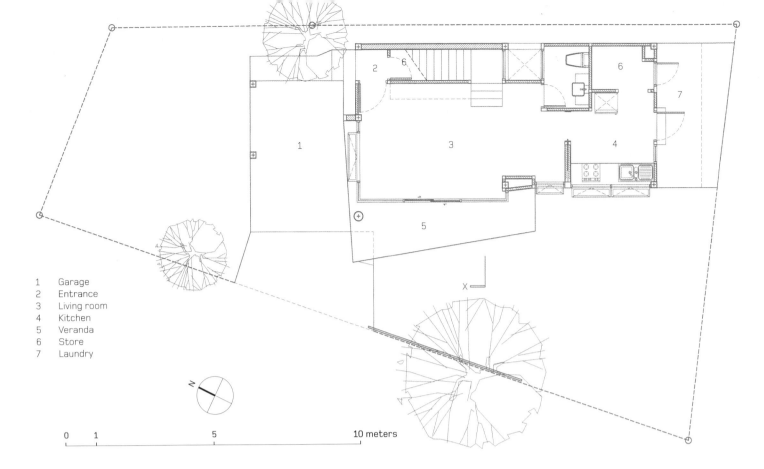

1 Garage
2 Entrance
3 Living room
4 Kitchen
5 Veranda
6 Store
7 Laundry

0 1 5 10 meters

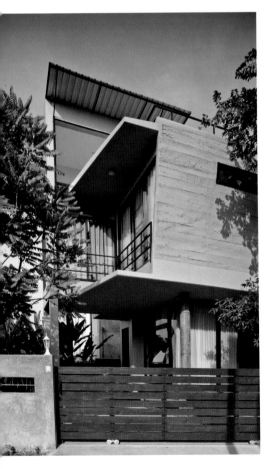

Baan Jew, translated as 'Tiny House', is a compact modern dwelling on a 220-square meter corner plot near Chiangmai University. Kwanchai Suthansoa and Tanit Choomsang, the Executive Director of Plankrich Architects, designed the 165-square meter house set within a small garden for Nawaree Summasanti, a retired automotive engineer.

Tanit Choomsang studied architecture at Ratchamangala University of Technology Lanna in Chiangmai and then pursued a Masters in Urban Design at the prestigious University of the West of England in the UK, before returning to Chiangmai where he set up practise in 2005 with fellow architect Khwanchai Suthamsao, a graduate of King Mongkul Institute of Technology Ladkrabang, and civil engineer Sakchai Thongpanchang.

Plankrich Architects is an inventive architectural practice whose other notable projects include Baan Khun Kaew and Mo Rooms, a twelve room boutique hotel in Chiangmai that the venerable Dr Sumet Jumsai has hailed as 'one of the most exciting designs I have ever seen'.[1] Plankrich is based in a striking minimalist modern office, also designed by the practise, with a cake shop at the entrance for staff and passersby. In mid-April 2011, when I met Tanit, his two fellow directors were outstation during the Songkran Festival and I was informed they were 'driving to China'.

Built for just one million baht (£30k), the simple two-bedroom Baan Jew demonstrates the architects' ability to create a beautiful object on a limited budget. The ground floor of the house is raised one meter above the level of the garden and entered by a short flight of stairs. The house is designed to make the maximum use of available space and is built without excess. Materials are modest. Walls are fair-faced concrete and floors polished cement. Ceilings are relatively low at 2.7 meters and space uses are planned to overlap. Cross-ventilation is achieved by opening the entrance door. An open-sided staircase gives the appearance of additional volume in the living area. A steep internal ladder gives access to a roof deck from the upper floor, and a roof light along the boundary wall introduces daylight.

The lesson to be learned from Baan Jew is that it is not necessary for a house to be large or for money to be lavished on expensive materials. Here, simple, clean lines and the manipulation of space and light create a tiny jewel.

1 Sumet Jumsai, in correspondence with the author, 19 April 2011.

Above The house demonstrates the architects' ability to create a beautiful dwelling on a limited budget.

Top First floor plan.

Pages 146–7 Baan Jew is a compact modern house for a retired automotive engineer.

Right Materials are modest, such as the off-form concrete external walls.

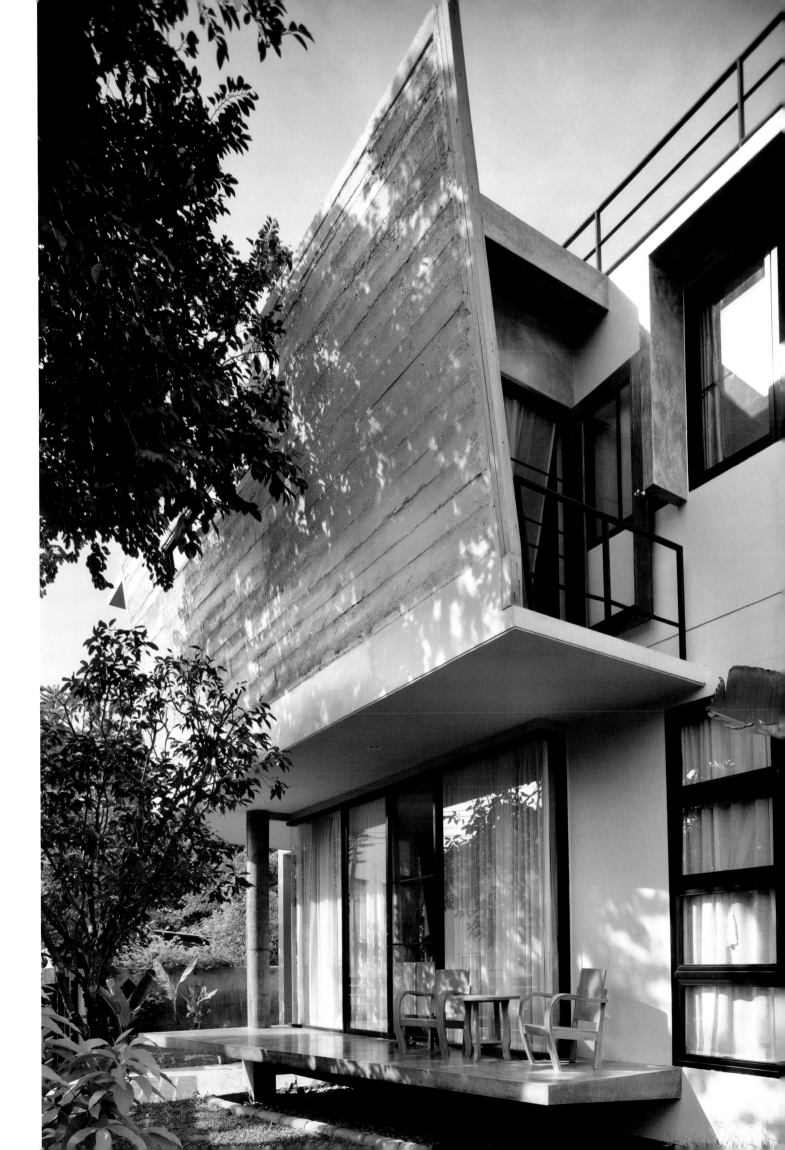

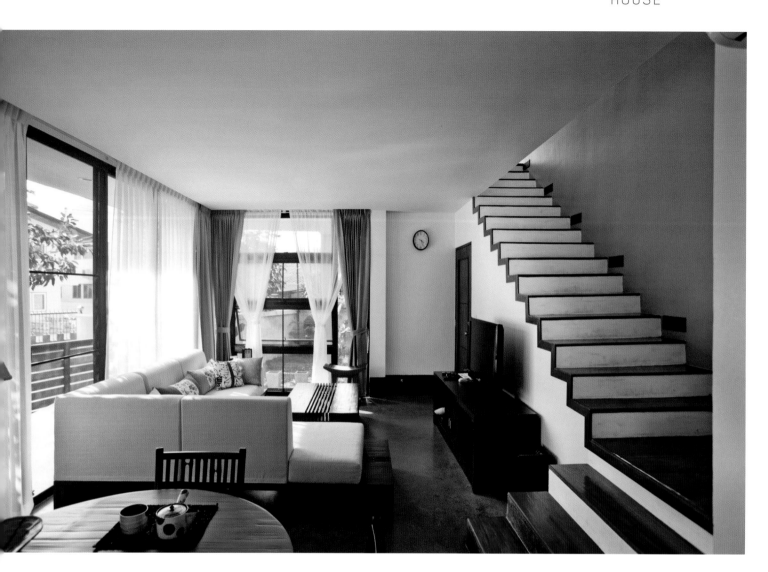

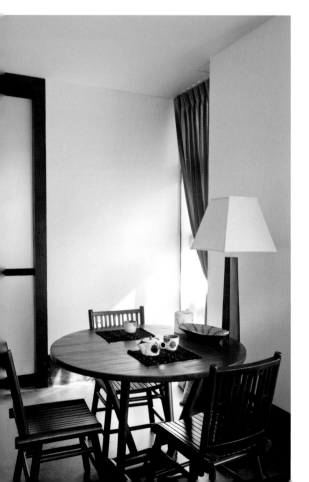

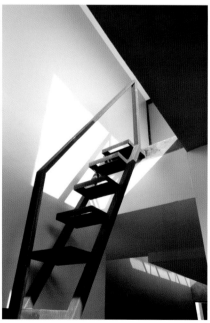

Top and left The
compact living and
dining area, with an
open-sided staircase
to the upper level.

Above left and right A
steep ladder provides
access to the roof and a
skylight brings daylight
into the main stairwell.

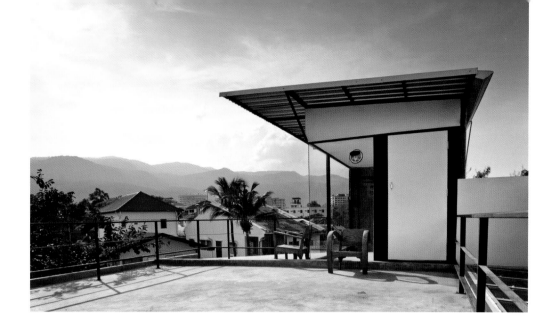

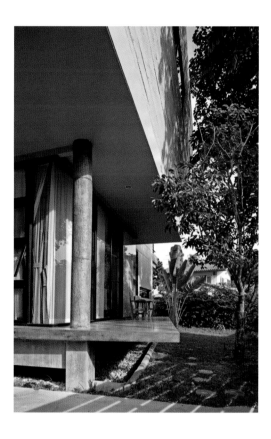

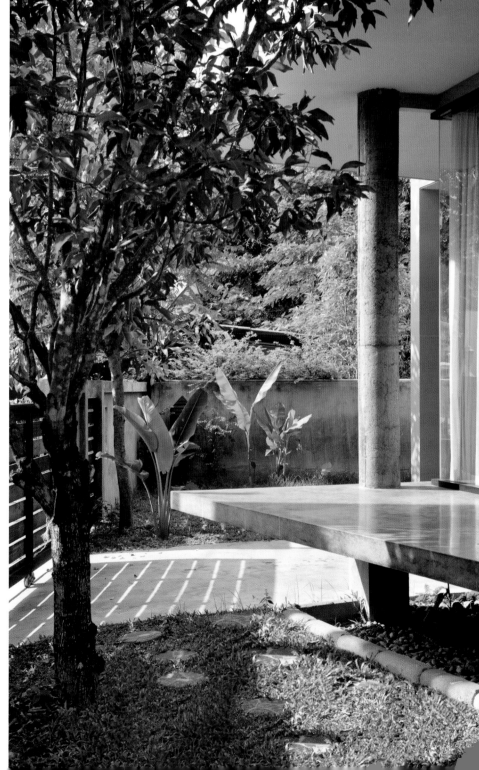

Top A spacious roof terrace gives views to the horizon.

Above and right The living area is extended out to a sheltered veranda raised one meter above the ground.

SOI WAT UMONG HOUSE
CHIANGMAI
ARCHITECT: AROON PURITAT OF AROON
PURITAT ARCHITECT IN ASSOCIATION WITH
FERNLUND + LOGAN ARCHITECTS

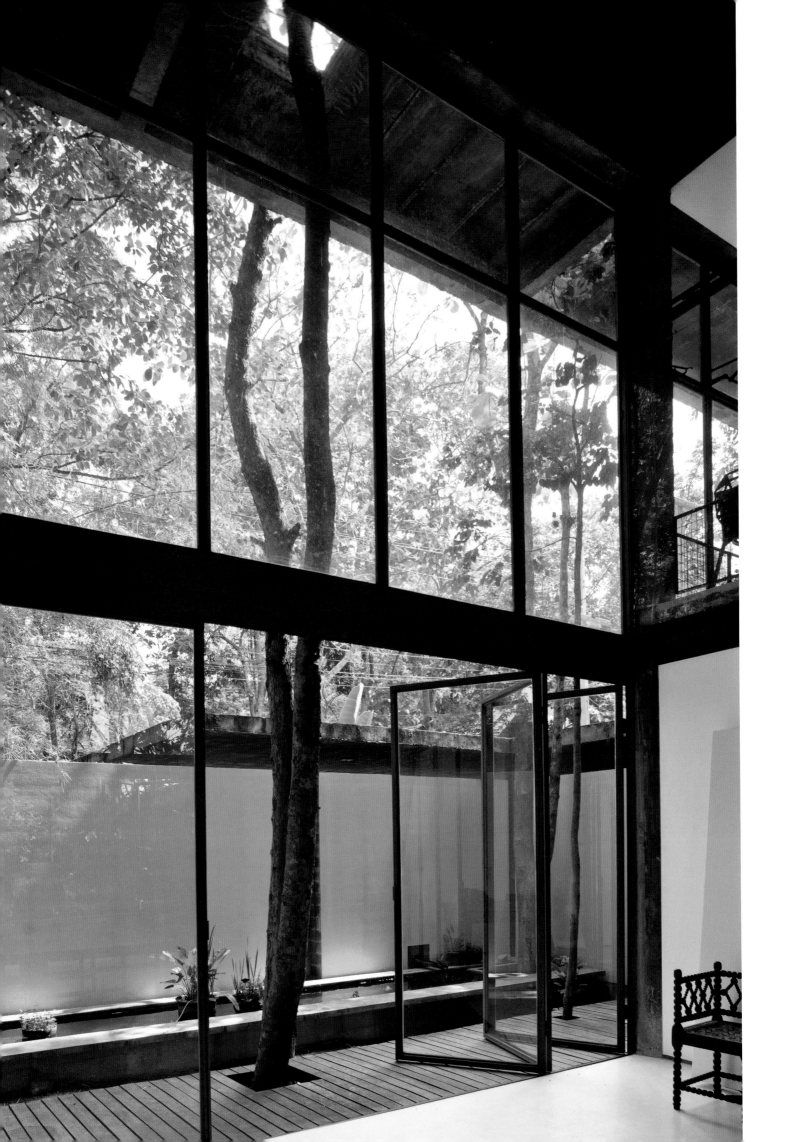

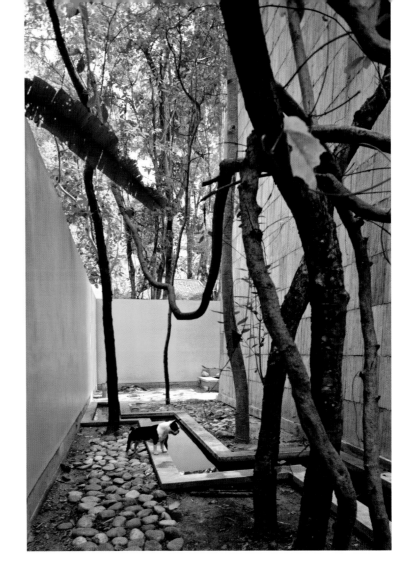

The Soi Watt Umong House is a 'Miesien' composition of concrete and glass pavilions grouped around a courtyard and set in secondary tropical forest. The site is located close to Chiangmai University in Thailand's second largest city.

The owners of the house are Rirkrit Tiravanija, an internationally acclaimed Thai artist,[1] born in Buenos Aires, Argentina, in 1961, who spent his childhood years in Ethiopia and Thailand, and his Japanese/American wife Antoinette Aurell, a photographer who worked in Paris and New York before moving to Chiangmai. The couple live with Antoinette's two children from a previous marriage, a boy who is studying at an international school in Chiangmai and a daughter who attends college in the US.

The design of the house originated from a physical model constructed by Rirkrit in 2005. Photographs of the model were sent to Neil Logan (of Fernland + Logan Architects in New York), an American architect and friend, who made modifications to the structure and designed built-in closets, kitchen shelves and stainless steel work surfaces. The drawings were later passed to Aroon Puritat, a graduate of the Faculty of Architecture at Silpakorn University, who resides in Chiangmai.[2] The two had met

while Aroon was researching his graduate thesis on contemporary art museums. In the process, he had examined works such as *Pad Thai* (Untitled 1990) by Rirkrit. He also worked with Rirkrit on The Land, a community of artists close to Chiangmai (1998).

The house was to be built without destroying any trees on the site so at the outset all the trees were marked. The other requirements included a workroom for Rirkrit and a photography studio for his wife. The owners consulted *feng shui* master Kochakorn

Promchai to finalize certain details, such as the auspicious positioning of the entrance door. She recommended that 'the house entrance be from east to west, that the kitchen should face north—the person cooking should face north—and that there must not be any water in the middle of the home'.[3] Aroon adjusted the drawings to fit the site, the available materials and the capabilities of the construction industry in Chiangmai and then finalized the architectural drawings for submission to the authorities.

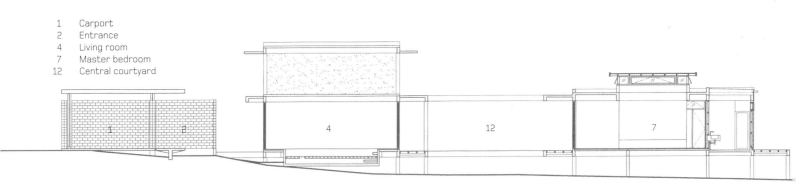

1 Carport
2 Entrance
4 Living room
7 Master bedroom
12 Central courtyard

Left The high-ceilinged studio looks out to an enclosed water court.
Above Section drawing.

Top The water court returns along the flank of the studio.

Pages 152–3 The house is located in secondary forest close to Chiangmai University.

0 1 5 10 meters

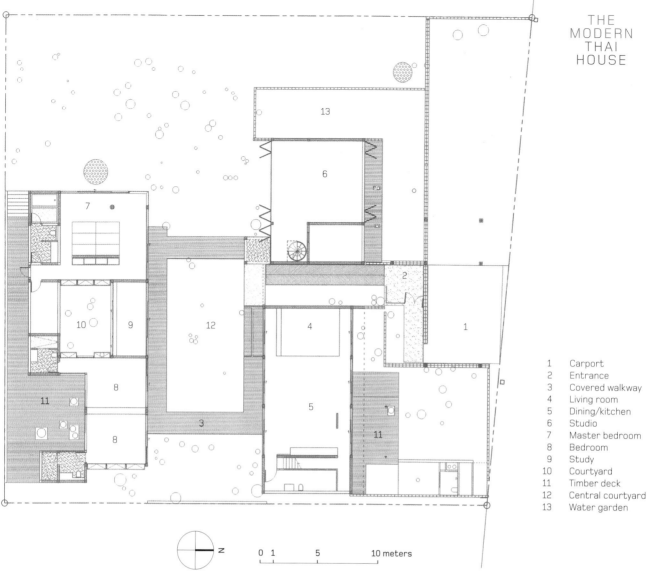

1 Carport
2 Entrance
3 Covered walkway
4 Living room
5 Dining/kitchen
6 Studio
7 Master bedroom
8 Bedroom
9 Study
10 Courtyard
11 Timber deck
12 Central courtyard
13 Water garden

N 0 1 5 10 meters

Above First floor plan.

The design process included Paponsak Laor, who contributed jade green tiles for the bedroom and inner courtyard wall; Professor Kamin Lertchaiprasert, who produced large drawings of a dragon, intending it to be applied to the ceiling of the library and a phoenix for the ceiling of the carport; Sethatwut Pinyorit, who was responsible for various structural features, and Taneeya Yuktadatta, who advised on lighting design.

The collaborative relationship was by all accounts challenging as Aroon strove to reconcile his architectural training and the requirements for a coherent end product with Rirkrit's desire for 'incompleteness' for the house. For an architect, a commission that invites experimentation at each step is rare. The result, as one writer has noted, is that the dwelling is, in a sense, a 'new work' by the artist arrived at through the medium of architecture.[4] In an interview with Calvin

Tomkins of the *New Yorker* on 17 October 2005, Rirkrit stated that many of the concepts behind his work borrow from Buddhism, where Doing Less is the same as not trying to embellish or make something more than what it is.

'I am fascinated by architecture,' explains Rirkrit, who in 1996 produced a 1:2 scale reconstruction of Philip Johnson's Glass House at New York MoMA. 'In particular, I am interested in modernism and the idea of self-criticism it contains [and] the conceptual problems relating to it.'[5]

Towards the end of 2005, Rirkrit and Antoinette moved from the USA to Chiangmai to supervise the construction of the house although Rirkrit insists that the house was really 'designed' by the workers on the site and that it was a hand-made process, 'closer to sculpture than architecture'.[6] The collaboration between the owners and the

architects continued with frequent emails from Neil Logan that were translated and implemented by Aroon Puritat.

Essentially, the house has an orthogonal U-shaped plan around a central courtyard. Soft dappled light penetrates into the heavily planted central court and a gentle breeze rustles the leaves. The house is remarkable for its silence. The structure is basically a concrete frame with concrete block and glass infill. The ground floor is lifted one meter above the terrain—typical of traditional Thai houses—in order to avoid mud and floodwater after heavy rain and also vermin. In addition, it permits under-floor ventilation. A shaded timber deck runs around the perimeter of the central garden giving access to the various functions.

An ever-present character in the remarkable house is Harry—the friendly offspring of a French bulldog and a Boston terrier that

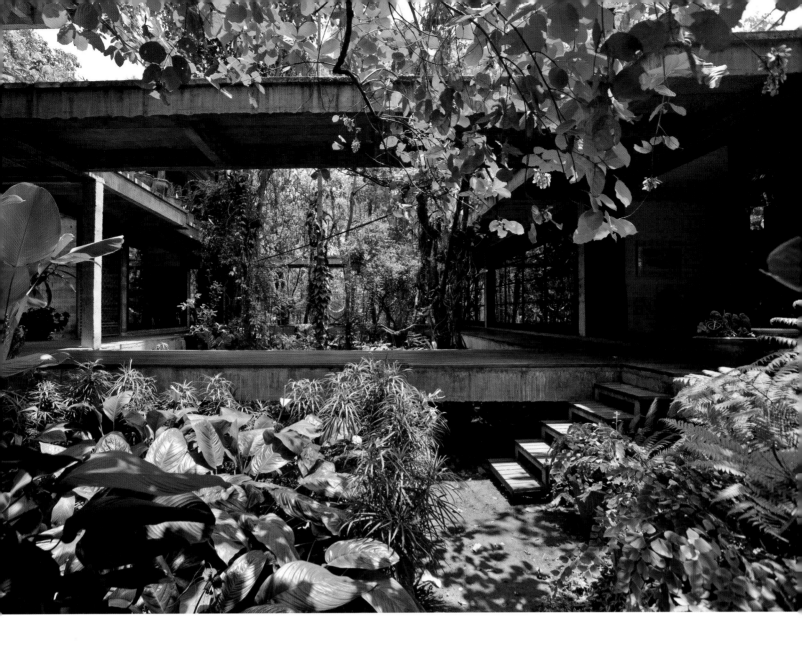

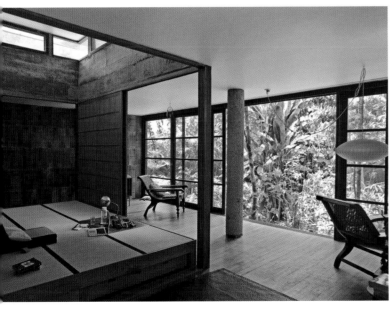

Top A timber walkway encircles the central courtyard.

Above The master bedroom has a distinct Japanese influence with dimensions derived from a tatami mat.

Above The bathroom design is based on a traditional Japanese tub.

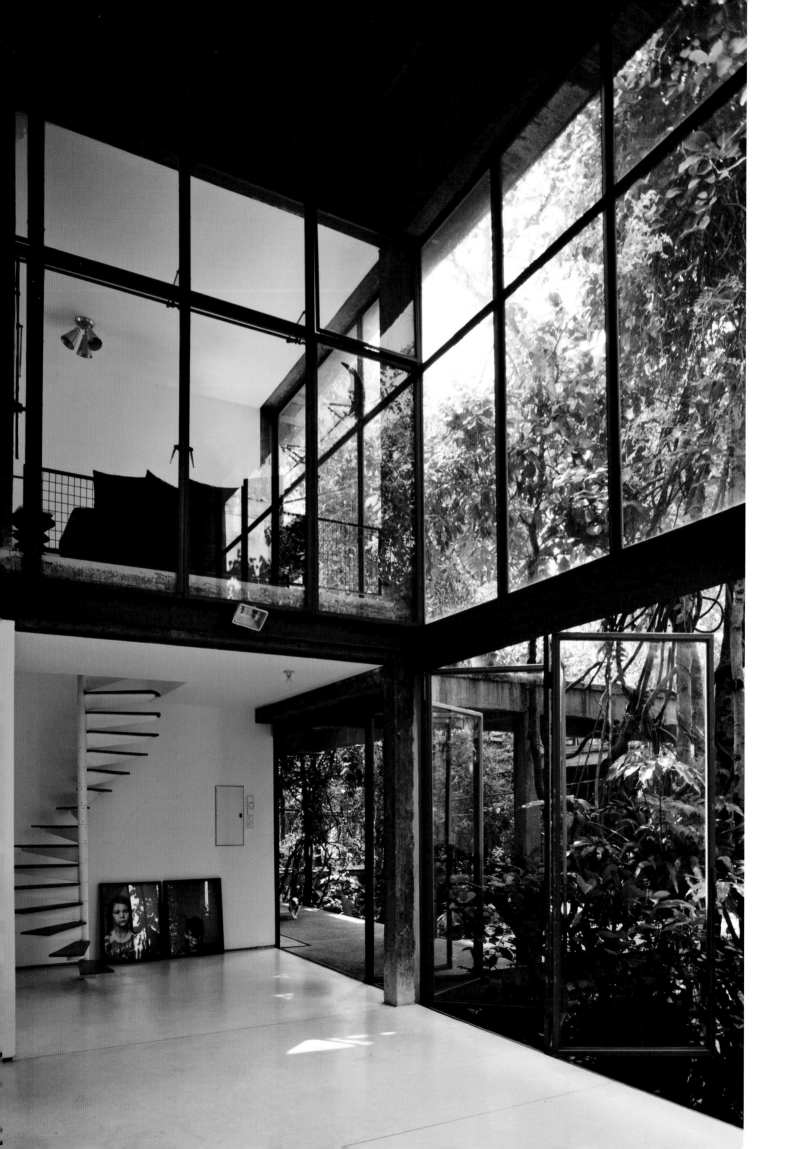

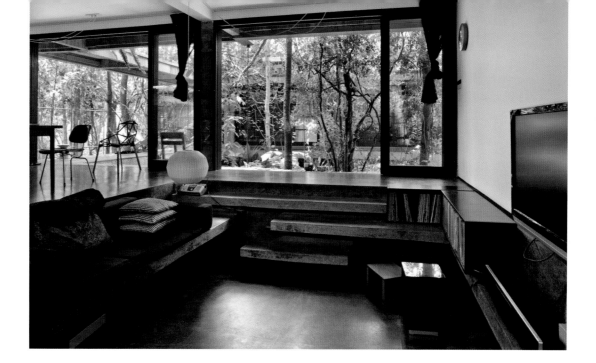

appears whenever a photograph is about to be taken, along with another less ebullient old dachshund named Torru.

The focus of family life is the open-plan kitchen and dining area adjoining the living area, which has a large square kitchen table, a smaller *kopi tiam* table and a sunken pit in the living space for gatherings of family and friends.

There is a distinct Japanese influence in the interior design, specifically in the master bedroom, which is based on the dimensions of a tatami mat, with futons spread on the floor. Sliding timber wall panels and the proportions of the fenestration also attest to a Japanese sensibility. The master bathroom was designed by Antoinette based on a traditional Japanese tub. The circular staircase up to the studio office was a direct copy from Charles Eames, while the office shelving was a modified copy of a Charlotte Perriand wall unit. Antoinette and Rirkrit selected all the interior and exterior finishes, including terrazzo, tiles and wood.

Guided by the expertise of a horticulturist friend, Stuart Rodgers, Antoinette was initiated into planting and gardening and has developed an obsession with tropical plants. In the northern corner of the site she has created what she describes jokingly as a *petit trainon,* an enclosed tropical garden that alludes to a space in the Palace of Versailles where her namesake Maria Antoinette and invited guests 'could take light meals away from the strict *étiquette* of the Court'.

1 The artist's work focuses on the creation of spaces of interaction, which allow art to unfold as communication—as 'what happens between people'. He has presented solo shows at the Secession, Vienna (2002), the Serpentine Gallery, London (2005) and the Musée d´Art Moderne de la Ville de Paris (2005). He is guest professor at Columbia University, New York.

2 Aroon Puritat has built several of his architectural designs, including the Annex House (2001) in Chiangmai and the Mud House for the Chiangmai Art Museum (2002). He also works as a freelance writer for *art4d,* an art, design and architecture magazine, and for *Wallpaper* magazine (Thai edition).

3 Rirkrit Tiravanija, in conversation with Rachaporn Choohuey, Aroon Puritat and Stefano Mirti, 'La Casa di Rirkrit Tiravanija', *Arbitare*, No. 478, Milan, February 2008, pp. 2–13.

4 Sant Suwatcharapinun, 'Rirkrit House', *art4d,* No. 140, Bangkok, August 2007.

5 Rirkrit Tiravanija, op. cit.

6 Ibid.

Left The circular staircase to the studio is a direct copy from Charles Eames.

Top The sunken pit in the living area provides a space for gatherings of family and friends.

Above left A section of the timber walkway that encircles the central courtyard.

Above right The entrance to the house.

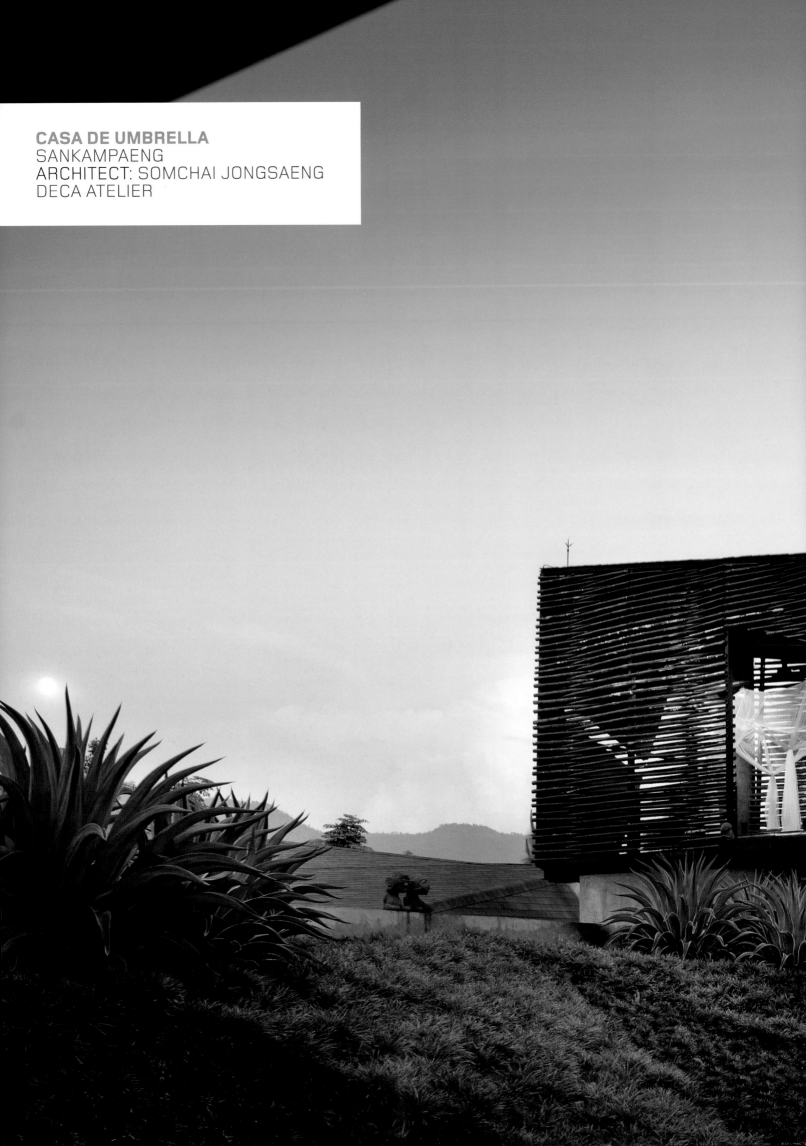

CASA DE UMBRELLA
SANKAMPAENG
ARCHITECT: SOMCHAI JONGSAENG
DECA ATELIER

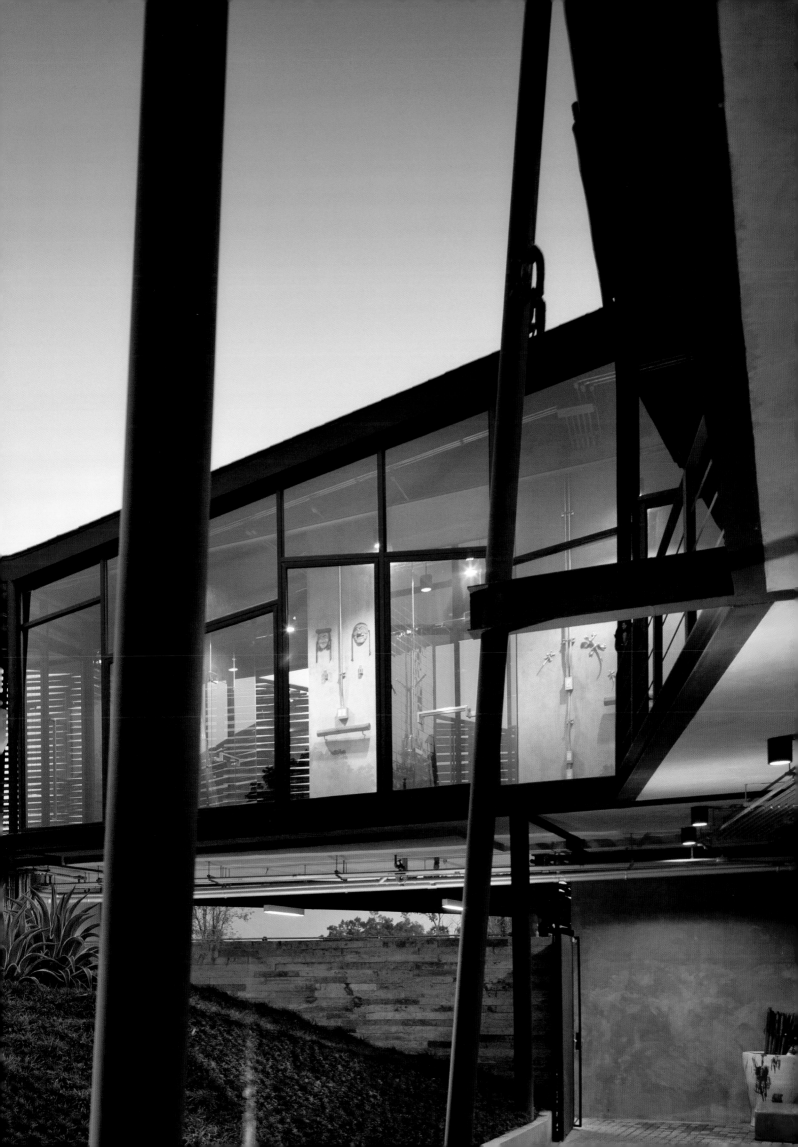

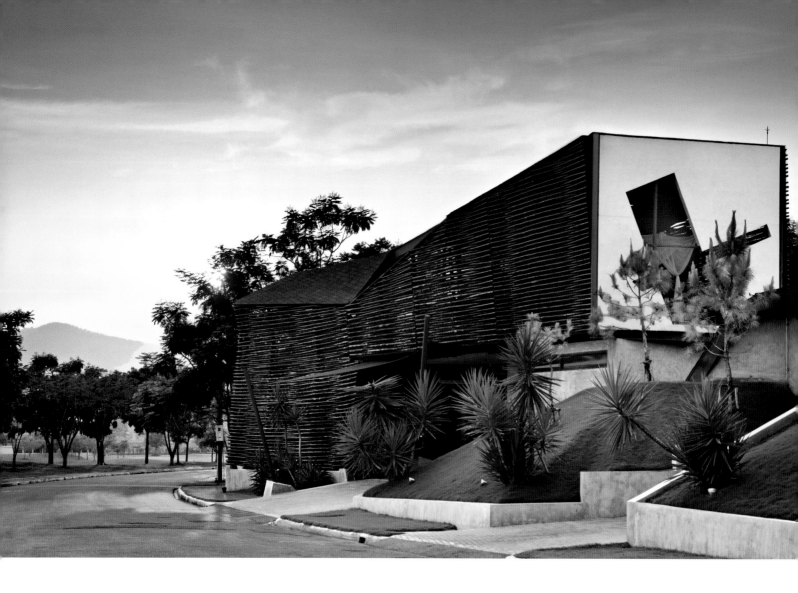

Completed in 2009, Casa de Umbrella is a highly unusual house clad with a plaited bamboo 'skin' that extends, like a huge tent, over a supporting steel structure. The purpose of the woven bamboo is to filter out the sun's direct rays, but it also adds a rare touch of magic and experimental originality. As the house name implies, the design employs the metaphor of a bamboo parasol to shade the living areas.

Located in Sankampaeng province some 42 kilometers to the east of Chiangmai in a broad valley fringed by mountains, the house lies within the Chiangmai Highlands Golf Resort adjacent to the third green. Radab Kanjanavanit, the owner of the house, is a structural engineer and Managing Director of RKV Engineering Consultants. He is a self-confessed golf addict, but a 4x4 vehicle, two powerful Suzuki motorbikes and four mountain bikes in the carport, all superbly maintained, speak of a passion for other outdoor activities; indeed, he is one of

Thailand's foremost yachtsmen, and he regularly features on the leader board of the Phuket King's Cup, Asia's premier yachting event, sailing his trimaran 'Cedar Swan'.

The architect of the two-story house is Somchai Jongsaeng of DECA Atelier, a Bangkok-based designer whose own residence I published in 2001.[1] Somchai worked in close collaboration with the owner who was enthusiastic to experiment with structural and cladding solutions. The supporting structure is playful, with 100-mm-diameter inclined RHS columns beneath the bamboo umbrella while electrical services are surface-mounted in conduit. Various mechanical and electrical devices supplement the natural ventilation to ensure comfortable conditions. These include misting devices and outdoor radiant heating, for nights can be very cold in the highlands.

The open texture of the bamboo umbrella permits the house to breathe. The reception area and kitchen/breakfast area, located on

the ground floor, are naturally ventilated while the living area and the dining area on the upper floor, accessed by an open-riser steel staircase, are both open-sided. There is a sense of living in a huge *sala* with immediate visual and olfactory connection with the natural environment. In the afternoons, an intermittent breeze springs up from the northeast to stir the air and there is a pleasant sound of wind chimes suspended from the eaves. The roof has wide overhangs, yet the openness of the main living areas requires that bamboo chick blinds be lowered when it rains heavily. The bamboo umbrella performs a secondary function of protecting the house occupants from the occasional miss-hit golf ball that soars over the third green.

A steel bridge gives access to the bedroom wing from the living area. The air-conditioned master bedroom, which has an attached open-to-sky bathroom, extends to a sheltered semi-outdoor space with a bed and mosquito net for sleeping under the stars on

Above Located in Chiangmai Highlands Golf Club, the site is a broad valley fringed by mountains.

Pages 160–1 The semi-transparent house appears to float above the landscape.

Above right A large retention pond alongside the house is a water hazard on the golf course.

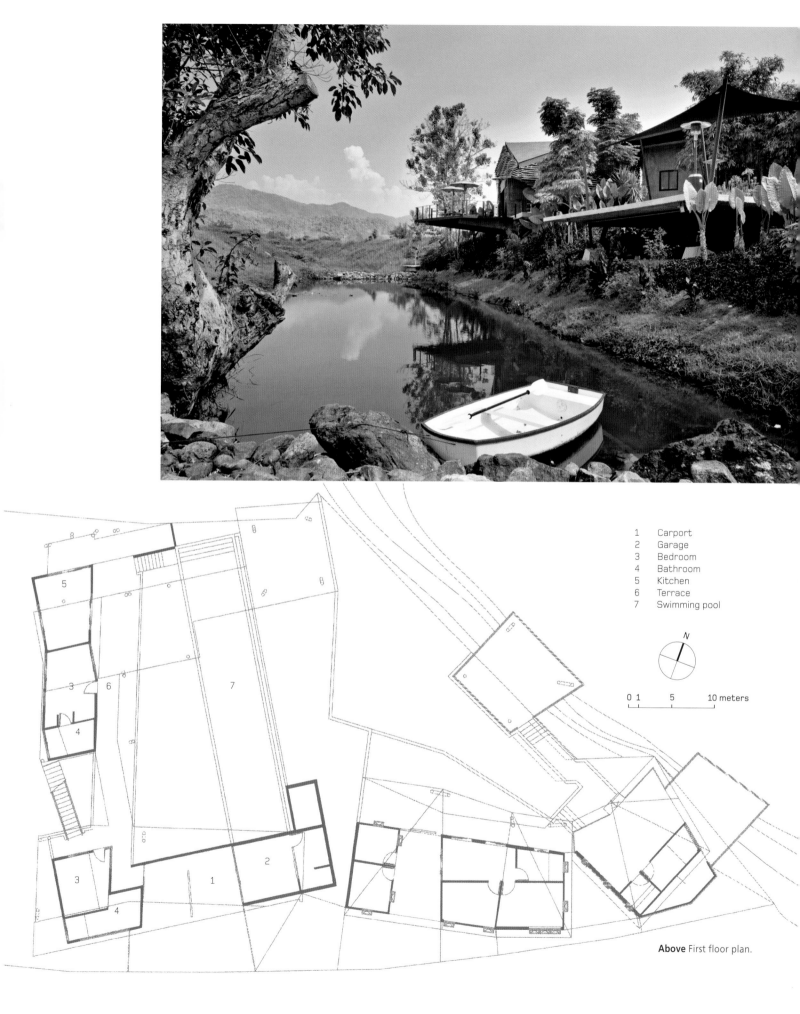

1 Carport
2 Garage
3 Bedroom
4 Bathroom
5 Kitchen
6 Terrace
7 Swimming pool

0 1 5 10 meters

Above First floor plan.

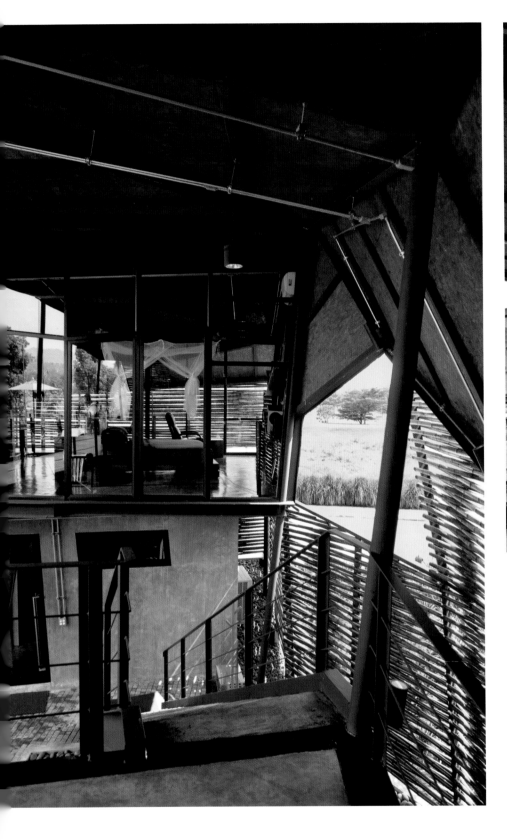

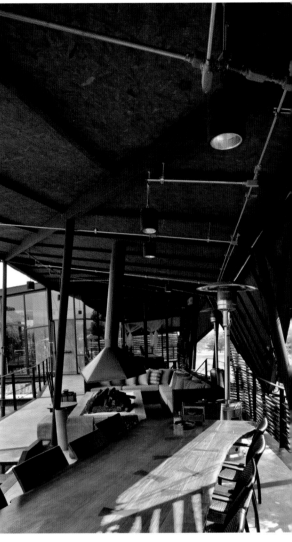

Above left The transparency in the house is evident in the view from the living area to the master bedroom.

Above right The semi-outdoor dining space, with a wide oversailing roof and permeable walls.

cool nights. The bedroom is the most personal space in the house and here there is an opportunity to display contemporary art works. Overall, the house is light and airy, relying on the cool breezes in this mountainous region to refresh the living areas. The transparency of the house becomes increasingly evident at dusk when, from a distance, the organic profile of the roof merges with the skyline of the distant hills. Once the golfers and their motorized carts have departed in the early evening, the house becomes quiet and secluded.

A 25-meter lap pool and outdoor showers contribute to a relaxed, resort-like ambience, and a small gym and massage room overlook a retention pond at the edge of the golf course that assists in cooling the house. A timber deck extends from the living room over the pool.

Materials include thermoplastic tiles on the external roof and walls, plaster/cement rendering on internal walls, polished cement floors and stained chipboard. But the predominant memory is of the unique bamboo cladding, resembling a permeable brown cloak draped over the structure and suspended over the open veranda. The bamboo was specially selected and was recommended by artisans who had worked with the architect on a project in Chiangrai.

The material was placed in water to make it pliable and then rendered with a chemical solution to enhance durability.

Radab Kanjanavanit is the owner of another impressive house, also designed in collaboration with Somchai Jongsaeng, located on a cliff face near the Yacht Marina in Phuket. That house, too, is experimental, incorporating a variety of bridges, elevators and terraces as it steps down the precipitous slope, in the process framing impressive views of the ocean. Some of the structural details, like those of Casa de Umbrella, reflect the owner's expert knowledge of yacht technology.

1 Robert Powell, 'Somchai Jongsaeng House', *The New Asian House*, Select Publishing, Singapore, 2001, pp. 164–7.

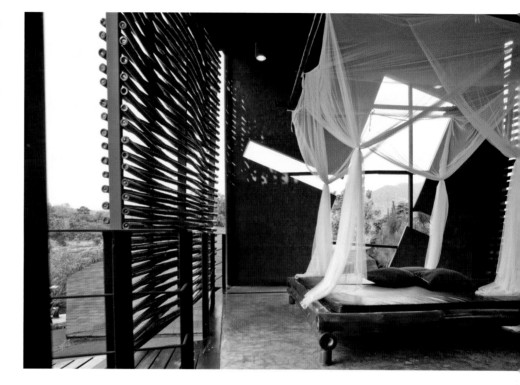

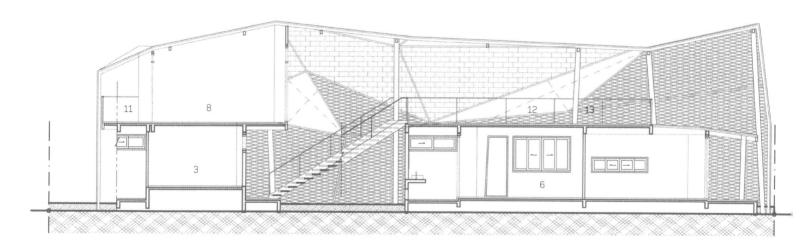

<table>
<tr><td>0 1</td><td>5</td><td>10 meters</td></tr>
</table>

3	Bedroom	11	Balcony
6	Terrace	12	Living area
8	Master bedroom	13	Dining area

Top A sheltered outdoor bed space draped with a mosquito net for sleeping 'beneath the stars'.

Above Section drawing.

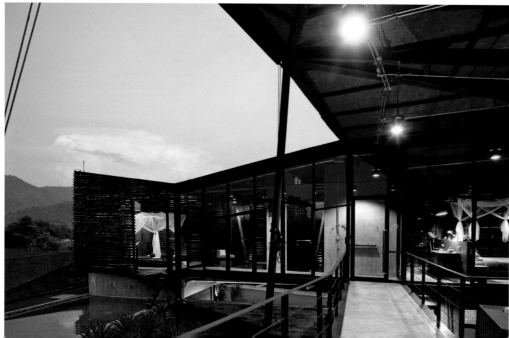

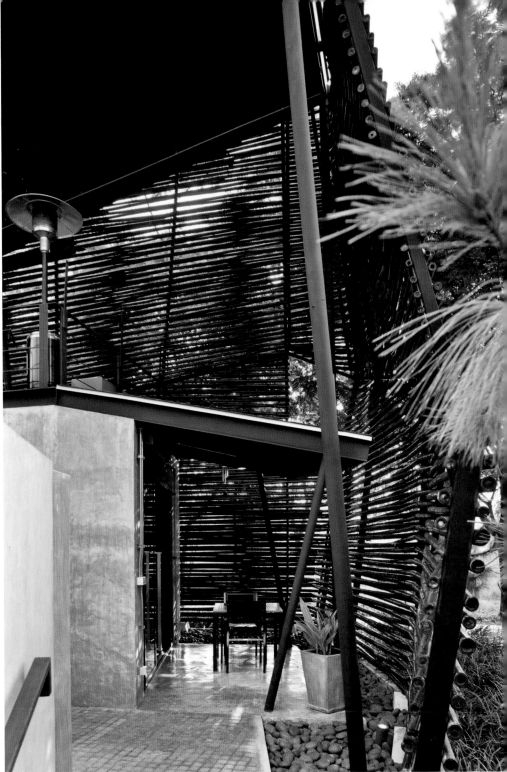

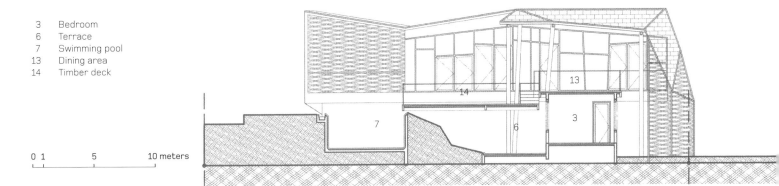

3 Bedroom
6 Terrace
7 Swimming pool
13 Dining area
14 Timber deck

0 1 5 10 meters

Above Section drawing.

Left A steel bridge connects the living area and the more private bedroom.

Above left The air-conditioned master bedroom overlooks the living/dining area.

Top Permeable walls enclose the breakfast area.

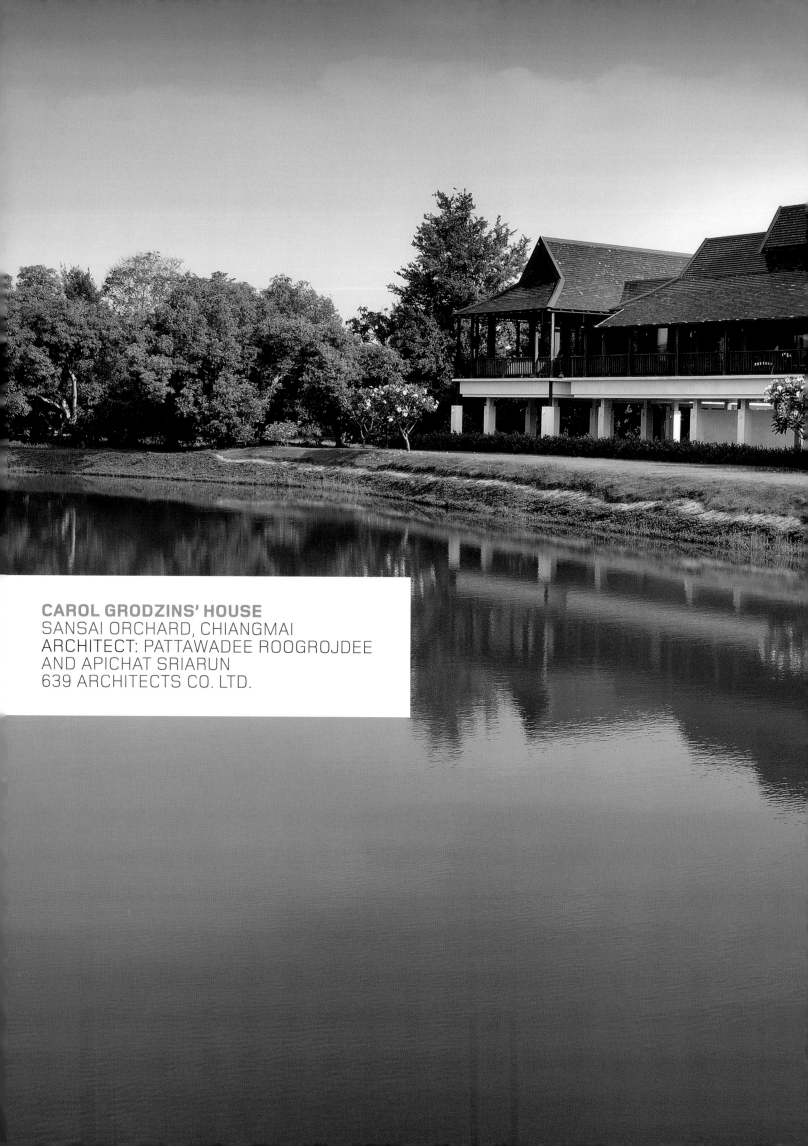

CAROL GRODZINS' HOUSE
SANSAI ORCHARD, CHIANGMAI
ARCHITECT: PATTAWADEE ROOGROJDEE
AND APICHAT SRIARUN
639 ARCHITECTS CO. LTD.

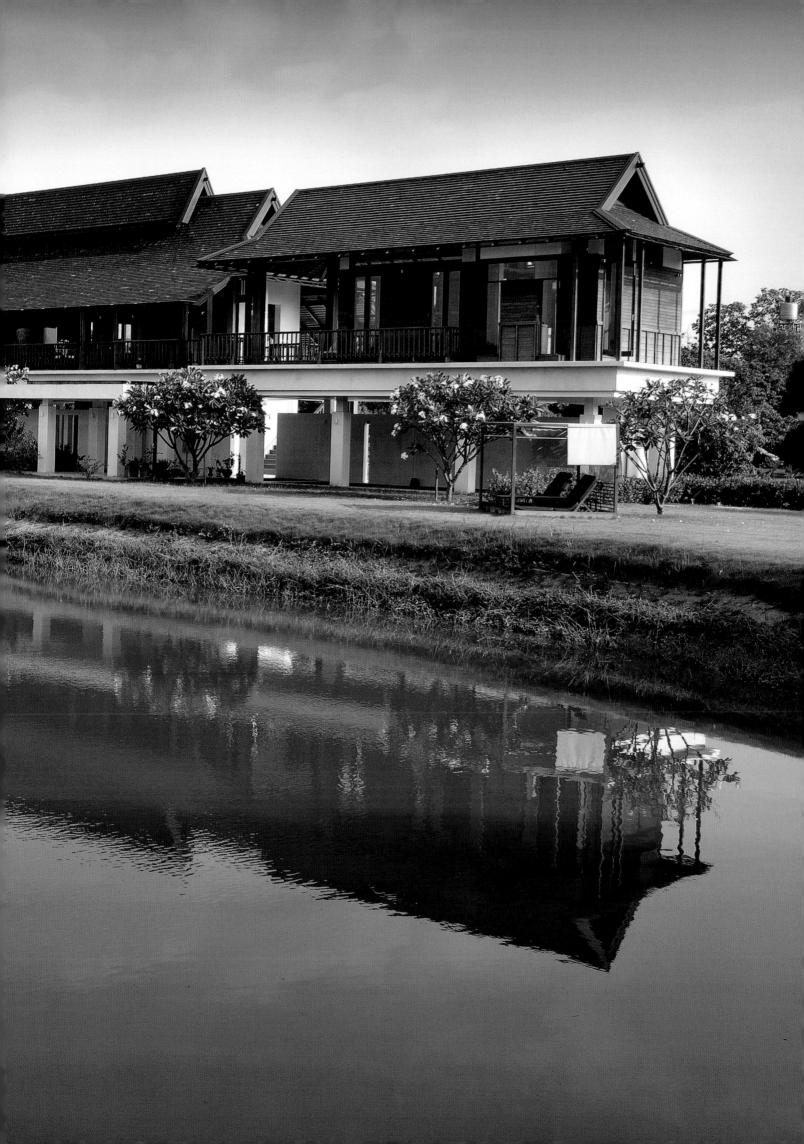

The inspiration for Carol Grodzins' House was a Dayak longhouse in Borneo. In the 1960s, the owner, after completing her undergraduate studies in Russian Language and Literature in the US, decided to join the Peace Corps established by John F. Kennedy. She was posted to Sarawak where she taught in a Dayak school for two years, from 1967 to 1969. In the time she was there, she lived in a Dayak longhouse much like the ones depicted in *Pendian Dirumah Panjai (Life in a Longhouse)* by Hedda Morrison.[1] On her return to the US, Carol abandoned Russian studies and took up nursing, expecting one day to return to Sarawak to help build healthy communities. Soon after, however, she met her husband, a physics professor at Harvard University. They have two grown sons.

A social entrepreneur and activist at heart, Carol worked to change obstetrical practise in Massachusetts toward family-centred birthing, and then addressed what she saw as the number one public health threat in America—nuclear war—by launching the Massachusetts Nuclear Freeze Movement. In 1989, bringing together her commitments to international development, public policy and health reform, she joined the Harvard Institute for International Development and spent the next eleven years there and at Harvard's Kennedy school.

Carol directed the Edward S. Mason Program in Public Policy, whose graduates include Lee Hsien Loong, Prime Minister of Singapore, Sir Donald Tsang Yam-Kuen, Chief Executive and President of the Executive Council of the Government of Hong Kong, and M. R. Chatu Mongol Sonakul, former Governor of the Bank of Thailand. In 2000, Carol left Harvard to become Vice President of Ashoka: Innovators for the Public. Ashoka envisages a world where everyone realizes they have the right, the skills and the capacity to improve society.[2] Now retired and a senior advisor to Ashoka, Carol teaches 'social entrepreneurship' at Chiangmai University.

While living in Massachusetts, Carol became familiar with the modern architecture of Walter Gropius at Lexington and lived in a community designed by the Architects Collaborative, but equally importantly she is a frequent visitor to Sri Lanka where she has experienced the work of Geoffrey Bawa. Upon deciding to build her house in Chiangmai, Carol drew on her earlier experience of the Dayak longhouse. She recalled the wisdom of cross-ventilation, orientation to catch the prevailing breeze, balconies and verandas, and wide overhanging eaves to provide shade, and resolved to draw upon what she terms the 'ancient wisdom'. All of this would have been recognizable to Bawa.

In 2006, the owner saw the site at Sansai, located some 10 km north of Chiangmai. It was part of the development of a former orchard instigated by Suthini Jumsai. She was subsequently introduced to Pattawadee Roogrojdee and Apichat Sriarun of 639 Architects Co. Ltd., who have earned a reputation as designers of modern houses and resorts that draw upon the traditional form of the Northern Thai House. Pattawadee is a graduate of Chulalongkorn University in Bangkok where, in 1995, she obtained a

Above left The house is entered from the southeast through a symbolic gateway.

Below left The timber house is raised upon a strong concrete podium.

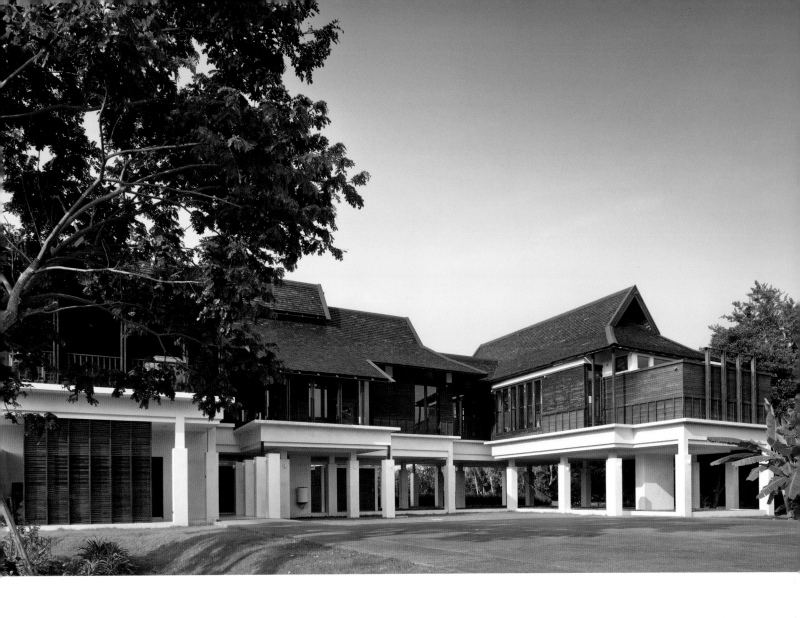

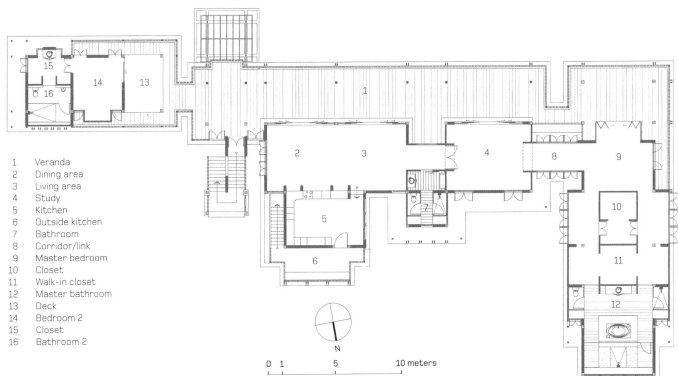

1 Veranda
2 Dining area
3 Living area
4 Study
5 Kitchen
6 Outside kitchen
7 Bathroom
8 Corridor/link
9 Master bedroom
10 Closet
11 Walk-in closet
12 Master bathroom
13 Deck
14 Bedroom 2
15 Closet
16 Bathroom 2

0 1 5 10 meters

N

Pages 168–9 The house form was influenced by the owner's experience of living in a Dayak longhouse.

Top The design is in what is termed the 'Modern Lanna Style'. **Above** Second floor plan.

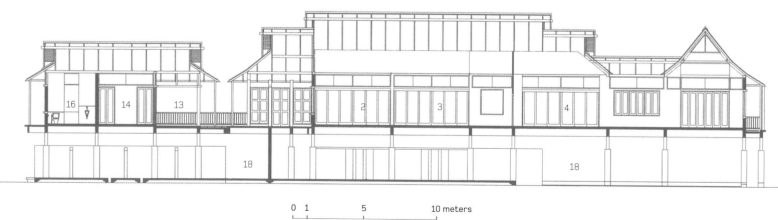

Top Looking east toward the pedestrian entrance.

Above Section drawing.

2	Dining area
3	Living area
4	Study
13	Deck
14	Bedroom 2
16	Bathroom 2
18	Walkway

0 1 5 10 meters

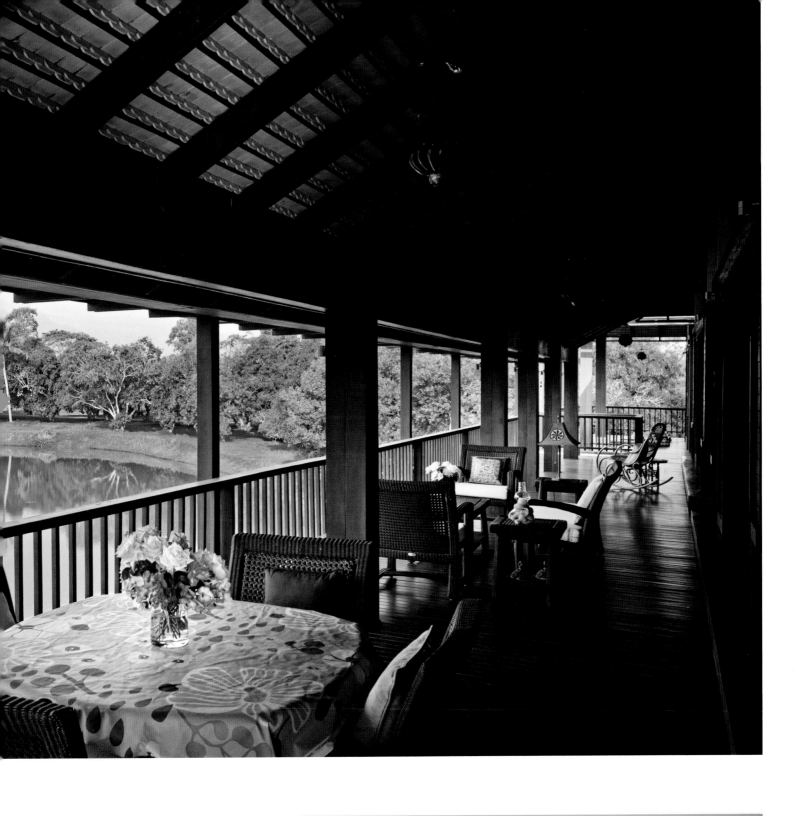

Above A broad timber veranda provides a space for relaxation in a semi-outdoor space.

Right The house is raised on concrete piloti to avoid flooding and snakes.

Masters degree in Building Technology that focussed on energy conservation. She is familiar with the work of the Malaysian architect Ken Yeang and studied Yeang's Menara Mesiniaga project when writing her M.Arch. thesis. She currently teaches energy conservation in building design and day-lighting design at Ratchamangala University of Technology Lanna in Chiangmai.

Apichat Sriarun is a graduate of Silpakorn University, who over forty years in practise has developed an expertise in Northern Thai architecture. He is best known as one of the designers of the renowned Four Seasons Resort in Chiangmai. He also teaches con-ceptual design and site planning at the same university as Pattawadee.

Carol Grodzins' House is raised on tall concrete piloti to avoid flooding and snakes, and has a linear plan form entered from the southeast through a symbolic gateway and thence, alongside a pavilion that houses a guest bedroom, to an external 'dog-leg' staircase that ascends to a broad linear south-facing veranda. The timber deck gives access to three more pavilions, the first housing the living room, dining room and kitchen with a service stair; the second accommodating a study, and the third the principal bedroom. All the principal rooms face a lake that cools the prevailing southwest wind. The house, detailed in 'Modern Lanna Style' is, to quote the owner, 'an antidote to modernism'. The house is undoubtedly a success in terms of its sustainability. It is largely naturally ventilated and the owner

has planted banana and fruit trees while fish are available from the lake.

Materials include white cement that should not require painting, traditional roof tiles on a Thai-style roof pitched at 40 degrees that helps create a stratification effect, recycled timber floors internally and redwood decking externally. The configuration of the house, which is one room wide, enables comfortable conditions to be achieved with natural ventilation. It is a remarkable residence— the product of a close working relationship between the owner and the architects.

1 Hedda Morrison *Pendian Dirumah Panjai (Life in a Longhouse)*, Borneo Literature Bureau, Kuching, Sarawak, 1962.

2 Carol Grodzins, in correspondence with the author, 12 August 2011.

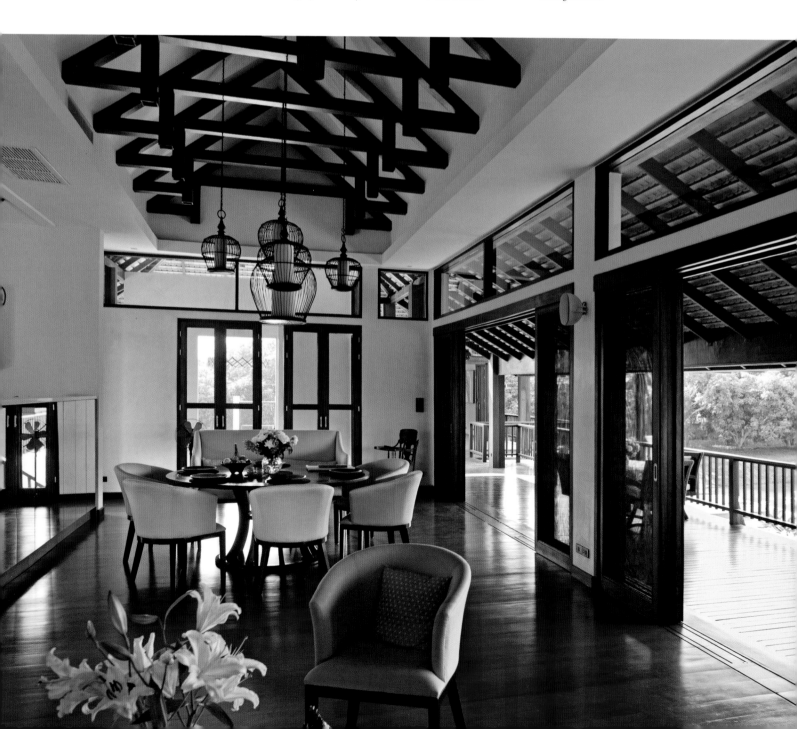

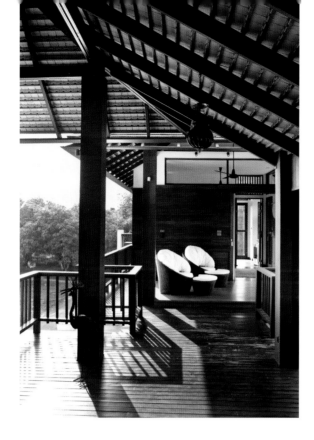

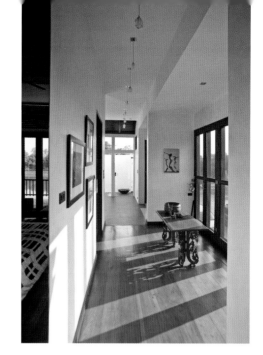

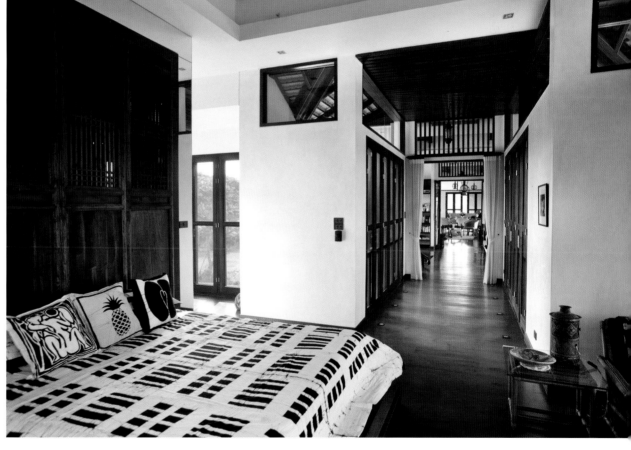

Left The spacious dining area is naturally ventilated but can be air-conditioned.

Top left All the main rooms have views toward the lake.

Top right Throughout the house there is is a strong sense of materiality.

Above A central axis connects all the principal rooms.

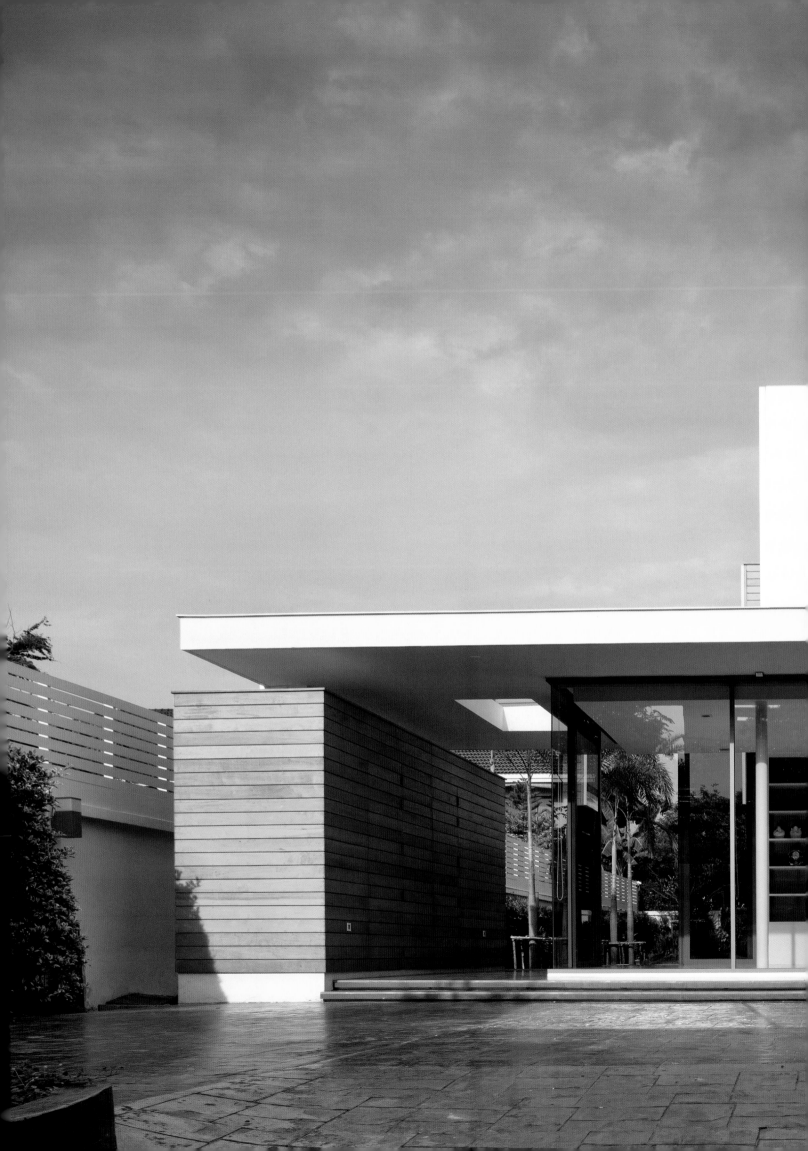

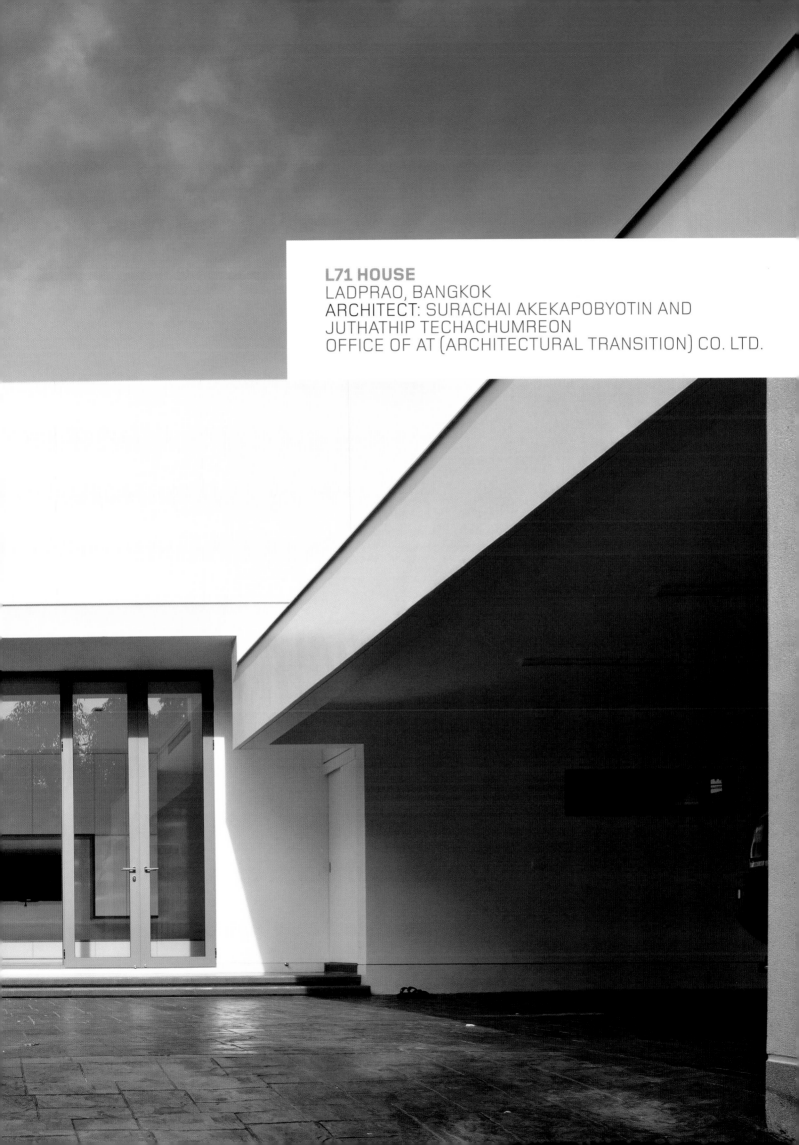

L71 HOUSE
LADPRAO, BANGKOK
ARCHITECT: SURACHAI AKEKAPOBYOTIN AND
JUTHATHIP TECHACHUMREON
OFFICE OF AT (ARCHITECTURAL TRANSITION) CO. LTD.

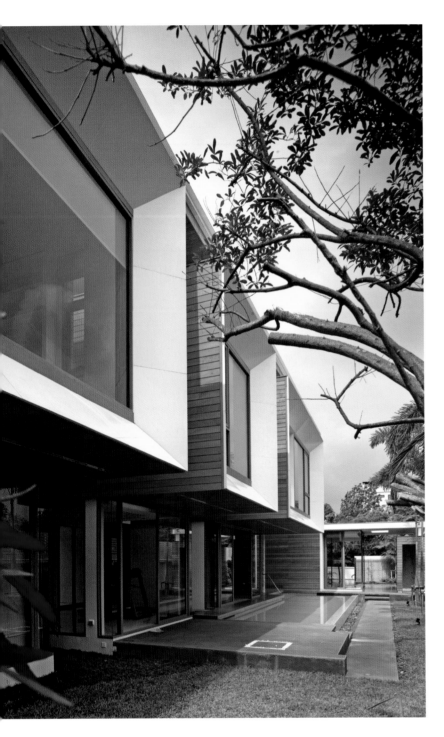

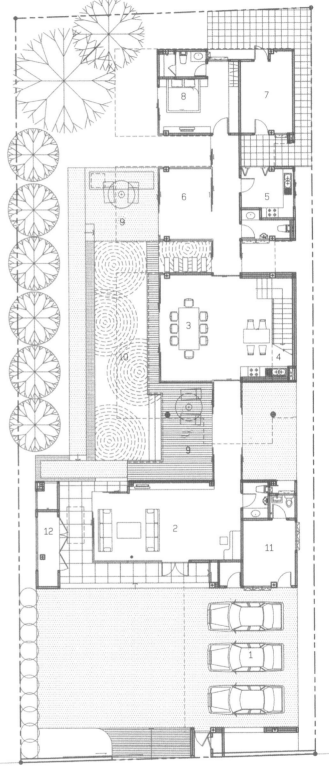

1 Carport
2 Living room
3 Dining room
4 Pantry
5 Kitchen
6 Exercise area
7 Laundry
8 Bedroom
9 Terrace
10 Swimming pool
11 Maid's room
12 Store

0 1 5 10 meters

N

Above The house is a linear configuration of interlocking spaces. **Right** First floor plan.

Pages 176–7 The entrance court also serves as an outdoor entertainment space.

The L71 House is a clearly articulated composition in a modern architectural language that responds logically to climatic imperatives. The designers of the house, which was completed in 2010, are Surachai Akekapobyotin and Juthathip Techachumreon of The Office of Architectural Transition (Office AT Co. Ltd.) Both partners are graduates of King Mongkut Institute of Technology Ladkrabang in Bangkok. Upon graduating both worked for large architectural practises in the capital, Surachai with Plan Associates and Juthathip with A&A Architects, before undertaking their Masters degrees at the University at Michigan, Ann Arbor, USA.

On completion of their studies, they both worked in New York for three years. While there, they won a competition organized by the Van Allen Institute for the design of a public transition space from subway to sky train. Returning to Thailand, they set up practise and shortly after won another competition, this time for the Bangkok University Art Gallery. The gallery is complete and has subsequently won an award from the Association of Siam Architects under Royal Patronage. They continued to garner awards with another competition winning entry for the National Discovery Museum Institute exhibition and auditorium. Their practice now employs six staff. The two architects are part of a young architects group in Bangkok that meets informally to discuss issues relating to architecture.

The L71 House occupies a long, narrow site perpendicular to the public road. The site configuration and context drive the plan form, resulting in a linear east/west axis. All the principal rooms are to the north of the axis, overlooking a swimming pool and rectangular garden, while the subsidiary spaces are to the south of the axis. There is a clear allocation of 'served' and 'servant' spaces as defined by the modern master Louis Kahn. The orientation and the cantilevered upper floor also maximize shade in the principal rooms.

The brief of the owners, Tosaporn and Samorn Wongweratom, called for the separation of 'public' and 'private' spaces.

Right All the principal rooms face north toward the pool and garden.

The various functions of reception, living and dining are consequently rationally planned in a linear configuration of interlocking spaces, and external landscape is 'inserted' into the spatial planning. Doors and windows open in both long elevations and, consequently, there is excellent cross-ventilation. The house owners have occasional parties and thus the public areas are located close to the parking at the entrance to the house, while private areas such as the dining room are located at the rear. The living room was extended across the site to create a private space for the swimming pool.

The materials used throughout the house are a delightful combination of white marble, polished limestone and pale wood, with a particularly striking central staircase in limestone highlighted by daylight that penetrates from a skylight above the stairwell. Skylights are used elsewhere in the house to emphasize specific features, including a family altar. The restraint of the design and the manipulation of daylight are reminiscent of some contemporary Japanese architecture, and the partners admit to the influence of the innovative work of Toyo Ito, Kengo Kuma and Kazuyo Sejima.

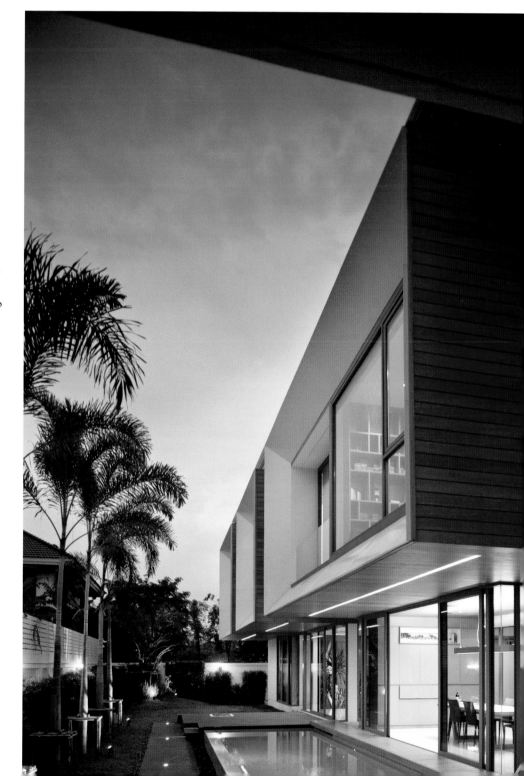

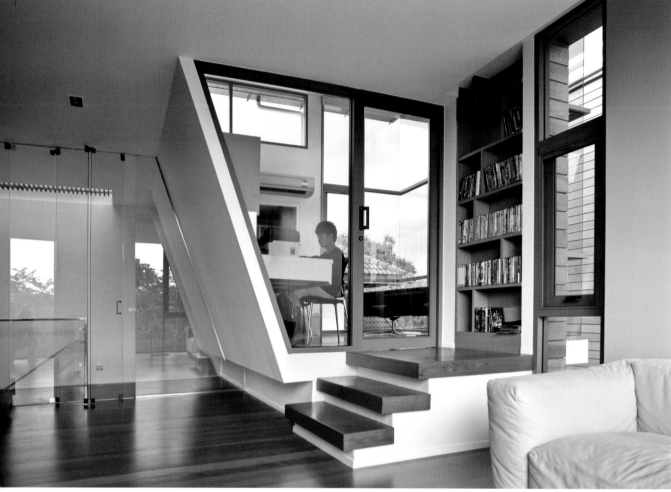

1 Carport
2 Living room
3 Dining room
5 Kitchen
7 Laundry
15 Buddha room
17 Family room

0 1 5 10 meters

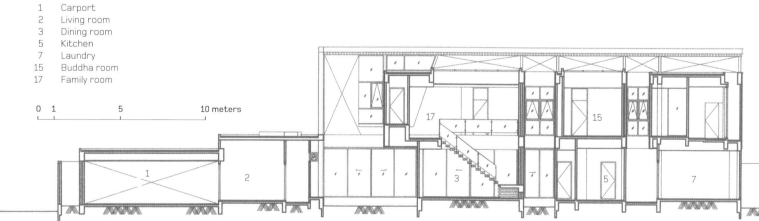

Top A library and
computer 'pod' are
slightly elevated above
the second floor level.

Above Section drawing.

Above right The
kitchen and dining
room are at the heart
of the plan.

Right The dining room
opens to the pool deck.

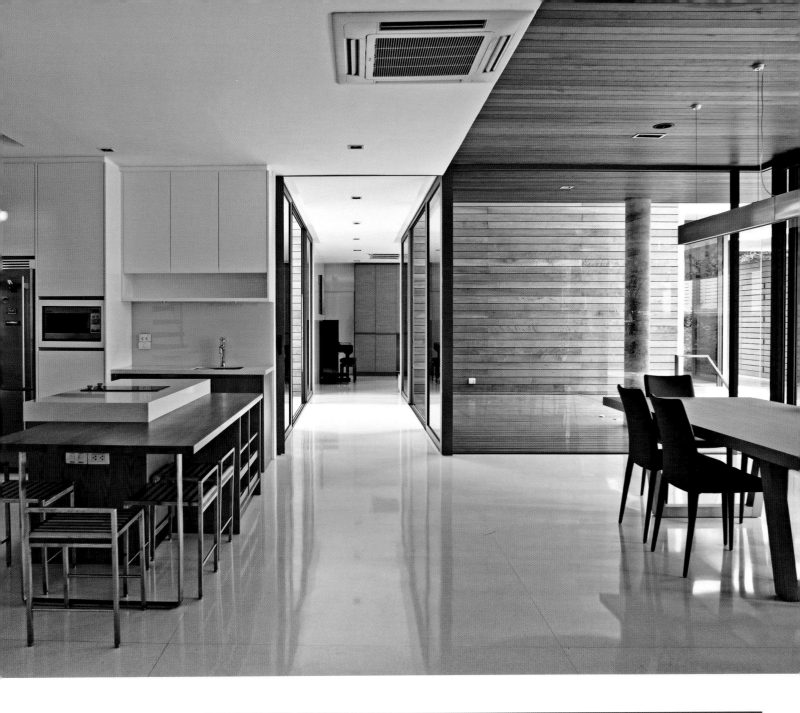

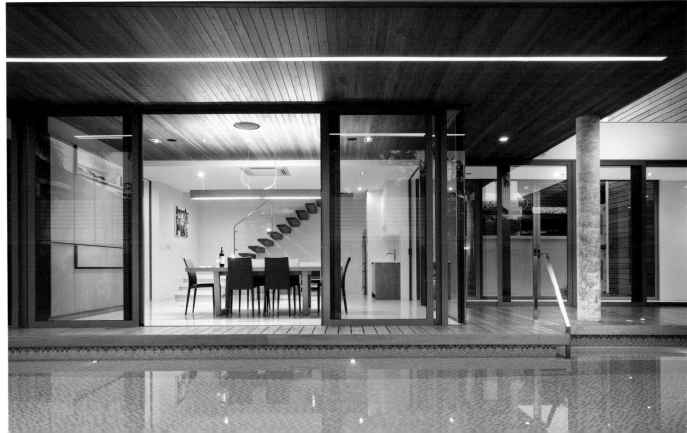

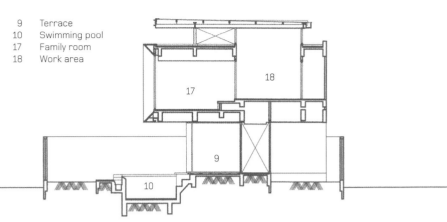

9 Terrace
10 Swimming pool
17 Family room
18 Work area

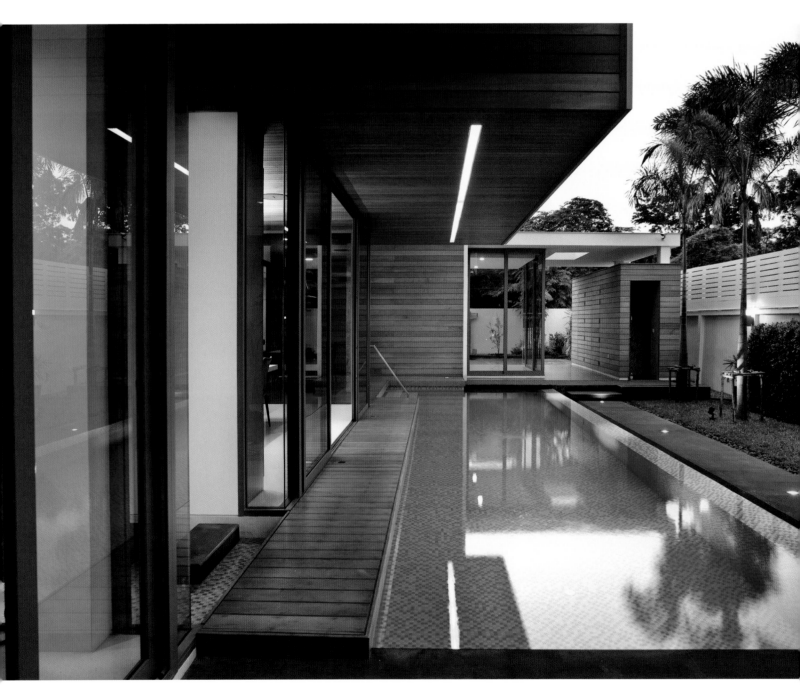

Top left A child's
bedroom.
Top right Section
drawing.

Above The cantilevered
upper floor shades the
first floor windows.

Above Vertical 'slots' in the built form induce cross-ventilation.

ACHARAPAN HOUSE
NAKORN CHAISRI, NAKORN PRATHOM
ARCHITECT: BOONLERT HEMVIJITRAPHAN
BOON DESIGN

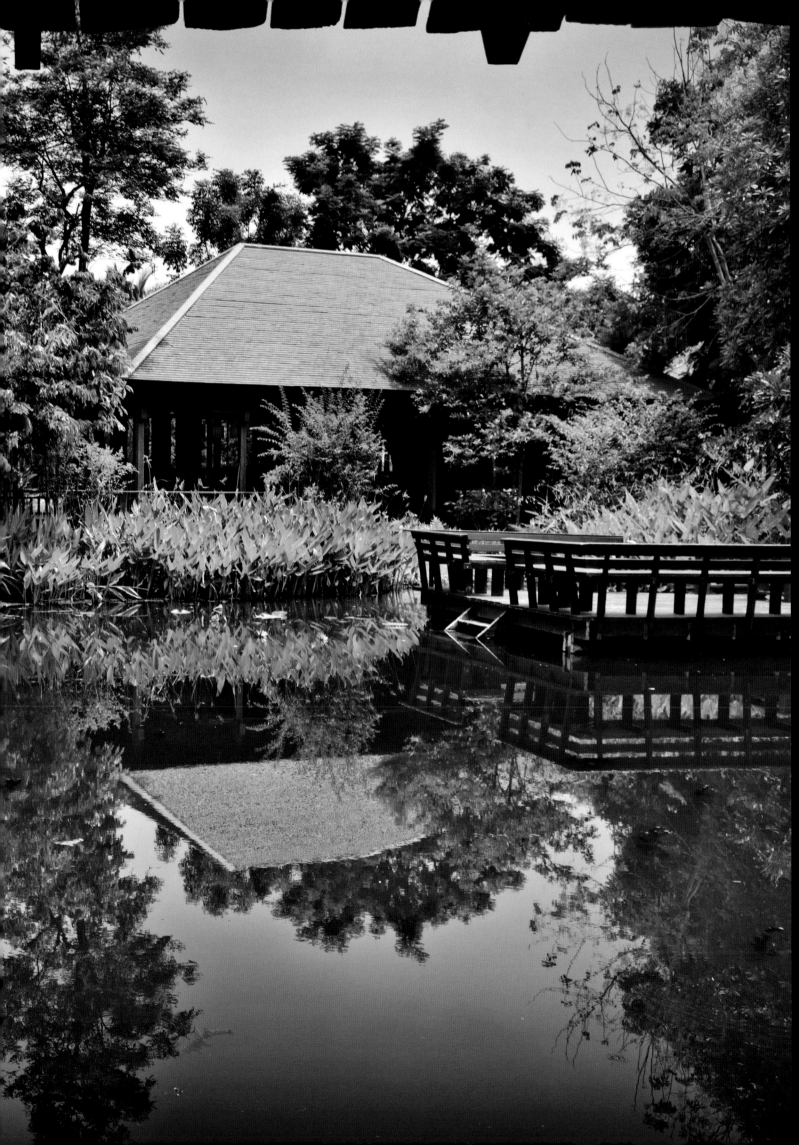

1 Entrance
2 Veranda
3 Living
4 Dining
5 Bedroom
6 Bathroom
7 Closet

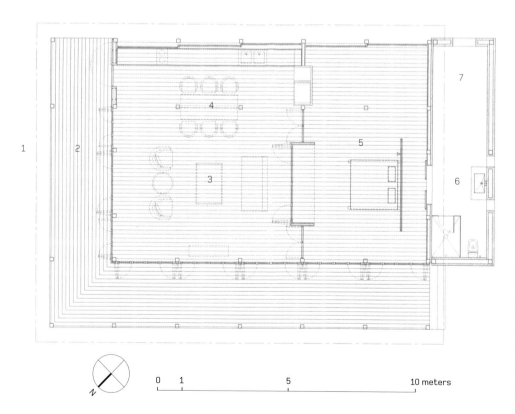

The Acharapan House is located some 60 km west of Bangkok in the Baan Suan Kwan Estate—a tranquil, bucolic landscape of paddy fields. The house is also referred to as the Pa Ji (Aunty Ji) House after its owner, Acharapan Paiboonsuwan, a popular Thai TV personality and veteran stage actress. The secluded site, located alongside a large pond flanked on two sides by drainage ditches, has been protected by the construction of berms on three sides to prevent flooding. The buildings are also elevated.

The residence consists of two pavilions with simple hipped roofs. One incorporates a dining/living space, a principal bedroom and an *en suite* bathroom and toilet. The other serves as a guest pavilion. There is rich materiality in the teak-framed pavilions, both of which have high timber-lined ceilings and are roofed in traditional clay tiles without gutters. The floors, too, are polished teak. The house is orientated to benefit from the southwest and northeast breezes, while trees shade the external walls.

It is an extraordinarily sensitive design that responds well to climate and context. The house has walls that can be opened up entirely to the broad, shaded verandah, and the 'in-between' space that is the essence of all good houses in the tropics is thoroughly exploited. The owner craves silence when she arrives here, and surrounded by rice paddy she finds it, for the surrounding gardens, designed by Monthon Jiropas, are serene and tranquil.

The architect, Boonlert Hemvijitraphan of Boon Design, explains his design: 'I appreciate buildings that are humble, so that when you enter you feel at peace. It is also important to experience nature—the wind and the rain.' His philosophy is simple: 'Do not fight with nature.'[1]

The house replaces an older dwelling on the site that was connected by a timber walkway to a traditional Thai pavilion built on stilts which is used as a kitchen and servants' quarters. Pa Ji had consulted four other architects, but eventually settled on Boonlert who advised that she demolish the main house and start anew while retaining the service building. The architect designed the house to reflect the lifestyle of Pa Ji and it is pared down to the essentials. She has no desire to collect paintings or souvenirs. 'I want to live in a tidy and clean house. I require only necessary furniture like a bed, bench and closet. I don't like a messy house full of unnecessary and unused things.'[2]

The result is a traditional form but there are some elements of modernity—the mosquito net is motorized and concealed, and the HÄFELE television retracts into a timber box. The elegant wooden house is comparable to a large *sala* in a garden. The walls are essentially open to the elements though protected from sun and rain.

0 1 5 10 meters

Top Section drawing.
Above First floor plan main pavilion.

Pages 184–5 The house is located alongside a large pond some 60 km west of Bangkok.

Opposite The guest pavilion is located to the rear of the main residence.

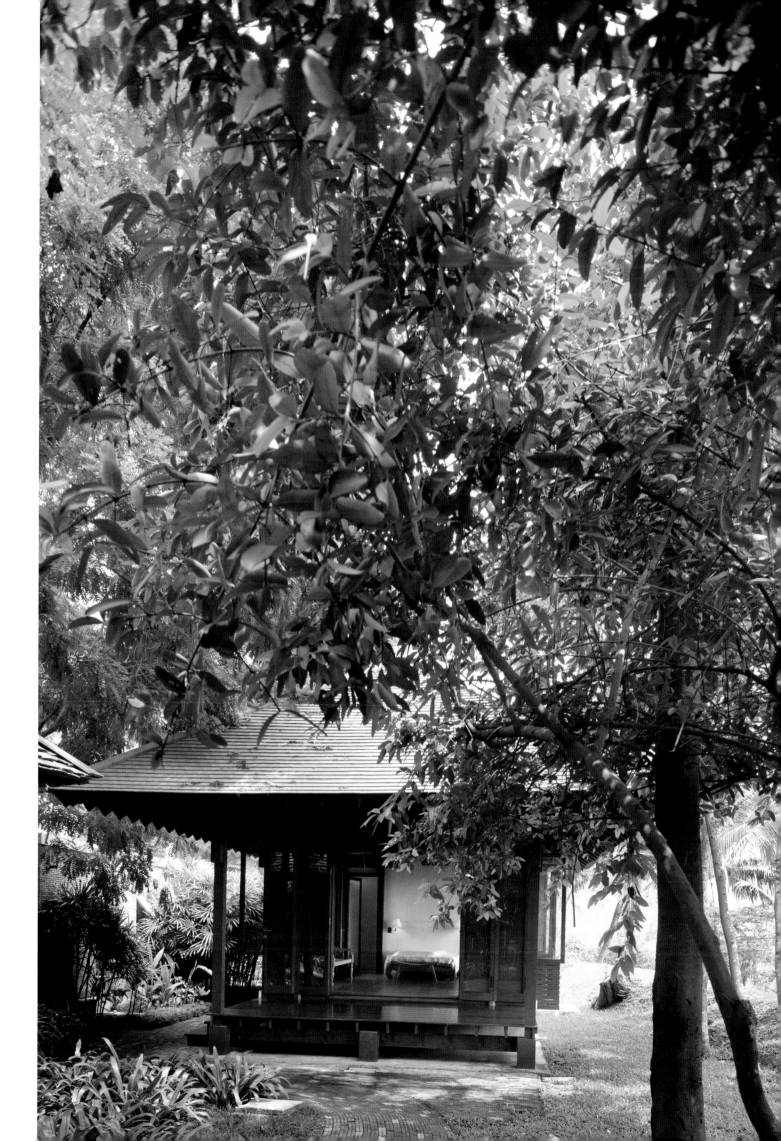

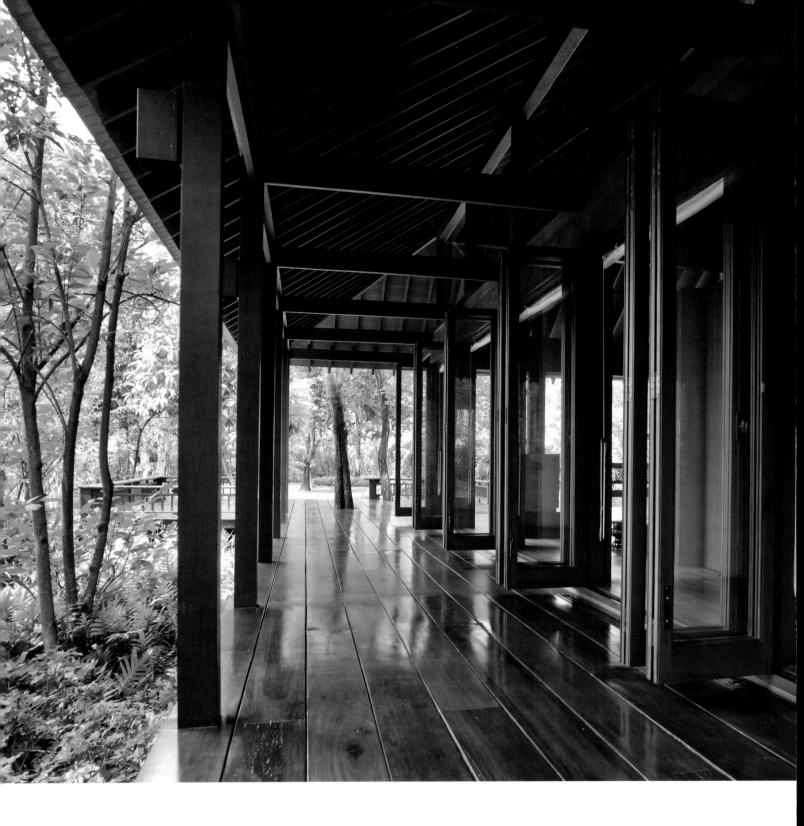

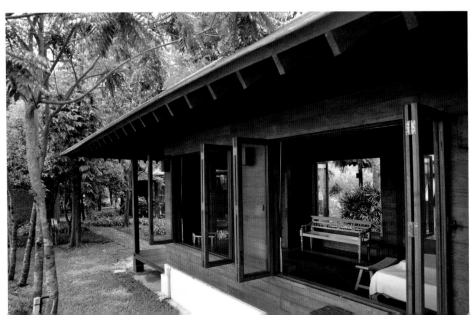

Left Wide eaves and a raised floor are a wise response to climate.

Above A broad teak veranda runs along the flank of the main pavilion.

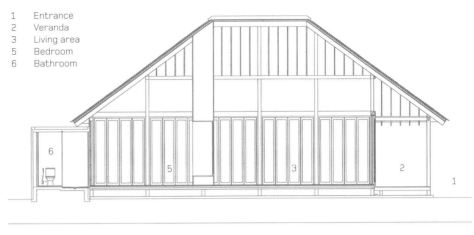

1 Entrance
2 Veranda
3 Living area
5 Bedroom
6 Bathroom

0 1 5 10 meters

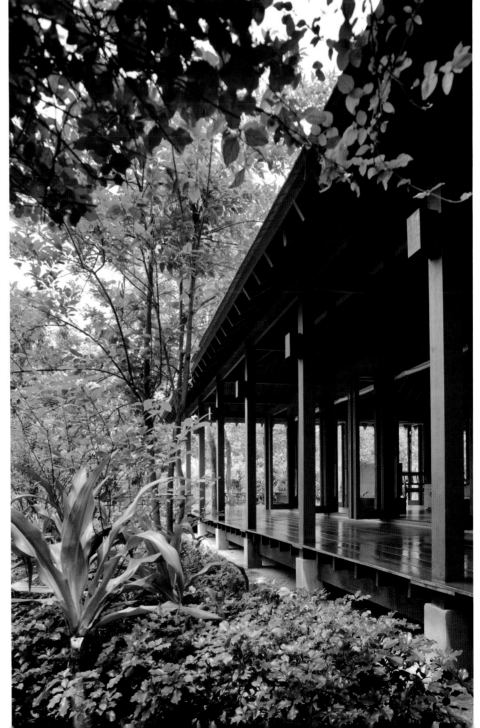

Above right Section drawing.

Right The walls of the house are essentially open to the elements and the house benefits from excellent cross-ventilation.

When the owner arrives at the house, she is happy to live a simple life amidst natural surroundings. 'When I have to work I stay in my house in Bangkok,' she remarks. 'But whenever I am free from all burdens, I will head to my second home, my favorite place, to relax my body and soul.'[3]

Boonlert talks about other architects' work that he admires. 'I love Frank Gehry's architecture—the first of his buildings that I experienced was Loyola Law School in California (1978). It is very clever and reveals the complex program. I would never say no to complexity but I like things to be simple.' He continues: 'I once attended a lecture by Peter Zumthor at the AA in London. He talked about the Therme Vals and what impressed me most was his emphasis on sensory aspects of architecture.' Boonlert reflects that 'two aspects of life that will be expensive in the future are nature and culture.'[4]

In 2008, *Baan Lae Suan* magazine voted Pa Ji's house one of the ten most beautiful homes in Thailand.

1 Pirak Anurakawachon, 'Boon Studio', *art4d*, No. 179, Bangkok, March 2011, p. 35.

2 'When a House is More Than a Home', Estates Report, *Bangkok Post*.
 http://www.estatesreport.com/a34938

3 Ibid.

4 In conversation with the author, 3 April 2011.

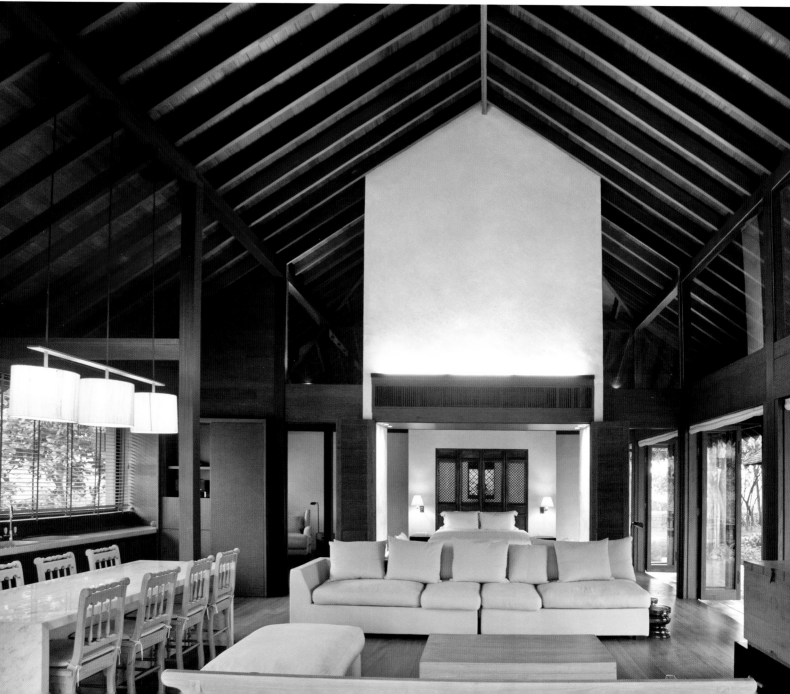

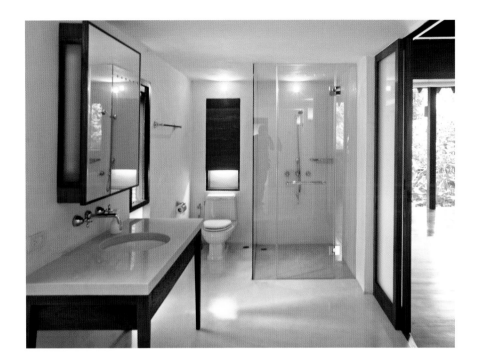

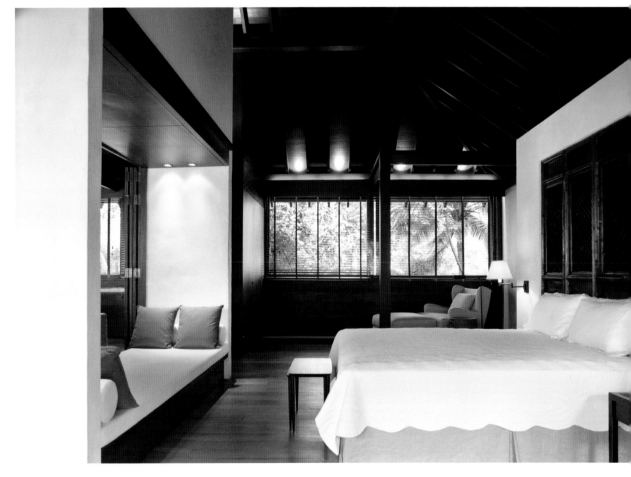

Above left A tactile
brick detail.
Left The high-ceilinged
living and dining space
is utterly delightful.

Top The elegant yet
minimal bathroom.
Above The simple
bedroom is stripped
to the essentials.

KOMKRIT HOUSE
BANGKOK
ARCHITECT: BOONLERT HEMVIJITRAPHAN
BOON DESIGN

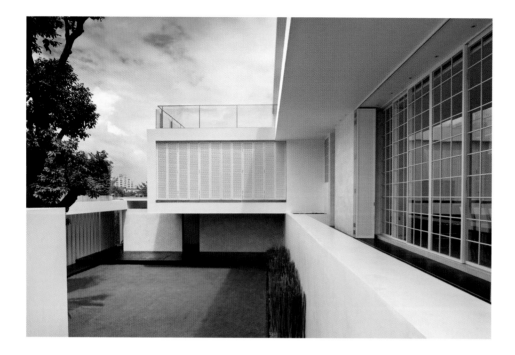

The Komkrit House is a precisely articulated cubist composition that embodies Japanese and Western influences. The 'cool' modern residence is located in an expensive gated settlement off Pattanakarn Road, Bangkok.

The owners of the house, lawyers Komkrit Kietduriyakul and Chaveewan Likhitwattana-chai are both graduates of USA universities—Harvard, Boston and Cornell—and are now partners in the law firm of Baker and McKenzie that was founded in Chicago in 1949. In their work, the couple have an international orientation, but their house is traditional in the sense that it is a three-generation residence. In addition to the owners and their daughter, the house is home to a sister, who lives in a self-contained apartment on the lower floor of the main house, and a retired parent, formerly an engineer with a Japanese automotive firm.

Surrounded by a high white wall, the house occupies two plots in the gated Noble Estate and is entered via a vehicular court in the southeast corner of the site. The sliding entrance gate is flanked by a white cherry blossom tree. A sharp left turn through a narrow gap opens out to a tranquil turfed courtyard surrounded by white walls that hosts a tall tree and a reed bed. Directly ahead to the west is the ground floor

accommodation for the parent and an entrance lobby with stairs leading to the upper floor that contains the principal rooms. The dining space looks east toward a swimming pool. From the courtyard, a 180-degree turn to the right leads to a broad flight of external stairs that ascends to the pool deck and visitors' accommodation in a poolside *sala*.

The house is intended to be a minimalist, neutral background to family life. The predominant color is white, in the form of smooth Turkish marble. The Japanese influence is most evident in the design of fenestration and internal sliding screens. Interior designer Barbara Barry carries through the meticulous detailing of the architecture to the design of the furniture and a system of cabinets. The powder room is palatial, with an impressively high ceiling.

The architect of the stunning modern house is Boonlert Hemvijitraphan, the principal of Boon Design. Explaining the very different architectural language of the Komkrit House when compared with others he has designed, such as the Aurapin House (page 16) and the Acharapan House (page 184), Hemvijitraphan emphasizes, 'This is not my house. It is my client's and I design each house for the owner, not for myself.'

Above and opposite At the heart of the house is a tranquil turfed courtyard. **Opposite below** Section drawing.

Pages 192–3 The house is a precise cubist composition surrounded by a high white wall.

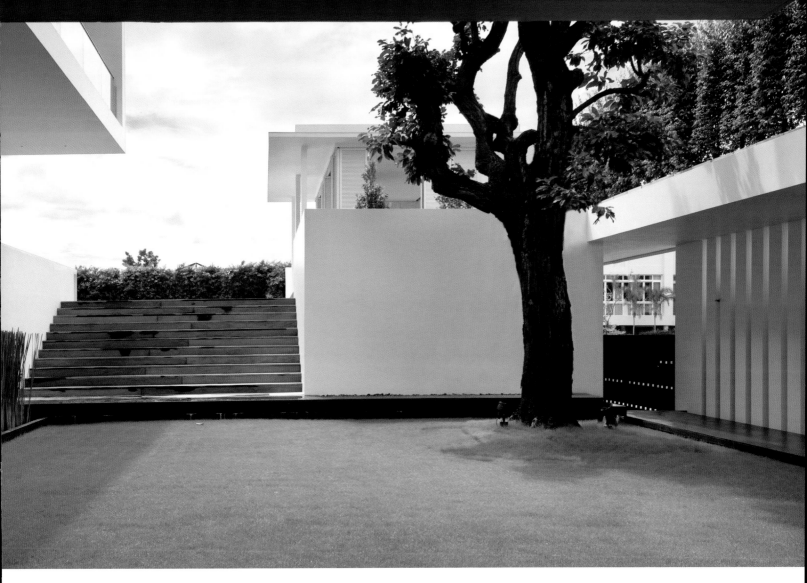

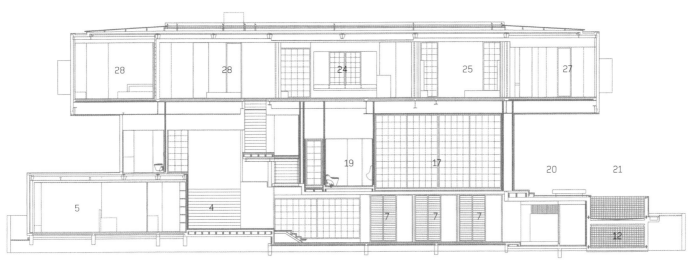

4	Foyer	20	Terrace
5	Living room	21	Swimming pool
7	Maid's room	24	Family room
12	Water tank	25	Master bedroom
17	Dining room	27	Walk-in closet
19	Powder room	28	Bedroom

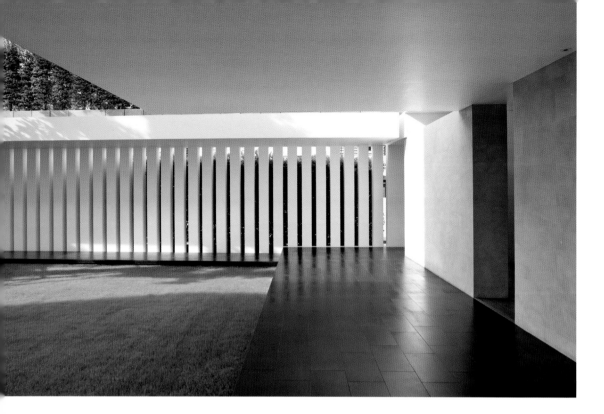

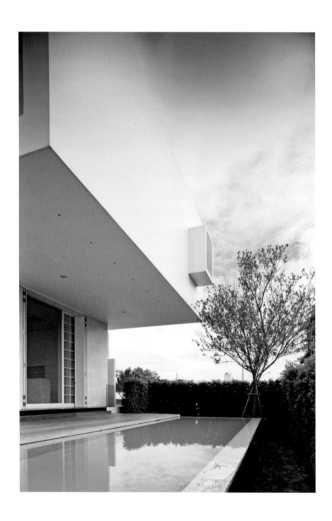

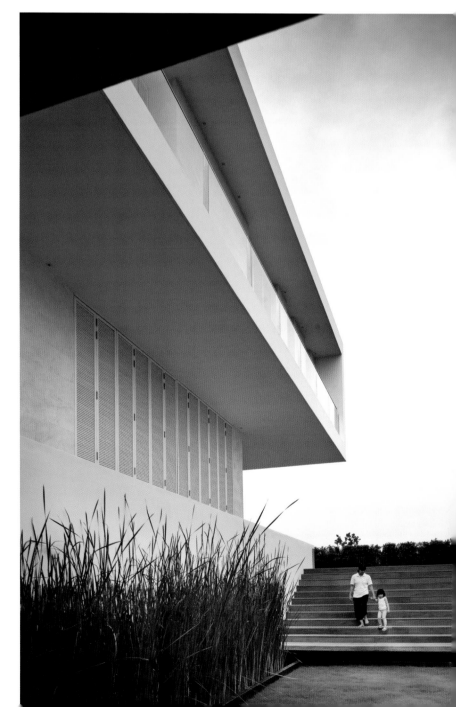

Top A timber deck leads from the carport to the entrance door.
Above The living and dining rooms open to the pool deck.

Right A dramatic flight of steps leads from the turfed courtyard to the pool deck.

Left above and below
The sequence of entry
to the house from the
gate via the courtyard.

Above A grand
staircase leads from
the foyer to the second
floor reception area.

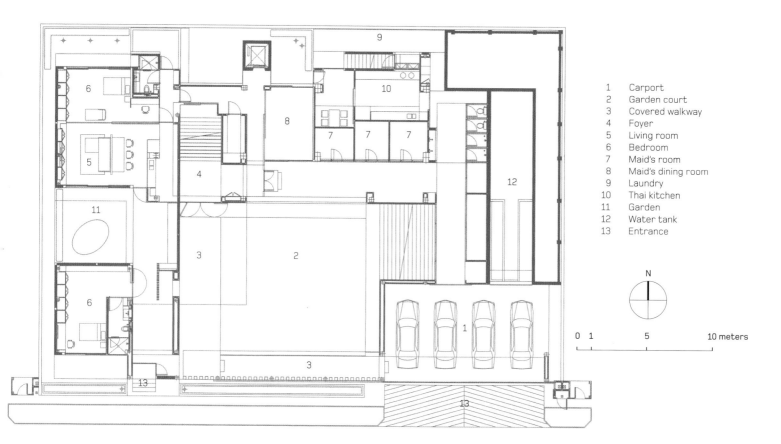

1 Carport
2 Garden court
3 Covered walkway
4 Foyer
5 Living room
6 Bedroom
7 Maid's room
8 Maid's dining room
9 Laundry
10 Thai kitchen
11 Garden
12 Water tank
13 Entrance

0 1 5 10 meters

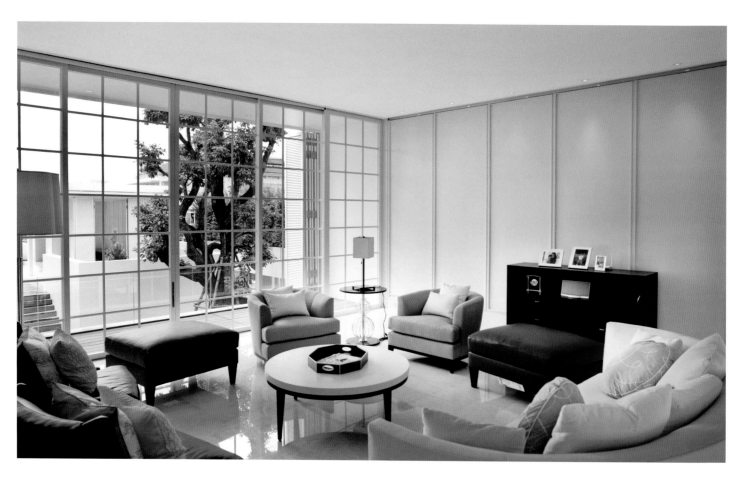

Top First floor plan.

Above The living room overlooks the turfed entrance courtyard.

Top The dining room has an aura of understated sophistication.

Above left and right The master bedroom suite.

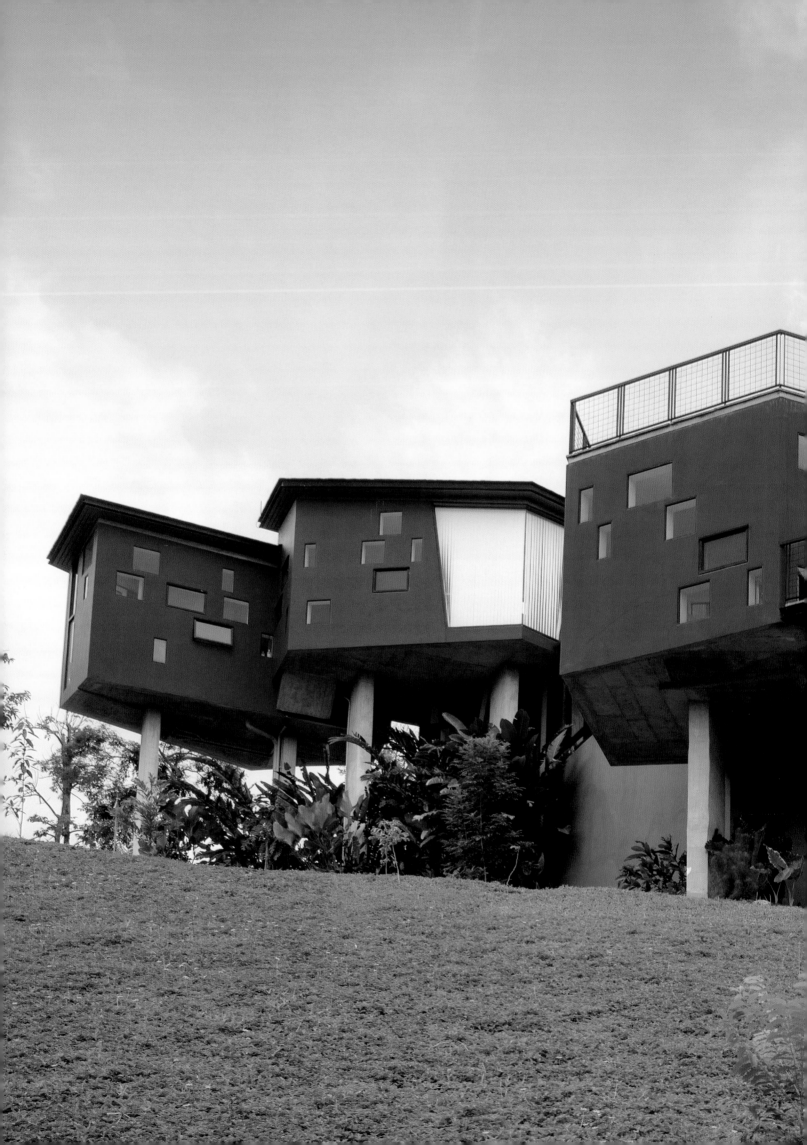

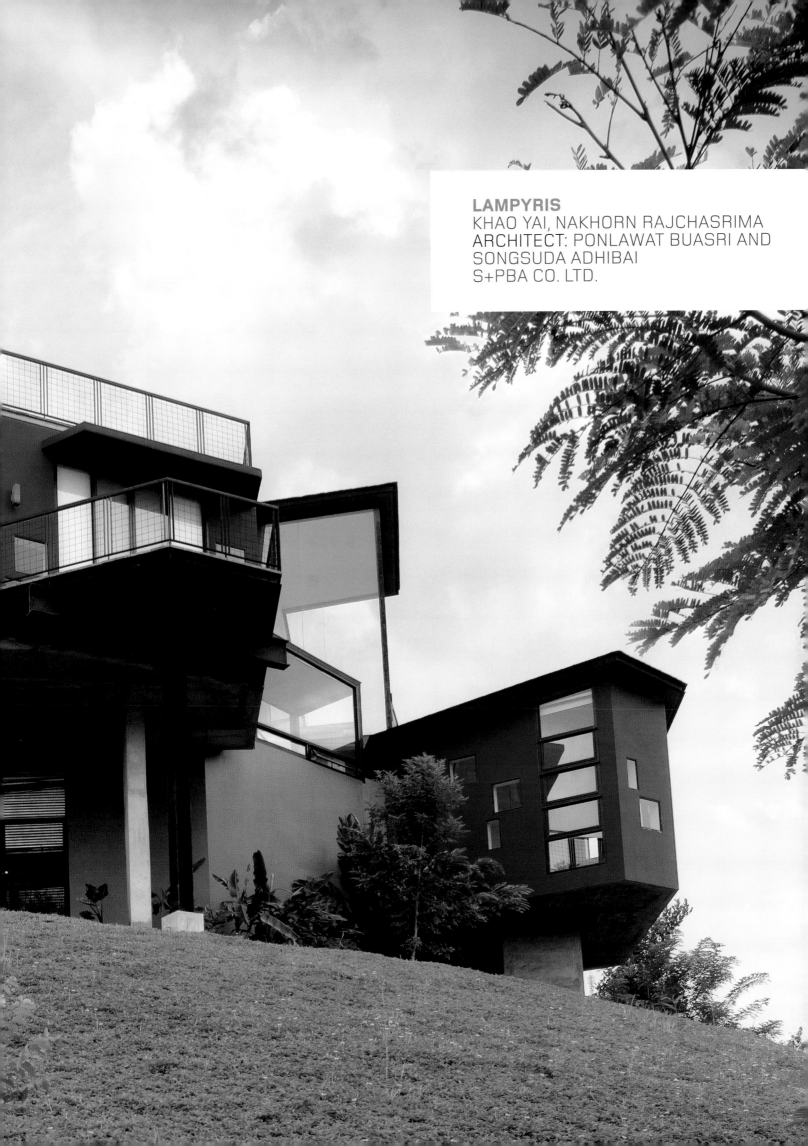

LAMPYRIS
KHAO YAI, NAKHORN RAJCHASRIMA
ARCHITECT: PONLAWAT BUASRI AND
SONGSUDA ADHIBAI
S+PBA CO. LTD.

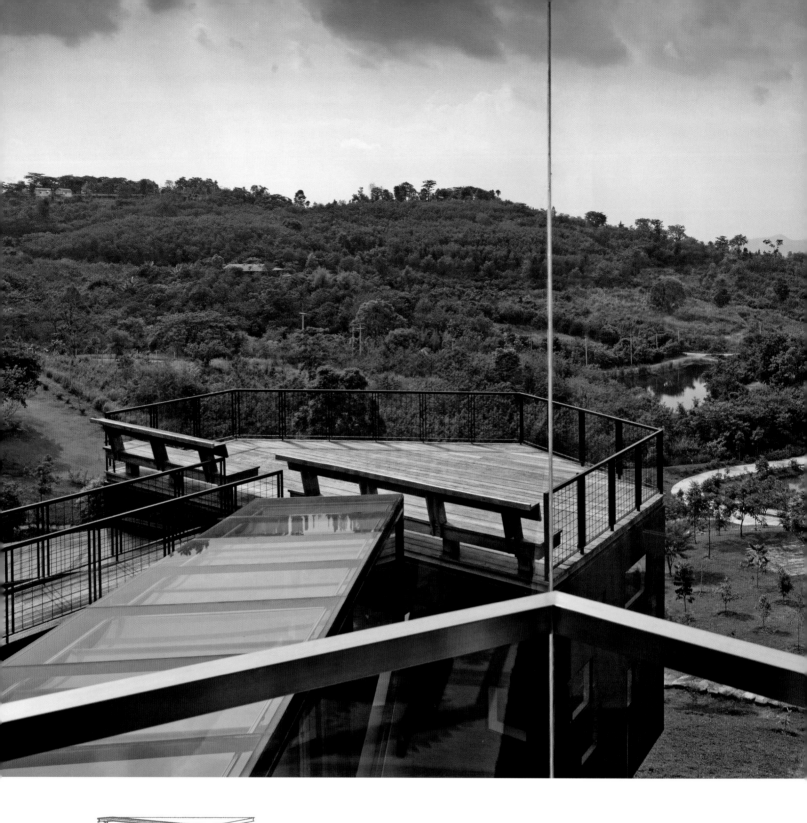

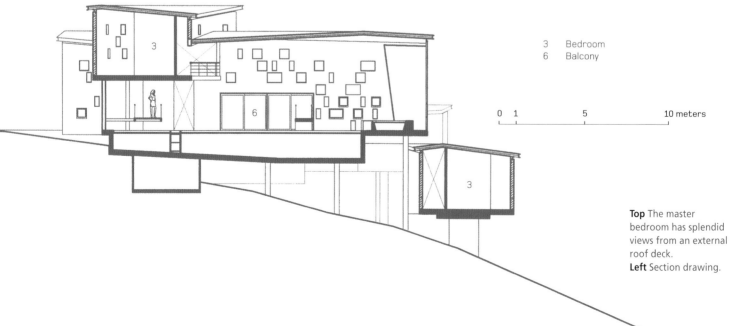

3 Bedroom
6 Balcony

0 1 5 10 meters

Top The master
bedroom has splendid
views from an external
roof deck.
Left Section drawing.

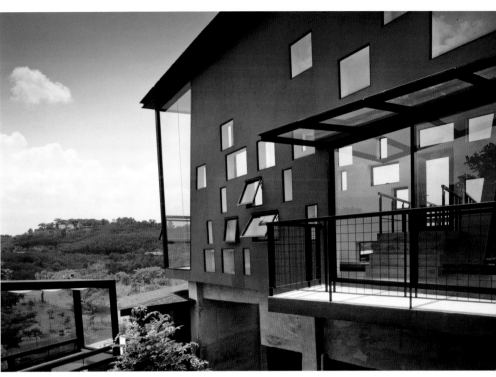

The Lampyris House is a striking modern residence located on sloping high ground adjacent to Wat Mongkutkiriwan and close to the boundary of Khao Yai National Park some 120 km northeast of Bangkok. It is the weekend retreat of Kamolwan and Prasert Fungwanich. The location in a secluded area is very quiet and intensely dark at night. At the heart of the residence is a magnificent tall 'swimming pool hall', with a kaleidoscopic array of rectangular windows.

The architects of the house are Ponlawat Buasri and Songsuda Adhibai of S+PBA Co. Ltd. Ponlawaat Busara is a graduate of Chulalongkorn University, Bangkok (1991), where his 'Linkage' design was selected by Tadao Ando and Jeffrey Kipness as winner of the Association of Siam Architects under Royal Patronage Experimental Architecture Competition. His partner in the firm, Songsuda Adhibai, graduated from King Mongkut Institute of Technology Ladkrabang in Bangkok and gained a Masters degree in Landscape Architecture from the University of Colorado at Denver in 2000. Both serve on the faculty of the School of Architecture at King Mongkut University of Technology at Thonburi.

The couple set up their practise in Bangkok in 2005, having gained recognition both nationally and internationally. They were named one of the finalists in the 2002 Grand Egyptian Museum competition sponsored by UNESCO and the International Union of Architects, and one of five finalists in a 2004 competition for the design of a World Performing Arts Village in Limerick sponsored by the Royal Institute of Architects of Ireland. More recent notable successes include first place in a competition for the Sport Center at Thailand Science Park, Pathumthani, in 2007. One year later, they were awarded first place in a competition for the 'Garden of Innovation' Laboratory at the Science Park.

Ponlawat expounds on the firm's philosophy: 'Our office has grown in Bangkok, a hybrid city that has hundreds of problems for creating good architecture. Our working method attempts to find an innovative design solution for each project.' A third partner in the practise is Taylor Rhodes Lowe, a Literature graduate of the University of California at San Diego and an M.Arch. graduate of the School of Art Institute of

Pages 200–1 The house is a constellation of polygonal buildings raised on stilts.

Above The exterior walls of the house are painted a deep purple.

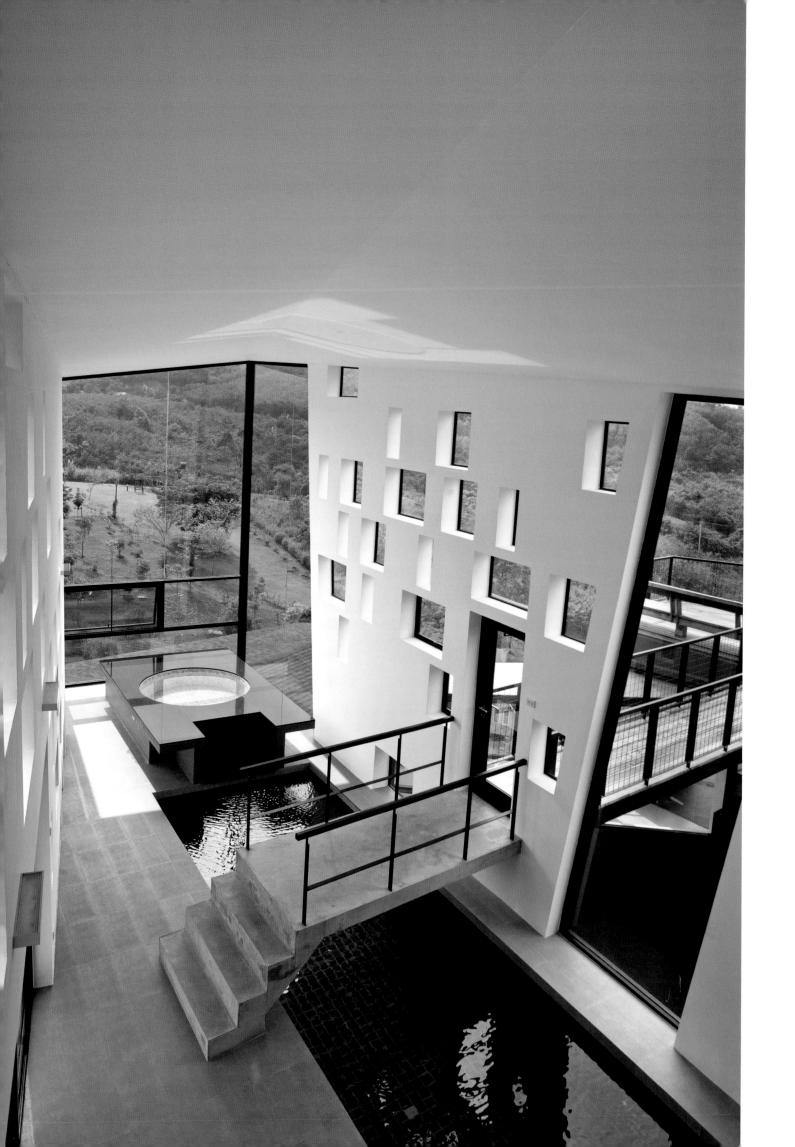

Chicago, who articulates the theoretical underpinnings of the firm's design methodology. His critical writing has earned him both the Berkhadt Prize and the Schiff Prize. He currently teaches in the International Program in the Faculty of Architecture at Chulalongkorn University.

The Lampyris House is constructed of concrete and glass and is raised on piloti. 'To create rooms with a single view was not the best design solution for this site,' Ponlawat explains. 'Thus, at the start we decided to raise the building up in the air. Each "room" is constructed on rectangular columns and floats at treetop level.'

The house is a multilevel dwelling descending the slope. An audio-visual space, living space, kitchen/dining room and bedrooms are located in a constellation at different levels around the swimming pool hall and a landscaped courtyard. The external form of the house is generated by a 'diagram' with the primary functions of the dwelling joined, like a space station, by 1.3-meter-wide glazed corridors and stairs, which allow the house occupants to experience a constantly changing environment when they move from room to room. The master bedroom overlooking the swimming pool hall has distant views from an external roof deck. Ponlawat describes it thus: 'The Lampyris House … fosters endless activity. We decentered the programme into an accentric system with connected nodes of activity … it is a constellation of polygonal buildings.'[1]

The entrance hall at the highest point of the site generates the main circulation route, which is a loop to connect rooms at different levels together and returns to the point of origin. The separation of the architectural mass meant the construction required only two trees to be cut down. Opening windows in opposite external walls induces natural ventilation.

The outside of the house is painted a deep purple, while the interior is pristine white. The evocative name of the residence refers to a small insect that glows in the dark northern forests. Similarly, the 'purple

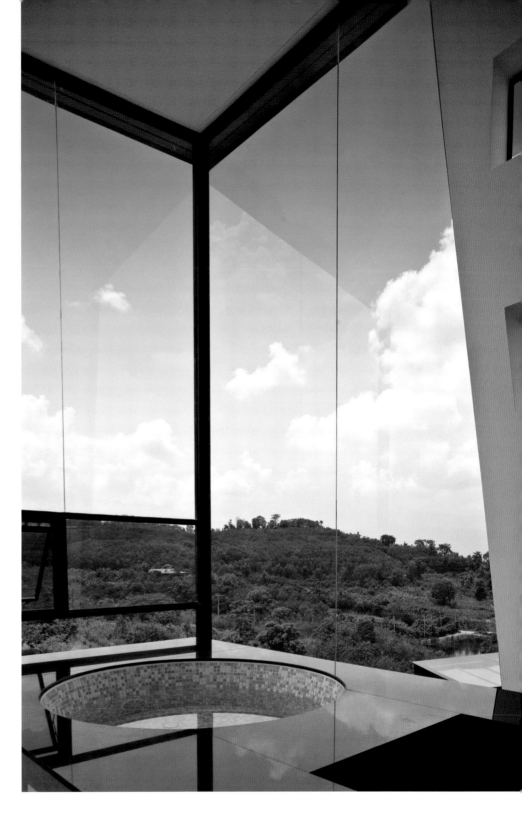

exterior dissolves into the night sky'[2] and emits light from numerous separate windows, but during the day the windows frame multiple views of the surrounding mountains and a large pond in the foreground. The intention is to reforest the site, which had previously been cleared for agriculture.

For a visitor, the functions of spaces are often ambiguous. 'The house', architect Ponlawat concludes, 'is about journeys not destinations. Anyplace can be anything. You can sit anywhere and have multiple experiences. Activities are not assigned to specific spaces but at places along the way.'[3]

1 Taylor Rhodes Lowe, *Make Less into More: S+PBA*, Amarin, Thailand, 2010, p. 45.

2 Ibid., p. 57.

3 Ibid., p. 46.

Opposite The house owners experience a constantly changing environment as they move from room to room.

Above Users of the Jacuzzi enjoy panoramic views of the surrounding landscape.

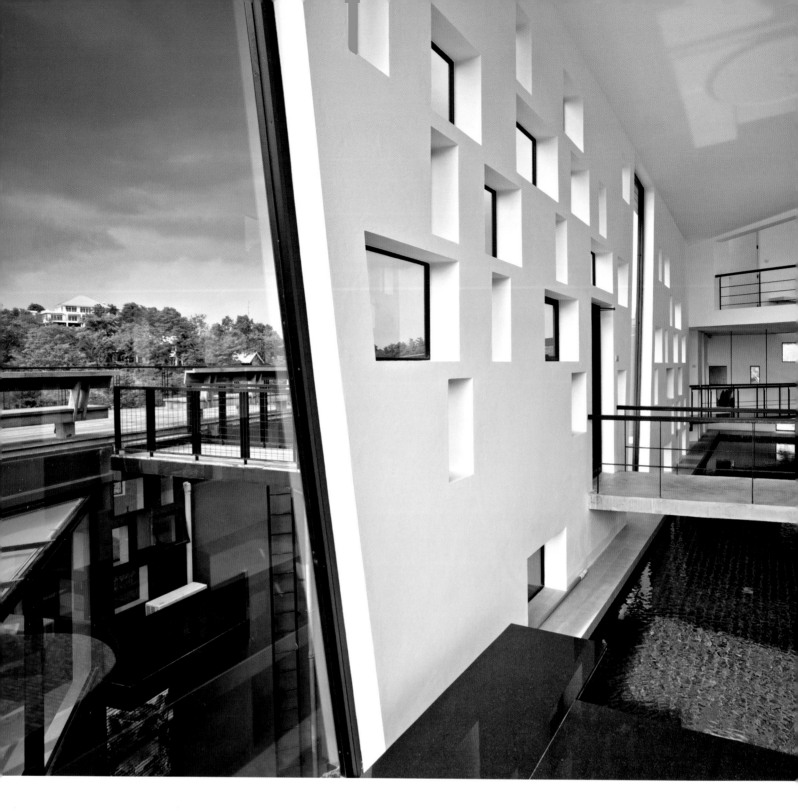

Left The house is a multilevel dwelling descending the slope.

Above Rooms in the house are arranged in a constellation around the swimming pool hall.

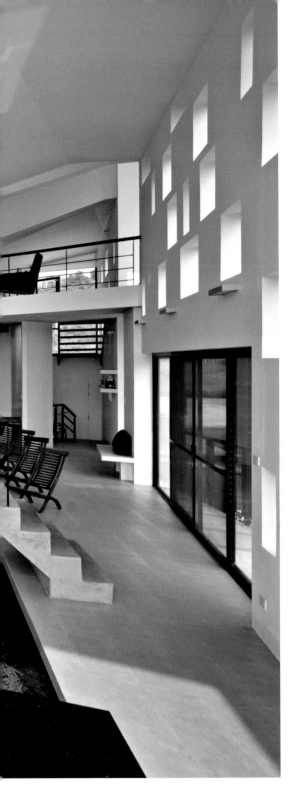

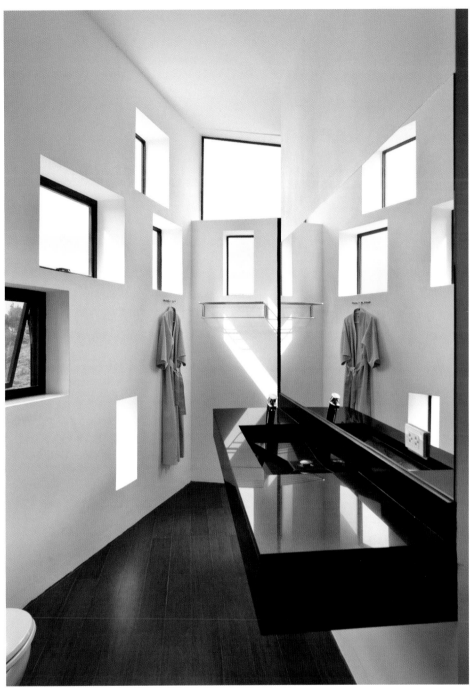

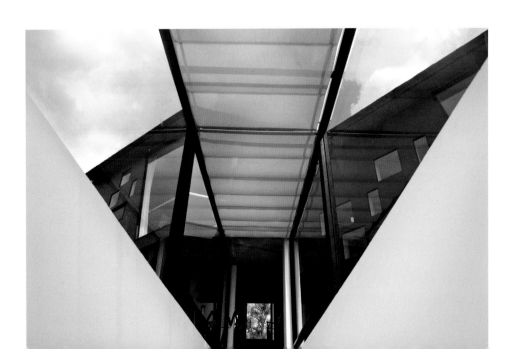

Above right Users of the bathroom enjoy multiple framed views.

Right The primary functions are joined by a 1.3-meter-wide corridor.

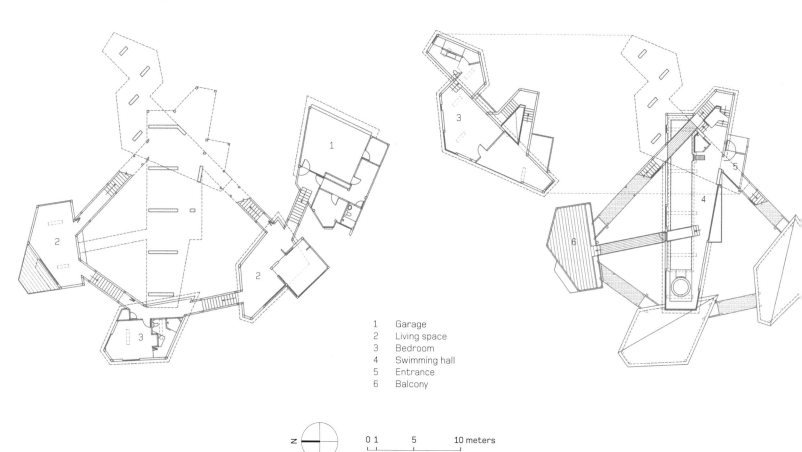

1 Garage
2 Living space
3 Bedroom
4 Swimming hall
5 Entrance
6 Balcony

N

0 1 5 10 meters

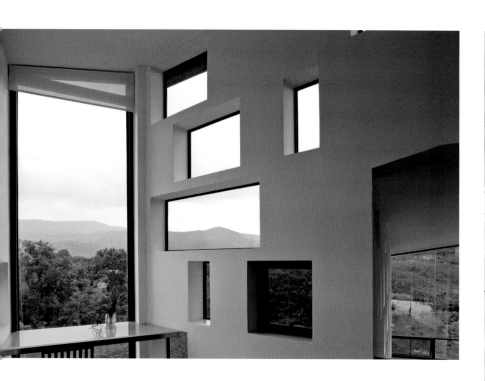

Above Activities are assigned to places along the way.

Top First, second and third floor plans.
Right A detail of the kitchen.

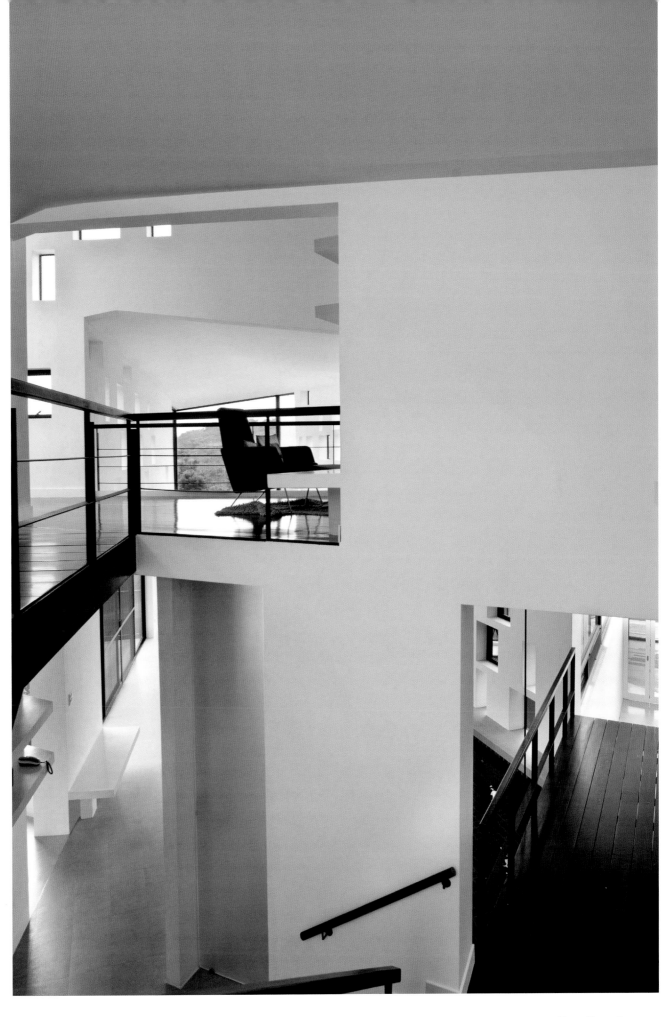

Above The various
components of the plan
are linked by corridors.
The interior walls of the
dwelling are all white.

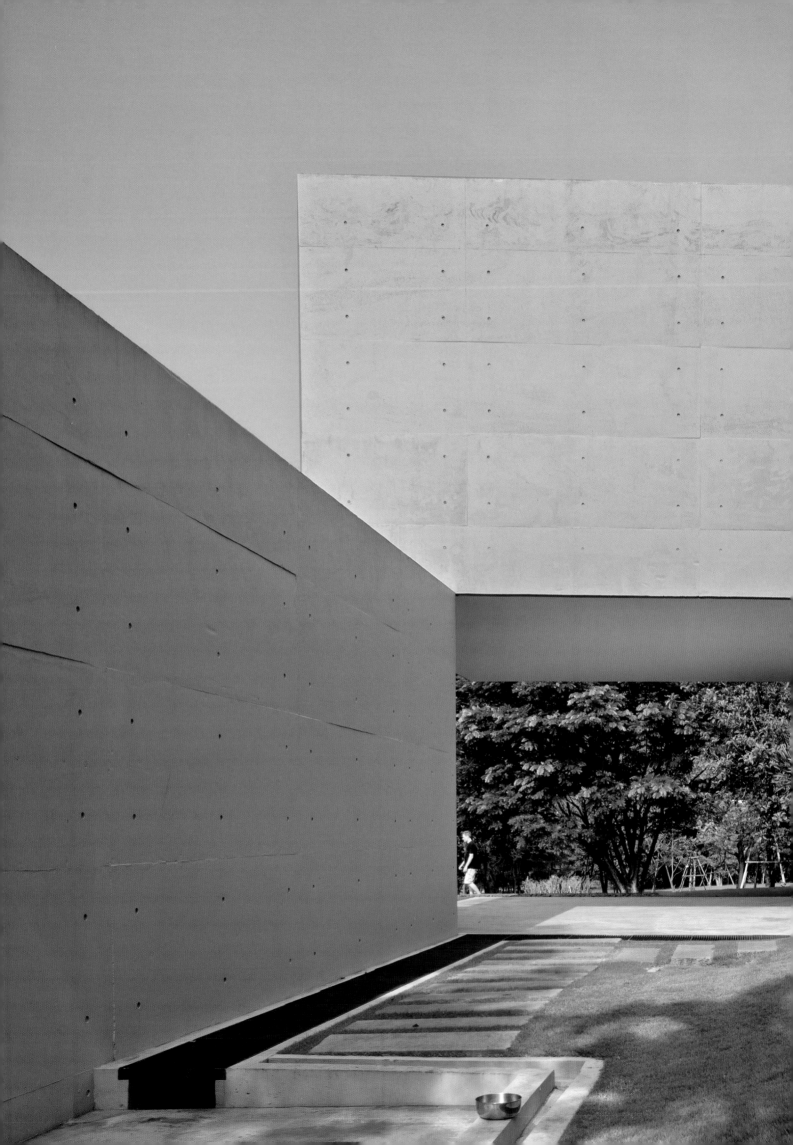

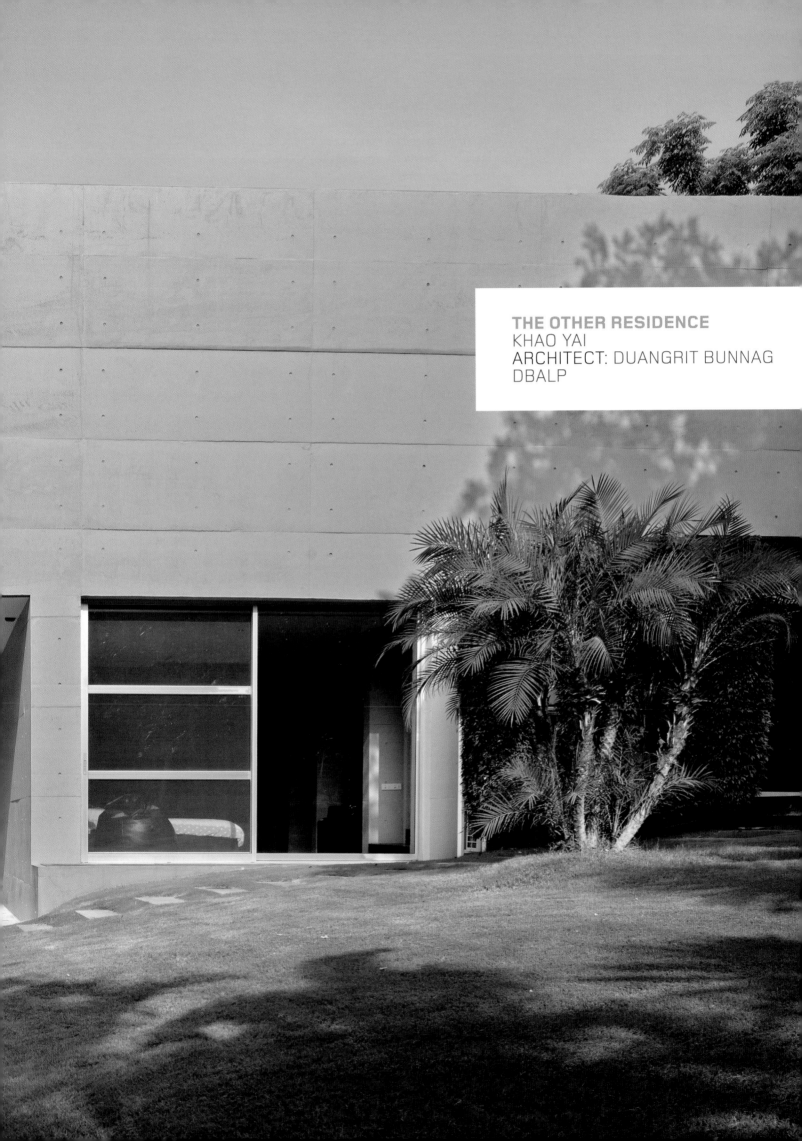

THE OTHER RESIDENCE
KHAO YAI
ARCHITECT: DUANGRIT BUNNAG
DBALP

The Other Residence is a cubist composition located on the edge of Khao Yai National Park. Surrounded by high mountains in the relative isolation of a broad valley, the house has a 'U'-shaped plan backing onto a steep forested hillside to the north and enclosing a timber-decked courtyard with a lap pool and a mature tree that shades an outdoor dining area. There is a dynamic contrast between the precise horizontal lines of the architecture and the natural landscape in which it is set.

The owners are Dr Jens Niedzielski and Paramee Thongcharoen. Both are directors of an international brand consultant and advertising agency with headquarters in Bangkok. Paramee Thongcharoen, a Thai, studied Business Management at California Technical University and later graduated with a Masters in Interior Design from the University of California at Los Angeles, but she has always worked in advertising. She lived for many years in Los Angeles before returning to Bangkok via Germany where she met Jens Niedzielski, who is of German origin, in Dusseldorf, while she was working for BMW. They have another residence in central Bangkok, but they enjoy escaping to Khao Yai at every possible opportunity. 'The capital is a quality place to work,' says Jens, 'but not to live. This house is an antidote to life in Bangkok.'

The architect of the residence is Duangrit Bunnag. He is a close friend of the couple, who were looking for a specific 'style' of architecture. Jens describes the house as 'in the spirit of the Bauhaus of the 1920s', which is exactly what he appreciates, along with the work of Tadao Ando and 'architectural masterpieces' in Southern California. They knew Bunnag's work well and considered him the best man for the job.

The house took three years to build. It is constructed in lightweight concrete for thermal mass, but neither the architect nor the contractor had used this method of construction before and learned by doing. There was wide variation in concrete quality,

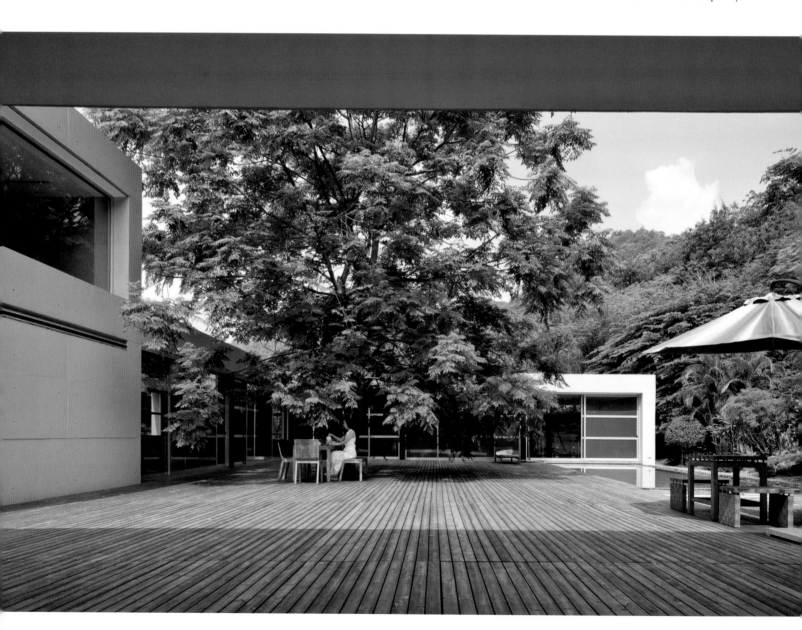

Above The expansive swimming pool deck is embraced by the mountainside.

Pages 210–11 The house is a strong cubist composition.

Opposite top Section drawing.

Opposite center and below The master bedroom cantilevers six meters over the house entrance.

0 1 5 10 meters

and on one occasion the contractor attempted to pour a whole floor in the rainy season. Consequently, there was lots of tearing down and rebuilding before a satisfactory finish was achieved.

Jens is technically inclined—he explains in great detail how they specified a 'well-built' house. Consequently, the pump room and electrical system are purposefully over-specified to cope with any emergency. The house is designed to cope with extremes of climate, for temperatures can be 9 degrees at night rising to 35 degrees during the day. His wife Paramee speaks more of emotional attachment to the house—of Thai cultural traditions. But both were united in their requirement that the house should be 'a home away from home', not a vacation home but a family residence.

They lived on site during the construction in a small dwelling that is now occupied by Paramee's parents, and their new residence was completed when their daughter was three weeks old. The accommodation includes a bedroom for their teenage son, a movie and audio room and a games room. The master bedroom suite is cantilevered six meters over the house entrance, which is otherwise somewhat uncelebrated. The couple designed the kitchen themselves using Siemen's components. It is a double-height space in an open plan that connects to the dining and living area. While the house is predominantly white, there are brilliant splashes of magenta on selected walls. The planar geometry generates beautiful effects of light and shade.

The couple muse upon the response of other people to their house. They observe that it is sometimes mistaken for a clubhouse

or a school. 'Most Thais are conservative and would not build a house like this. Indeed, to many a flat roof is "unfinished". As in other cultures, the so-called "mainstream" has a very stereotypical image of a house.' Perhaps it is travel and education that changes perception of what a house can be. It is also true that a house is 'a portrait of its owner(s)'.

5 Kitchen
6 Bedroom 1
12 Deck
18 Master bedroom
19 Master bathroom

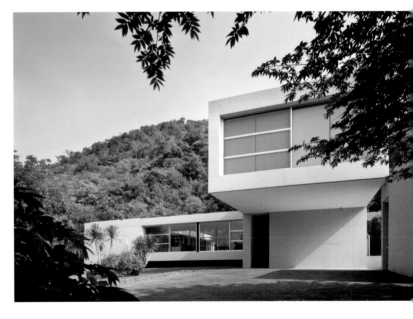

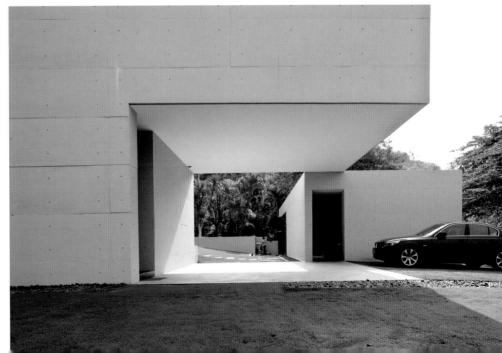

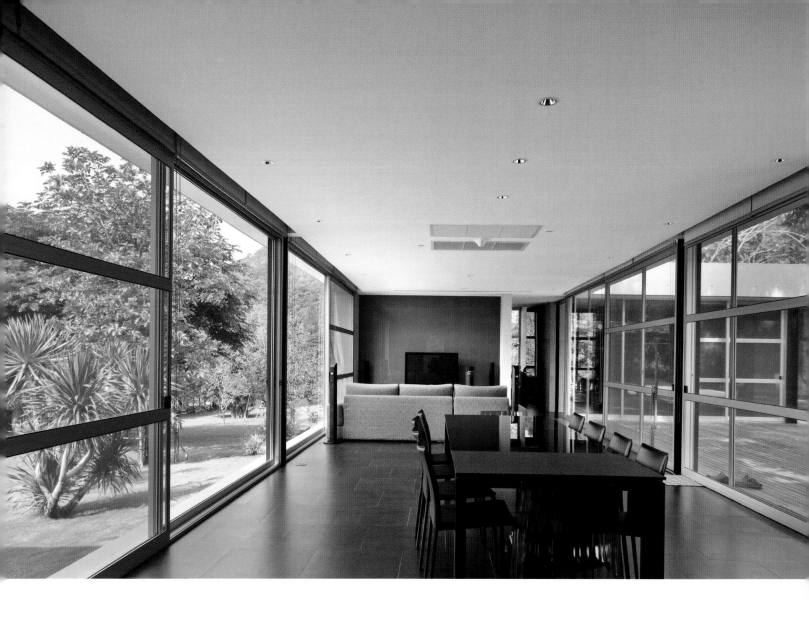

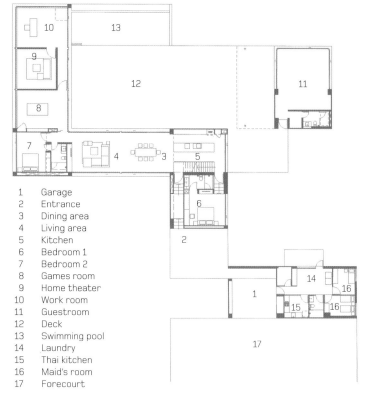

1 Garage
2 Entrance
3 Dining area
4 Living area
5 Kitchen
6 Bedroom 1
7 Bedroom 2
8 Games room
9 Home theater
10 Work room
11 Guestroom
12 Deck
13 Swimming pool
14 Laundry
15 Thai kitchen
16 Maid's room
17 Forecourt

Top The house is predominantly white, with vivid splashes of magenta on selected walls.

Above The games room opens to the pool deck.
Right First floor plan.

N

0 1 5 10 meters

Above right The owner describes the house as 'in the spirit of the Bauhaus'.

Right A large mature tree has been retained in the pool deck, offering shade during the day.

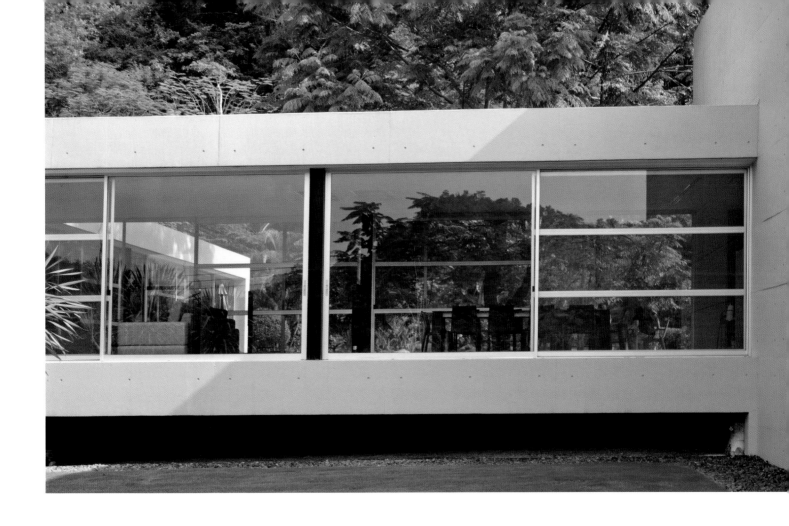

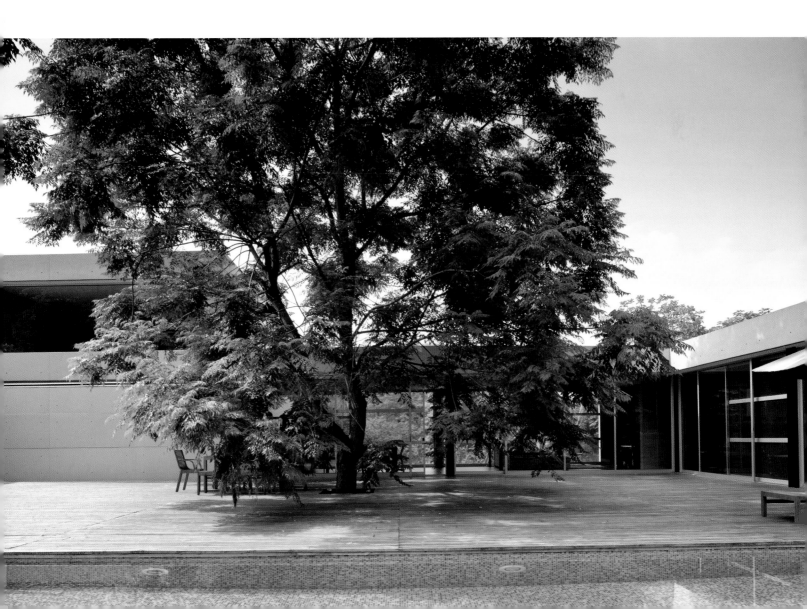

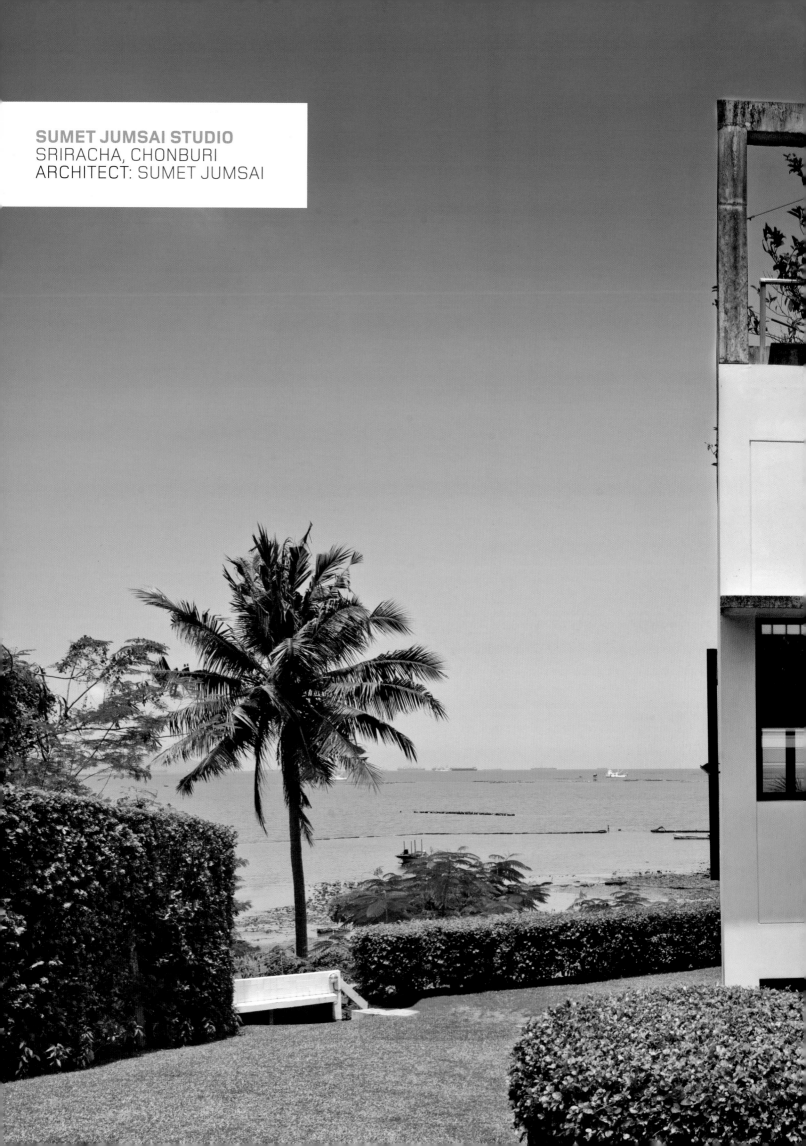

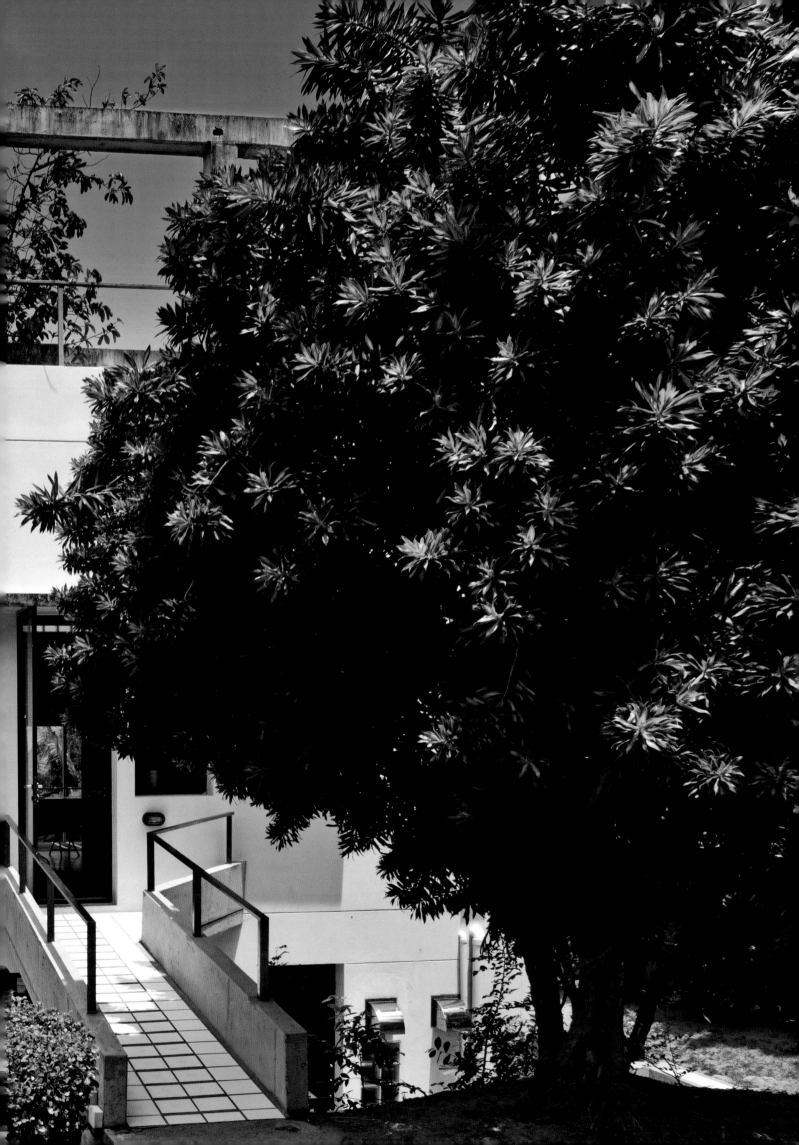

1 Studio
3 Bridge
4 Yard
5 Living/dining area
7 Bed space/library
9 Roof garden

N

0 1 5 10 meters

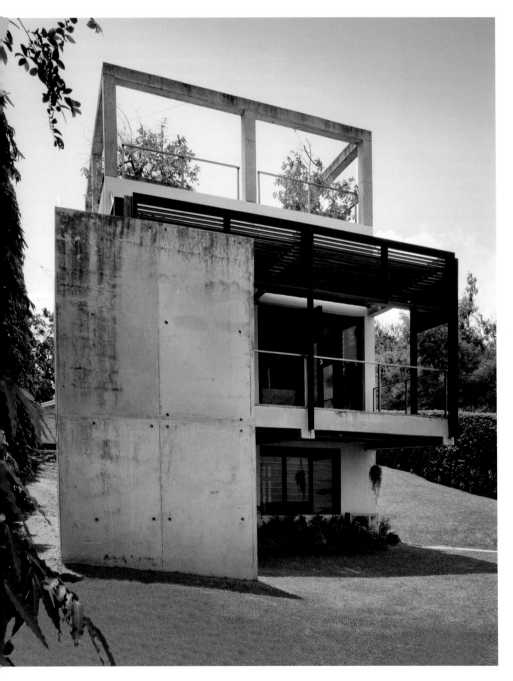

Sumet Jumsai's studio is a marvelous Le Corbusier-inspired weekend residence and painting studio. The off-form concrete structure is essentially a white box sitting in a garden of carefully mown grass against a backdrop of the ocean and sky. The form is generated by a 6 m x 6 m square ground floor plan extruded vertically, with an upper floor of the same dimensions and a flat roof, accessed by a very steep external stair.

The studio was designed by the renowned Thai polymath for his own use. Sumet Jumsai is a direct descendent of Siam's King Rama lll, who lived from 1788 to 1851. Sumet was educated in France and England and was awarded a Ph.D. in architectural studies from Cambridge in 1967. Le Corbusier was a major source of inspiration when he was an undergraduate. Being conversant in English and French when Corbusier visited Cambridge, Sumet found himself briefly assigned as an interpreter to the modern master.

Sumet was also influenced by Colin Rowe and Buckminster Fuller, and he has applied contemporary European forms and technical innovations to buildings designed within the Thai context.

In 1969, he formed his own private practise. His best-known early work is the angular Science Museum in Bangkok (1977) in collaboration with Tri Devakul and Kwanchai Laksanakorn. But his most famous and controversial designs are the Robot Building (1986), the Bank of Asia's head-quarters—now UOB's HQ—on Sathorn Road

Top Section drawing.
Above The studio is a Le Corbusier-inspired off-form concrete box.

Pages 216–17 The studio is located on the coast of the Gulf of Siam.

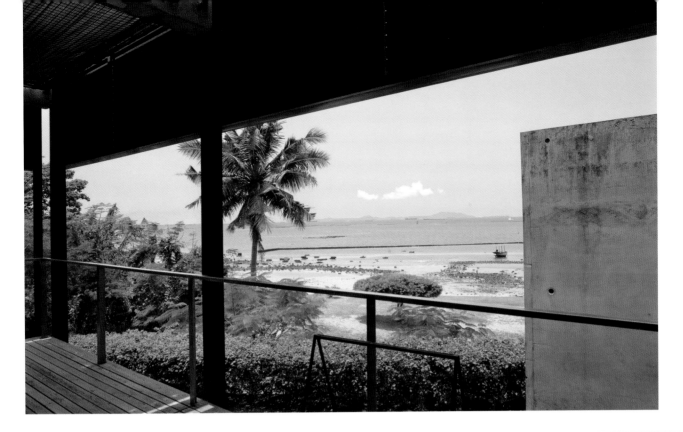

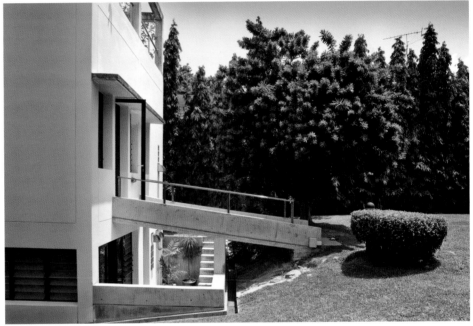

in Bangkok that was selected by Genova, the Cultural Capital of Europe in 2004, to be part of the exhibition 'Arti and Architecttura 1990–2004', and the Nation Building (1988). The latter, a distinctive tower block, is the headquarters of Bangkok's leading newspaper. Sumet is also the author of *Naga: Cultural Origins in Siam and the West Pacific*, a seminal book on the origin of civilization and architecture in Southeast Asia that grew out of collaboration with Buckminster Fuller.

Now the septuagenarian architect has retired from architectural practise and concentrates his energies on painting. He planned from the late 1989 onwards that he would build a studio on a 1,400-square meter plot of land purchased thirty years earlier at Sriracha, on the coast of the Gulf of Siam, 80 km to the southeast of Bangkok. It would be the ultimate scheme for what he has described as his 'graceful disintegration'.[1] Allegedly influenced by the political turmoil that engulfed Bangkok in 2006, he swiftly designed the small dwelling and construction commenced on the site in 2007. Eight months later, the studio/residence was complete and Sumet now escapes from the city at every opportunity to pursue his passion for painting. Sriracha is a one-hour drive from Bangkok and is a place where, unlike the metropolis,

the skies are clear in the afternoons and evenings and the light is excellent for painting.

Sumet studied in Paris as a young man before going on to Cambridge University. In France, the works of the Spanish painter Pablo Picasso shaped his ideas. 'Picasso was part of my generation in the early 1960s, plus Vivaldi and modern jazz.... I was drawing and painting from an early age,' he recounts, 'but my father didn't want me to be an artist. So I decided to study architecture, as it was the nearest thing to art. But I discovered that

architecture is art. It's a very important form of art, and it's also a form of poetry in concrete and steel, wood and glass.'[2]

The architect's love of European culture is immediately evident, for upon entering the studio the music of St. John Passion by Bach, sung by the choir of St. John's College, Cambridge (his own college) is being played at full volume, and before long a bottle of Chianti is opened.

This is one of the few private homes he has designed. The lowest floor is equipped with a

Top The studio opens to a veranda that overlooks the beach and the activities of local fishermen.

Above The bridge at the entrance evokes memories of Le Corbusier's Mill Owner's Association building at Ahmadabad.

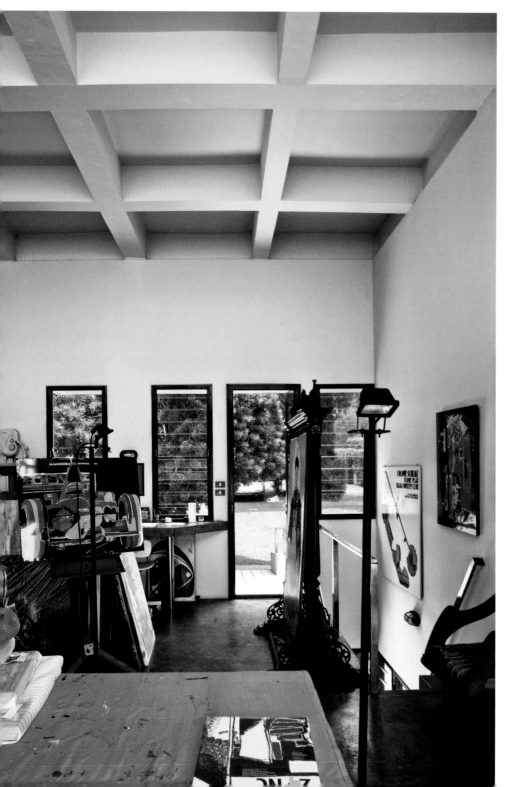

small kitchen, a food preparation area, dining space, a bathroom, a bed space and a library. The service entrance is from a sunken court-yard on the landward side of the house.

The upper floor is entered via a bridge over the courtyard. The bridge evokes memories of the entrance to Le Corbusier's Mill Owner's Association building at Ahmadabad, India, and Sumet confirms that this was the indeed the precedent. This floor is his painting studio—there are easels and a long bench facing the window and the Gulf of Siam beyond. There is a high ceiling in the studio, and a brightly colored red 'samba' staircase connects to the living space below. The studio is filled with paintings, on easels and hung on or stacked against the walls. All the works of art are rendered with intense color. In addition, there is a small, door-less bathroom separated from the room by a 1.5-meter-tall cupboard. The architect explains that it was designed this way in order to induce the most spacious and simple effect possible, in keeping with a lifestyle of simplicity where the main focus is on painting.

Projecting out from the studio on the seaward side is a broad timber balcony with views of fishermen tending their boats and mending their nets. It is a timeless place, and the view cannot have changed much for centuries. Access to the roof deck is gained from the balcony by the external stair.

'This house has been designed for the use of one person,' explains the architect/owner. 'I come here to paint on weekends.' Other than the homage to Le Corbusier, Sumet Jumsai's studio also employs a color scheme reminiscent of Gerrit Rietveld's Schroeder House or a Mondrian painting.

1 Woraphan Klamphaiboon, 'Home Alone', *art4d*, No. 132, Bangkok, November 2006.

2 For more information on this period of Sumet Jumsai's life, see Jim Algie, 'Building a Name in Paris', *AsiaWeek*, Vol. 25, No. 50, 17 December 1999.

Above left The artist's bed space and library.

Above right and left The high-ceilinged studio space.

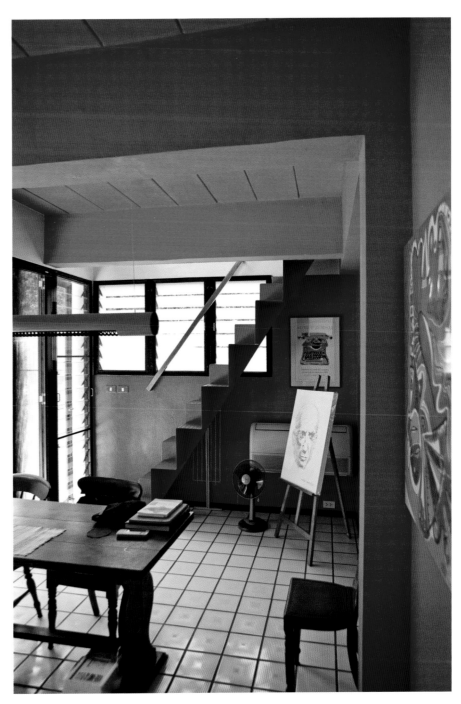

Top and below left
Works by the artist
hang on the walls.

**Above and center
left** The living/dining
area and staircase are
painted in primary red.

SELECT BIBLIOGRAPHY

ARCHITECTS DIRECTORY

Algie, Jim, 'Building a Name in Paris', *Asia Week*, Vol. 25, No. 50, 17 December 1999.

Bensley, Bill, *Paradise by Design*, Periplus Editions, Singapore, 2008.

'Bunker House', *Room: Ideas for Better Living*, No. 79, Bangkok, September 2009, pp. 70–5.

Chadanuch Wangroongaroona (ed.), *Thailand: Two Decades of Building Design 1968–1989*, Sang-Aroon Arts and Culture Center, Bangkok, 1989.

Chutarat Noochniyom, 'A Smaller House', *art4d*, No. 108, 2004.

'Commune by the Great Wall', *d+a (Asia)*, No. 009, 2002.

Curtis, William J. R., *Modern Architecture Since 1900*, Phaidon Press, Oxford, 1982.

Duangrit Bunnag, 'Co-Evolving Heterogeneity', in Robert Powell, *The New Thai House*, Select Publishing, Singapore, 2003, pp. 10–21.

Frampton, Kenneth (ed. John Cava), *Studies in Tectonic Culture: The Poetics of Construction in Nineteenth and Twentieth Century Architecture*, Illinois, MIT Press,1995.

Goad, Philip and Pieris, Anoma, *New Directions in Tropical Architecture*, Periplus Editions, Singapore, 2005.

Khwanchai Sutumsao et al, *Plankrich Portfolio*, Chiangmai, 2008.

Koompong Noobanjong, 'A Literature Review', *Power, Identity and the Rise of Modern Architecture: From Siam to Thailand*, University of Colorado, 2001.

London, Geoffrey, *Bedmar & Shi: Romancing the Tropics*, Oro Editions, New York, 2007.

Lowe, Taylor Rhodes, *Make Less Into More: S+PBA*, Amarin, Thailand, 2010.

Nithi Sthapitanonda (ed.), *Houses by Thai Architects*, Vol. 1, Li-Zenn Publishing, Bangkok, 2008.

Powell, Robert, '173 Polo House', *d+a (Asia)*, No. 007, 2007, pp. 47–9.

_____, 'Somchai Jongsaeng House', *The New Asian House*, Select Publishing, Singapore, 2001, pp. 164–7.

_____, *The Asian House*, Select Books, Singapore, 1993.

_____, *The New Asian House,* Select Publishing, Singapore, 2001.

_____, *The New Thai House,* Select Publishing, Singapore, 2003.

_____, *The Tropical Asian House*, Select Books, Singapore, 1996.

_____, *The Urban Asian House*, Select Books, Singapore, 1998.

_____, 'Tropical Danish', *Steel Profile*, No. 80, 2002, pp. 14–17.

Powell, Robert (ed.), *Architecture and Identity: Exploring Architecture in Islamic Cultures*, Vol. 1, The Aga Khan Award for Architecture, Concept Media, Singapore, 1983.

_____, *Criticism in Architecture: Exploring Architecture in Islamic Cultures*, Vol. 3, The Aga Khan Award for Architecture, Concept Media, Singapore, 1989.

_____, *Regionalism: Forging an Identity*, School of Architecture, National University of Singapore, 1991.

_____, *Regionalism in Architecture: Exploring Architecture in Islamic Cultures*, Vol. 2, The Aga Khan Award for Architecture, Concept Media, Singapore, 1987.

_____, *The Architecture of Housing: Exploring Architecture in Islamic Cultures*, Vol. 4, The Aga Khan Award for Architecture, Aga Khan Trust for Culture, Geneva, 1990.

Pirak Anurakyawachon, 'Boon Studio', *art4d*, No. 179, March 2011.

_____, 'Casa de Umbrella', *art4d*, No. 182, August 2011.

_____, 'Paths to Paths', *art4d*, No. 126, May 2006.

_____, 'We Love Concrete', *art4d*, No. 156, February 2009.

Pussadee Tiptus, 'Architecture in Thailand in the Rattanakosin Period', in Chadanuch Wangroongaroona (ed.), *Thailand: Two Decades of Building Design 1968–1989*, Sang-Aroon Arts and Culture Center, Bangkok, 1989.

Ricouer, Paul, 'Universal Civilisations and National Cultures', *History and Truth,* Northwestern University Press, Evanston, 1965, pp. 271–84.

Riley, Terence, *The Un-Private House*, Museum of Modern Art, New York, 1999.

Rirkrit Tiravanija et al, 'La Casa di Rirkrit Tiravanija', *Arbitare,* No. 478, February 2008, pp. 2–13.

Sant Suwatcharapinun, 'Rirkrit House', *art4d*, No. 140, August 2007.

Smyth, Darlene (ed. Oscar Rierra Ojeda), *5 in Five: BEDMaR & SHi*, Thames and Hudson, London, 2011.

Sumet Jumsai, *Naga: Cultural Origins in Siam and the West Pacific*, Oxford University Press, Singapore, 1987.

Taylor, Brian Brace, *Geoffrey Bawa*, Concept Media, Singapore, 1986.

Virilio, Paul, *Bunker Archaeology*, Princeton Architectural Press, 1994; originally published in French, 1975.

Warren, William, *Thai Style*, Asia Books, Bangkok, 1988.

Woraphan Klamphaiboon, 'Home Alone', *art4d*, No. 132, November 2006.

Author's Note

Architects in Thailand use a variety of conventions when annotating floor plans. For consistency I have adopted the US convention where the ground floor is usually referred to as the First Floor Plan. The floor immediately above is referred to as the Second Floor Plan and the floor below the First Floor is referred to as The Basement Plan.

Aroon Puritat Architect
23 Nimmanhaemin Soi 9, T. Suthep, A Muang, Chiangmai 50200, Thailand.
aroon17@gmail.com

Boonlert Hemvijitraphan, Boon Design
113 Soi Praditimanutham 19, Praditimanutham Road, Ladprao, Bangkok 10230, Thailand.
Tel: +66 (0) 2 5301765-6
boon_design@yahoo.com

Bundit Kanisthakhon, Tadpole Studio
666 Prospect Street, # 307 Honolulu, Hawaii 96813, USA.
Tel: +1 808 679 7688
tadpole@tadpolestudio.org

Duangrit Bunnag Architect Limited (DBALP)
989 Floor 28, Unit A2-B3, Siam Tower, Rama 1 Road, Patumwan, Bangkok 10330, Thailand.
Tel: +66 (0) 2658 0580-1
office@dbalp.com
www.dbalp.com

Ernesto Bedmar, Bedmar and Shi Pte Ltd
12A Keong Saik Road, Singapore 089119.
Tel: +65 62277117
www.bedmar-and-shi.com

John Bulcock Design Unit Sdn Bhd
8th Floor Syed Kechik Building, Jalan Kapas, Kuala Lumpur 59100, Malaysia.
Tel: +60 3 2096 1933
Mob: +60 (0) 126576957
john@designunit.com.my
info@designunit.com.my
www.designunit.com.my

Kanika Ratanapridakul, Spacetime Architects Co. Ltd.
32 Soi Soonvijai 8 (3), Petchaburi Road, Bangkapi, Huaykwang, Bangkok 10310, Thailand.
Tel: +66 (0) 2718 1533-5
admin@spacetime.co.th
www.spacetime.co.th

Neil Logan,
Fernlund + Logan Architects
414 Broadway, New York,
NY 10013, USA.
Tel: 212 925 9628
neil@fernlundlogan.com
www.fernlundlogan.com

Pattawadee Roogrojdee and
Apichat Sriarun, 639 Architects
Co. Ltd.
Chiangmai, Thailand.
+66 89 956 3293; +66 (0) 5 3499180
+66 (0) 818850521
dearpattawadee@yahoo.com

Pirast Pacharaswate,
Chulalongkorn University and
EAST Architects
321/53-54 Nanglinchi Road,
Yannawa, Bangkok 10120, Thailand.
Tel: +66(0) 2 285 4224
eastarchitects@eastarchitects.com
www.eastarchitects.com

Ponlawat Buasri and Songsuda
Adhibai, S+PBA Co. Ltd.
1060 Paholyothin 32 Road, Jatujak,
Bangkok 10900, Thailand.
Tel: 66 (0) 2 5611665
s_pba@yahoo.com
www.spluspba.com

Somchai Jongsaeng, DECA Atelier
Co. Ltd.
4/7 Senabadee Building 1, 1Fl,
Soi Phaholyothin 11 Phaholyothin
Road, Samsennai, Phayathai,
Bangkok 10400, Thailand.
Tel: +66 (0) 2 2799285-6
deca_atelier@yahoo.com
interior@deca-atelier.com

Srisak Phattanawasin, Faculty of
Architecture and Planning
Thammasat University,
Rangsit Campus, Khlong Luang,
Pathumthani 12121, Thailand.
Tel: +66 (0) 2 9869605-6
srisak@ap.tu.ac.th
sriza1411@yahoo.com

Stefan Schlau, Atrium Design
Co. Ltd.
22 Soi Polo (Trok Rongpaksaladaeng),
Wireless Road, Pathumwan,
Bangkok 10330, Thailand.

Tel: +66 2 655 8512
atriums@gmail.com
www.atriumss.com

Sumet Jumsai, SJA Co. Ltd.
106/1 Sukhumvit 53,
Bangkok 10110, Thailand.
Tel: +66 2 2590035 Ext 12
sumet.jumsai@gmail.com

Surachai Akekapobyotin and
Juthathip Techachumreon, Office
AT (Architectural Transition) Co.
Ltd.
61/56 2nd Floor, Soi Taveemitr 8,
Rama IX Road, Huay-kwang, Bangkok
10310, Thailand.
Tel: +66 2 6122477–8
Fax: +66 2 6122480
surachai@officeat.com
juthathip@officeat.com
contact@officeat.com
www.officeat.com

Tanit Choomsang and Kwanchai
Suthamsao, Plankrich Architects
25 Soi 13, Sirimankalajarn Road,
Suthep Muang, Chiangmai 50200,
Thailand.
+66 (0) 53894816; +66 (0) 818857543
tanitmail@gmail.com
plankrich@gmail.com
www.plankrich.com

Vasu Virajsilp and Boonlert
Deeyuen, VaSLab Architecture
344 Soi Sukhumvit 101, Sukkumvit
Road, Bangchak, Prakanong,
Bangkok 10260, Thailand.
Tel: +66 (0) 2 7418099
vaslab@vaslabarchitecture.com
vasu@vaslabarchitecture.com
www.vaslabarchitecture.com

AUTHOR: Robert Powell
R5 Marine Gate, Marine Drive,
Brighton BN2 5TN, UK.
Mob: +44 (0) 7918724261
robertpowell42@yahoo. co.uk
www.robertpowell-architect.com

PHOTOGRAPHER: Albert Lim KS
12 Koon Seng Road,
Singapore 426962
Mob: +65 96425350
albertlim55@yahoo.com.sg

Published by Tuttle Publishing, an imprint of Periplus Editions
(HK) Ltd.

www.tuttlepublishing.com

Text © 2012 Robert Powell
Photographs © 2012 Albert Lim Koon Seng

ISBN: 978-0-8048-4278-5

Distributed by

North America, Latin America & Europe
Tuttle Publishing
364 Innovation Drive, North Clarendon, VT 05759-9436 USA
Tel: 1 (802) 773-8930; Fax: 1 (802) 773-6993
info@tuttlepublishing.com
www.tuttlepublishing.com

Japan
Tuttle Publishing
Yaekari Building, 3rd Floor
5-4-12 Osaki, Shinagawa-ku, Tokyo 141-0032
Tel: (81) 3 5437-0171
Fax: (81) 3 5437-0755
sales@tuttle.co.jp
www.tuttle.co.jp

Asia Pacific
Berkeley Books Pte. Ltd.
61 Tai Seng Avenue, #02-12, Singapore 534167
Tel: (65) 6280-1330
Fax: (65) 6280-6290
inquiries@periplus.com.sg
www.periplus.com

15 14 13 12 10 9 8 7 6 5 4 3 2 1
Printed in Singapore 1206CP

Front endpaper Dama zAmya, Phuket. Architect: John
Bulcock, Design Unit.
Page 1 Serenity, Cape Yamu, Phuket. Architect: Duangrit
Bunnag, DBALP.
Page 2 Three Parallel House, Nonthaburi. Architect:
Spacetime Architects.
Page 4 Lampyris, Khao Yai. Architect: Ponlawat Buasri
and Songsuda Adhibai, S+PBA.

ACKNOWLEDGMENTS

First, I must record my gratitude to the owners of the houses included in this book for permitting me to feature their homes. They include Acharapan Paiboonsuwan (Pa Ji), Anthony and Anna Wilkinson, Boonlert and Aurapin Hemvijitraphon, Carol Grodzins, Chaisri Sophonsiri, Frank Flatters and Duangkamol Chotana (Jeab), Gary Dublanko and Dea Zoffman, Dr Jens Niedzielski and Paramee Thongcharoen, Julien and Yen Reis, Kamolwan and Prasert Fungwanich, Komkrit Kietduriyakul and Chaveewan Likhitwattanachai, Naris and Maria Siamwalla, Nawaree Summasanti, Panupong and Busakorn (Kai) Harirak, Radab Kanjanavanit, Radja Smutkojon and Ravee Purananda, Rirkrit Tiravanija and Antoinette Aurell, Siriwan Tiensuwan and Noppasorn Duangtawee, Sivika Sirisanthana, Somprasong Sahavat and Buachompoo Ford, Srisak and Panadda Phattanawasin, Surachai and Wannaputt Utaobin, Tanaphon Him and Vorarat Manavutiveth, Teerasit Sophonsiri and Aim-on O-parirat, Tosaporn and Samorn Wongweratom, Veronica and H. Chin Chou, and Vasu Virajsilp.

Equally, I must thank the architects of these houses, including the internationally acclaimed architect/artist Dr Sumet Jumsai and the 'next generation' that includes Aroon Puritat of Aroon Puritat Architect, Boonlert Hemvijitraphan of Boon Design, Bundit Kanisthakhon of Tadpole Studio, Duangrit Bunnag of DBALP, Kanika R'kul (Ratanapridakul) of Spacetime Architects, Khwanchai Suthamsao and Tanit Choomsang of Plankrich Architects, Pattawadee Roogrojdee and Apichat Sriarun of 639 Architects, Pirast Pacharaswate of EAST Architects, Ponlawat Buasri, Songsuda Adhibai and Taylor Rhodes Lowe of S+PBA, Somchai Jongsaeng of DECA Atelier, Srisak Phattanawasin, Surachai Akekapobyotin and Juthathip Techachumreon of Office AT (Architectural Transition), and Vasu Virajsilp and Boonlert Deeyuen of VaSLab Architecture. Almost all are in their late thirties or early forties.

I have included three houses by non-Thai architects: a vacation residence in Phuket designed by the Argentinean architect Ernesto Bedmar, who is based in Singapore; another by John Bulcock, a British architect who operates out of Kuala Lumpur, and a third by Stefan Schlau, a German architect who has lived in Bangkok for nearly twenty years. There is also a collaborative work involving Neil Logan of Fernland and Logan Architects in New York and Aroon Puritat.

Numerous other individuals have assisted me, including my longtime friend Bill Bensley, Chatchawan Sethaburth, Chirakorn Prasongkit, Craig Arndt, Howard Buckingham, Jaree Suwunnaluck, Jariyawadee Lekawatana, Luke Yeung, Maliwan Meeintha, Manop Nilsonthi, Mark Pincock, Natee Suphavilai, Nitra Ruamrak, Orawan Jongsomjitr, Piya Bamrungras, Pornchai Boonsom, Ratthaphon Sujatanonda, Songtam Srinakarin, Tan Hock Beng, Terdsak Choedchu-amphai, and Veron Lee.

Eric Oey of Periplus/Tuttle Publishing and the staff in Singapore, including June Chong and Chan Sow Yun, have been supportive and I appreciate the contribution of the book's editor, Noor Azlina Yunus, in Kuala Lumpur, for her meticulous reading and astute comments. I must also thank my collaborator Albert Lim. We work well together and traveling with Albert is always enlightening. This is now the ninth book we have produced together and his brilliant architectural photography has done much to raise the level of appreciation of good design in Southeast Asia.

Finally, to my wife Shantheni Chornalingam and our daughter Zara Shakira, my heartfelt thanks for their enduring support.

THE TUTTLE STORY
"Books to Span the East and West"

Most people are surprised to learn that the world's largest publisher of books on Asia had its humble beginnings in the tiny American state of Vermont. The company's founder, Charles Tuttle, came from a New England family steeped in publishing, and his first love was books—especially old and rare editions.

Tuttle's father was a noted antiquarian dealer in Rutland, Vermont. Young Charles honed his knowledge of the trade working in the family bookstore, and later in the rare books section of Columbia University Library. His passion for beautiful books—old and new—never wavered through his long career as a bookseller and publisher.

After graduating from Harvard, Tuttle enlisted in the military and in 1945 was sent to Tokyo to work on General Douglas MacArthur's staff. He was tasked with helping to revive the Japanese publishing industry, which had been utterly devastated by the war. When his tour of duty was completed, he left the military, married a talented and beautiful singer, Reiko Chiba, and in 1948 began several successful business ventures.

To his astonishment, Tuttle discovered that postwar Tokyo was actually a book-lover's paradise. He befriended dealers in the Kanda district and began supplying rare Japanese editions to American libraries. He also imported American books to sell to the thousands of GIs stationed in Japan. By 1949, Tuttle's business was thriving, and he opened Tokyo's very first English-language bookstore in the Takashimaya Department Store in Ginza, to great success. Two years later, he began publishing books to fulfill the growing interest of foreigners in all things Asian.

Though a westerner, Tuttle was hugely instrumental in bringing a knowledge of Japan and Asia to a world hungry for information about the East. By the time of his death in 1993, he had published over 6,000 books on Asian culture, history and art—a legacy honored by Emperor Hirohito in 1983 with the "Order of the Sacred Treasure," the highest honor Japan bestows upon non-Japanese.

The Tuttle company today maintains an active backlist of some 1,500 titles, many of which have been continuously in print since the 1950s and 1960s—a great testament to Charles Tuttle's skill as a publisher. More than 60 years after its founding, Tuttle Publishing is more active today than at any time in its history, still inspired by Charles Tuttle's core mission—to publish fine books to span the East and West and provide a greater understanding of each.

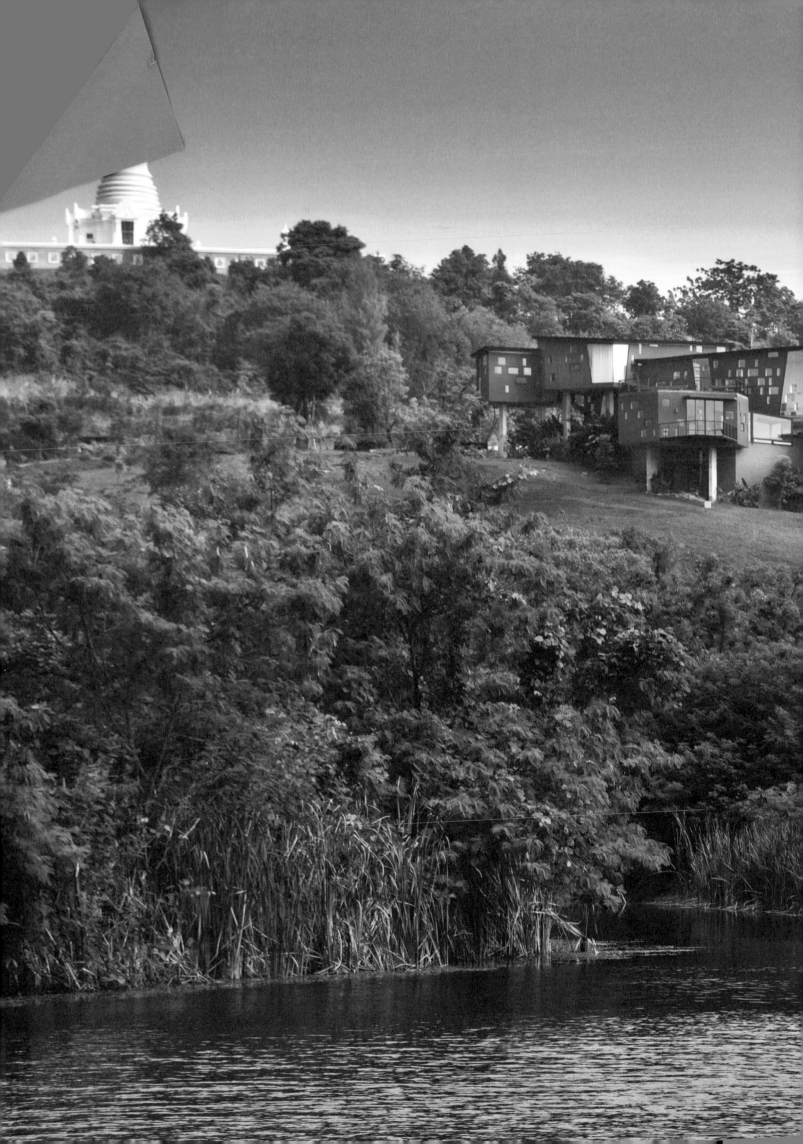